*Art & Emp*

MW00608836

*Perspectives on the Art and Architectural History*
*of the United States Capitol*

Donald R. Kennon, Series Editor

Donald R. Kennon, ed., *The United States Capitol:*
*Designing and Decorating a National Icon*

Vivien Green Fryd, *Art and Empire: The Politics of Ethnicity*
*in the United States Capitol, 1815–1860*

# Art & Empire

The Politics of Ethnicity in
the United States Capitol, 1815–1860

Vivien Green Fryd

Published for the
United States Capitol Historical Society
by Ohio University Press
Athens

Ohio University Press, Athens, Ohio 45701
© 2001 by Ohio University Press
Printed in the United States of America
All rights reserved

First published 1992 by Yale University Press.
First Ohio University Press edition 2001.

Earlier versions of some of the material in this book have appeared in
*The Augustan Age* 1 (1987); *The American Art Journal* 19, no. 2 (1987); and
*The Italian Presence in American Art, 1760–1860* (New York: Fordham University
Press; Rome: Istituto della Enciclopedia Italiana, 1989), pp. 132–49.

*Ohio University Press books are printed on acid-free paper* ⊗ ™

10 09 08 07 06 05 04 03 02 01    5 4 3 2 1

Library of Congress Cataloging-in-Publication Data

Fryd, Vivien Green.
  Art & empire : the politics of ethnicity in the United States
Capitol, 1815–1860 / Vivien Green Fryd.
    p. cm. —(Perspectives on the art and architectural history of
the United States Capitol)
    Originally published: New Haven : Yale University Press,
c1992.
    Includes bibliographical references and index.
    ISBN 0-8214-1342-2 (pbk. : alk. paper)
    1. Art, Modern—19th century—Washington (D.C.) 2. Art
and state—Washington (D.C.) 3. Allegories. 4. Minorities in art.
5. United States Capitol (Washington, D.C.) I. Title: Art and
empire. II. Title.

N6535.W3 F78 2000
709'.73'074753—dc21
                                                        00-044592

*to Martin Fryd and Emma Renee Fryd*

# Contents

# Preface

*Art and Empire* focuses on the roles of race and politics in the decoration of the United States Capitol during the nineteenth century, but the topic is a timeless one, given the symbolic associations of the building with our country's democratic government and its ideals of liberty and equality. Alexander Lawson's 1814 engraving, *View of the Capitol of the United States after the Conflagration in 1814*, makes clear the relationships among the building, liberty, and slavery.[1] In this illustration from an abolitionist text, chained and whip-scarred slaves stand to the right, looking at the building under the "cloud-borne 'geniuses of *Liberty and humanity.*'" Chapter 8 in *Art and Empire* clearly indicates that Jefferson Davis, secretary of war in charge of the Capitol Extension's decoration after 1850, worked to erase any references to slavery in the U.S. Capitol decoration, especially the dome statue by Thomas Crawford. Within this context, the absence of the dome and Rotunda that had yet to be inserted in the U.S. Capitol building symbolically registers the silence on the subject of slavery that some statesmen attempted to achieve in its decoration.

Thomas Nast understood the relationship between Crawford's *Statue of Freedom* (1863) and slavery. Nast's *The Emancipation of the Negroes—The Past and the Future*, published in *Harper's Weekly* on January 24, 1863, shows Crawford's triumphant statue atop an oval frame in which an African American

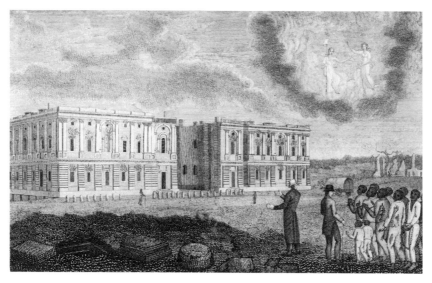

Alexander Lawson, after Alexander Rider. *View of the Capitol of the United States after the Conflagration in 1814.* Engraving. From Jesse Torrey, *A Portraiture of Domestic Slavery in the United States* (Philadelphia, 1817). Courtesy of the American Antiquarian Society, Worcester, Massachusetts.

family participates in domestic activities under the watchful eyes of Lincoln, whose portrait hangs by the fireplace.[2] Given the forced separation of slave families prior to 1863, the presence of the mother, father, sons, and daughters together at last around the hearth signifies that Lincoln's act enabled former slaves to form a tight nuclear family. The vignettes outside the oval on the left side illustrate the hardships of slave life, including beatings, the auction of male slaves, the tearing of families apart, and forced labor. The right side shows the prosperity and family life that African Americans will enjoy as free people; they exchange money at a bank, attend school, and exist as a family. Nast placed the *Statue of Freedom* in front of the word "Emancipation," which is emblazoned in light and clouds, clearly connecting the statue with the very conditions of African American Southern life that entailed slavery and the hope for freedom. Justice, at the top right, holds the scales, while on the left, allegorical figures, perhaps the Demons of Slavery, chase slaves in a field. Nast implies that Crawford's statue promises emancipation and now stands proudly viewing the scenes below, a message counter to Secretary of War Davis's intentions.[3]

Both Lincoln and the statue, Nast suggests, ended the horrors of the past and issued the promise of the future that seems to be illustrated in the smaller encircled motif below, in which Father Time holds a white child on his lap. These two figures probably represent Kronos, a newborn child who symbolizes dawn and the beginning of a new day, and Orthros, who appears to take the chains off the African American man standing before him, symbolizing the new day of freedom for his race.

Carlton Wilkinson's photograph of the Million Man March that took place in Washington, D.C., in 1995 further indicates the power of race and its con-

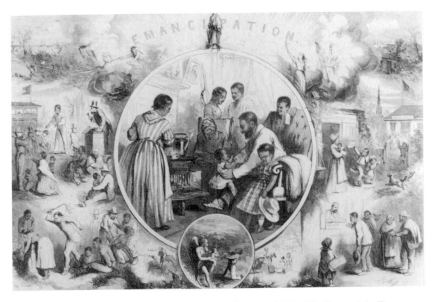

Thomas Nast. *The Emancipation of the Negroes, January, 1863—The Past and the Future.* From *Harper's Weekly*, January 24, 1863. Photograph by Herb Peck.

tradictions inherent in the U.S. Capitol decoration. The figures standing on top of a fountain in Wilkinson's photograph and the statue on the U.S. Capitol dome form a series of similarities and polarities. The black men and the *Statue of Freedom* both establish dark shapes against the blue sky: the statue in the distance and smaller, the men in the foreground and larger. The height of the statue that seems pushed upward by the gleaming Capitol dome competes for attention with these proud men who view the masses in attendance at this march, but also assert their position in the United States as African American men who will lead their people toward unified goals of prosperity and education. The men are free, but their ancestors may have been enslaved in the South. Even if this is not the case, all blacks—not just those with Southern roots—trace the current atmosphere of racism to the former oppression of slavery. The men participated in the Million Man March to share their universal suffering, strengthen their spirits, and pledge to rebuild communities. The female figure of the statue, on the other hand, symbolizes the very oppression of black people that these men march to protest against. She stands unmovable with sword in hand, supposedly ready to enforce democracy throughout the world; but for Jefferson Davis in the 1850s, democracy could not apply to his slaves. The immobility of the statue contrasts with the men who are poised for action, ready to move forward with their freedom and claim it as their human right.

Wilkinson's photograph captures the hopes and dreams that still need to be realized for the African American men who wait outside the U.S. Capitol building, not unlike the slaves in Lawson's engraving. For a black audience (Wilkinson himself is African American), the men stand above the fountain to

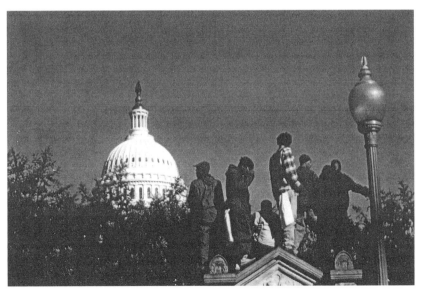

Carlton Wilkinson. *Standing on Capitol Hill.* 1995. Ilfordchrome print.
Courtesy of Carlton Wilkinson.

proclaim their rightful place within the nation, not separate from the government nor from the freedom promised by that government. This photograph indicates that the issues of race embodied in the Capitol decoration of the nineteenth century still have meaning for us today.

It is my hope that this book will enable us to understand racist attitudes of the past toward African Americans and Native Americans as they applied to the U.S. Capitol decoration, especially now, at the beginning of the twenty-first century, when the population of the United States moves increasingly toward the domination of minority groups. Rather than attempting to hide examples of the stereotypes and racist attitudes of the past (by removing from the Capitol, for example, Luigi Persico's *Discovery of America* and Horatio Greenough's *Rescue*, a topic addressed in chapter 4), we should instead retain them in the building and study them as a way to remember and change such attitudes still prevalent in our culture today. It is my hope that the greater accessibility of this book in paperback for the general public will enable Americans and people of other nationalities to understand the past as a means to change the present.

I would like to thank the Ohio University Press, especially its director, David Sanders, for publishing this book in paperback, making it more affordable for visitors to the U.S. Capitol. I also want to express my appreciation to the United States Capitol Historical Society and especially to Chief Historian Donald R. Kennon for their assistance with the cost of publishing the illustrations and for enabling this book to be a part of the Perspectives on the Art and Architectural History of the United States Capitol series. Susan Sochaki did the arduous task of writing for permission to republish these photographs, for which I am grateful. Finally, I would like to acknowledge my daughter, Emma Renee Fryd, who was a baby when I looked over the galleys of the first book manuscript and who now understands a little of what I do when I am in my "professional" role as scholar and art historian.

## Notes

1. I first learned about this image from John Davis's "Eastman Johnson's *Negro Life at the South* and Urban Slavery in Washington, D.C.," *Art Bulletin* 80 (March 1988): 71.

2. I would like to thank Jochen Wierich for making me aware of this illustration.

3. The wood engraving furthermore evokes Christ in the *Last Judgement*. Here Crawford's statue replaces Christ to become a secular savior; on her left appear the saved African Americans who are free, on her right are the damned who suffer under slavery. Traditionally the damned are located on Christ's left and the saved on the right. Nast's engraving may reverse this traditional location of damned and saved, thereby placing the viewer in the position of Christ as Judge.

# Acknowledgments

No project on the United States Capitol and its artworks can be complete without consulting the archival material collected by those who have worked in the Office of the Architect of the Capitol. The assistance of Barbara Wolanin (Curator for the Architect of the Capitol), John Hackett (Archive Specialist), Florian Thayn (former Art and Reference Specialist), and Pamela Violente (Museum Specialist) was invaluable over the years when I did research in the office, as well as later, during the final revisions of the manuscript.

The financial assistance of various organizations supported my research. A Vanderbilt University Research Council Direct Research Support Grant (1986), a Capitol Historical Society Fellowship and Smithsonian Short Term Visitor's Grant (1987), and an American Council of Learned Societies Grant-in-Aid (1988) enabled summer research trips to Washington, D.C., Boston, and New York. A Vanderbilt University Research Council Fellowship helped finance a year's sabbatical from my teaching duties so that I could complete the manuscript, and the Capitol Historical Society and Vanderbilt Subvention Fund assisted with the costs of the photographs.

Many people have contributed greatly to the substance of the book. In a four-day marathon, Emily Umberger listened to my rambling ideas, helping me synthesize the material and organize the chapters. Others who helped me sort out my ideas in numerous conversations are Dan Cornfield, Angela Miller, Cecelia Tichi, Valerie Traub, and Alan Wallach. Cecelia Tichi also patiently read drafts of each chapter and supplied invaluable suggestions. Her enthusiastic support provided inspiration throughout my sabbatical year. Others who read portions or all of the manuscript are Nancy Anderson, Sarah Burns, Joyce Chaplin, Dan Cornfield, Leonard Folgarait, Jimmie Franklin, Barbara S. Groseclose, Angela Miller, Annette Stott, Valerie Traub, Alan Wallach, and Barbara Wolanin. To all these people I am indebted. Pat Willis deserves recognition for confirming my citations. I also would like to thank Ann Abrams, George Gurney, and Annette Stott for assisting me in finding and ordering photographs. I am grateful to David Lubin and Cecelia Tichi for encouraging Yale University Press to publish this book; to the reader of the manuscript, Michele Bogart, for many suggestions and questions; to Richard Miller, manuscript editor, whose careful reading helped improve the text; and to Judy Metro, senior editor, for her support and encouragement.

During the summers I spent in Washington, D.C., my brother and his family helped make my time away from home enjoyable and filled with special memories. Marnie, Joshua, and Shana probably never realized that as they grew from infancy, so did this book. Finally, my husband, Martin, deserves thanks for his unwavering support, enthusiasm, and love through the years during which he had no choice but to live with this book.

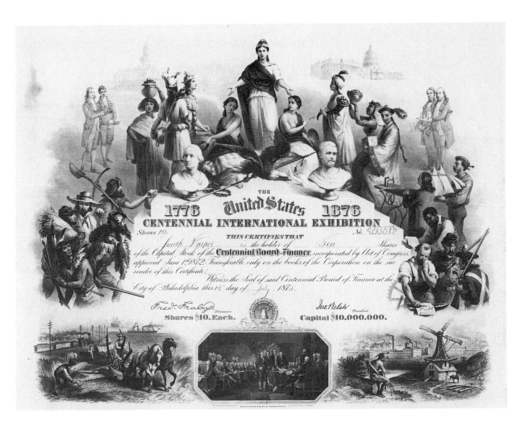

1. F. O. C. Darley and Stephen J. Ferris. *Centennial Stock Certificate.* C. 1874–1875. Engraving. 18½ × 22½ in. Courtesy of Professor and Mrs. Ellwood C. Parry III.

# Introduction

The United States Capitol in Washington, D.C., not only "embodies the basic tenet of democracy, that the people ought to govern themselves";[1] the building also symbolizes other values that can be discerned only by paying attention to the works of art located inside and on the east facade. In this book I put forward one interpretation of the art in the Capitol produced between 1815 and 1860, dates that mark the close of one war (the War of 1812) and the onset of another (the Civil War). I begin in the year that Congress and the president decided to rebuild the Capitol after the British had set fire to the uncompleted legislative building in 1814. (Many works produced before that time were lost in the fire). The War of 1812 had consolidated a sense of nationhood among U.S. citizens, and not surprisingly, the Capitol's reconstruction strengthened the building's emergence as a national symbol of democracy and liberty. Despite various periods of financial difficulty and some congressmen's apprehension over what they considered to be ostentatious embellishment,[2] the decoration of the Capitol continued until the outbreak of the Civil War, when almost all funds slated for artworks were diverted to the military effort. The Civil War thus brings this book to a close, for although works of art continued to be commissioned after that conflict—most notably those to fill Statuary Hall (established in 1864) and Constantino Brumidi's *Apotheosis of Washington*, painted in the interior of the dome in 1865—these must be examined within the different historical contexts of postwar Reconstruction and early twentieth-century developments.

The subject matter and iconography of much of the art in the Capitol forms a remarkably coherent program of the early course of North American empire, from the discovery and settlement to the national development and westward expansion that necessitated the subjugation of the indigenous peoples. No one planned a systematic decorative program in the nineteenth century; yet from the perspective of the late twentieth century, an iconographic and thematic consistency prevails in the art that thematically traces the course of empire.

This course is perhaps most strikingly seen in the stock certificate issued in 1875 by the Centennial Board of Finance established for the centennial of the birth of the United States and purchased by Smith Harper, producer of farm and garden implements. This business voucher (fig. 1) is framed by images that form a narrative text summarizing the evolution of the United States from 1775 to 1875. A woman in flowing robes wears a cap that identifies her as Liberty. Flanking her on the right and left are ethnic women who bear gifts (a secularized version of the three wise men who bring gifts to the newborn Christ). The women personify the four parts of the world: America, Europe, Asia, and Africa. Seated beside Liberty are two more personifications, America on the left with a flag draped around her torso, and the Arts with a brush in one hand and a palette in the other. An

American eagle flies at the feet of Liberty and is flanked by two simulated sculpted portrait busts of George Washington and Rutherford B. Hayes, the first and current presidents of the United States. Standing on the outskirts of this centralized group are four men who hold minuscule models of trade and manufacture.

A lower tier of images, located in the center of the voucher on either side of the text, represents men of diverse occupations: a farmer with wheat and another with cotton, a fur trader with rifle, and a miner with shovel and pickaxe. It also shows a Native American in feathered headdress, holding a bow and some arrows. Similarly, the right side features a sailor, two manufacturers, and two soldiers—one from the Revolutionary War and the other from the Civil War—as well as an African American. Below are three separate vignettes. John Trumbull's painting of *The Declaration of Independence* adorns the center. On the left, farmers plow and harvest a wheat field, with three modes of transportation—a Conestoga wagon, a locomotive, and some boats—occupying the surrounding landscape. In the right vignette, an Indian is seated upon a log facing a windmill and a town filled with factories. Crowning the top of the certificate are less discernible images, the Philadelphia State House and U.S. Capitol—two federal buildings that indicate an association between the country's market economy and its political system.

Taken together, these representations and their relations outline the progress of the United States in its first hundred years. The two men on the left of the lower tier, for example, not only represent farmers but also refer to specific regions (the North and the South), because of the wheat and cotton associated with them. Their placement among other figures takes on additional significance when it becomes apparent that the fur trapper, miner, and Native American refer to the Midwest and West, and when the actions and positions of these regional signifiers are considered: except for the southerner, who gazes at his northern counterpart, the white men look and move toward Liberty, America, and the Arts. The Native American, on the other hand, stands with his back to these centralized personifications, looking behind him as he prepares to flee the onslaught of civilization. This figure must be considered in relation to the other Native American, in the lower right vignette, who is separated from the vast industrial town. His position beside a tree indicates his association with the untamed land that is still untouched by progress. The seated pose of the native and his contemplative gaze add to the meaning of this illustration and the rest of the motifs, for he represents the Vanishing American. A codified image in nineteenth-century American art and literature, it refers to white America's conviction that with the progress of the United States, the indigenous population will become extinct.[3]

The engraved copy of Trumbull's *Declaration of Independence* and the Revolutionary soldier on the right indicate that from the moment of the nation's independence and creation, American civilization and progress—manufacturing, farming, and commerce—have blossomed across the continent, resulting in the inevitable demise of the native population. The wealth and power of the hundred-year-old country is acknowledged by other nations as personified by the

gift-bearing women. The presidents of the United States (represented by the two portrait busts) and the federal government (referred to by the two buildings) have led the nation in its progress toward fulfilling its destiny.

My interpretation of the stock certificate derives not only from the images themselves but also from the history of nineteenth-century American events and beliefs. Westward expansion, for example, provides the historical basis for understanding why Native Americans are rendered as Vanishing Americans: these natives will have to forfeit their land so that white Euro-Americans may farm, build towns, and engage in various businesses. The images on the stock certificate are connected to white America's conviction that the nation's successful enlargement (through emigration, treaties, and conflict) derives from its destiny to spread democracy and progress throughout the continent.

The interpretation of this artifact and my contextual approach serve as models for the study of other motifs in both high and popular art—that is, works by trained artists intended as one-of-a-kind, rarified objects and those by trained artists and untrained artisans formulated for mass production. In this book, I apply the same approach to artworks created by American and European artists for the Capitol building. Because, like the images on the stock certificate, these objects are located within one structure and commissioned by one patron (in this case the federal government), the images must be considered not in isolation but in relation to one another. By examining many of the works of art separately and then in conjunction with other objects of similar subject matter and meaning, I show that much of the sculpture and painting in the U.S. Capitol forms an iconographic program that outlines the course of North American empire by promoting and legitimizing the subjugation of the Native Americans. Just as the centennial stock certificate includes personifications, portraits, pioneers, farmers, Native Americans, and soldiers that take on particular meanings when considered as a whole, the art in the Capitol includes some similar and many different configurations and relationships that in conjunction embody ideologies. By the term *ideology* I mean dominant, state-supported beliefs and values. I recognize that there were other ideologies in the United States during the nineteenth century and that these emergent and residual ideologies were often in conflict with the dominant ones, but these did not influence nor become manifest in the art in the Capitol building.[4]

It is my contention, then, that since the portraits, reliefs, allegories, and history paintings are located in the Capitol building, and since they were financed by the federal government, they must have been both consciously and unconsciously intended to suggest particular implications in which race relations function as a chief mechanism for justifying white Euro-American domination over Native Americans. This applies to most of the works executed during the antebellum period although others refer to different themes such as those of war and peace and the apotheosis of George Washington.[5]

Based on the interrelationship between politics and public art, my approach combines standard art-historical methods of formal and iconographic analyses with social and political history.[6] It embodies a social history of art beginning and

ending with the work of art, and reading its meaning through an analysis of subject matter, composition, and iconography, on the one hand, and politics and ideological beliefs, on the other.[7] The two are not parallel developments but are closely connected.

The iconographic program of the Capitol unfolded over a period of time that extends before and beyond the period covered in this book. Because the entire scheme evolved piecemeal, with works created by various artists during numerous administrations and under the aegis of various government officials (the commissioner of public buildings, the secretary of the interior, and the secretary of war), it is only in hindsight that one can discern such a program. Nevertheless, Montgomery C. Meigs (1816–1889) recognized the implications of the artworks already in place when he served as supervising engineer of the Capitol extension between 1853 and 1859. He recommended subjects and meanings for new works that would amplify on those already embodied in the decoration, thereby deliberately extending and focusing the iconographic program.

The political strife that spanned the nineteenth century affected the subject matter and meaning of some artworks in the Capitol, and conversely, some artworks influenced statesmen in their debates. In effect, the art functioned as a stage on which congressmen acted out national tensions and conflicts. At times, the allegories, portraits, and historical narratives related to debates in Congress that historians have clearly analyzed: Indian removal, westward expansion, tariffs, states' rights, and sectional discord over slavery. This becomes increasingly evident when the art is examined in the light of contemporary events: the nullification crisis of 1828–1833; the passage of the Indian Removal Act (1830); the Mexican War (1846–1848); the annexations of Texas, Oregon, and California (1845, 1846, and 1848); and the establishment of the reservation system for the Indians (1850s). The close intertwining of art and politics during the early and middle decades of the nineteenth century allows us to analyze the polemical underpinnings of particular commissions. Sometimes the artists themselves proposed subject matter for their works. Often particular statesmen and federal employees—presidents, cabinet members, architects, superintendents of engineering, congressional committees, senators and representatives—guided the subject matter and meaning of particular works of art. As a result, individual artworks and groups of artworks embody political ideologies. At the same time, however, these images do not simply express the beliefs and values of politicians; they also encompass the dominant ideological values in the United States.

The overlapping and reinforcing themes in the Capitol art reproduce several dominant political discourses and ideologies when citizens and statesmen sharply disagreed on such issues as extension of slavery to the territories and the solution to the "Indian problem." The art in the Capitol served to legitimize congressional legislation and to coalesce divergent beliefs into a state-supported, unified ideology to create a semblance of consensus in the face of intractable political and sectional divisions. The art in the Capitol presented a mythologized American history that allowed Americans to believe in their manifest destiny to absorb western lands and relocate Indian tribes to enable frontier expansion and the

development of a market economy; it justified, reinforced, and promoted white male politicians' imperialistic ideals and actions. Not accidentally, the art excluded African Americans just as it marginalized, subjugated, and dehumanized Native Americans. These ideals and actions became apparent to some critics and politicians not only in ways of which contemporaries were conscious, but also in less explicit ways. The relationships between the themes and meanings embodied in the Capitol artworks and antebellum literature, popular arts, and political discourses help us understand these less explicit implications, as do the critical responses to and the omissions or inversions of certain kinds of imagery.

Although the representation of the Native American has been explored in American literature, few critics have analyzed white America's construction of this subject in the visual arts.[8] As Barbara S. Groseclose has accurately observed, "We call these natives 'Indians' as did Columbus (who thought he had reached India), thereby perpetuating European dominance through the controls of language: permanently misnaming Indians, we define them as, among other things, irrevocably out of place."[9] But Native Americans do have a prominent and permanent place in Capitol art as a dislocated and subjugated race, their representations becoming the property of the federal government and, by extension, the "American" people. The implications and meanings of these representations— constructions that tell us more about the artists' and patron's attitudes than about the indigenous peoples and their customs—form the central focus of this book.

I employ terms that can be considered ethnocentrically constructed: *Indian*, *primitive*, *savage*, *heathen*, and *civilization*. But despite not placing them in quotation marks, I do not condone the implications of these words as used in the nineteenth century and even today. Despite the pejorative connotations, nineteenth-century white Americans used these terms for specific meanings that cannot be reconstructed without resorting to similar words. Also, *North America* here refers to the political entity founded by Europeans that became the United States, and the term *American* refers to Euro-Americans and white Americans; other ethnic groups, like Native Americans and African Americans, are identified as such.

Besides examining the images that are present in the U.S. Capitol, I also consider what is absent. Policymakers wanted stereotypes of Native Americans as noble and ignoble savages who must be vanquished for white American domination of the continent. Furthermore, they explicitly rejected images that they thought of as sympathetic to Native Americans and their culture, ones that failed to promote the extinction of the native population. At the same time, the figure of the educated and integrated black man in the post-Civil War centennial stock certificate is virtually absent from the Capitol embellishment, a deliberate effort to exclude references to slavery on the part of both northerners and southerners. Jefferson Davis, secretary of war in charge of the Capitol extension between 1853 and 1857, especially wanted no references in the national legislative building to the slave system that he supported and that caused such sectional turmoil and disagreement.

There are other exclusions. The federal government commissioned only male

artists. Few white American women painters were trained academically before the Civil War, and even fewer (if any) executed history paintings, the preferred genre for the Capitol murals. Although a colony of American women sculptors, described by Henry James as "a white marmoreal flock," lived and worked in Rome during the middle of the nineteenth century, these artists did not receive any federal commissions for Capitol statuary.[10] (Vinnie Hoxie Ream was the first woman to receive a commission to do a work of art for the Capitol: her 1870 statue of Abraham Lincoln stands in the Rotunda).[11]

Given that men created the artworks and that white middle- and upper-class men served in the federal government, it is not surprising that the iconographic program in the art decoration of the Capitol represents the white male experience of the frontier. As Annette Kolodny has shown, whereas frontier women imagined the western frontier as a domestic garden, their spouses set out to conquer both the land and the Indian.[12] Just as the American historical novel primarily focused on the male fantasy of "regeneration through violence,"[13] glorifying the conflict between the white man and the Indians and heroicizing such mythic pioneers as Leatherstocking and Daniel Boone, the art in the Capitol represents this male version of the white experience in the United States visually, contributing to a fiction of the American experience.

I also examine other themes that are assembled in the Capitol, those associated with various myths involving George Washington, Christopher Columbus, Pocahontas, the Pilgrims, William Penn, Daniel Boone, the discovery of the western continent, the early settlement of the eastern seaboard, and pioneer experiences in the western wilderness. The art of the period embodies, crystallizes, and reinforces these myths as a part of American history.[14]

The closing years of the twentieth century are a propitious time in which to examine those issues and conflicts that still persist in race relations, interregional rivalries, and the uneasy relationship between art and federal patronage. The 1992 quincentennial of Christopher Columbus's arrival in the New World triggers thoughts about what has occurred in the past five hundred years, and how and why Columbus became honored as the founder of the United States.[15] The examination of how the history of the country's formation became sanctified and mythologized through the art in the Capitol contributes to our understanding of how nineteenth-century Americans thought about the legacy inherited from such historical figures as Christopher Columbus and George Washington. It suggests that they saw an uninterrupted evolution of civilization in the New World, initiated by the first discoverer and continued by the first president of the United States and his successors.

# Part One

## The Capitol Reconstruction
## 1815–1849

# 1

## The Rotunda Reliefs

If we could have visited the reconstructed Capitol in 1830, fifteen years after its destruction at the close of the War of 1812, we would have found the building even more physically imposing than it is today. At that time, it stood alone on a wooded hill, without such surrounding structures as the present-day Library of Congress and Supreme Court to detract from it. Upon entering the Rotunda, we would have viewed a much sparser decorative scheme. Jonathan Elliot's 1830 guidebook, *Historical Sketches of the Ten Miles Square Forming the District of Columbia*, indicates that the four reliefs of historical subjects that now occupy the lofty room then already adorned the interior space. If we follow Elliot's tour, we first spot *Preservation of Captain Smith by Pocahontas* (see fig. 11) above the western entrance and then turn around to see *Landing of the Pilgrims* (see fig. 14) over the east door. To the right, we find *Conflict of Daniel Boone* (see fig. 19) over the south door and in turning around again, *Penn's Treaty with the Indians* (see fig. 15) over the north door. As Elliot notes, John Trumbull's four history paintings constituted the only additional decoration.[1] Consequently, in 1830, few works of art detracted from the architectural setting of the Rotunda, with its coffered ceiling in the hemispherical dome (now replaced by Thomas U. Walter's higher coffered dome and Constantino Brumidi's frescoes) and its entablature ornamented with twenty olive wreaths and supported by Grecian pilasters.

Although in 1830 only Trumbull's pictures and the bas-reliefs adorned the Rotunda interior, statesmen considered plans for one additional work of art. A subcommittee in the House of Representatives recommended that a statue of George Washington be placed in the center, above the former president's entombed remains. This was neither the first nor the last time that Congress would consider placing a monument above the interred body, which nonetheless was never removed from Mount Vernon. The interior walls with the paintings and reliefs thus continued as the focus of the embellishment until 1841, when Horatio Greenough's *George Washington* became the center of attention.

The Rotunda reliefs along with John Trumbull's four Revolutionary War scenes thus constituted the first works commissioned by the federal government after the War of 1812 to decorate the rebuilt Capitol. These reliefs, with their simple compositions, minimal settings, shallow stages, and limited number of figures placed laterally in a frieze parallel to the representational screen and against a flat surface, emphasize through dress and physiognomy the distinctions between people from two cultures: the Europeans and the Native Americans.[2] Through the representation of divergent peoples and the mythicohistorical subjects that involve the discovery of new land and the dispossession of the Indians, these reliefs introduce us to the subject of race relations in the Capitol decora-

tion. Some background is necessary, however, to understand the relationship between the architecture and its embellishment.

<div align="center">*Setting the Scene*</div>

In 1790, during George Washington's first term as president, Congress established an area ten miles square along the Potomac River between Maryland and Virginia for the new federal city and hired Pierre-Charles L'Enfant to draw the plans. L'Enfant, a French-born architect and engineer who had served in the Continental army, situated the "Congress House"—as the Capitol was designated on a map drawn in 1791—on the highest hill in the area, following the precedent of the Capitolium, the religious and political center in Rome after which the U.S. Capitol was named.[3]

The federal government sponsored a competition in 1792 for a plan of the new national legislative building. William Thornton, a physician and amateur architect from the West Indies, won the prize for designing (in the opinion of Thomas Jefferson) a "simple, noble, beautiful, excellently arranged" structure.[4] Based on the Roman Pantheon, this initial conception nevertheless changed through the input of various construction supervisors, most notably the Frenchman Stephen Hallet, whose blueprint had pleased the judges of the competition. By the time the seat of government moved from Philadelphia to the District of Columbia in 1800, a portion of the building had been completed, and by 1803, when Benjamin Henry Latrobe became the second Architect of the Capitol (Thornton was the first to hold that office, from 1793 to 1803), the north wing had been finished. Latrobe remodeled the interior of the original Senate wing, changed the House chamber from an elliptical form to a room with two semicircular ends connected by colonnades, redirected the focus of the main facade from the west to the east, and extended the colonnade on both sides of the central portico.[5] By 1814, construction of the north and south wings was almost complete; only the central portion remained unfinished.

In August of that year, the British torched the Capitol.[6] Dismayed and outraged over the destruction of the newly built national building, the president along with Congress decided to renovate the Capitol as a symbolic affirmation of the country's second triumph over Great Britain, rehiring Latrobe, who had resigned in 1811 to work on other buildings. Latrobe remained Architect of the Capitol until 1817, when he quit again, this time over a dispute with the new commissioner of public buildings, Colonel Samuel Lane, under whom he had become subordinate.[7] No longer constricted by the plans of earlier architects, between 1815 and 1817 Latrobe created the Hall of Representatives as a half-domed, semicircular area, designed the Senate chamber, added domed roofs with cupolas on the wings, and changed the east and west porticos.

After Latrobe's resignation, many people directed the Capitol's construction and maintenance. From 1818 to 1829, Charles Bulfinch served as Architect of the Capitol. This Harvard-educated and European-trained architect followed Latrobe's plans to construct the central section, but he substituted a low wooden dome covered by copper, which protruded more than did his predecessor's

mound. When the office of Architect of the Capitol was abolished in 1829, the secretary of the interior became the administrator of the Capitol's maintenance and decoration, first through the commissioner of public buildings and grounds, then in 1836 through the architect of public buildings, Robert Mills. Fifteen years later, in 1851, Thomas U. Walter became the third Architect of the Capitol (after the office had been reinstated) in charge of the Capitol extension, first under the aegis of the secretary of the interior and then in 1853, under the secretary of war. Under Walter's supervision, the north and south wings for the House and Senate were added, as was the monumental iron dome.[8]

The various superintendents of the Capitol building also supervised its decoration. Benjamin Henry Latrobe had initiated the Capitol's embellishment when, in 1805, he contacted Philip Mazzei in Rome, asking his assistance in procuring European sculptors.[9] "The Capitol was begun at a time when the country was entirely destitute of artists," Latrobe explained, "and even of good workmen in the branches of architecture. . . . It is now so far advanced as to make it necessary that we should have as early as possible the assistance of a good sculptor of architectural decorations."[10]

In the United States at this time, craftsmen carved such utilitarian and decorative objects as ship figureheads, furniture, and gravestones. Thus, when the Virginia state legislature determined to place a portrait of Washington in Jefferson's capitol building at Richmond in 1784, Thomas Jefferson and Benjamin Franklin recognized that no Americans could carve a monumental portrait from marble. They consequently urged that a French artist, Jean-Antoine Houdon, be commissioned. Later, in 1815, when the North Carolina legislature voted to erect a monument to the first president in their statehouse, Thomas Jefferson recommended another foreigner, "Old Canove [sic] of Rome," an artist "considered by all Europe as without a rival." Jefferson accurately assessed that no American "would offer himself as qualified to undertake this monument," adding that "no quarry of statuary marble has yet, I believe, been opened in the U.S."[11]

It is not surprising, then, that when Benjamin Henry Latrobe determined in 1805 to arrange for the first sculptural carvings in the U.S. Capitol, he wanted to procure the services of a foreign artist, selecting the renowned sculptor Antonio Canova. "It is proposed to place in the Chamber of Representatives a sitting figure of Liberty nine feet in height," Latrobe wrote Mazzei. "I wish to know for what sum such a figure would be executed by Canova in white marble, and for what sum he would execute a model in plaster (the only material I believe in which it could be brought hither), to be executed here in American marble from the model."[12] Mazzei replied that the internationally acclaimed artist was unavailable, recommending instead two Italian artists of less repute, Giovanni Andrei from Carrara, who excelled in decoration, and Giuseppe Franzoni, son of the president of the Academy of Fine Arts at Carrara, who Mazzei predicted "will soon be a second Canova."[13] Andrei and Franzoni arrived in this country in February 1806 and carved allegories, national symbols, and capitals, such as Latrobe's famed cornstalk and tobacco leaf columns. Giuseppe Franzoni, however, executed most of the statuary for the Hall of Representatives, probably

realizing Latrobe's designs: a colossal eagle in the frieze of the entablature over the Speaker's chair, four larger-than-life allegorical figures of Agriculture, Art, Science, and Commerce over the entrance, and Liberty above and behind the Speaker's chair. None of these works survived the burning of the Capitol by the British in 1814.[14]

The second phase of decoration occurred between 1815 and 1850, with the focus shifting from the House of Representatives to the Rotunda. First, in 1817, Congress invited the American painter John Trumbull to execute four large scenes from the Revolutionary War for the Rotunda walls. Next, Congress commissioned foreign sculptors to add relief panels, expanding the interior decoration with subjects derived from an earlier period in American history. These works were completed between 1825 and 1828. During the next two decades, four Americans executed more murals for the Rotunda; Horatio Greenough from Boston created his colossal portrait of George Washington; and two groups, Greenough's *Rescue* and Luigi Persico's *Discovery of America*, adorned the outside central staircase.

### Formation and Decoration of the Rotunda

John Trumbull began his history paintings of the Revolutionary War while in London in 1785. His teacher, Benjamin West, had suggested the subject to the young patriot, recognizing that his own position as the court painter to George III would not enable him to pursue the project. Trumbull consequently executed a series of small oil sketches with the intention of having them engraved and sold in the new republic. These historical pictures enabled the Harvard-educated artist to aspire to the highest genre of painting in the eyes of artistic circles in Europe, and to realize his ambition to create works of republican virtue that would bypass the pomp and splendor he disliked in European art. Beginning in 1794 and continuing for the next six years, however, the former Revolutionary War soldier devoted himself to various diplomatic activities, in part because of economic and political problems in the United States. When he returned to his preferred profession in 1800, Trumbull executed literary and religious subjects, as well as portraits, because he perceived national disinterest in the recent war.[15] Trumbull did not return to his earlier series until sixteen years later, with the resurgence of patriotism as a result of America's victory in the War of 1812. Beginning in 1816, Trumbull lobbied to receive a commission from the federal government to decorate the new legislative building, first by asking his old friends Thomas Jefferson and John Adams for letters of recommendation, then by placing his unfinished sketch of *The Declaration of Independence* in the Hall of Representatives.[16] After some debate in Congress over the propriety (given the national debt) of federal patronage of the arts, Congress on February 6 authorized the president to employ Trumbull "to compose and execute four paintings commemorative of the most important events of the American Revolution, to be placed, when finished, in the Capitol of the United States."[17]

The patriarch of American history painting met with President James Madison to discuss the size and subjects of the paintings. Madison recommended

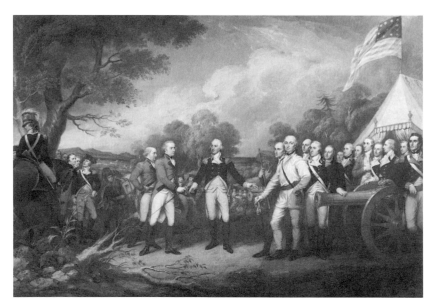

2. John Trumbull. *The Surrender of General Burgoyne at Saratoga, 16 October 1777.* 1822. Oil on canvas. 144 × 216 in. U.S. Capitol Rotunda. Courtesy of the Architect of the Capitol.

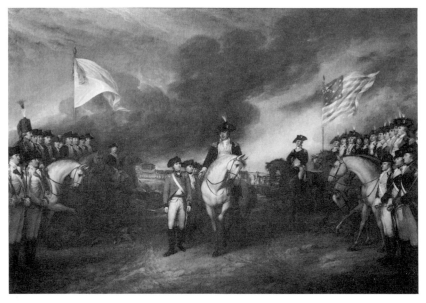

3. John Trumbull. *The Surrender of Lord Cornwallis at Yorktown, 19 October 1781.* 1787–1820. Oil on canvas. 144 × 216 in. U.S. Capitol Rotunda. Courtesy of the Architect of the Capitol.

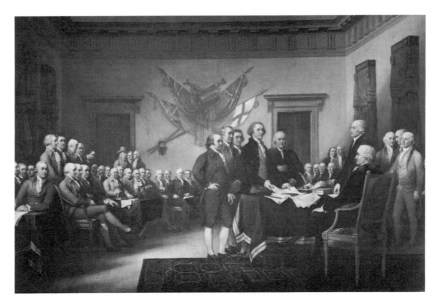

4. John Trumbull. *The Declaration of Independence, 4 July 1776*. 1787–1819. Oil on canvas. 144 × 216 in. U.S. Capitol Rotunda. Courtesy of the Architect of the Capitol.

that the figures be life-size so as not to be diminished by the Rotunda's vast space. These two men then agreed on two military scenes, the first celebrating the turning point of the war (*The Surrender of General Burgoyne at Saratoga*, completed in 1821; fig. 2), and the second commemorating the victory of the colonial forces (*The Surrender of Lord Cornwallis at Yorktown*, completed in 1820; fig. 3). The president concurred with the artist that two civic subjects should round out the commission: *The Declaration of Independence* (completed in 1818; fig. 4), a subject that Jefferson had recommended and Trumbull had begun under his tutelage in 1786, and *The Resignation of General George Washington, 23 December 1783* (completed in 1824; fig. 5), a subject that Trumbull, former aide-de-camp of General Washington, considered "one of the highest moral lessons ever given to the world."[18]

In his four history paintings, "the graphic historiographer"[19] of the Revolutionary War eschewed the baroque drama and momentary action of his earlier oil sketches in favor of neoclassical austerity more appropriate to the Capitol's temple-like characteristics. Even the military scenes, with their stormy clouds and diagonal lines, retain a static, rigid composition through the figural groupings and frozen gestures, establishing a ceremonial timelessness befitting the subjects that Trumbull believed would produce a "powerful moral effect . . . on the human mind."[20]

Besides initiating the idea that paintings should decorate the vast Rotunda interior, Trumbull also contributed to its architectural features. This began when Latrobe corresponded with the Connecticut artist to discuss plans for the yet-

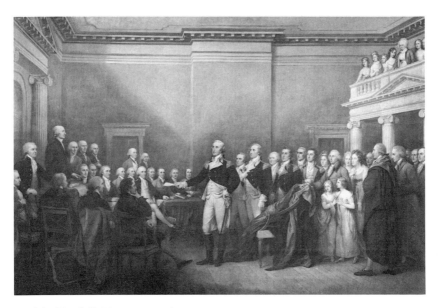

5. John Trumbull. *The Resignation of General Washington, 23 December 1783.* 1822–1824. Oil on canvas. 144 × 216 in. U.S. Capitol Rotunda. Courtesy of the Architect of the Capitol.

unbuilt Rotunda. The Architect of the Capitol explained his intention to recess the paintings within semicircular niches so that the architecture would dominate. Trumbull, however, envisioned the building as a mere backdrop to his pictures, proposing to reduce the width of the wall between the works. Before a compromise could be reached, the British-born architect resigned his position.

Charles Bulfinch followed his predecessor's procedure in consulting the artist for the Rotunda's design. This next Architect of the Capitol had planned a large staircase for the Rotunda and a separate gallery for the Revolutionary War paintings, but Trumbull submitted a counterproposal. Rather than have a staircase that would disrupt the unbroken space of the circular Rotunda and destroy his plans to hang at least twelve paintings on the walls, Trumbull instead advocated "plain solid walls, embellished only by four splendid door-casings of white marble and elegant workmanship; a fascia of white marble running around the room . . . and a frieze crowning the top of the wall, where . . . basso-relievos may be introduced."[21] This simple, circular architectural setting with unbroken wall space would have enabled Trumbull to realize his dream of emulating a panorama through the placement of enormous pictures on the walls.[22]

Bulfinch may have been influenced by the artist's recommendations, for he eliminated the flight of steps and relocated Trumbull's works inside the Rotunda. Rather than follow the painter's suggestion that the walls contain "not a column nor a capital," however, Bulfinch situated Trumbull's four pictures between prominent pilasters that support an entablature ornamented with twenty olive wreaths.[23] A sketch of 1818 (fig. 6) reveals that he also conceived of horizontal

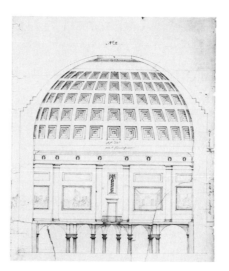

6. Charles Bulfinch. *U.S. Capitol Sectional Elevation.*
Between 1817 and 1828. Ink, graphite,
wash, and watercolor. 14¼ × 15½ in. Massachusetts
Institute of Technology. Courtesy of
the Library of Congress.

rectangular reliefs of floral patterns above Trumbull's pictures and vertical reliefs above the north and south doors. According to this drawing, the vertical panels each would have contained an eagle perched on the fasces, the ancient Roman symbols appropriated by the United States for its first national shield as a symbol of national unity.

Bulfinch, for reasons unknown, eventually decided to replace these abstract symbols derived from antiquity with reliefs that would illustrate scenes from America's colonial past, expanding the original two plaques to four, one over each doorway in the Rotunda. But he retained the floral motifs first sketched in his 1818 drawing, allowing artists to carve either abstracted botanical designs in four panels or festoons placed symmetrically around busts of early explorers in four more reliefs. These eight rectangular inserts decorate the areas directly above Trumbull's paintings and the four additional Rotunda murals that were commissioned and executed between 1837 and 1855. Trumbull's works thus illustrate events from the Revolutionary War that postdate the subjects found in the smaller but equally prominent reliefs and the accompanying painted murals.

No information survives about the explorer portraits, but documentation on the historical sculptures allows for a piecemeal construction of their creation. At this stage, the Architect of the Capitol seems to have had free reign to select the artists and subject matter with the final approval of the commissioner of public buildings, who never disagreed with Bulfinch's plans. This is evident in the manner in which one sculptor received a commission and two subjects were chosen. In

July 1822, four years after conceiving the Rotunda's interior decorative scheme, Bulfinch contacted Enrico Causici about plans for sculpture in the Rotunda, explaining that the commissioner of public buildings delegated the relief sculpture to the architect. A native of Verona purported to be a pupil of Canova, Causici had arrived in the United States earlier in the year, first settling in New York City and then moving to the capital city in search of patronage. Presumably someone introduced Causici to Bulfinch or informed the architect of the Italian sculptor's interest in working. In a letter to Causici in 1822, Bulfinch proposed four subjects, hoping the sculptor would choose two for the east and west doors, "one to represent, either the discovery of America by Columbus, or which I should prefer, the landing of Capt. Smith in Virginia; & the other, the Declaration of Independence, or the adoption of the Federal Constitution."[24]

By 1822 Bulfinch had selected, in lieu of the eagle and the fasces, historical subjects concerning America's discovery, colonization, and federation, as well as the codification of its legal system. In one panel, either Columbus's discovery of the New World or Captain John Smith's landing in Virginia would have been represented, thereby documenting one of two instances of the early European arrival and settlement of the New World. The second relief would have echoed the subjects found in two of John Trumbull's large history paintings: *Declaration of Independence* and *Resignation of General Washington*. It seems that Bulfinch wanted another civic scene like those created by Trumbull, in which the painter documented momentous occasions of the republican triumph over Great Britain's monarchy.[25] Three years before the placement of Trumbull's paintings in the Rotunda in November 1826, it appears that the architect wanted a unified interior decorative scheme in which the paintings and reliefs would relate thematically through painted and sculpted historical narratives.

Despite Bulfinch's preliminary plans, the reliefs represent scenes from the colonial history of the United States. Instead of illustrating any of the four subjects that Bulfinch had recommended in his letter of 1822, Causici executed *Landing of the Pilgrims* in 1825 (see fig. 14) and *Conflict of Daniel Boone and the Indians* between 1826 and 1827 (see fig. 19). Apparently Causici had considered the first subject that the architect had recommended, for on February 25, 1823, the Speaker of the House presented a memorial from Causici in which the artist proposed to represent in "alto relievo for the centre building of the capitol . . . the landing of Columbus on the new continent."[26] It is unclear why the Italian never translated his design into stone, a subject later adopted by Luigi Persico for his group sculpture (see fig. 53), at one point located outside on the east facade's central staircase, and by Randolph Rogers for the lunette of his Rotunda bronze doors (see fig. 77). But since Bulfinch preferred the Smith subject (as he stated in his 1822 letter and possibly reiterated to Causici in person), it seems reasonable that Causici abandoned the Columbus relief. He may have replaced the landing of Columbus with the landing of the Pilgrims as a means to satisfy the architect's preference for a subject from the early seventeenth century.

Foreigners also executed the other two reliefs for the Rotunda. An Italian, Antonio Capellano, carved *Preservation of Captain Smith by Pocahontas* (see fig. 11)

in 1825, and a Frenchman, Nicholas Gevelot, executed *William Penn's Treaty with the Indians* (see fig. 15) in 1827. Capellano, a Florentine sculptor, had first settled in Baltimore in 1815, where he carved the figure of Washington for the battle monument. By 1824, however, the emigrant apparently wanted to be hired by the federal government, for he wrote Joseph Elgar, the commissioner of public buildings, that if he could not find employment in Washington, he would return to Italy. Offering to "execute two drawings on stone," the Italian proposed motifs that related thematically to those Bulfinch had suggested to Causici. "The subjects I have thought most appropriate were first, when Columbus, the Indians refusing to give him the accustomed provisions, announced to them that the God, whom he served, to manifest his indignation against them for their conduct would cover the Moon with a veil." When an eclipse appeared the next night, Capellano elaborated, the Indians in fear brought him abundant supplies. The artist also proposed a scene "when [Captain John] Smith received provisions from the Indians on the banks of the river Shecoughtan in return for their Okee or God, which had been taken from them." Capellano nonetheless did not illustrate either of these topics even though he sent sketches for the landing of Columbus to Elgar. Instead, he depicted a subject that had strong appeal to nineteenth-century Americans: Pocahontas's rescue of John Smith.[27]

The few details about Gevelot's life and career that are known allow only a sketchy reconstruction of his single commission for the Capitol's ornamentation. The Frenchman had submitted two small clay models for the competition held in 1825 for the central pedimental decoration on the east facade. President John Quincy Adams had rejected all thirty-six proposals, declaring that they failed to express adequately a new national mythology. Elgar nevertheless offered to employ Gevelot, not for the central pedimental statuary that was executed by Persico, but to assist Capellano in finishing the Pocahontas-Smith tablet. Because the two sculptors worked in divergent styles, Capellano understandably objected to Gevelot's assistance.[28] As compensation, the commissioner of public buildings allowed Gevelot to create a relief over the north door. The artist himself probably chose the subject of Penn's treaty with the Indians. What is different about Gevelot's commission is that the commissioner of public buildings, not the Architect of the Capitol, negotiated the contract.

The panels above the large murals contain portraits of the early explorers of North America and are emblems of American history before European settlement. These icons, carved between 1824 and 1829 by Causici, Capellano, and Francisco Iardella—an Italian from Carrara who had earlier modeled the tobacco capitals in the small rotunda near the old Senate chamber and who replaced Giovanni Andrei in 1824 as superintendent of work done in carving—represent busts of four notable explorers within circular recessions between symmetrical, abstracted foliage.[29] The artists included few historical details beyond clothing and hairstyle, and the profiles show little in the way of individual features. Only the name of the person—Raleigh, Cabot, La Sale [*sic*], and Columbus—inscribed beneath each bust and visible only when one stands directly under the portraits, enables viewers to place each figure within its historical context.

Americans still consider Christopher Columbus (fig. 7), the fifteenth-century Italian explorer who directed a Spanish fleet and landed on the island of San Salvador in the Bahamas in 1492, as the discoverer of the New World. John Cabot (fig. 8), an Italian who emigrated to England, set off in 1497 to find the northwest passage to the Orient for Great Britain, landing at Cape Breton Island or Newfoundland. Sir Walter Raleigh (fig. 9) sponsored an attempt by the English to colonize America, establishing the failed Roanoke settlement in 1584 and then the successful Jamestown colony in 1607. French explorer and fur trader René-Robert Cavelier, Sieur de la Salle (fig. 10),navigated the Mississippi River to its mouth, naming the region Louisiana in 1682.

These men had been among the first to discover and explore the North American continent, claiming this "new paradise" as extensions of the British, Spanish, and French empires. As nineteenth-century citizens of the United States knew, however, the British triumphed in North America, establishing the basis for the continent's later emergence as an independent nation. These icons of conquest in the form of portrait busts refer to the discovery and future settlement of North America and provide an introduction to the sculpted and painted historical narratives in the Rotunda that will be mirrored by 1858 in the Brumidi frieze.

### *Assimilation:* Preservation of Captain Smith

The earliest work in the chronology of America's colonial history as represented in the Rotunda narratives is Antonio Capellano's *Preservation of Captain Smith by Pocahontas* (fig. 11). It alludes to Raleigh's explorations of the New World that had led to the settlement of Virginia by the Virginia Company of London, a business established under the temporary leadership of Captain John Smith, whose record of the colony's early history contains the anecdote pictured in Capellano's relief. On April 26, 1607, Smith and his party arrived in the tidewater region of Virginia with a mandate from King James I to explore the area, fortify a settlement, search for natural resources, and discover a route to the Indian Ocean.[30] Unknown to these emigrants, however, one tribe, the Powhatans (under their chief, also known as Powhatan), virtually formed an empire over the other tribes in the exact area settled by the British. Not surprisingly, shortly after the Europeans arrived in Powhatan territory, the resident natives attacked the colony, leading to further altercations between the two races.

In December 1607 (not 1606, as the relief designates),[31] Smith undertook an expedition on the Chickahominy River to procure corn and to explore the river to its headwaters in the hopes of discovering a passage to the Indian Ocean. The Powhatans took Smith captive, offering him freedom only if the emigrant would assist the tribe in attacking the Jamestown fort. Smith refused. The aborigines then paraded the Jamestown settler to various tribes, gathering perjured evidence of Smith's battles against their people. Finally, the Indians brought the captive to Powhatan. As related by Smith in the third person, "two great stones were brought before Powhatan: then as many as could layd hands on him, dragged him to them, and thereon laid his head, and being ready with their clubs,

7. Enrico Causici and Antonio Capellano. *Christopher Columbus.* 1824. Sandstone. U.S. Capitol Rotunda, above *Surrender of General Burgoyne.* Courtesy of the Architect of the Capitol.

8. Enrico Causici and Antonio Capellano. *John Cabot.* 1828. Sandstone. U.S. Capitol Rotunda, above *Landing of Columbus.* Courtesy of the Architect of the Capitol.

9. Enrico Causici and Antonio Capellano. *Sir Walter Raleigh.* 1824. Sandstone. U.S. Capitol Rotunda, above *Surrender of Lord Cornwallis.* Courtesy of the Architect of the Capitol.

10. Enrico Causici and Antonio Capellano. *René Robert Cavelier, Sieur de La Salle.* 1829. Sandstone. U.S. Capitol Rotunda, above *Discovery of the Mississippi River.* Courtesy of the Architect of the Capitol.

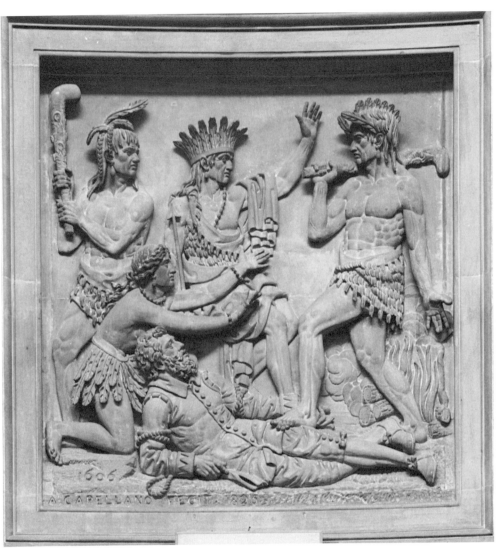

11. Antonio Capellano. *Preservation of Captain Smith by Pocahontas.* 1825. Sandstone.
U.S. Capitol Rotunda, above west door. Courtesy of the Architect of the Capitol.

to beate out his braines." The chief's daughter, Pocahontas, immediately inter-
vened, taking Smith's "head in her armes, and laid her owne upon his to save him
from death."[32] This event, described in Smith's *Generall Historie of Virginia*
(1624), is embellished in numerous poems, plays, and books, some of which
contain illustrations such as Robert Vaughan's engraving from *Generall Historie*
(fig. 12) and the frontispiece from John Davis's *Captain Smith and Princess
Pocahontas, an Indian Tale*, published in 1817 (fig. 13).[33]

Capellano did not derive his composition from Smith's account of his rescue
(except for the detail of Indians ready with clubs); nor did he copy these images,
even though one 1830 guidebook to the Capitol asserted that the "design is partly
taken from a rude engraving of this event, in the first edition of Smith's History of
Virginia."[34] Nonetheless, the pictures in combination with various texts must
have influenced the artist's conception. In Capellano's composition, Chief
Powhatan forms a central axis symmetrically framed by Indians facing inward.
The Indians' upright poses parallel the vertical framing margins, left and right,
and the reclining figure of Captain John Smith reinforces the base. The chief,
slightly smaller than the two other standing Indians, raises his left arm in a
forceful gesture that causes his tribesmen to stop their violence.

At first Pocahontas may seem secondary in importance, owing to her location
in the left corner of the panel, her suppliant form, and her diminutive size created
by her crouching. But the twelve-year-old girl's elongated, outstretched arms lead
up toward her father's commanding gesture, suggesting that Powhatan's action
derives from his daughter's entreating pleas. Following Smith's own interpreta-
tion and nineteenth-century assessments of Pocahontas's significance, Capellano
presents Pocahontas as an intercessor responsible for the Jamestown settlement
and for the subsequent birth of the United States.[35]

The Pocahontas-Smith sculpture telescopes a historical narrative of violence
into a vivid, theatrical image that summarizes the relationship between the ear-
liest English colony and the Powhatans. As Richard Brilliant has noted about the
viewer's participation in the visual narrative process, "In seeing or registering
that work of art, the viewer must employ an inductive method of analysis, not
only to recognize the subject represented but also to integrate it within a larger
context, especially through the operation of memory."[36] Anyone familiar with
the Pocahontas-Smith story could identify the specific episode that Capellano
portrayed, and numerous books and plays in the nineteenth century would have
helped Americans locate Capellano's image within a larger narrative discourse:
John Davis's *Captain Smith and Princess Pocahontas, an Indian Tale* (1817), George
Washington Custis's *Pocahontas, or the Settlers of Virginia* (1830), Robert Owen's
*Pocahontas* (1844), Charlotte Barnes Conner's *The Forest Princess, or Two Centuries
Ago* (1846), and John Brougham's *Pocahontas, or the Gentle Savage* (1855). Conse-
quently, the viewer of the Pocahontas relief establishes "a narrative context of
greater dimension than the narrative bit presented."[37] Although the English
arrival on the Virginia shore is not depicted, the viewer nevertheless realizes that
this was the catalyst of a chain of events that led to Smith's rescue. And those

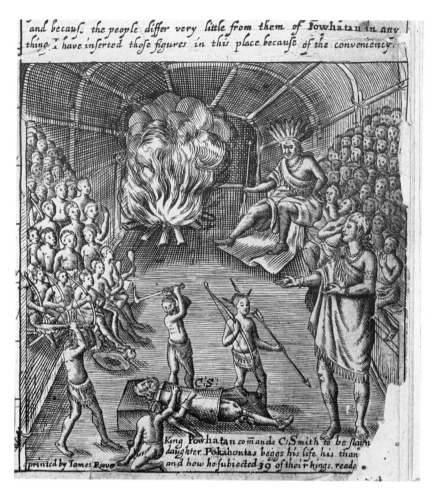

*and becauſ the people differ very little from them of Powhatan in any
thing I have inſerted thoſe figures in this place becauſe of the conveniency*

*King Powhatan comands C.Smith to be ſlain
daughter Pokahontas beggs his life his than
and how he ſubiected 39 of their kings. reade*

*printed by James Reeve*

C·S·

12. Robert Vaughan. *Pocahontas Saving Smith.* 1624.
Engraving. Courtesy of the Library of Congress.

familiar with Pocahontas's life would remember that she went on to marry an
Englishman, John Rolfe, after her conversion to Christianity.

Capellano's relief alludes to these later events. Pocahontas's prayerlike ges-
ture and beatific facial expression seem to foreshadow her religious conversion.
The close connection between Pocahontas and Smith—both figures are on the
ground, while the woman shelters the captive beneath her arms and torso—
suggests the future assimilation of Pocahontas among the Jamestown settlers that
became realized by the princess's later marriage and baptism, the latter subject
depicted by John Chapman in his Rotunda painting (see fig. 20). The U-shaped
composition, created by the two framing Indians who link up with Pocahontas
and John Smith, hints at the peaceful relationship that resulted, albeit briefly,

from the Indian princess's intercession. *Preservation of Captain Smith by Pocahontas* thus reconstructs one episode from the seventeenth-century emigrant's account of his experiences with the native population, representing the account, whether or not it had actually occurred, with the idea of assimilation in mind. Pocahontas's marriage to John Rolfe and her giving birth to a son of mixed heritage demonstrated that amalgamation could occur, even though current events portended otherwise. In Capellano's work, Pocahontas and Smith stand out in greater relief than Powhatan and the other Indians. Their projection outward and Powhatan's recession inward relate to the future prominence of the white man and the assimilated and converted Indians over those Native Americans who retreated from or battled against Euro-American settlements.

<center>*Segregation:* Landing of the Pilgrims</center>

In moving from Capellano's *Pocahontas* relief to Causici's *Landing of the Pilgrims* (fig. 14), we shift from a scene of peaceful assimilation to one fraught with implications regarding white settlers' potential dominance over indigenous peoples. John Quincy Adams had introduced the Pilgrims into national mythology in ~Plymouth~ a speech delivered in December 1802 to commemorate the first landing in New England. Subsequent oratory and books about the Separatists' pilgrimage, such as Michael Corne's *Landing of the Pilgrims at Plymouth Massachusetts* (c. 1803) and Henry Sargent's *Landing of the Pilgrim Fathers* (1813), transformed the landing

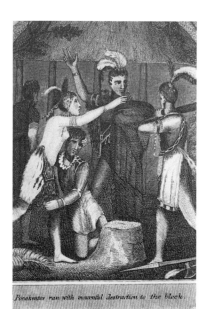

13. *Pocahontas Ran with Mournful Distraction to the Block.* 1817. Engraving. Courtesy of the Library of Congress.

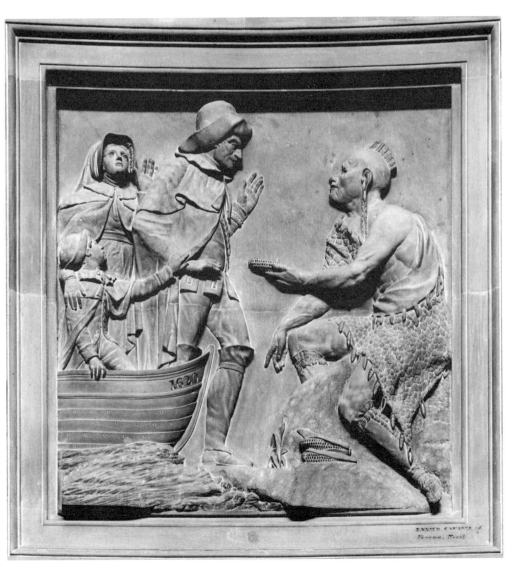

14. Enrico Causici. *Landing of the Pilgrims.* 1825. Sandstone. U.S. Capitol Rotunda,
above east door. Courtesy of the Architect of the Capitol.

into a rite of passage—from ocean to land, past to future, Englishman to American—to signify the course of empire in the United States. In 1820, Daniel Webster declared in an oration delivered to commemorate the Pilgrim settlement of New England that the English had established "smiling fields," villages, and "the patrimonial blessings of wise institutions, of liberty, and religion." According to the orator, all these blessings extended from Plymouth Rock westward to "the murmur of the Pacific seas," fulfilling the nation's providential mission. Twenty years before the term *manifest destiny* became current, Webster's speech expressed its essence and summarized how some Americans interpreted their ancestors' contributions.[38]

Causici's relief reflects this growing awareness and conviction of the historical significance of the Pilgrims' arrival in the New World. The colonists form a compact group of interrelationships conveyed through pose and gesture. The son stands in profile, reaching toward his father with his left arm and looking up toward his mother, who embraces him with her right arm. The woman unites the group through her frontal position and massive form. The father does not turn to his family and enclose the group but instead faces the opposite direction, toward the Indian. The line of the high boot around the European's knee leads toward the Indian's right hand, which in turn points to the settler's foot. In *Picture of Washington* (1848), William Force interpreted the interactions among this family group: "His little son seems to caution him ere he ventures among the savages. But the mother, with her eyes elevated to Heaven, places her trust there, and restrains the boy."[39]

The composition of this tranquil scene suggests that the two cultures meeting here will never merge as equals, despite the Indian's gesture of tribute and conciliation in providing an ear of corn to the travelers. The gift-giver symbolically offers the crop that became a staple in the colonial New Englander's diet and early economy, often enabling the transplanted Europeans to survive in the strange land.[40] The two large ears of corn beneath the Indian's bent leg indicate that the New World will become a garden of plenty for the newcomers. In the relief, the Indian's gesture to sustain the aliens' bodies seems contrasted with the pose and gesture of the woman, whose nourishment and salvation come from above. The family group of the arriving Pilgrims echoes the familiar subject of the Holy Family's Flight into Egypt, another contrast with the non-Christian Indian.

The composition is divided into two parts emphasizing the cultural and religious distinctions between the races. Whereas the Pilgrims form a solid mass of smooth surfaces, the Indian's uneven contours and rough surfaces—created by the musculature and animal-skin robe—underscore the differences between the two cultures. The Indian is in fact almost a caricature of the noble savage, whose childlike innocence, naiveté, and goodness show through as he straddles a stone that signifies Plymouth Rock. The English father's left leg with bent knee and the paternalistic gesture of his hand raised in greeting are juxtaposed by the Indian's outstretched left arm, right hand pointing downward, and bent right knee; unlike a jigsaw puzzle, where angles, curves, and notches interlock, the contours of these

two figures do not match. This disparity is heightened by the space between giver and taker: although the Indian's gesture with his left hand reaches out toward the Pilgrim, the two men never touch.

The Native American, though larger and more muscular than the Pilgrim father, is clearly subservient, for his crouching position diminishes his towering size and strength. His contours are not the smooth curves that unify the colonists but instead are a combination of broad arches (evident along his back) and jerky angles (created by his bent knees, arm gestures, and profiled facial features). That the Indian points downward with his right hand toward the European's foot—drawing the viewer's eye to this motion—suggests the Indian's recognition of the future course of events, and emphasizes the Pilgrim's movement from left to right (though not from east to west), from ocean to land, from Europe to the New World, from civilization to a country inhabited by people perceived as primitives. The forward movement of the Englishman toward the Indian and the presence of the Pilgrim child presage the supplanting of the native inhabitants by the European white man, who begins, using Robert C. Winthrop's metaphor from his 1839 oration, "the triumphal entry of the New England Fathers upon the theatre of their glory."[41] (What happened in actuality is that the Pilgrims, like the Puritans, claimed title of the land by virtue of *vacuum domicilium* because the area had been temporarily vacated upon their arrival.)[42]

*Land for Peace:* Penn's Treaty with the Indians

The message in Capellano's Pocahontas-Smith relief is that of peaceful assimilation and peace in war. The conflict between the Powhatans and the Europeans is mediated by Pocahontas, who brings peace to the two groups through her intercession on behalf of Captain Smith and her later conversion and marriage. Causici's *Landing of the Pilgrims*, on the other hand, suggests war in peace. A peaceful scene in which the Indians welcome the Pilgrims nonetheless intimates compositionally that the natives will yield to the morally superior race. The next relief, *William Penn's Treaty with the Indians*, by Nicholas Gevelot (fig. 15), shows egalitarian relations between the Indians and the colonial English, although in this case the peace between them exists because of the Quakers' desire for more land. Nevertheless, this work is unique in representing peace, especially in relation to the tensions manifest in the other three reliefs.

Early nineteenth-century popular biographies about William Penn detailed his life in England and the American colonies, explaining among other things his role in protecting and sustaining the Quaker movement, in founding Pennsylvania, and in negotiating with various tribes. Yet the Great Treaty with the Delawares depicted by Gevelot in his relief, declared by William Clarkson in 1813 as "the most glorious of any in the annals of the world," became the most celebrated agreement and event in the life of William Penn. According to tradition, in 1682 the Quaker had met chiefs of the Delaware tribes under "widespreading branches" of an "elm tree of prodigious size" at Shackamaxon to sign a treaty in which the natives agreed to sell land in exchange for gifts. As *Niles' Weekly Register* concluded in 1825, instead of using the sword as "the instrument

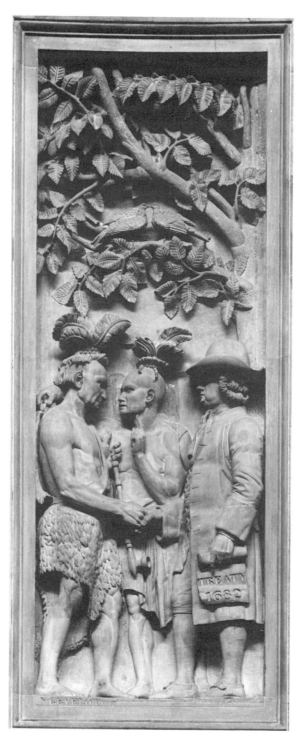

15. Nicholas Gevelot. *William Penn's Treaty with
the Indians.* 1827. Sandstone. U.S. Capitol Rotunda,
above north door. Courtesy of the Architect of the Capitol.

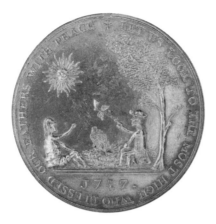
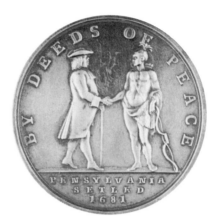

16. *Richardson Medal*. Reverse. 1757.
Silver. 1¾ in. dia. Courtesy of the Historical
Society of Pennsylvania.

17. Silvanus Bevan. *William Penn Medal*.
Reverse. 1720. Silver. 1⅝ in. dia. Courtesy
of the Historical Society of Pennsylvania.

of gaining ascendancy over the natives," Penn employed "the even scales of justice and mild persuasion of Christian love . . . [to sway] the mind."[43]

A series of peace medals issued between 1764 and 1766 codified Penn's Indian diplomacy.[44] These medals, given to tribal chiefs as "symbols of allegiance from the new Great Father,"[45] contained a bust of a British authority on one side and an Indian scene on the other. Although early nineteenth-century biographies provided information about many of the agreements Penn signed with various tribes in Pennsylvania, such peace medals as the Richardson Medal of 1757 (fig. 16) usually depict a treaty under an elm tree, suggesting that Penn's famous compact with the Delawares along the river served to signify all treaties between the two cultures.

In Gevelot's relief, the position of Penn and the Indian who faces him on the left, the handshake between the two, and the Quaker's features and clothing all seem to derive from the reverse of Silvanus Bevan's William Penn Medal of 1720 (fig. 17), a motif that also influenced Benjamin West in his painting of the same subject.[46] The sculptor added a second Indian, in the center in lower relief, and the elm tree marking what Clarkson identified as the "Treaty of eternal Friendship."[47] The harmonious coexistence between the Quakers and the Delawares that resulted from the agreement held in Penn's left hand is emphasized by the compact, semicircular arrangement of the stationary figures and by the firm handshake that links the Englishman on the right and the Indian chief on the left. The enclosed grouping of the three figures—united by the gestures and glances—is created in part by the device of Penn's hat, which leads to the central Indian. This figure's position away from the Quaker but facing his tribesman directs our view to the Indian on the left, whose outstretched right arm points to

Penn's left hand grasping the treaty. Penn's downward-pointing forefinger directs us to the inscription on the scroll, "Treaty 1682."[48]

The handshake functions as an iconographic reference to peace. Although not all of the nineteenth-century books about Penn indicate that such a ritual occurred during the meetings between the Quakers and the Indians, the gesture found in the Bevan Medal became codified first in the Thomas Jefferson medals (fig. 18) and then in such later ones as the James Madison medals and the Zachary Taylor medals.[49] In these, two clasped hands float against a flat, unornamented surface. The inscription, "Peace and Friendship," and the crossed ax and pipe above the hieroglyph are the only additional motifs found on the coins. The text identifies the meaning of the image that Gevelot had included in his relief: the handshake and the pipe grasped by one Delaware symbolize friendship and peace.[50]

The composition splits into a lower portion that contains the human figures, planted firmly on the ground and involved in a civilized activity, and an upper area, in which the branches allude to the elm tree and thus to the Great Treaty in the wilderness. Two subsidiary lines within the figural grouping lead the eye upward and downward: the peace pipe points to the three feet in the middle, each of which touches the other, thereby suggesting assimilation and integration. The central figure's upward-pointing finger—an echo of Penn's downward gesture—directs our gaze to the tree in which two centralized, symmetrical kissing birds symbolize peace. Except for the differences in clothing and headgear—the Indians wear feathered headdresses and animal fur while Penn wears a Quaker suit and hat—the three men are equal in size, with similar physiques and amicable mannerisms.

Gevelot's conception in fact corresponds to the good savage and the good Quaker first detailed by Voltaire in his *Lettres Philosophiques* (1734), in which the

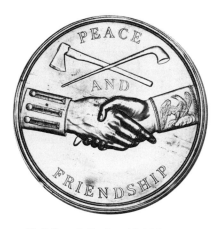

18. *Jefferson Indian Peace Medal.* Reverse.
1801. 41 in. dia. Courtesy of the
American Numismatic Society.

*The Rotunda Reliefs*

French philosophe gave an account of Penn's Quaker colony.[51] John Galt, in his biography of Benjamin West, discusses the significance of the Great Treaty, noting Voltaire's observation that the treaty between the Indians and William Penn had constituted "the first public contract which connected the inhabitants of the Old and New World together" and "the only treaty that has never been broken." Voltaire asserted that Pennsylvania was "the first country which has not been subdued by the sword, for the inhabitants were conquered by the force of Christian benevolence."[52]

Voltaire was correct. Penn, unique among colonial leaders in the seventeenth century, demonstrated justice and decency in his treatment of the Native Americans. But as the historian Francis Jennings has pointed out, Penn's motivation also derived from his desire to expand his territorial claims in New York and Maryland and to obtain trading profits.[53] Although the Quaker succeeded in establishing his colony without conflict, he nevertheless negotiated with the Indians in order to expand his empire and wealth, a reality ignored by nineteenth-century books and images. As Michael Rogin has aptly stated, treaties "engaged Indians in consent to their own subjugation."[54]

Nicholas Gevelot created a work that adheres to Voltaire's assessment of the Quaker-Delaware relationship in Pennsylvania, but the subtext takes on a new meaning given our twentieth-century view of Penn's motivations. The composition implies equality, but a different set of circumstances existed than that which Gevelot was willing to reveal or could have understood. According to Gevelot's relief, the Native Americans amicably forfeited their land. But what is not apparent is Penn's motivation for peaceful negotiation. He avoided conflict yet achieved the same result that war would have accomplished: the exploitation and subjugation of the Delawares.

### *Subjugation:* Conflict of Daniel Boone and the Indians

As we move on to the final relief in the group, we shift from the seventeenth to the eighteenth century, from a peaceful scene fraught with implications regarding European dominance to one that shows the inevitable conflict between the two races. In Causici's *Conflict of Daniel Boone and the Indians* (fig. 19), the Anglo-Saxon and Native American are again facing one another in profile, but now the gap between pioneer and Indian is closed as they engage in combat, forming the apex of a triangle whose base is created by the one dead Indian. The stability established by the triangular figural composition, a prevalent format in Renaissance and Baroque art, is countered by the diagonal lines of the rifle and tomahawk held by Boone and the Indian. Their right and left legs press isometrically as they crush against the defeated Indian, forming an angle that leads the eye first to Boone's chest and then to his face and rifle. The swag of drapery beneath the Indian's left arm extends the line of Boone's rifle, pointing toward the compressed legs, one naked, the other in a high boot. The Indian's bulging, muscular thigh and calf are countered by the knife Boone holds in his right hand. The settler is poised to strike his opponent.

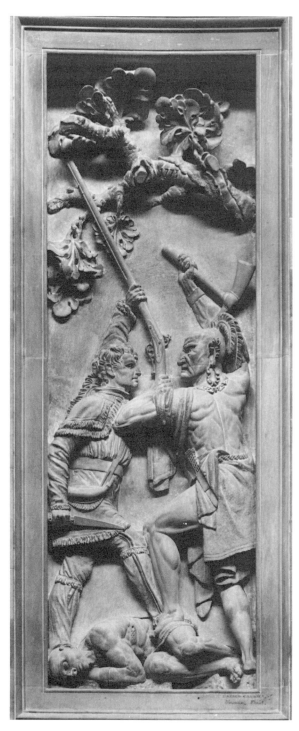

19. Enrico Causici. *Conflict of Daniel Boone and the Indians.* 1826–1827. Sandstone. U.S. Capitol Rotunda, above south door. Courtesy of the Architect of the Capitol.

John Filson's popular biography of Boone, published in 1784 and reissued several times, had first recounted the pioneer's "dangerous, helpless situation, exposed daily to perils and death amongst savages and wild beasts . . . in the howling wilderness,"[55] thereby transforming the historical person into a paradigm of white settlers on the frontier. Later authors, such as Daniel Bryan in his 1813 epic poem, *The Mountain Muse*, and Timothy Flint in his 1833 *Biographical Memoir of Daniel Boone*, perpetuated the notion of Boone as a mythic hunter-adventurer who led the Chosen People westward, acting as an agent of civilization.[56] Causici's relief freezes Boone's struggles against the Indians in his attempt to subdue savagery and the wilderness, the latter symbolized by the tree that branches over the figures. According to Robert Mills, the future Architect of Public Buildings, who wrote a guide to the Capitol in 1834, the foliage identifies the setting as "the deep lone forest of the 'far west,'" the far west where the Dangerfields in James Kirke Paulding's *Westward Ho!* of 1832 moved to become, like the great "patriarch . . . of 'Old Kentuck,'" the "founders of a new empire."[57]

Located toward the center of the lowest branch is the date 1773, allowing us to identify the specific episode illustrated by the artist. As Filson recorded in his biography of Boone, on October 10 the settler penetrated the Kentucky frontier with at least five other families: "The rear of our company was attacked by a number of Indians, who killed six, and wounded one man. . . . Though we defended ourselves, and repulsed the enemy . . . we retreated forty miles."[58] Rather than portray the death of white settlers and their retreat from battle, Causici instead distorted reality by showing Boone struggling with an Indian greater in physical strength. Taller and brawnier than his opponent, the Indian will nevertheless succumb to Boone, who is empowered and supported by moral strength (indicated by the serene expression on his face) and by the superiority of his weapon, that of an advanced civilization: the rifle. The impending defeat of the indigenous people is suggested by the vanquished Indian at the base, who, in the opinion William Force articulated in his 1848 guidebook to Washington, "admirably expresses the proud spirit of a fallen savage, unsubdued even in death."[59] The relief thus transcends the specific episode to become an icon of the conflict that Americans perceived as an inevitable experience on the frontier.

### The Displacement of Ideology by Aesthetics

In 1842, Henry A. Wise, a Whig from Virginia, decried the sculpture in the Capitol Rotunda during a session in the House. Wise reminded his colleagues about Tristam Burges's earlier critique of the *Conflict of Daniel Boone*, in which Burges had argued that "it very truly represented our dealing with the Indians, for we had not left them even a place to die upon." According to Wise, Burges complained that "the whole ground in that panel [is] occupied by the body of the Indian already despatched, so that when the other fell it must lie on the body of his countryman." Before quoting the disparaging remarks of his colleague, Wise had interjected his own appraisal of the sculptured wall panels. He began his commentary with *Landing of the Pilgrims*, describing its representation in which

the New World, in the form of an Indian, welcomed "the old" by "giving it corn." Next, *Penn's Treaty with the Indians* portrayed, according to Wise, the white man cheating the Indian. Mentioning the last two works, *Preservation of Captain Smith by Pocahontas* and *Conflict of Daniel Boone and the Indians*, the statesman imagined how Indians would interpret the reliefs: "We give you corn, you cheat us of our lands: we save your life, you take ours." The concerned Virginian correctly concluded: "A pretty faithful history of our dealing with the native tribes."[60] It seems extraordinary that both Wise (an advocate of slavery) and Burges (with whom Wise had a heated exchange in 1834 over the mural paintings for the Rotunda) comprehended the implications and contradictions inherent in the Rotunda reliefs. Their disparaging assessments, however, belong to minority voices amid nineteenth-century white Americans who couched their ideological comments about the Rotunda reliefs in aesthetic terms.

This tendency to critique the reliefs for ideological reasons is evident in other reviews of the Rotunda reliefs. Two guidebooks to the Capitol related anecdotes about the supposed response by the Wisconsin Winnebagos, a group of whom visited the Capitol after having sold their land to the federal government and having been relocated to Iowa. Both P. Haas in 1839 and William Force in 1848 asserted that the "noble looking fellows" from the tribe had been clothed and ornamented in a warlike manner with scalping knives and tomahawks. Upon "passing through the Rotundo, their attention was arrested by this group of statuary—Boone killing the Indian." According to Force, the tribesmen formed a semicircle and after "scrutinizing and recognizing every part of the scene . . . they raised their dreadful war-cry and ran hurriedly from the hall."[61] Despite their militant facade, Force implies, the Winnebagos clearly and graphically saw the superior strength of the white man and his declaration of war as shown in the *Boone* relief and hence fled the Capitol building in fear—and perhaps in preparation for a prolonged conflict.

Most mid-century critiques appraised the *Boone* relief as superior in its execution, design, and historical accuracy. "There is more of the Indian character and costume represented in these figures than in any of the other sculpted pictures," Robert Mills asserted, continuing that "full justice has been done to the form and features of the intrepid Boon [sic], whose cool resolution and self-possession are strongly contrasted with the ferocity and recklessness of the savage." Haas asserted in his *Public Building and Statuary of the Government* (1839) that the genius of the piece resided in the faces of the two opposed men, "the fierce revenge of one, the calculating, calm courage of the other." In short, nineteenth-century observers considered the *Boone* composition to be the most accurate Rotunda relief given the contrast between the bloodthirsty "savages" and the self-possessed, clearheaded pioneer.[62]

Americans frequently criticized the other three Rotunda reliefs for their composition and inaccurate details, although these concerns camouflage the covert and possibly unconscious reasons for such disparaging remarks. Here aesthetic responses replace ideology under the subterfuge of connoisseurship, cloaking racial criticisms with an aesthetic veneer. To understand how aesthetics displace

ideology, we must consider the comments made by nineteenth-century critics found mostly in guidebooks to the Capitol and among the remarks of some congressmen.

Complaints about the composition in *Penn's Treaty with the Indians* suggest anxiety about the work's content. Haas, for example, declared the work "below mediocrity," and John Elliot in his *Historical Sketches* wrote, "The artist . . . has not received very general approbation for his work; for contrasted with the animated and spirited efforts of Causici and Capellano . . . it is thought heavy and dull, in its execution."[63] It would seem that these authors felt uncomfortable with this scene in which the well-modeled, rounded figures technically surpass the awkward poses and caricatured musculature in the other three reliefs. By condemning Gevelot's work, Elliott expressed his unease at viewing a peaceful scene in which the Indians are rendered strong, benign, and classically inspired and equal to the whites.

Besides denouncing the composition, nineteenth-century Americans denigrated Penn's clothing as incongruous and fraught with too many details. "Phidias could not have given immortality to a modern martinet, in dress, with all his frogs and taggery," complained Samuel L. Knapp in his history of the United States. "The sculptor would have preferred the Winnebago, in his war dance, almost in native nakedness, to one so bedizened." This statement suggests that Knapp would have felt more comfortable viewing fierce, bellicose savages along the lines of Causici's rendition in the preferred *Conflict of Daniel Boone* than the peaceful natives pictured in Gevelot's relief. Instead of explicitly admitting his trepidation over the work's content, however, Knapp focused on Penn's clothing.[64]

This lack of awareness is especially suggested by the objections to the *Penn* relief that one congressman raised during the House's consideration in 1826 of an appropriation for the completion of the Capitol. Samuel D. Ingham, a Republican from Pennsylvania, took this opportunity to rebuke the portrait of his state's founder, complaining that "no person could cast his eye on the figure intended for that great and venerable person, and not turn away in disgust." The representative from Pennsylvania asserted that he "had always heard and read that William Penn was a portly figure, with rather a commanding and dignified appearance; but the figure here sculptured was a dwarf, and his appearance more ludicrous than anything else."[65] The crucial word here is *dwarf*, for in fact Penn stands eye to eye with the Delawares. That he is only equal in stature to the natives seems to have troubled the statesman.

In the case of *Preservation of Captain Smith*, critics denounced the Powhatan's costumes and features as erroneous. Capellano "had seen more Italians than Indians," concluded Samuel Knapp, "and his savages are Italian banditti, and his intended child of the forest an Italian queen." Elliot complained, "The faces and head-dress of Pocahontas are somewhat Grecian, and the features of Powhatan are less like an Indian than a European."[66]

Whereas the *Boone* relief corresponded to white America's stereotype of the Indian as a bloodthirsty devil whose brave opposition to the Euro-American

settlement inevitably resulted in failure and death, the other three did not. *Preservation of Captain Smith* pictures a heroic Powhatan princess, *Penn's Treaty with the Indians* depicts athletic and muscular Delawares equal in stature and size to the Quaker, and *Landing of the Pilgrims* represents an extreme disparity between the sizes of the two races. As none of the Rotunda reliefs portrays accurate ethnographic images of Indians with diverse tribal traditions in dress and heterogeneous physiognomies, the censure of the works seems perplexing. Why did these nineteenth-century politicians and historians praise one work while condemning the others? The answer lies in white attitudes towards Native Americans, indicated in congressional policy toward Indians and evident in criticisms of the Rotunda wall sculpture. White onlookers camouflaged their chauvinistic attitudes under the guise of aesthetics.

### The Indian Problem

During a debate in 1825 over the bill to preserve and civilize the Indian tribes, one member of the Committee on Indian Affairs, John Elliott, expressed the official attitude toward the Indians that had become the majority viewpoint by the end of the decade. The senator from Georgia argued:

> So long as the Indian tribes within our settlements were strong enough to wage war upon the States, and pursue their trade of blood with the tomahawk and scalping-knife, it was neither the policy nor the duty of the Federal Government to consult their comfort, or to devise means for their preservation. The contest, then, was for the existence of our infant settlements, and for the attainment of that power by which a civilized and Christian people might safely occupy this promised land of civil and religious liberty. It was, then[,] to be regarded as a struggle for supremacy between savages and civilized men, between infidels and Christians. But now, sir, when, by successive wars, and the more fatal operation of other causes, hereafter to be noticed, their power has departed from them, and they are reduced to comparative insignificance, it well becomes the magnanimity of a humane and generous Government to seek out the causes of their continued deterioration, and, as far as practicable, to arrest its progress, by the application of the most appropriate remedies.[67]

Eight years after Elliott made his statement in Congress in favor of Indian removal, *Niles' Weekly Register* reported the capture of eight murderers who had escaped prison at Fort Winnebago. These Indian convicts had been incarcerated for attacking white emigrants who had moved to the southwestern region of present-day Wisconsin to mine lead and cultivate the rich soil. Only six years earlier, in 1827, the Winnebagos had owned that land. But the failure of the Indian agent at Prairie du Chien to force 130 Anglo-Saxon trespassers off the Winnebago territory led to a formal treaty, in 1828, in which the tribe relinquished some of its property. Four years later, the War Department persuaded the Winnebago to sign another treaty, exchanging all their holdings in Wisconsin for acreage in Iowa.

Two significant points must be made concerning the outcome of this agreement. First, the Winnebagos' removal "has opened new fields for the new enterprise of emigrants," as *Niles' Weekly Register* proudly proclaimed. White Americans could move into this mineral and agricultural paradise without fearing Indian opposition. They could settle the region and build towns, schools, and churches without the continual threat of Indian attacks. Second, the dislocated tribe deteriorated from disease, from the physical and psychological strains of moving, and from hostile interactions with its neighbors, the Sac and Fox tribes.

The official policy of the federal government toward the Winnebagos provides the backdrop for understanding the Rotunda sculpted narratives. Earlier, in the eighteenth century, a consensus of opinion existed among white Americans about the continent's original inhabitants: they believed that the native population could become incorporated into their transplanted society. For this purpose, missionaries and agents under the direction of the Department of War taught Indians white agricultural practices and domestic arts. Thomas Jefferson, during his administration, especially promoted the civilization, education, and assimilation of Indians, drafting a seemingly philanthropic plan for them to abandon the hunter-warrior culture, tribal organization, and communal ownership of land. Hoping that the Indians would become yeoman farmers and intermix with the white population, Jefferson directed through the War Department the Indians' adoption of U.S. economic and social patterns as well as the English language. Just as the wilderness had been transformed into villages and farm communities, the Indians, purportedly living in a symbiotic relationship with the land, also could be molded—or so white Americans believed.[68]

Infused with the Enlightenment view of human improvement, Jefferson nevertheless favored racial amalgamation as a means to pacify the Indians and appropriate more land for the expansion of America's agrarian economy. He realized that by transforming the Indians from hunters into farmers, the aborigines would require less space for their livelihood. "While they are learning to do better on less land," Jefferson reasoned, "our increasing numbers will be calling for more land, and thus a coincidence of interests will be produced between those who have lands to spare, and want other necessaries, and those who have such necessaries to spare, and want lands." Jefferson's policy developed only because the architect of the Louisiana Purchase believed he could further increase the geographical domain of the United States through the education, civilization, and assimilation of all tribes. Most white Americans agreed with Jefferson that the Indians, by learning agricultural pursuits, would require less land and would cooperate in their own confinement.[69]

Although this approach had been largely successful for whites in the eighteenth century, events during the first two decades of the following century led the government to reassess its Indian policy. First, the alliance of various tribes with the British during the War of 1812 convinced many Americans that the two cultures could not peacefully coexist. Second, the conflict between Georgia and the Cherokee nation led some government officials to embrace the concept of removal for the Indians. In 1802, the federal government had agreed to terminate

its agreements that had entitled the Cherokee to holdings in Georgia. In exchange, the state ceded western land claims. But the government did not carry out its promise to the state, resulting in the governor of Georgia's request that Indian ownership be relinquished. Then, in 1827, the Cherokee drafted a constitution modeled after that of the United States and declared themselves an independent nation with sovereignty over their territories. Georgia responded with measures that curtailed Indian rights within its boundaries and, in the process, raised the same issue of states' rights that would be fought over the tariff by South Carolina and supported by other southern states.[70]

The War of 1812 and the Georgia-Cherokee crisis resulted in the government's vacillation over the "Indian problem," one dividing between the eighteenth-century belief in Indian assimilation and the growing conviction of the necessity for segregation. As the Indian agent and ethnologist Henry Schoolcraft wrote in 1828, "Nobody knows really what to do."[71] Until the Georgia-Cherokee conflict brought the issue to a resolution—one in which white Americans profited and the natives were forced to leave their ancestral homeland—the government continued the eighteenth-century Enlightenment policies of civilization. This is evident in President James Monroe's approval of the 1819 Indian Civilization Act, which provided for the acculturation of Indian tribes adjoining the frontier settlements by appropriating ten thousand dollars annually to employ people to instruct the Indians in agriculture and to educate their children. By the 1820s, however, the incorporation of southeastern Indians into white society presented an obstacle to expansionist intentions. This development, combined with the Cherokee actions, Georgia's unhappiness over the abrogation of its rights, and some white people's concern over Indian decimation, resulted in the policy of removal finally enforced in 1830.

The idea of removal had existed since the Louisiana Purchase, when Thomas Jefferson viewed the new territory as perfect for the relocation of Indian tribes. Although presidents Monroe and Adams enforced treaties that resulted in removal, it was not until Andrew Jackson's administration that, after much debate in both houses and a close vote in the House of Representatives, the president signed into law on March 28, 1830, an act that provided for the exchange of lands between the Indians and white Americans and stipulated Indian removal west of the Mississippi. As a result, the federal government extinguished Indian land titles and began moving tribes into the Great Plains. Perhaps the most notorious result of the Indian Removal Act was the Trail of Tears, in which the Cherokees experienced extreme hardships and suffered many deaths during the long trek from Tennessee to Oklahoma.[72]

Old Hickory had justified the relocation of the Indians by arguing that the policy would ensure the eventual civilization and acculturation of the "savage dogs," as the president called the natives. Nevertheless, despite the bill's enactment, some Jacksonian opponents believed that the Indian tribes had rights to self-government and to their lands, although they shared with their rivals the belief in white America's superiority to the uncivilized Indian. The Indian Removal Act prepared the way for the market revolution in the United States, in

which enslaved African Americans were moved onto the abandoned Indian land to cultivate cotton for the country's more complex economy. Unlike the Indians, blacks would not be expelled but instead, as Ronald Takaki has put it, "even more securely chained to white society and its political economy."[73]

Since the Indians could not restrain further settlement on their lands, evidenced in the Winnebagos' relocation from Wisconsin to Iowa, the only solution involved removal. By displacing the tribes from their ancestral homelands to areas relatively uninhabited by the white, the Indian race could be preserved. Andrew Jackson embraced this solution, forcing Congress to pass the Removal Act by a narrow vote. But this was only a temporary solution to the Indian problem.

It is questionable whether the foreign sculptors understood the changes in official Indian policy that occurred while they were carving their reliefs. And we have no evidence that Charles Bulfinch knew about the exact sequence of events concerning Indian policy that congressmen acted out during his tenure as Architect. Hence, even if Bulfinch contributed to the works' subject matter and compositions, he probably did not influence the works' relationship to the transformation in federal Indian policy. Nevertheless, the works resonate with official ideological implications. By showing the initial meeting between the two cultures in the colonial New World and the inevitable subjugation or assimilation of the Indian race, these reliefs present situations from the past that seem to condone the policies being contemporaneously formulated by Congress and the presidents.

The works reconstruct and represent historical realities as filtered through the imagination of nineteenth-century European artists who themselves became transplanted emigrants outside the mainstream of Anglo-Saxon culture, producing works for that culture in the Capitol building. These "outsiders" clearly studied previous images in order to create their visions of the nation's colonial past. In hindsight, it seems significant that Europeans executed the Rotunda reliefs that initiate the stereotyping of Native Americans in the Capitol decoration. True, Bulfinch had no choice but to commission foreigners because there were no professional sculptors at that time in the United States. Antonio Capellano, Enrico Causici, and Nicholas Gevelot came to the States in the hopes of establishing their reputations, probably recognizing that they could not surpass the leading sculptors in Europe. They did not become American citizens assimilated into American culture, however, but instead remained visitors, leaving this country sometime after completing their congressional commissions.

The Indians' overscaled sizes in the Rotunda reliefs thus may reflect the exaggerated threat they posed and their mythical status in the eyes of Euro-Americans. These works had been created in the decade before Indian removal, when the battle, in the words of Senator Elliott, raged between civilized Christians and infidel savages. It is not surprising, then, that nineteenth-century critics assessed the *Boone* relief as the most accurate and found fault with the more peaceful images.

The addition of four relief panels above the doorways of the Rotunda expanded the decorative program from Trumbull's "Hall of the Revolution,"[74] to

one that celebrated America's geographic extension, a significant alteration given the historical circumstances that involved the Native Americans and the 1820s notion of expanding empire. In concert, Bulfinch's relief panels and Trumbull's paintings outline the early history of the United States, showing its evolution from the European discovery of the continent to the Revolutionary War and the forming of a new nation.

In rendering episodes of discovery, conquest, and colonization in the New World, the Rotunda reliefs introduce a prominent theme in the Capitol's decoration, the interaction between the European emigrants and the original occupants in the newly discovered continent. The relations and interactions between the two cultures are simplified so that the first Americans are shown as primitive heathens who oppose the transplanted European, Christian society. These stereotypical images of the Indians provide an excuse for their subjugation by what white Americans believed to be a superior and civilized culture.

# 2

## *The Rotunda Paintings*

Between 1840 and 1855, American artists executed four more murals for the interior of the Rotunda, elaborating on the themes of discovery, settlement, and conquest first introduced by the reliefs. By the time these pictures were in place, the United States had a number of different supervisors of the Capitol, as well as various people in other positions who directed the building's decoration. The nation had entered a new era, one that involved sectional conflict and the settlement of different areas within the continent. Aggressive westward expansion marked the period with the annexation of the Texas Republic (1844), the dispute between England and America over the Oregon Territory (1844–1846), the war with Mexico (1846–1848), and the conquest of California (1847). The new Rotunda pictures, which depict similar subjects as those found in the reliefs, gain urgency and new depths of meaning when examined in the context of the nation's imperialist expansion.

The four new paintings in the Rotunda are John Chapman's *Baptism of Pocahontas at Jamestown, Virginia*, completed in 1840 (see fig. 20), Robert Weir's *Embarkation of the Pilgrims at Delft Haven, Holland*, completed in 1843 (see fig. 25), John Vanderlyn's *Landing of Columbus at the Island of Guanahani, West Indies*, completed in 1847 (see fig. 26), and William Powell's *Discovery of the Mississippi by De Soto*, completed in 1853 and in place by 1855 (see fig. 27). Although compositionally distinct, these seemingly isolated murals become linked in a pictorial narration to the other painted and sculpted images on the Rotunda walls because of their proximate locations within the architectural setting. These works, ranging from the Pilgrims' landing to the Revolutionary Era, achieve narrative continuity by their thematic associations, not by chronological arrangement.

Trumbull's works fill one half of the room. They are placed in a chronological pattern, moving from *Declaration of Independence* (1776) and *Surrender of Burgoyne* (1777) to *Surrender of Cornwallis* (1781) and *Resignation of Washington* (1783). The four additional pictures furnish the opposite semicircular space but follow no clear chronology from left to right (according to their placement prior to a change in the twentieth century): they are *Embarkation of the Pilgrims* (1620), *Landing of Columbus* (1492), *Discovery of the Mississippi* (1541), and *Baptism of Pocahontas* (1613).[1] When viewed sequentially, these works also establish a narrative, albeit a disjunctive one, that expands upon the themes of the Rotunda reliefs.

We encounter once again in the four new murals Pocahontas, Columbus, and the Pilgrims, all of whom participate in events different from those pictured in the smaller sculpted wall panels. The painted images represent the same subjects of discovery and settlement found in the reliefs, and they appear, on the surface at least, to address and reinforce the same issues as the earlier sculpted panels. In

fact, it might appear at the outset that these later pictures, like the sculpted reliefs, serve as a microcosm of the entire art program in the Capitol. But the evolution of the commission for the mid-century Rotunda paintings, the historical context, and the pictures themselves demonstrate that Jacksonian politics initially had driven artists and Congress back to what they perceived as historically "safe" and mythologized subjects. By the time some of the works had been completed, however, the bitter opposition to the Mexican War within President Polk's Democratic party and among such intellectuals as Henry David Thoreau added to the pictures' ideological implications. Given the imperialism of a divisive and unpopular war, regarded by some as an unjustified aggression on behalf of slavery, the paintings must be seen as efforts to legitimize national expansion, aggressive appropriation of Indian lands, and Indian relocation.[2] This is especially evident in the fact that military might is given greater importance in these works.

With the exception of Weir's *Embarkation of the Pilgrims*, these paintings represent early encounters between the original inhabitants of North America and Europeans. What is new in these images besides military conquest is the reference to religion; in each, spiritual expansion is linked to material attainment. In exchange for gold, wealth, and land, the European colonists offered Christianity, a religion alien to the Indians: under Columbus, when the natives of Hispaniola threw European holy relics on the ground and urinated on them, the Europeans burned the "offenders" alive in public.[3] Columbus established the precedent for Europeans' using religion to justify conquest, a prominent theme in these later Rotunda paintings.

At the same time, these pictures, like the reliefs, promoted various versions of national origins in which each state has its own myth of formation. William Penn founded Pennsylvania, John Smith and Pocahontas constitute the early history of Virginia, Daniel Boone settled Kentucky, de Soto traveled to Tennessee, and the Pilgrims landed in Massachusetts. The north, south, east, and west were thus united in these Rotunda murals and reliefs that render America's discovery and exploration. Sectional pride, which flared up at mid-century between advocates and opponents of slavery in the newly acquired territories, is manifest in these Rotunda images. Sectionalism also contributed to the selection of artists, despite the *New-York Mirror*'s plea of July 16, 1836, that "sectional motifs" not play a role in the decision of Congress.[4] As we shall see, congressmen promoted their constituents as one way to foster their state and region.

### Partisan Politics and the Fear of Jacksonian Adulation

The idea of having four additional pictures in the Capitol Rotunda originated with John Trumbull, who lobbied for a second commission when, in 1826, with his Revolutionary Era paintings now in place, the artist exhibited four oil sketches of Revolutionary War scenes under the empty niches of the Rotunda.[5] "There is a strong probability that I shall be ordered to paint *Four* others, to fill the vacant Spaces which now offend every Eye," wrote the optimistic chronicler of American history in 1827; "I think it wise therefore to remain on the Spot, until some decisive measure is adopted on the subject."[6]

Charles Bulfinch also objected to the "vacant Spaces," noting in his 1827 report to the commissioner of public buildings that the Rotunda could not be considered complete with the four large panels empty.[7] The Architect of the Capitol probably disliked the fact that one half of the Rotunda contained large murals while the other contained empty areas between the framing pilasters.

Urging that measures be taken to add paintings "on great national subjects" to the walls, Bulfinch highlighted a topic that had concerned various congressmen and artists during the decade since Trumbull had received his commission. For example, already one month after the congressional resolution for the Revolutionary and federalist scenes, in February 1817, Aaron Ward of New York had proposed that Congress order a fifth work from the Connecticut artist for the central hall depicting the capture of Major John André.[8] No action was taken on this resolution, but Trumbull did not abandon his quest to decorate the Rotunda with additional paintings.

The seventy-one-year-old artist, however, never realized his ambition, nor did Bulfinch direct the continuation of the Rotunda wall embellishment. Some congressmen expressed anger that Trumbull had exhibited his paintings for profit in various cities before they arrived in Washington, D.C., while others felt disappointed with his artistic accomplishments.[9] John Randolph of Virginia, who earlier had supported Trumbull's patronage by the federal government, ridiculed *Declaration of Independence* as "the *Shin-piece*," because of the profusion of legs, and admitted to feeling "ashamed of the state of the Arts in this Country" every time he walked through the Rotunda.[10] Many assessed Trumbull's final works as more wooden than his oil sketches, resulting in some politicians' reluctance to commission additional works from the artist.

Trumbull nonetheless did not stand alone in his aspirations. In 1824, two years before Trumbull exhibited his sketches in the Rotunda for congressional consideration, John Vanderlyn—who had studied in Paris and had struggled for recognition as a neoclassical history painter in the United States—had presented a memorial to Congress to pictorialize the Battle of New Orleans. Various committees in the Senate considered the artist's petition, but it eventually was tabled without a vote.[11] Then in 1826, one month after Trumbull had exhibited his oil sketches in the Rotunda, the Committee on the Library of the House of Representatives submitted a report in response to its directive "to enquire into the expediency of offering a suitable premium for each of the best four designs in painting, to be taken from some of the most interesting and remarkable events of the American Revolution other than those executed by Colonel Trumbull . . . [to] be furnished by native artists."[12] The committee reasoned in its two-page report that professional American artists probably would refuse to participate in a competition, an assessment later proven in 1853, when Hiram Powers declined to submit a design for the House pediment. Apprehensive that excellent sketches might not translate into superior history paintings (as evidenced in the opinions of some of Trumbull's works), the committee recommended that Congress select the artists and subjects rather than offer a premium for designs.

A few weeks later, James Hamilton, Jr., of South Carolina took the initiative in the House of Representatives. He selected an artist, Washington Allston—a prominent Romantic painter from his own state and a close friend of John Vanderlyn (the two had traveled from the Low Countries to Paris together)—and the subject, the same one that Vanderlyn had earlier proposed: the Battle of New Orleans. Hamilton's motion initiated a prolonged debate during which two additional resolutions were proposed, six amendments offered, and seven votes taken.[13] This heated two-day debate in the House reveals that congressmen allowed partisan politics to govern their consideration of subjects for the Capitol's artistic decoration, and that they tried to use art in the Capitol as a means to promote their presidential candidate, Andrew Jackson, whose earlier victory at the close of the War of 1812 had elevated the general to the stature of national military hero. Hamilton, in fact, submitted his resolution on January 8, 1828, the fourteenth anniversary of the Battle of New Orleans, and looked to the commission primarily to immortalize Old Hickory's victory on the Rotunda walls.[14]

As a British spectator, Basil Hall, noted about this debate, the balloting procedure wasted precious time and confused the issue, as did the amendments. Indeed, Hall accurately observed that the current presidential campaign between Andrew Jackson and the incumbent president, John Quincy Adams, fueled the discussion and succeeded in mystifying and overloading "with extraneous matter" the original resolution so that the majority Jackson party failed to win the vote.[15] The National Republicans immediately comprehended Hamilton's political agenda and proceeded to entangle the debate. This is evident in Edward Everett's recommendation that the resolution eliminate reference to "the great man who had achieved that victory" and instead more ambiguously refer to "appropriate paintings."[16]

The different political agendas between the Jacksonian Democrats and the National Republicans, however, was not the only factor in the obstruction of progress on the Rotunda's murals. Money also persisted as an issue. In 1830, the chairman of the House Committee on Public Buildings, Gulian C. Verplanck, a Jacksonian Democrat from New York, tried to solicit two pictures of American historical subjects from his old friend Washington Allston, whom he had met almost fifteen years earlier while in London.[17] Other members of the committee, Leonard Jarvis of Maine and William Drayton of South Carolina, also supported Allston's employment, but because of limited funds they failed in appending the commission onto the bill for the improvement of public buildings.[18]

Eight years later, on January 24, 1834, when financial restrictions had been slightly eased, Henry A. Wise introduced a resolution in the House instructing the Committee on Public Buildings to consider the employment of American artists to execute four national paintings for the Rotunda.[19] The committee reported on February 11 a joint resolution similar to Wise's specifying that four artists select the subjects under supervision of the committee.[20] On December 15 the bill received its third reading, during which some discussion ensued.

Besides debating whether four competent American artists could be found

and whether the United States should, in the words of Wise, "bestow her favors and lawful patronage" on Americans instead of foreigners (a move he supported),[21] the issue of Jackson's idolization once again arose, this time during President Andrew Jackson's second administration. Tristam Burges revived consideration of the Battle of New Orleans as a subject by expressing his opposition. The anti-Jacksonian explained that he "had no objection that posterity should know all the achievements of General Jackson" but that the man had become "a public convenience and accommodation."[22] Although Burges failed to fuel the same impassioned responses that erupted during Jackson's first campaign for the presidency, both Democrats and National Republicans nevertheless attempted to eliminate the threat of Jacksonian adulation by suggesting that the subjects predate either 1783 or 1781. "You must go back until you meet events hallowed by time, and magnified and mystified by antiquity," astutely reasoned Wise, a Jacksonian, while Samuel F. Vinton, an anti-Jacksonian and Whig from Ohio, moved to amend the resolution by inserting "colonial or revolutionary" before the word "historical." The House adjourned before voting on the resolution, once again leaving the issue of the Rotunda paintings in limbo.[23]

In 1836, Congress again considered the empty Rotunda panels, finally passing without debate or roll call a measure to contract "with one or more competent American artists for the execution of our historical pictures upon subjects serving to illustrate the discovery of America; the settlement of the United States; the history of the Revolution; or of the adoption of the Constitution."[24] Congress assigned the selection of artists to a Select Committee, who reported on February 28, 1837, that they would ask the following artists to execute the works: John Vanderlyn, the New York artist who had earlier submitted a memorial to Congress and who in 1832, through the assistance of Gulian Verplanck and Washington Allston,[25] had received a commission for a portrait of George Washington for the House of Representatives; Robert Weir, a teacher at the U.S. Military Academy in West Point who had studied in Italy; Henry Inman, a leading New York City portrait painter; and John Chapman, a young artist from Virginia who had recently returned from Rome. The committee left the specific subjects to the artists and offered ten thousand dollars for each picture.[26] Because Inman died in 1846 before completing his picture, *The Emigration of Daniel Boone to Kentucky*, William H. Powell, a student of his from Cincinnati, Ohio, created the fourth painting, *Discovery of the Mississippi*.[27]

The process for commissioning works for the Capitol had changed since the 1820s, when the Architect of the Capitol, under the commissioner of public buildings, directed the building's decoration. With the dissolution of the former office, Congress had a greater voice in artistic matters, with various committees appointed the task of making decisions. As a result, four men in particular used their knowledge about art and artists to influence the selection of painters: Edward Everett of Massachusetts, chairman of the Joint Committee on the Library; Gouverneur Kemble, Democratic representative from New York and an art collector; Henry A. Wise, a Jacksonian at the outset of his political career who had advocated federal patronage of American artists and had succeeded in expedi-

ting a House resolution for the Rotunda murals; and Gulian C. Verplanck, a former member of Congress who used his influence with his former colleagues.[28]

At the same time, these men probably contributed to the artists' choice of subject matter. What is significant about the final resolution for the four additional Rotunda paintings is that the bill designated subjects that predate the Battle of New Orleans, thereby bypassing the polemics inherent in the glorification of one man, Andrew Jackson, and his party, the Democrats. The squabbles that had surfaced during Jackson's first presidential campaign and again toward the end of his second term in office were suppressed through the selection of colonial subjects. Congress had settled on what initially seemed like politically neutral periods in American history. As a result, John Vanderlyn, John Chapman, Robert Weir, and, later, William Powell rendered scenes that satisfied the stipulation of the resolution that they illustrate the discovery and settlement of America—in other words, events that occurred before the War of 1812. However, the fact that the first three artists did not choose subjects from the Revolutionary War or the federal period, epochs also designated in the resolution, takes on significance, given that their friends and promoters were avid expansionists who promoted the annexation of new lands.[29] Everett, Kemble, Verplanck, and Wise lobbied on behalf of the nation's geographic extension and probably encouraged their friends to select subjects that would buttress their political agendas.

### Civilization and Conversion: *John Chapman's* Baptism of Pocahontas

John Chapman's painting (fig. 20), the first to be completed (in 1840), represents a later event from the life of Pocahontas than the one immortalized in Antonio Capellano's relief placed diagonally across and above. Rather than show Pocahontas's rescue of Captain John Smith, Chapman depicted the sacred ritual of baptism, the moment when the Indian princess converted to Christianity and in so doing abandoned her native tradition in favor of British culture.

Three figures form the central focus of the composition from left to right: the minister, Alexander Whiteaker, the Indian princess, Pocahontas, and the convert's betrothed, John Rolfe. The two standing men—Whiteaker and Rolfe—reiterate the vertical pine columns that frame the clergyman and enclose the kneeling Pocahontas. The colors of her dress, shawl, and hair—white, red, and dark brown—are deliberately repeated in the clothing of Whiteaker and Rolfe in order to suggest the Indian princess's affinity with her adopted people. Instead of resembling her own family members, who occupy the right portion of the composition, Pocahontas evokes the Virgin Mary, whose purity, humility, and spirituality are suggested by her bent head, clasped hands, and benign facial expression.

Five Indians dominate the right portion of the composition, primarily because of their dark skin, beardless faces, seminude bodies, exaggerated poses, and exotic dress and ornamentation. The mother in the foreground stares at her sister in awe, wonderment, and adulation, and echoes the pose of the seated male Indian. He is Opechankanough, Pocahontas's uncle, identified in the pamphlet published to explain the painting as "the sullen, cunning, yet daring" chieftain

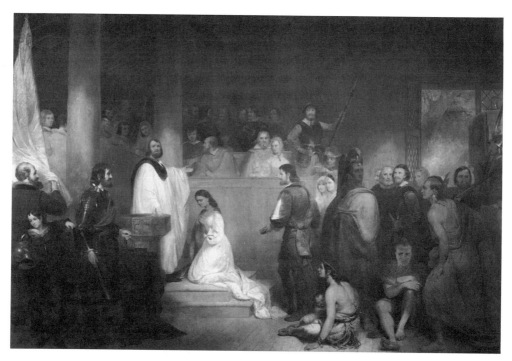

20. John Chapman. *Baptism of Pocahontas at Jamestown, Virginia, 1613.* 1836–1840. Oil on canvas. 144 × 216 in. U.S. Capitol Rotunda. Courtesy of the Architect of the Capitol.

who had kept Captain Smith hostage before delivering him to his brother, at which time the rescue by Pocahontas had occurred.[30] Later, in 1622, Opechankanough had ended the Peace of Pocahontas when he orchestrated a successful massacre of the Jamestown settlement. Separated from the others, obscured by shadow, and bending over with arms on his knees, this morose man refuses to acknowledge the ceremony. He instead appears lost in his thoughts, presumably planning his later assault on the settlers. Nantequaus also psychologically removes himself from the event. Monumental in his proud stance, plumed headdress, and impenetrable physique covered by drapery, Powhatan's son, classified by Smith as "the manliest, comeliest, boldest spirit I ever saw in a Salvage," turns his head away from his sister to express his dissatisfaction.[31] Only Pocahontas's sister and her uncle on the far right watch (and hence acknowledge) the Christian ceremony.

In depicting the baptism of Pocahontas, Chapman chose a theme from his native state's early history that artists seldom commemorated but writers often celebrated in poems, plays, and novels. Pocahontas's rescue of Captain Smith, found in Capellano's relief and in numerous illustrations, such as the engraving in James Wimer's 1841 *Events in Indian History* (fig. 21) and the frontispiece to Davis's 1817 *Captain Smith and Princess Pocahontas* (see fig. 13), became popular

themes in the visual arts. Chapman himself had painted this subject (fig. 22), as well as other colonial Virginia themes, such as *The Landing at Jamestown* and *The Crowning of Powhatan*.[32] Pocahontas's 1614 marriage to John Rolfe also became a familiar motif in the visual arts, as in *The Marriage of Pocahontas*, engraved by John C. McRae in 1855 (fig. 23), and *The Wedding of Pocahontas*, by George Spohne (1867; fig. 24). Chapman's choice of the baptism thus distinguishes him among nineteenth-century artists who rendered various events from the life of the renowned Indian princess. (Even Constantino Brumidi selected the rescue scene over that of Pocahontas's conversion in his later grisaille fresco painted at the base of the Rotunda dome; see fig. 87.)

The *Picture of the Baptism of Pocahontas*, a pamphlet published to explicate the visual image, alludes to these more popular themes from the convert's life. Besides providing a key that identifies some of the figures in the painting, the brochure includes selections from seventeenth-century documents that detail the early

21. *Capt. Smith Rescued by Pocahontas.* 1841.
Engraving. Courtesy of the Library of Congress.

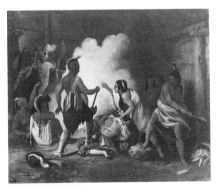

22. John Chapman. *Rescue of Captain Smith.*
C. 1836–1840. Oil on canvas. 21 × 25¼ in.
Courtesy of the New-York Historical
Society, New York City.

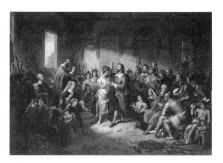

23. John C. McCrea. *The Marriage of Pocahontas*. 1855.
Engraving. Courtesy of the Library of Congress.

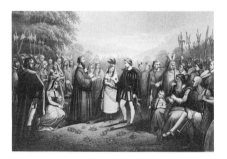

24. George Spohne. *The Wedding of
Pocahontas with John Rolfe*. 1867. Lithograph.
Courtesy of the Library of Congress.

British settlement of the Jamestown colony, Pocahontas's rescue of Captain Smith, her conversion to Christianity, and her marriage to John Rolfe.[33]

Identifying Pocahontas as one of the "children of the forest" who has "been snatched from the fangs of barbarous idolatry," the pamphlet celebrates the princess's conversion from "her idols to God," from Pocahontas to Rebecca, and from tribal costume to European garb as indicative of the forefathers' largess in propagating "the blessings of Christianity among the heathen savages."[34] The Jamestown colonizers did more than "exterminate the ancient proprietors of the soil, and usurp their possessions": they succeeded in associating the rise and progress of Christianity with the political destinies of the United States.[35]

The government publication thus supports the meaning conveyed by Chapman's painting. The picture clearly distinguishes between the New World Indians and Pocahontas, who, as Rebecca, has discarded her family, her tribal customs, and her religion to become a Christian Englishwoman and found a line of prominent Virginians. The pamphlet underlines this message but also provides the textual narrative needed to place the event within a broader historical context, even admitting the extirpation of Indians and expropriation of property

to make way for Christianity in the New World. This destruction of people for the appropriation of land is achieved through moral rather than physical persuasion, according to the pamphlet, although it is the Europeans who bear armor and weapons in the holy church. (The regulation of the colony dictated that the colonists wear their arms even to church and that Indians discard their weapons before entering the town.)[36]

Although the image promotes the peaceful assimilation of the Native Americans into Euro-American culture, the subtext of the painting conveyed by the recalcitrant members of Pocahontas's family is underscored by the pamphlet. Chapman's canvas shows Pocahontas as a symbol for the success of missionary and government plans for the Indian adoption of European ways, whereas the government publication indicates the urgency of Indian removal (a policy enforced seven years earlier) as a necessary means to separate such rebellious natives as Pocahontas's warlike uncle and brother to release eastern lands for white occupancy. The government-sponsored picture and pamphlet thus suggest that peace between the two peoples can occur only when those natives who threaten settlement are relocated; those who are peaceful and willing to forfeit their culture and tradition through conversion or intermarriage may stay in their ancestral homelands, which will be transformed into towns and cities. As the superintendent of Indian affairs in Saint Louis asserted in 1851, "an intermixture with the Anglo-Saxon race is the only means by which Indians of this continent can be partially civilized"—and, he might have added, controlled.[37]

Pocahontas belongs to the history of one state, Virginia, and the painting celebrates the founding of that southern colony as crucial for the future formation of the United States. On the eve of renewed sectional division over the acquisition of western territories, regional pride came into focus in *Baptism of Pocahontas*, not surprisingly given that artist himself was a Virginian, as was his patron, Henry A. Wise.[38] Chapman commemorated an individual from his state's history who had become assimilated into national mythology as well as white civilization, and who answered New England's claim to have planted the seeds for the American republic. Through Chapman's painting, then, Pocahontas entered the annals of American history as someone who marked the success of (to quote the pamphlet) "the first permanent Christian community in this great Confederation."[39]

*Rite of Passage: Robert Weir's* Embarkation of the Pilgrims

The second painting completed and placed in the Rotunda (in 1843), Robert Weir's *Embarkation of the Pilgrims* (fig. 25) is unusual among the reliefs and second group of Rotunda paintings because the portrayed event takes place in Europe. Rather than render the cultural confrontation between Old and New World people, as in Causici's *Landing of the Pilgrims* (located to the mural's left and above the doorway), Weir depicted the Pilgrims at the moment before their long and arduous voyage across the Atlantic to the shores of New England. In Weir's painting, we see a group of Separatists from the Church of England, including William Brewster, William Bradford, and Miles Standish, assembled on the *Speed-*

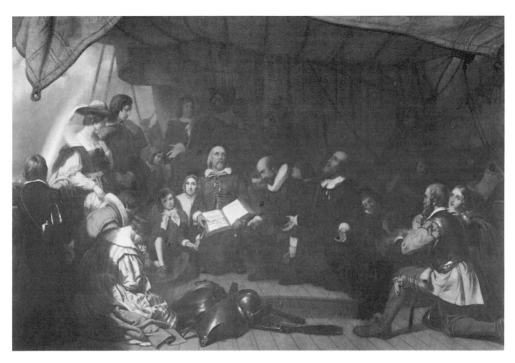

25. Robert W. Weir. *Embarkation of the Pilgrims at Delft Haven, Holland, 22 July 1620.* 1836–1843.
Oil on canvas. 144 × 216 in. U.S. Capitol Rotunda. Courtesy of the Architect of the Capitol.

*well*, the ship that was to have transported the future fathers and mothers of New
England from their eleven-year exile in Holland to the New World.[40]

The *Speedwell* provides a stage for the figures, which are arranged in a semicir-
cle in a shallow space. Initially, Robert Weir conceived of his subject as an
anecdotal dockside scene, with the focus on those on the shore who grieve over
the departure of their friends.[41] He settled, however, on a close-up view of the
Pilgrims led in prayer by their pastor, John Robinson, in preparation for their
departure on July 20, 1622.[42] Except for the Dutch town visible on the right and
the ocean on the left, the sail forms a horizontal curtain that cuts off from view the
landscape setting. The colorful rainbow set against the cloudy left sky signifies
hope, the very emotion that is expressed by the facial expressions, poses, and
gestures of the people in prayer and meditation who ask for guidance in their
search for religious freedom. Hope is also manifest in the vessel, called by Weir
"the bow of promise," and the sail, on which is written in white, "God with us."[43]

Weir's *Embarkation of the Pilgrims* goes back in time and place to the moment
before American history takes form for those people who will establish a new
colony. The Pilgrims are suspended in a moment of transition in a rite of passage
"from one kind of space to another, from ocean onto land, from past to future,
from Englishmen to Americans."[44] The English men and women will cross the

ocean to complete their transformational passage into the New England fathers and mothers. According to *Ballou's Pictorial Drawing-Room Companion*, they became "the founders of a great empire."[45] As Robert Winthrop asked in his 1839 New York oration, "Were these . . . the men, through which, not New Plymouth only was to be planted, not New England only to be founded, not our whole country only to be formed and moulded, but the whole hemisphere to be shaped, and the whole world shaken?" The answer, of course, is yes. "They were the pioneers in that peculiar path of emigration" under the guidance of "the Great Master," who created a "civilized society on this whole northern Continent of America."[46] These men and women formed "the germ of our Republic," as the title page to the guide of Weir's painting exclaimed.[47]

The artist from New York thus presents one section's version of national origins rooted in the east that had been widely accepted but not unchallenged, especially by southerners, who employed the "Jamestown countermyth" from the life of Pocahontas pictured in Capellano's relief and Chapman's painting. Southern apologists like William Gilmore Simms, in his essay "Pocahontas: A Subject for the Historical Painter," also propagated that myth.[48] Weir consciously promoted New England as the seat for the nation's birth, explaining in his published guidebook to the picture that he thought that "there should be at least one picture in our National Hall, whose subject should commemorate an event connected with the history of our eastern states; since they were the first to grapple in that struggle for liberty, the achievement of which is our glory and boast."[49]

Regional pride also comes through in the discourses about Weir's painting. Steven G. Bulfinch, a Unitarian clergyman from Boston and son of the former Architect of the Capitol, published an oration about the mural, in which he extolled "the heroic founders of our nation" who left Europe in search of liberty.[50] Mayor Morris's toast during the Pilgrim Day celebration by the New England Society of New York in homage to Weir's *Embarkation of the Pilgrims* perhaps best expressed how easterners thought about the colonizers of New England: "Religious Toleration, the foundation of political liberty—of individual independence, affluence and happiness."[51]

In Weir's paintings, a group of Pilgrims prepare for their voyage to bring religious toleration to the North American continent and to plant the seed of religious and civil freedom in the United States. Although the figures in prayer dominate, nevertheless the focus of the painting resides not in the humans, nor the open Bible the pastor holds in his hands, but in the still-life arrangement of armor and weapon. Located in the foreground and framed by the seated woman on the left and the kneeling man on the right, these highlighted metal accoutrements are the closest objects to the viewer. Someone has discarded his military clothing to participate in the community prayer for salvation. But these still-life motifs of armor and rifle, references to future conquest, become the focus of the composition and are juxtaposed with the prominent Bible of similar hues located directly above. The peaceful scene of prayer is thus ironically subverted by the icons of military might that dominate the mural.

Within this context, the rainbow represents more than hope. It also refers to

the Chosen People, who seek the millennial destiny for mankind in the chosen land and who will use force in order to achieve their providential mission in the name of "Our Lord & Saviour Jesus Christ," the inscription that is prominently displayed in the open New Testament held by Brewster (the orthogonal lines in the wooden floor lead to him). That Robert Weir taught art at West Point may have had something to do with the focus on military might in the painting. But it will become evident that these still-life motifs of arms and armor also perform a significant symbolic role within the context of westward expansion.

*Possession and Dispossession: John Vanderlyn's* Landing of Columbus

In place by 1847, John Vanderlyn's *Landing of Columbus* (fig. 26) continues the theme of military conquest, although the issue of regional pride is absent. Vanderlyn had wanted to create a history painting for the Capitol Rotunda ever since he had learned about John Trumbull's Revolutionary War murals.[52] Although he failed to get an order for the Battle of New Orleans in 1824, he finally received the coveted commission in 1837, at which time he selected the subject of Columbus's arrival in the New World, a theme that applied to the resolution's specifications for such subjects as "the discovery of America."

Vanderlyn's *Landing of Columbus at the Island of Guanahani, West Indies* represents the admiral's arrival in the New World, which constituted the first contact between Europe and America. For historical accuracy, the artist visited the West Indies to sketch the vegetation and went to Madrid to consult a portrait of Columbus; he derived his narrative episode from Washington Irving's popular biography, *The Life and Voyages of Christopher Columbus*, which Washington Allston had earlier proposed to illustrate.[53] Depicted in a pose similar to that of Persico's statue (see fig. 53), which was placed on the outside of the Rotunda three years before Vanderlyn completed his picture, the explorer stands in triumph, wearing his splendid red garment (still pristine after the long voyage), leaning on his drawn sword with his right hand, and holding the royal standard with his left in a symbolic act of possession of the newly discovered island in the name of the Spanish empire.[54] Some of the sailors are still kneeling after having kissed the earth; others stand as they cluster behind their leader. The captains hold the two banners of the enterprise that Irving had described in his book, "emblazoned with a green cross, having on either side the letters F. and Y. the initials of the Castilian monarchs Fernando and Ysabel, surmounted by crowns."[55] Behind the central group are more newcomers, two of whom kneel in the ritual of kissing the earth; others dance in celebration, and still more are disembarking from their ship.

These European men dominate the composition, forcing the New World people to the right periphery of the work. Washington Irving informs the reader that the "uncultivated" island "was populous, for the inhabitants were seen issuing from all parts of the woods" and upon first seeing the boats "fled in affright to the woods." Irving elaborates: "Finding, however, that there was no attempt to pursue nor molest them, they gradually recovered from their terror, and approached the Spaniards with great awe; frequently prostrating themselves on the earth, and making signs of adoration."[56] Although Vanderlyn does not depict a

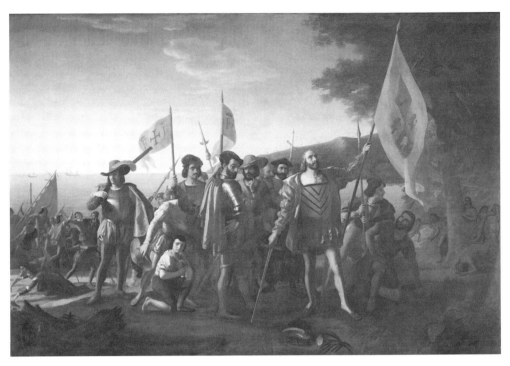

26. John Vanderlyn. *Landing of Columbus at the Island of Guanahani, West Indies, 12 October 1492.*
1836–1847. Oil on canvas. 144 × 216 in. U.S. Capitol Rotunda. Courtesy of the Architect of the Capitol.

large population of natives, he nevertheless adhered to Irving's account in his
grouping of a few Indians in the woods who hover behind trees, bow on the
ground, flee, or watch in fascination and with trepidation. Vanderlyn further-
more followed the author's repeated assertions that the natives of the island
"were entirely naked," that they were beardless and of "tawny or copper hue," and
that their hair either fell to their shoulders or was cropped above the ears.[57] The
artist added a secondary and smaller group of Indians on the other side of the inlet
that curves behind the foreground scene. They gaze in wonder at the three other
ships that appear on the horizon in the expanse of ocean that extends into the
distance.

Compositionally, the painting is divided into three sections: the central
group of Europeans, who cluster in a semicircle, the travelers to the left and
behind the major protagonists, who still are disembarking from the ship, and the
right wilderness section, in which the Indians reside.[58] In an oil sketch (c. 1840,
National Museum of American Art) for the painting, Vanderlyn originally lo-
cated the two people on the same ground, but in the final work he used light and
shadow to divide his painting at an angle from left to right between the fore-
ground wilderness that Columbus and his compatriots inhabit and the highlighted
background. The Italian navigator has invaded the Arawack's territory, the

darkened area, bringing Old World civilization, represented by the highlighted shore and ocean. Not only are the Indians smaller than the dominant arrivals, but they are also painted with thinly applied pigment with loose edges, unlike the more hardened contours of the sculpturally defined central figures. The different means by which the two races are painted suggest that the Europeans are separate from their surroundings. By contrast the Indians (identified by the pamphlet published to explicate the painting as "tawny savages, in Arcadian simplicity") have a symbiotic relationship with nature and are able to merge into their surroundings in retreat from "the mysterious strangers," who appear, according to the guidebook, "as beings of a higher order."[59]

Christopher Columbus had viewed himself as an evangelizer and colonizer who took possession of the New World for his Spanish patrons and for Christianity, linking spiritual expansion to material conquest. Regarding himself as charged with a divine mission, the Genoese admiral set off on a crusade to liberate Jerusalem and in the process discovered a strange new world inhabited by alien people, some of whom he took back with him to Europe and sold into slavery. Columbus initiated the invasion and displacement of the resident population upon his symbolic possession of the island he named San Salvador, "in homage to His Heavenly Majesty who has wondrously given us all this." The two contrary attitudes he held toward the Indians contributed to the beliefs that would continue in the following centuries. On the one hand, Columbus conceived of the Indians as equal and identical, resulting in assimilation; on the other, he viewed them, as Tzvetan Todorov puts it, as "truly other, something capable of being not merely an imperfect state of oneself." Todorov explains that Columbus eventually shifted away from assimilation "to an ideology of enslavement, and hence to the assertion of the Indian's inferiority."[60]

Vanderlyn probably had not read Christopher Columbus's writings. The artist nevertheless captured the essence of the admiral's narrow and predetermined analysis of the strange people he encountered, perhaps because he had consulted Irving's biography of Columbus and shared with his contemporaries a belief in the superiority of the Euro-Americans and the inferiority of the New World inhabitants. Consequently, in his painting, Vanderlyn portrays Columbus's arrival on the island as one step toward the submission and inequality of the Indians. By claiming, weapon in hand, the island for the Spanish crown, the Italian navigator initiated the forcible displacement of the indigenous people.

*Relinquishment and Conquest: William Powell's* Discovery of the Mississippi

Like the written histories in the nineteenth century, the art in the Capitol shows the discovery of America by Columbus as the beginning of America, ignoring the history of Native Americans prior to the arrival of Europeans and acknowledging subsequent explorers as crucial for the Europeanization of the continent.[61] Busts of Columbus, Raleigh, Cabot, and La Salle are enshrined in the Rotunda reliefs situated above four of the paintings.[62] And with one of the Rotunda paintings a fifth adventurer joins the pantheon of notable explorers in the Capitol's pictorial fiction of New World discovery: Hernando de Soto, the Spanish governor of

27. William H. Powell. *Discovery of the Mississippi by De Soto, A.D. 1541.* 1847–1855. Oil on canvas. 144 × 216 in. U.S. Capitol Rotunda. Courtesy of the Architect of the Capitol.

Cuba who had landed on the Florida coast in 1539, crossed the Mississippi River south of present-day Memphis in the spring of 1541, and traveled to what is now eastern Oklahoma before returning to the Mississippi, where he died in 1542. It is de Soto's arrival at the Mississippi River that William H. Powell painted for his commission of 1847 (completed in 1855; fig. 27).

Upon learning of Inman's passing, Powell lobbied for the congressional order. Besides soliciting assistance from Washington Irving, who wrote a letter of recommendation, Powell exhibited *Columbus before the Council of Salamanca* in the Library of Congress, gaining the support of Joseph J. McDowell, the representative from his Ohio district, who proposed a joint resolution directing the Joint Committee on the Library to sign a contract with Powell.[63] After limited debate in the House, during which time other discovery scenes were proposed, the resolution for the commission passed by a vote of 89 to 48.[64] Powell then submitted a number of drawings to the joint committee, who selected the subject of de Soto's arrival at the Mississippi.[65] Since the three other paintings were in place by the time he received his commission, the subjects having been chosen by the artists rather than by a joint committee in Congress, it is possible that the delegates selected the de Soto sketch because they thought that it would best fit into the narrative scheme of America's discovery and colonization without duplicating figures and events already portrayed.

In preparing to execute *Discovery of the Mississippi*, Powell consulted Bancroft's *History of the United States*, Theodore Irving's *The Conquest of Florida* (1835), and *The Account of Luis Hernandez de Biedma* (1544), among other works.[66] By the time the history painting was completed, the subject of de Soto's adventures in the south had become even more popular. On April 7, 1855, *Ballou's Pictorial* summarized the Spanish conquistador's pilgrimage, as did Henry Rowe Schoolcraft in *Scenes and Adventurers in the Semi-Alpine Region of the Ozark Mountains of Missouri and Arkansas* (1853) and Lambert A. Wilmer in *The Life, Travels and Adventures of Ferdinand de Soto* (1858). (Wilmer's book included an engraving of Powell's Rotunda painting as its frontispiece.)[67] A number of other artists, such as William Ranney, Peter Rothermel, Seth Eastman, and Carl Wimar had also painted similar subjects.[68]

The regal-looking de Soto, seated atop a white horse and surrounded by empty space, dominates the composition. He is accompanied by a number of Spanish and Portuguese men on the left: standard-bearers, a confessor, men in helmets, and a young cavalier. Indian tepees and European flags frame de Soto right and left, juxtapositing two cultures and their symbols—one "savage," the other "civilized," according to two pamphlets published in 1855 to explain the painting.[69] In the foreground, the European explorers form a semicircular frame that moves from left to right. These struggling and weary men carry emblems of military and religious conquest: a canon, some muskets and a breastplate that rest against an iron camp chest, a helmet on the chest, and a cross that is being buried in the ground. These "implements of war" form a secondary focus to de Soto in the composition, commanding attention because of their location in the central foreground.[70]

Instead of standing in the wilderness that is suggested by the left background trees, the Indians inhabit the shore of the broad river that extends into the right background of the painting. In the Indian group are two bare-breasted women—one bows in respect to the foreigner, the other recoils in fear—and three standing chiefs. One is described in the guidebook as "erect, full of spirit, fire and daring, gazing upon a new rival invading his empire"; next to him is "an old cacique . . . bearing a pipe of peace . . . [and] bending before the conqueror"; and near him "the ideal of the 'Uncas' of Cooper," who has thrown his bow and arrow to the ground "in a token of outward submission." Other Indians crowd behind and beside their leaders, and still more are located in canoes in the river.[71]

Without having to fire a shot, the conquistadors have taken over the land, which the Indians symbolically hand over through the elder chief's gesture of relinquishing his rudimentary weapons and hence his power to de Soto, who looks at the area as "an illimitable scene of future empire for his distant sovereign."[72] As the *National Intelligencer* explained in a review published in Henri Stuart's pamphlet, Powell has rendered "on the canvass . . . the great ideas of the submission of the Indian tribes, and the important part played by religion, allied with force, in the conquest of the New World."[73] In fact, Powell shows the conquest not only of North America, for as Stuart notes in his guide to the painting, the armor-bearer of de Soto "forms an admirable allusion to the then

recent fall of Grenada, and the overthrow of the Moorish Empire of Spain."[74] Aiming "to rival, if not surpass, the glory of the Mexican and Peruvian conquerors," de Soto sits upon his white horse in splendor and triumph as the premier conquistador in the New World, who lifted the "dark curtain that covered the region."[75]

Powell selected a peaceful scene from the otherwise bloody exploits of de Soto in the New World in order to demonstrate the Old World's superiority in arms, religion, dress, and demeanor that resulted, according to Stuart, "in opening a mighty empire to exploration and civilization."[76] Like Vanderlyn in *Discovery of America*, Powell renders the European colonizers as dominating the landscape, indicating the future displacement of the New World inhabitants who willingly relinquish their authority to the superior conquistadors under what the *Washington Sentinel* called "the harbinger of civilization."[77] Once again regional pride is involved, this time locating American progress in the northwest. As the *National Intelligencer* asserted, de Soto's arrival at the banks of the Mississippi constituted "the starting point in the history of that remarkable region, which has already astonished the world by its growth, its vigor, and its vast resources, and which is destined to be perhaps in less than two centuries the citadel and centre of the world's civilization and the world's freedom."[78] The painting records "a national event," according to its guidebook, in which the "republic . . . stretched from ocean to ocean" as a result of such explorers as de Soto.[79]

## Mid-Century Expansion

By the time Congress had ordered this second group of murals in June 1836, the United States had entered a period of increased westward expansion signaled four months earlier during the siege of the Alamo in San Antonio. In July, the Senate and the House adopted resolutions calling for the recognition of the Republic of Texas, governed by Sam Houston, but the United States did not annex Texas and grant it statehood until 1845, five years after the first Rotunda painting was in place. The following year, in 1846, when war broke out with Mexico, the United States made inroads into the Pacific Northwest through the acquisition of Oregon. By the close of the Mexican War in 1848, it had acquired half a million square miles of territory including California, Nevada, Utah, Arizona, most of New Mexico, and portions of Wyoming and Colorado. The nation had expanded from the original thirteen states to twenty-nine and had increased in area from 890,000 to 2,997,000 square miles to become what the historian David Potter has eloquently described as "a transcontinental, two-ocean colossus."[80]

During this second age of exploration and expansion in the middle of the nineteenth century, artists, writers, and public figures such as Thomas Hart Benton, William H. Gilpin, and Horace Greeley turned to fifteenth- and sixteenth-century precedents as proof that the current westward thrust of the nation fulfilled a providential design inaugurated by Columbus, Raleigh, Cabot, de Soto, and others. As art historian William Truettner has stated, "history became an instrument that enabled Americans to test their progress, celebrate their triumphs—and reassure themselves that the end of their mighty westward

drive would justify the means they had chosen to accomplish it."[81] Artists during this period, like such historians as George Bancroft and William Prescott, became mythmakers celebrating the nation's expansion and linking it to previous events. "The prior vacancy of the continent was their crucial founding fiction," Myra Jehlen has explained, "both asserted directly and implicit in the self-conscious narrativity with which the story of America 'began.'"[82] In other words, Euro-Americans saw the continent as a vast, empty space, despite the presence of the Indians, waiting to be saturated by European settlers who were fulfilling a providential mission.

It is during this period of expansion in the 1840s and 1850s that American artists painted scenes of the earlier events of discovery and settlement. Emanuel Leutze's *Return of Columbus in Chains to Cadiz* (1842, private collection), Robert Weir's *Landing of Henry Hudson* (c. 1838, Joselyn Art Museum, Omaha), and John Chapman's *Good Times in the New World* (*The Hope of Jamestown;* 1841, private collection) represent the kinds of subjects selected by artists around mid-century. These painters produced works that would have satisfied Congress's desire for subjects predating the Battle of New Orleans. Their impetus did not derive from partisan politics, however, but instead from the nation's belief in its typological mission.

This helps explain why the four artists who received government commissions for the Rotunda paintings did not select subjects from the War of Independence or the adoption of the Constitution, two topics mentioned in the resolution. They instead went back to the earlier period of discovery and colonization in order to evoke analogous current events and suggest that America was realizing its destiny. Congress probably had not consciously intended these works as indices of the white man's cultural and moral superiority over the displaced resident population, but their completion during the nation's second age of expansion points to a parallel between earlier and present-day conquests of new land. Those politicians who influenced the choice of artists also may have affected their selection of subject matter and thereby encouraged works supporting the nation's aggressive growth westward. In granting Powell in particular his commission in the midst of the Mexican War, the committee selecting the subject must have had in mind a work that would promote western settlement and Indian subjugation.

Surprisingly, the current explosive antagonism between North and South over slavery in the new territories did not play a role in this matter, although the emphasis on the white man's domination over the New World Indians may have served as a means to focus attention on a less divisive issue than extension of slavery into the territories. This especially must have been the case with Powell's commission, which Congress granted while embroiled in the controversy over the Wilmot Proviso to prohibit slavery in all new territories annexed from Mexico. Furthermore, the regional pride suggested by the subjects of the paintings by Vanderlyn, Weir, and Powell may be seen as one way to satisfy sectional self-esteem. The imagery in the Rotunda paintings thus functioned as one arena around which tensions and conflicts in national identity were centered.

The murals depict events in which religion plays a dominant role, as do military superiority and conquest. In Powell's *Discovery of the Mississippi*, ecclesiastics plant a monumental wooden cross with an image of the crucified Christ. The Spanish thereby proclaim the land to be under Christian hegemony, as does Columbus in Vanderlyn's painting. The future conversion of the Indians, who watch the arrival of de Soto and Columbus, is presaged in Pocahontas's baptism painted by John Chapman. And Wier's *Embarkation of the Pilgrims* depicts a group of Pilgrims prepared to bring their religion to North America.

Many antebellum Americans considered themselves involved in a redemptive mission.[83] The cyclical theory of world progress provided the explanation for past, present, and future events in the minds of Americans who applied "Christian forms of meaning" to the secular sphere.[84] According to the typology of America's mission, civilization first emerged in the Orient, where it declined, but then reemerged in the Occident.[85] From Europe, the founding mothers and fathers journeyed to the New World. There civilization spread from its eastern ports to the Great Plains. It would then travel over the mountains of the Far West to the Pacific coast, where a passage would open to the Orient, bringing enlightenment back to its origins. A reviewer of a book about the Plymouth colony reflected, in 1840, "We are now beginning to regard our whole history, from the settlement of the country to the present time, as but one chain of events, each and every link of which is equally important and equally necessary to the consummation of its grand design."[86]

This mind-set constituted a prehistoricist framework that "turned the past into prologue and the future into fulfillment of America's republican destiny." Rather than free history from a sacred framework—the task of historicism, which views all events in relation to prior events in secular historical time (this idea began to pervade the American consciousness during the Gilded Age)—the prehistoricist, nineteenth-century American viewed history as the working out of God's millennial plan. As Dorothy Ross explained in her analysis of historicism and prehistoricism in American culture, "When independence was won, fervent Protestants identified the American republic with the advent of that millennial period, which was to usher in the final salvation of mankind and the end of history. America thus represented a radical break in history and a radical breakthrough of God's time into secular history. The country's progress would be the unfolding of the millennial seed, rather than a process of historical change."[87]

The Rotunda reliefs and paintings represent various links in the providentially guided "unfolding of the millennial seed" that continued with the contemporaneous settlement in the new regions of the continent. By presenting such historical events, the works seem to condone the nation's aggressive annexation of lands and relocation of the Indians, who, it was believed, had to be removed for America to fulfill its destiny and mission.

## 3

## *Horatio Greenough's* George Washington

Four years before Congress finally passed a resolution to decorate the empty Rotunda panels, the chairman of the Committee on Public Buildings, Leonard Jarvis, reproached Congress for its repeated failure to realize plans for a statue of George Washington in the Capitol building. He reviewed the circumstances when the Continental Congress "had unanimously voted a statue of General Washington" at the close of the Revolutionary War, and then complained that although "several of the States had . . . showed their sense of Washington's virtues and services, by erecting statues to his memory," the "United States had done nothing but pass resolutions. . . . When we looked round for the statue, the monument, the mausoleum they had ordered, it was not to be seen." Jarvis correctly asserted that "these things existed nowhere but in the journals of Congress." Expressing his hope that "this national reproach would at length be done away, and that this Congress would perform what other Congresses had only promised," the representative from Maine encouraged his colleagues to realize the earlier attempts to place a statue of the first president in the Capitol Rotunda.[1]

Jarvis made these remarks seven days before the centennial celebration of George Washington's birth, an occasion for him and others to lobby for a portrait of the first president in the U.S. Capitol building. Initially placed in the Rotunda upon its completion in 1841, Horatio Greenough's *George Washington* (see fig. 34) relates to the Rotunda reliefs and murals and celebrates its subject as an agent of North American civilization. An examination of the debates voiced during the Washington centennial, however, suggests that Congress focused on different issues from those of geographic extension. The discussions contained the kernels of discontent among some states that eventually blossomed into the nullification crisis, a tariff-based issue of states' rights. That the two questions were discussed on the same day—Greenough's portrait and the celebration of Washington's birthday—suggests that they were linked. In this chapter I shall show that some congressmen considered the monument to Washington as a way to unite the country behind a symbol of nationhood, but that the artist redirected the iconography of the work to relate to the larger issue of westward expansion.

The initial idea for a statue of George Washington to be commissioned by the federal government arose forty-nine years before Jarvis's remarks. The Continental Congress passed a resolution in 1783 calling for a bronze equestrian statue of General Washington clothed in a Roman uniform, to be executed by the best artist in Europe and displayed in the future residence of the national legislature.[2] Basing its proposal on the original imperial equestrian monument of Marcus Aurelius in Rome and Joseph Wilton's *King George III*, which had once stood in

New York City (until the colonists destroyed the statue in a ritual of regicide in 1776), the Continental Congress envisioned a monarchical symbol that would have been inappropriate to the new republican government.[3] This plan probably foundered on the contradictions inherent in the proposed equestrian statue, as well as on the fact that the construction of the Capitol building had not yet begun.

Nevertheless, the resolution of the Continental Congress marks the beginning of many attempts to have George Washington symbolically present in the Capitol Rotunda in sculptural form. In fact, the president's death on December 14, 1799, led to two attempts to commemorate him with a monument. First, on the day of Washington's demise, a joint committee appointed by both houses of Congress reported to the Senate that his remains should be deposited under a marble shrine erected in the Capitol "to commemorate the great events of his military and political life."[4] Five months later, Henry Lee read two resolutions in the House. One called for the realization of the earlier plans for an equestrian statue for "the centre of an area to be formed in front of the Capitol," and the second declared that a marble monument should be erected in the Capitol "to commemorate his services, and to express the regrets of the American people for their irreparable loss."[5]

The ensuing discussions in Congress about the appropriate format for Washington's tomb exposed the ideological differences between the Federalists and the Democratic-Republicans. The former party suggested the enlargement of the monument from an indoor tomb to an outdoor mausoleum in the form of a stepped pyramid, a proposal the Democratic-Republicans rejected as too ostentatious for a nation of self-governing men. Consequently, Congress tabled the measure because it could not agree on the final version.[6]

Three more attempts to commemorate the commander in chief through sculpture failed in subsequent years. First, in 1816, a joint committee submitted a resolution to the House for the implementation of the 1799 call for a marble monument "to commemorate the military, political, and private virtues of George Washington." It specified that a receptacle for Washington's remains be prepared in the basement of the Capitol and that a monument be placed in the center of the Rotunda.[7] Four years later, the House heard another resolution to honor Washington, this time by placing his remains in the Capitol and raising a bronze equestrian portrait above the mausoleum.[8] The third attempt occurred in 1830, when a subcommittee in the House again recommended Washington's entombment within a marble sarcophagus in the Capitol crypt and the erection above it, in the Rotunda, of a full-length marble standing figure of the former president.[9]

Despite the 1799 resolution calling for Washington's interment in the Capitol, the family followed the stipulation in the general's will that he be buried at Mount Vernon. In preparation for the eventual transfer of Washington's remains to the basement of the Capitol, however, the builders left a circular opening about ten feet in diameter in the center of the Rotunda floor, enabling visitors to view in the crypt a statue of Washington that was eventually to be placed above this tomb. In 1828, Congress ordered the closing of the aperture, because damp-

ness emanating from it adversely affected John Trumbull's paintings on the walls of the Rotunda. It was not until 1832, during the Washington centennial, that the General Assembly of Virginia and John A. Washington, grandnephew of the general, ended all hopes of removing the remains by rejecting Congress's petition to place them beneath the Capitol crypt.[10]

These frustrated attempts to obtain the remains of George Washington provide the backdrop for Horatio Greenough's commission, which passed the House by a vote of 114 to 50 on the very day that the legislators learned that his remains would stay at Mount Vernon.[11] Two days earlier, on February 14, Jarvis reported on resolutions passed by the Committee on Public Buildings calling for two portraits of Washington to be placed in the Capitol, one to be painted by John Vanderlyn and one to be carved by Horatio Greenough.[12] The House tabled the committee chairman's report, however, probably because it considered more important the celebration of Washington's birthday, preparations for which were debated extensively the previous day and the following two days in both the Senate and the House.[13] In fact, as soon as Jarvis submitted the committee's report, the policymakers returned to a discussion of the removal of Washington's remains as a means to celebrate the holiday.

Congress began discussing this issue the day before, on February 13, when the Joint Committee of the Celebration of the Centennial Birthday of George Washington, composed of members from each state, recommended that the first president's body be moved to the Capitol in accordance with the 1799, 1816, and 1830 resolutions.[14] Arguments arose over the interpretation of Washington's will, in which he had asked to be buried at Mount Vernon. Disputed issues included whether Martha Washington had acted with full knowledge of that will when she agreed to have her husband's body placed in the Capitol,[15] whether the removal of his body would be sacrilegious, and whether the nation had the right to deprive Virginia of continued stewardship of what Augustin Clayton of Georgia called "those sacred ashes."[16] As sociologist Barry Schwartz has observed, "Washington's birthday was . . . a sacred day: a time for communion, a time when the sanctity of the nation, and the strength of the people's attachment to it, could be reaffirmed."[17] Yet what began as a ritual expression of common national sentiments eroded into a debate that involved sectional dissension, especially evident in Virginia's attempts to keep Washington's remains at Mount Vernon.

Both northerners and southerners understood Virginia's claim as an issue of states' rights versus the rights of the federal government. Most Virginians contended that since the "illustrious man" was a native of their state, Congress should not "deprive the land which had given him birth . . . of the last consolation of being the depository of his bones."[18] To be sure, Virginians who argued along these lines based their refusal to relinquish the remains on a denial or an inability to accept that the state was in fact part of the nation. In other words, to allow the body's interment in the Capitol would indicate that Washington symbolized the United States rather than the state of his birth. That other southerners argued along similar lines, however, suggests that more than pride in a single state stimulated opposition to the proposal.[19]

At the core of the prolonged debate in the House about Virginia's claim resided the larger question of centralized versus decentralized authority, which would drive the looming nullification crisis and had contributed to the Georgia-Cherokee dispute. The Cherokees' claim to sovereignty sparked Georgia's demands that the federal government protect its rights over those of the indigenous people. President Andrew Jackson's belief in states' rights, together with his conviction that attempts to civilize the Indians had failed, made him an ardent supporter of removal, an idea originated by Jefferson in 1803, when the acquisition of Louisiana made Indian displacement to the vast territory above the thirty-first parallel feasible.

Removal only temporarily quelled the states' rights controversy and the Indian problem that faced the United States during the 1820s. In the early 1830s, the states' rights issue retained its prominence in the political arena because of the furor over the tariffs of 1828 and 1832. Nullifiers in South Carolina insisted that a state had the right to declare the federal protective tariffs unconstitutional and therefore null and void within its boundaries. In November 1832, South Carolina implemented nullification and threatened to secede from the Union. Three months later, Henry Clay's compromise tariff reform diffused the constitutional crisis, averting civil war.[20] Although the nullification crisis reached its apogee after Congress's debate over the Washington centennial, the divisions between the advocates of particularism and the nationalists had already been defined as early as 1830. Thus the centennial celebration provided an additional arena for politicians to air the same sentiments as those behind the contemporaneous debates over the tariff.[21]

In recommending that Congress place a sculpted portrait of Washington in the Capitol Rotunda, the Committee on Public Buildings—chaired by Jarvis, a northerner, from Maine—probably intended the statue to replace Washington's remains and to unite the man and the nation into one symbol of centralized power and authority, thereby supporting the nationalist agenda in the hopes of avoiding, as Wiley Thompson of Georgia stated, "the possibility of a severance of this Union." As William F. Gordon of Virginia surmised during the discussion of the centenary, "The way to cement the Union was to imitate the virtues of Washington; to remove not his body, but, if possible to transfer his spirit to these Halls." Although Gordon made this comment as a means to support his state's claim to Washington's tomb, it reveals the rationale for Washington's symbolic placement in the Rotunda. Henry Clay expressed similar sentiments during one of the few discussions concerning the statue. The author of a compromise bill that would settle the nullification crisis asserted that an image of "this great man . . . was required in this capitol—the centre of the Union—the offspring, the creation, of his mind and of his labors."[22] The earlier disagreements over whether Washington should be honored through a figural monument apparently became resolved when Congress learned that his remains would not be placed in their legislative building. They recognized that through sculpture Washington could be spiritually present in the Capitol, standing as a symbol of centralized authority.[23]

Americans in the nineteenth century turned to George Washington as a symbol of unity, especially when regional divisions threatened the country. In his farewell address, Andrew Jackson appealed for national cohesion by recalling Washington's farewell: "He has cautioned us . . . against the formation of parties on geographical discriminations, as one of the means which might disturb our Union. . . . Has the warning voice of Washington been forgotten? or have designs already been formed to sever the Union?" In a prescient statement, Jackson warned that if the "Union is once severed, the line of separation will grow wider and wider, and the controversies" will move from "the halls of legislation" to "fields of battle."[24]

Greenough's monument nevertheless failed to relate specifically to the nullification crisis. The artist completed the statue's composition after the nullification crisis had been resolved, and no one informed the artist about the relation of these concerns to the statue. He probably had not read the congressional debates to discern the impetus for the commission. Nor did he reside in the United States, living and working instead in Florence. Furthermore, when the secretary of state, Edward Livingston, wrote Greenough to tell him about the congressional order, the cabinet member did not explain the complex factional issues involved. He instead sent a copy of the resolution to the artist, suggesting that Greenough make a square pedestal for the portrait and decorate it with bas-reliefs, "representing, first, the surrender of Yorktown; second, the resignation; third, his inauguration as President . . . ; fourth, an inscription."[25] Livingston thus envisioned a monument similar to the plan of the Continental Congress that would have celebrated the commander in chief's success in defeating the British, helping to forge a new nation, and leading the country forward in its republican agenda. Although the secretary of state had articulated his opposition to nullification during the Webster-Hayne debate of 1830—Webster's famous phrase "Liberty and Union, now and forever, one and inseparable!" captures our attention today more than Livingston's arguments—and although he was the author of Jackson's Nullification Proclamation of December 1832, in which the president condemned nullification as subversive to the Constitution and inimical to the Union, the former senator from Louisiana failed to explain the political underpinnings that contributed to the statue's commission. Livingston probably put aside his own polemics to be an impartial liaison between Congress and the artist.

What the Greenough commission shows is that the federal government had no standardized procedures for the patronage of artworks for the Capitol, and that this shortcoming contributed to the lack of communication between artist and patron. In this case, the House of Representatives passed a resolution submitted by the Committee on Public Buildings to have the president employ Greenough to create the statue. No contract was signed, nor did the Senate become involved in the matter until it considered appropriations.[26]

Greenough received the commission through the aggressive campaigning of Jarvis, who had been encouraged by Washington Allston to lobby on behalf of the sculptor.[27] Jarvis succeeded in convincing the committee he chaired to hire the

28. Horatio Greenough. *George Washington.*
Drawing. 1832. 19 × 13¼ in.
Courtesy of George R. Rinhart.

Boston artist, couching his arguments in patriotic terms. As Henry Dearborn of
Massachusetts explained on behalf of the committee, Greenough was "capable of
producing a work of distinguished excellence" and "had no rival among his
countrymen." The committee apparently felt compelled to support an American
rather than foreign sculptor, "a native citizen" who would "become the successor
of Canova and of Chantry."[28]

Shortly after learning about his government commission from the secretary
of state, Greenough began sketching out preliminary designs. Following the
resolution's stipulation that the artist create "a full length pedestrian statue of
Washington,"[29] Greenough made several drawings in 1832 of the figure of Wash-
ington, considering variations of the accoutrements, leg and arm positions, and
clothing.[30] One sketch (fig. 28), for example, depicts the founding father in a toga,
standing beside a podium. Washington clasps a scroll in his right hand, presum-
ably the Farewell Address. Another sheet (fig. 29) shows him in various classical
uniforms, and also includes a nude Washington holding the sword upright on the
podium. In a third portrayal (fig. 30), a classically draped Washington raises his
left arm in emulation of the ancient Roman *adlocutio* gesture to suggest the
statesman addressing his citizens.[31]

In these illustrations of George Washington, Greenough created an image of
the president as a citizen orator, a common motif in American painting and
sculpture.[32] During the eighteenth and nineteenth centuries, European and

29. Horatio Greenough. Drawing of George Washington. 1832.
19 × 13¼ in. Courtesy of George R. Rinhart.

American artists often utilized neoclassical motifs to portray civic heroes in order to appeal to the tastes of a classically oriented era. In 1768, for example, Charles Willson Peale had followed Continental fashion in clothing William Pitt in a Roman toga and tunic (fig. 31), basing the pose on works similar to the *Augustus of Prima Porta* (c. 20 B.C.; Vatican Museums). Sir Francis Chantry created a similar classicizing image of a statesmanlike orator in his portrait of George Washington (fig. 32), executed in 1826 for the Massachusetts state capitol. Greenough, who had emigrated to Italy in 1825 after studying the classics at Harvard, scrutinized ancient art and in fact utilized his 1826 drawing of the Borghese Warrior (fig. 33) as the foundation for Washington's pose and proportions in his 1832 drawings. In basing his conception on a specific ancient prototype, Greenough adhered to the accepted formula for portraiture.

Greenough, however, was subject to another influence in his completed statue (fig. 34), that of Edward Everett, the representative from Massachusetts who had objected to the Battle of New Orleans as a subject for one of the Rotunda murals and who probably had a hand in the selection of artists and subjects for these later paintings. A former chairman of Greek literature at Harvard University, Everett had studied ancient art and literature and advocated current neoclassical taste. He called the artist's attention to the Zeus by Phidias, a Greek statue that had decorated the temple at Olympus until its destruction in the sixth century A.D. Writing to the sculptor in July 1832, Everett advised Greenough to

30. Horatio Greenough. Drawing of
George Washington. 1832. 17½ × 12⅝ in.
Courtesy of George R. Rinhart.

31. Charles Willson Peale. *Worthy of Liberty
Mr. Pitt.* C. 1768. Mezzotint and engraving.
21¾ × 14¹³⁄₁₆ in. Courtesy of the Pennsylvania
Academy of the Fine Arts, Philadelphia.
The John S. Phillips Fund.

*Greenough's* Washington

32. Sir Francis Chantry. *George Washington.* 1826.
Marble. Courtesy of the Commonwealth of
Massachusetts, Massachusetts Art Commission.

33. Horatio Greenough. *Borghese Warrior.*
1826. Drawing. $9\frac{9}{16} \times 7\frac{3}{8}$ in. Roman sketchbook.
Courtesy of George R. Rinhart.

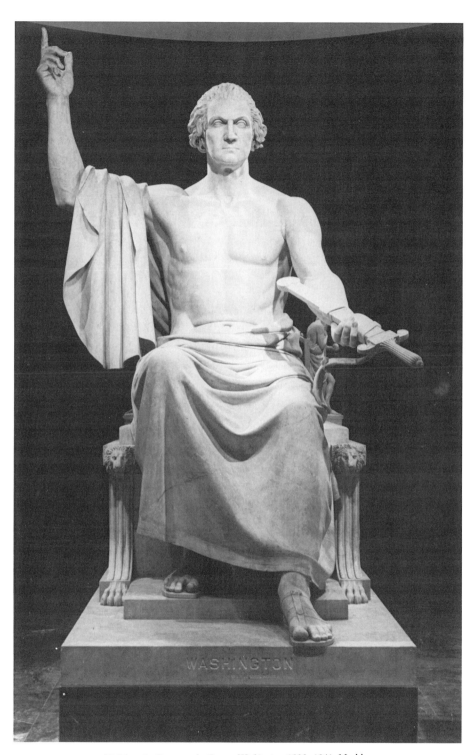

34. Horatio Greenough. *George Washington*. 1832–1841. Marble.
Courtesy of the National Museum of American Art, Smithsonian Institution.
Transfer from the U.S. Capitol.

*Greenough's* Washington

35. Antoine-Chrysostome Quatremère de
Quincy. *Jupiter vu dans son thrône*. 1815. En-
graving. Courtesy of the Boston Public Library.
Photograph by Thomas Brumbaugh.

36. Jean-Auguste-Dominique Ingres.
*Napoleon on His Imperial Throne*. 1806.
Oil on canvas. 104½ × 65¼ in. Courtesy
of Musée de l'Armée, Paris.

"elevate [his] imagination by reading the great works of the great masters and
particularly the greatest work of the greatest master [of] the Jupiter Olympus of
Phidias"—Quatremère de Quincy's *Le Jupiter Olympien* (1815), in which the
archeologist accurately duplicated the chryselephantine likeness of Zeus (fig. 35).
Noting that the Rotunda is probably "as spacious as . . . the temple of Jupiter at
Elis," Everett recommended that Greenough retain "that immortal work ever
before your mind" and make his Washington "seated like the Jupiter and as near
the colossal as modern taste permits."[33] Everett applied his knowledge of antiq-
uity to Greenough's monument, promoting Greek civilization as the basis of
American art.

Greenough may have had another source than Quatremère de Quincy's il-
lustration of the destroyed Zeus: the 1806 imperial portrait of Napoleon by
Ingres (fig. 36), which he possibly saw while visiting Paris in 1832 and again in
1834.[34] Greenough thereby created a symbol of authority based on two estab-
lished paradigms, one religious and the other monarchical. As in these prece-
dents, Greenough rendered a rigidly symmetrical, colossal, frontal, imperious,
and enthroned figure. But he replaced the Zeus's ancient pagan symbols and the
Ingres Napoleon's French imperial and Roman accessories with American motifs

adapted from antiquity; furthermore, he substituted Zeus's spear and statue of Victory and Napoleon's scepter and hand of Justice with a short sword and right arm pointing to heaven. Rejecting Ingres's more naturalistic details, Greenough emulated classical Greek art in clothing Washington *all'antica* and in carving a massive and blocky figure whose surfaces are highly polished with little textural contrast.

In his *Washington*, Greenough employed surface classicism, a term coined by archeologist John S. Crawford. In surface classicism, the sculptor adopts "the surface treatment, style of modeling, pose, anatomical proportions, and subject matter" of antiquity.[35] In this case, Greenough derived the throne, the seated posture, the idealized physiognomy, the classical drapery and sandals, the smooth surfaces, and the clear contours from the famous Greek statue of Zeus.

The composition also follows neoclassical precepts in the stasis established by horizontal and vertical lines. The throne—decorated with acanthus leaves and garlands "to hint at," as Greenough explained, "high cultivation as the proper *finish* for sound government and to say that man when well planted and well tilled must flower as well as grow"[36]—establishes the rectangular compositional boundaries reiterated by Washington's square chest and uplifted arm. Except for the left foot extending slightly over the base and the left arm advancing forward, the figure remains within the rectangular mass. The only variations from the rigid verticals and horizontals of this self-contained work are the curved front legs of the throne, the forward left leg, the concave folds in the drapery between the legs, and the diagonal line of the sword. The simple pose and clear contours of the figure create a lucid composition that commands attention, forcing us into confrontation with this stately man, whose stern facial expression matches his imposing physique and whose enclosed composition expresses strength.

The face in Greenough's monument (fig. 37) has its own tradition separate from that of the heroic body, for the sculptor based the likeness on two eighteenth-century portraits for which Washington sat: Jean-Antoine Houdon's bust (fig. 38) and Gilbert Stuart's *Athenaeum Washington* (fig. 39).[37] In 1827, five years before his federal commission, Greenough had made two drawings of Stuart's popular portrait, converting the humanized yet dignified visage into more sculpturally conceived sketches (fig. 40) with angular features, deeply set eyes, and distinctive shadows, elements he would later incorporate into his marble statue.[38] Then two years after learning of his commission, in the summer of 1834, Greenough went to Paris to make a plaster cast of Houdon's bust, fulfilling the resolution's requirement that "the head . . . be a copy of Houdon's Washington."[39] After studying the Houdon portrait, Greenough altered Washington's Roman senator–like features to get a more realistic countenance, as is evident in the design sent to Secretary of State Edward Livingston in January 1834 (fig. 41), which nonetheless is still idealized.

In the statue, Greenough transformed Stuart's softly rounded features of the elderly and paternal statesman and Houdon's spontaneous expression into a static face with deeply carved eyes, arched eyebrows, a square jaw, hardened edges, decisive angles, and balanced features. The sculptor did not attempt to convey

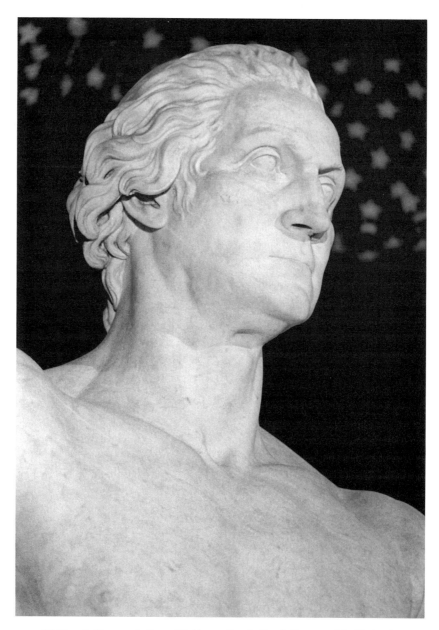

37. Horatio Greenough. *George Washington*. Detail of head. Courtesy of the National Museum of American Art, Smithsonian Institution.

38. Jean-Antoine Houdon. *George Washington.* 1785. Plaster. Courtesy of the New-York Historical Society, New York City.

39. Gilbert Stuart. *Athenaeum Washington.* 1796. Oil on canvas. 48 × 37 in. Jointly owned by the Museum of Fine Arts, Boston, and the National Portrait Gallery, Washington, D.C. William Francis Warden Fund and the Commonwealth of Cultural Preservation Trust. Courtesy of the Museum of Fine Arts, Boston.

40. Horatio Greenough. Drawing. 1827. 14 × 11 in. Courtesy of George R. Rinhart.

41. Horatio Greenough. Drawing. 1834. 14¾ × 9½ in. Courtesy of George R. Rinhart.

lifelike qualities but instead sought to create an image of authority, power, and transcendence, this last through the unfocused and upturned, deeply set eyes, the symmetry, and the heavy mass of wavy locks—characteristics derived from Hellenistic portraits of rulers, imperial Roman busts, and late antique effigies.[40]

By conflating a number of sources in his image, Greenough created a disjunction between the heroic physique and the mimetic head. Washington's body always retains its reference to the Greek god, reiterating the model's simplified drapery, sandals, bare chest, physique, and massiveness.[41] But the face refers to the individual, despite its classicizing features and characteristics of apotheosis. No matter how much the visage emulates ancient prototypes and departs from Washington's real features, we nevertheless can recognize the subject.

Although Greenough had created a neoclassical statue that satisfied current tastes of the educated, wealthy upper classes in Europe and the United States, many Americans expressed their opposition to the monument.[42] Henry A. Wise, the representative who had promoted John Chapman and the resolution for the second group of Rotunda murals, loosed a diatribe about Greenough's portrait before making his scathing condemnation of the Rotunda reliefs. The Virginia politician scoffed, "What was it but a plagiarism from the heathen mythology to represent a Christian hero . . . a Jupiter Tonans, or Jupiter Stator, in place of an American hero and sage? a naked statue of George Washington! of a man whose skin had probably never been looked upon by any living. It might possibly suit modern Italian taste, but certainly it did not the American taste."[43]

Wise's denunciation of Greenough's neoclassical style and emulation of an ancient god typified the numerous deprecating remarks voiced by Americans, who neither accepted the statue's heroic pose nor understood its national mythology. Instead, most Americans viewing the president's partial nudity felt that it blocked their ability to comprehend the statue's meaning and expressed their revulsion in terms of puritanical outrage.[44] Philip Hone was one of them: "Washington was too prudent and careful of his health to expose himself thus in a climate so uncertain as ours, to say nothing of the indecency of such an exposure."[45] Nathaniel Hawthorne concurred: "Did anyone ever see Washington naked? It is inconceivable. He has no nakedness, but I imagine was born with his clothes on and his hair powdered, and made a stately bow on his first appearance in the world."[46] Some Americans also took exception to Washington's sacred elevation; they could not reconcile Greenough's godlike hero with their perceptions of the former president, an elected official who reluctantly took office to serve his country and who lived a life of austerity at Mount Vernon. Leonard Jarvis, who had earlier pressed for Congress to commission Horatio Greenough, concluded in 1834 that Greenough "has undertaken to idealize our Washington and to make an emblematical Statue" but that "it is not *our* Washington that he has represented."[47]

None of these remarks takes into account the political context for the statue's commission—the nullification crisis—nor the meaning conveyed by this "emblematical" work. Since sectional differences had temporarily been resolved by the time of the statue's completion, it is understandable that no one made the

connection between the portrait and its political impetus. It is more difficult to ascertain why nineteenth-century critics failed to see the references to westward expansion in the subsidiary figures and reliefs. Perhaps the overwhelming size of the majestic president in toga and the statue's inherent contradictions between past and present, sacred and secular, idealism and realism, created a barrier to viewing the statue as a whole (a tendency still found in scholarly discussions of the work). Since both northerners and southerners—including Greenough's earlier champion, Jarvis—found fault with Greenough's *Washington*, it appears that politics did not influence aesthetic judgments in this case, unlike that of the Rotunda reliefs.

Recognizing that Horatio Greenough added storytelling figures and reliefs to create an emblematic portrait, however, is crucial to understanding the work's complex meaning. Roger B. Stein has defined the emblematic portrait as a work in which "the conceptual controls the perceptual," asking the viewer "to know the value of its subject through [the images that] surround it and stand for attributes, ideas, and values of the sitter. The emblematic portrait requires the viewer's knowledge of a system of meanings and his or her active engagement to create intellectual coherence and meaning out of the images so arranged—rather, that is, than merely perceiving persons in their living space at a particular moment in historical time."[48]

Charles Willson Peale's citizen-orator image of William Pitt (see fig. 31) exemplifies the type of emblematic portrait that Greenough emulated, as does Gilbert Stuart's 1796 Lansdowne Washington (fig. 42), the model for John Vanderlyn's painting commissioned for the Hall of Representatives at the same time as Greenough's statue.[49] In his painting of the British parliamentary leader, Peale included among other symbols a figure of Libertas, the Magna Carta (in Pitt's left hand), and the sacred altar of liberty. The Philadelphia artist thus combined traditional emblems with those derived from British history. Stuart also fused national and universal symbols in his emblematic portrait of Washington, adopting the regalia of office—"the column of order, the drapes of court, the seat of authority, the opening onto vistas of power"[50]—from seventeenth-century royal portraits of Louis XIV. To this he added Americanized classical symbols, such as the eagle and fasces, and books (standing under the table) entitled *Constitution of Laws of the United States* and *American Revolution.* Consequently, Stuart commemorated Washington as a gentleman statesman who enforces the law and fulfills his elected position, according to the limits established by the Constitution.

Horatio Greenough similarly combined traditional and culturally specific emblems in his portrait. Washington's gesturing upward to God and outward to the people conveys a specific meaning that relates to the nineteenth-century assessment of the man's public virtue. Greenough explained that he made Washington "*seated* as *first magistrate*," extending with his left hand "the emblem of his military command toward the people as the sovereign [*sic*]." Through the right hand pointing heavenward, the sculptor created a "double gesture . . . to convey the idea of an entire abnegation of Self and to make my

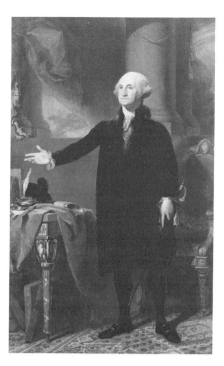

42. Gilbert Stuart. *George Washington*
(Lansdowne Washington). 1811. Oil on canvas.
96 × 60½ in. Courtesy of the Pennsylvania
Academy of the Fine Arts,
Philadelphia. Bequest of William Bingham.

hero as it were a *conductor* between God and Man."[51] Unlike Trumbull's Rotunda painting, *Resignation of General Washington* (see fig. 5), with its narrative details and multifigured composition, Greenough's statue does not allude to a single historical moment but instead evokes through the outstretched hand with sheathed weapon, whose hilt is offered to the viewer—the apotheosis of abnegation—Washington's retirement from the army and his later surrender of the presidency.[52] Although an inaccessible man of authority, Greenough's Washington is nevertheless an individual who relinquishes his military and civil power to the people, thereby establishing his commitment to republican democracy.[53] The gesture of offering the sword thereby refers to resignation and republicanism. The raised right arm suggests that God Almighty interceded to ensure the success of America's providential mission.

Two Lilliputian figures located behind Washington's gargantuan body and on the chair (fig. 43) are crucial emblems for deciphering the monument's meaning, even though the composition of the ideal-heroic commander in chief does not focus attention to the back of the monument and the body of Washington obscures the statuettes. (When the work was displayed in the Rotunda, its original location, the viewer could walk around the statue and see these figures.) Flanking

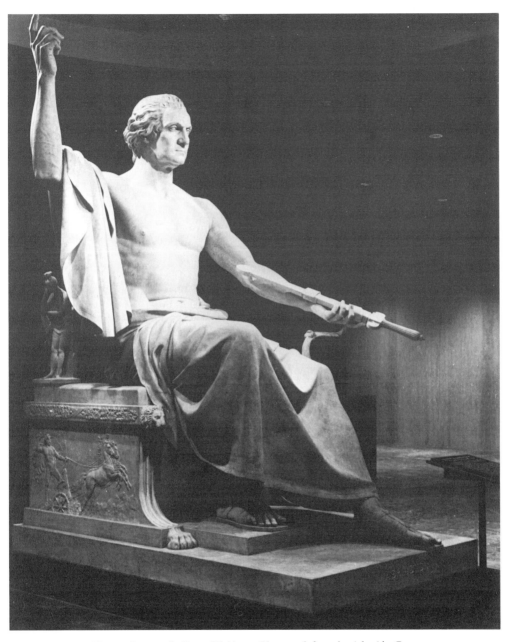

43. Horatio Greenough. *George Washington*. Photograph from the right side. Courtesy of the National Museum of American Art, Smithsonian Institution.

the larger-than-lifesize Washington on the right and left are Columbus (fig. 44) and an Indian (fig. 45). By the figure of Christopher Columbus in the Washington monument Greenough claimed that he "wished to connect our history with that of Europe."[54] Columbus, resembling a Biblical prophet with his long hair and beard and simplified toga, stands leaning against a support with his legs crossed, right arm against his chest, and a globe in his extended left hand. This rendering of the fifteenth-century explorer derives, however, not from images of Old Testament seers but from such Hellenistic and Roman representations of philosophers as the Second Style wall painting in a villa in Borscoreale of the first century B.C.[55] Greenough was not interested in conveying a narrative about Columbus's first contact with the indigenous people in a panoramic setting with a multitude of figures, as in John Vanderlyn's *Landing of Columbus* (see fig. 26) and Randolph Rogers's bronze doors (see fig. 77). He instead shows Columbus as a learned scientist who contemplates the significance of his proven hypothesis, his discovery of the New World, and subsequent voyages away from the Old. In short, the figure of Columbus becomes a symbol of discovery and of the beginning of America as a place that Washington helped form into a nation. As the *National Intelligencer* exclaimed in 1852, "Since the day when COLUMBUS first set his foot on American soil, no event has occurred which has so materially influenced the destinies of this quarter of the globe, and especially of the Northern Continent, now chiefly occupied by the United States, as the Birth of WASHINGTON."[56]

Opposite Columbus stands an Indian chief, also with crossed legs. According to the artist, this figure represents "what state our country was in when civilization first raised her standard there,"[57] the standard that Columbus placed on the West Indies island as seen in Vanderlyn's painting. Although clothed in native dress, the Indian also derives from the type of the ancient Roman philosopher. Greenough, however, has transformed the ancient motif into an American symbol. By depicting the Indian in a pose of meditation, leaning his lowered head against his right fist and his body against a tree stump, Greenough suggests that the aborigine contemplates the inevitable demise of his race, the result of the progress of civilization as represented by both Columbus and Washington—an appropriate message given the Indian Removal Act of 1830, the forced exodus of the Cherokees from Tennessee to Oklahoma in 1838, and white America's conviction about Indian destiny. "The aborigines of America are rapidly disappearing," proclaimed one citizen in June 1832, four months after the congressional requisition of the Washington statue, "and the period is not distant when that ill-starred race must become extinct. . . . The red man has gradually receded before the advance of his Anglo-Saxon conquerors. He is no longer to be seen on the borders of the Atlantic—his countrymen are fast passing beyond the mighty river of the West, and the last remnant of numerous and once powerful nations will expire on the distant shores of the Pacific."[58]

The image of the meditating Indian on Washington's throne became a standard iconographic code of the Vanishing American in nineteenth-century American art and literature, referring to the native's melancholy mourning over his imminent extirpation. James Fenimore Cooper, for example, incorporated this

44. Horatio Greenough. *George Washington*. Detail of Columbus. Courtesy of the
National Museum of American Art, Smithsonian Institution.

45. Horatio Greenough. *George Washington.* Detail of Indian. Courtesy of the National Museum of American Art, Smithsonian Institution.

pose of lamentation into the dramatic scene of Chingachgook's death. In *The Pioneer*, "this child of the forest," the last surviving member of the Delawares, grieves over the past glory of his people as he prepares for his heroic departure. Stretching his body forward and "leaning an elbow on his knee," Chingachgook accepts his fate: death in a wilderness forest fire.[59] Thomas Crawford utilized a similar motif in his statue of a dying chief (1856; fig. 64), for the Senate pediment of the Capitol, which shows American progress and Indian decline. The tree stump also has specific connotations in regard to the typology of the Vanishing American, for this emblem evokes the progress of civilization. Hence Greenough's inclusion of this motif in his statuette of the Indian emphasizes that the indigenous people will be supplanted by the advanced Anglo-Saxon culture that Columbus and Washington represent.

The bracketing, emblematic figures of Columbus and the Indian thus reiterate the themes of discovery and conquest found in the Rotunda sculptural embellishments and the four Rotunda paintings added between 1840 and 1855. Greenough had originally planned to place eagles on the hind posts of the chair, as is evident in his preliminary drawing of 1834 (fig. 46).[60] But after visiting the Capitol in 1836—the year that Congress finally passed a resolution for the additional murals—he decided to alter these symbols. The completed work thus expanded Greenough's initial intention of making Washington a demigod who relinquishes his authority to the people; now the sculpture would echo the content of the discoverer portraits and the narrative historical reliefs in the Rotunda, which Greenough had seen when he observed the future site for the monument. This alteration indicates that the expatriate consciously created a monument that would relate to and expand on the iconographic program already in place.

The designs on either side of Washington's throne reinforce those themes embodied in the three figures of Columbus, the Indian, and George Washington. On the left (fig. 47) are the infants Hercules and Iphikles, whom Hera had attempted to kill in a jealous rage by dispatching two great snakes. Greenough explained that he "represented the Genii of North and South America under the forms of the infants Hercules and Iphiclus—the latter shrinking in dread while the former struggles successfully with the obstacles and dangers of an incipient political existence."[61] Derived from the Hellenistic freestanding statue *Hercules Strangling the Serpent* (fig. 48), the relief modifies the ancient mythological theme so that the image refers to the Revolutionary War, George Washington's role in that conflict, and South America's more recent struggles for liberation from Spain and Portugal. The right panel (fig. 49) pictures another mythological motif: Apollo, whose pose echoes that of Washington, rides his chariot across the sky, representing the enlightenment that resulted from the North American nation's birth.[62] By placing the majestic Apollo and the somber Indian on the same side of the Washington statue, Greenough promoted a national mythology and alluded to an episode in Washington's career. The diminutive Indian behind Washington alludes to the former soldier's participation in the French and Indian War at the age of twenty-three, a fact commemorated in nineteenth-century American literature and art as portending his later role in founding the republic.[63]

46. Horatio Greenough. *George Washington*. Drawing of the model of *Washington*.
Courtesy of George R. Rinhart.

47. Horatio Greenough. *George Washington.* Detail of Hercules and Iphikles. Courtesy of the National Museum of Art, Smithsonian Institution.

48. Anonymous. *Hercules with a Serpent.* Marble. Courtesy of the Archive of the Negativo Archivio Fotografico dei Musei Capitolini.

49. Horatio Greenough. *George Washington.* Detail of Apollo riding his chariot.
Courtesy of the National Museum of Art, Smithsonian Institution.

The subsidiary figures and reliefs in Greenough's sculpture thus convey a
national historical narrative that presents Washington as a providentially ap-
pointed instrument of the nation's destiny. As Greenough explained in a letter to
Samuel F. B. Morse in 1834, "Washington's face and form are identified with the
salvation of our continent. That sword, to which objections are made, cleared the
ground where our political fabric was raised. I would remind our posterity that
nothing but that, and that wielded for years with wisdom, and strength, rescued
our rights, and property, and lives from the most powerful as well as most
*enlightened* nation of Europe."[64]

Although Greenough does not specifically link his work with the concept of
American millennialism that had become secularized in the nineteenth century,
he implies through the phrase *the salvation of our continent* that Washington is the
new Messiah, who leads the nation on its providential course. As we have seen in
the discussion of the Rotunda paintings (chapter 2), mid-century Americans
believed that Columbus's discovery of the New Jerusalem had initiated God's
grand design. They perceived Washington as having reaffirmed the promise of
fulfillment, providing the impetus for the great migration westward that was
causing the dislocation and destruction of the Indians. Within the context of
westward expansion, Greenough's statue accurately defines the nation's mission,
which would eventually transcend particularism. Through its reference to explo-
ration and geographical extension, the Washington monument suppressed sec-
tional discord through a self-contained symbol of national strength and unity.
Whether Greenough intended this is debatable, but by the time he visited the

Capitol in 1836, some politicians were focusing on the annexation of western lands as a means to resolve sectionalism. This political climate, in combination with the works already in place, probably influenced the sculptor to append the Indian and Columbus to his heroic *Washington* and thereby expand the work's meaning to encompass the idea of America's mission.

Greenough's *Washington* is compositionally based on the Pheidian Zeus, but its short-lived location in the Rotunda between 1841 and 1843 followed a Roman precedent: the Pantheon, dedicated to all the gods and the model for the Capitol's vast interior circular space, symbolically contained Zeus as the ruler of the heavens from the void seen through the oculus in the ceiling.[65] In the U.S. Capitol, Washington replaced the Roman god as the divine ruler. But unlike Zeus, he does not inhabit the sky: instead, he is earthbound, situated on the floor. Greenough's Washington was thus a liminal figure suspended between the secular and sacred stages, symbolizing the nation and embodying the promise of fulfillment.

Deciding that he did not like the Rotunda setting because of poor lighting conditions, Greenough pled that the statue be relocated, and in 1843 it was removed to the eastern grounds, where it remained for the next sixty-five years (fig. 50). Although located in two different places around mid-century—inside the Rotunda and outside the east facade—Greenough's *Washington* nevertheless successfully related to other works in these areas.[66] Whereas the Rotunda reliefs and paintings exhibit in narrative form America from its discovery and settlement through its development as a nation, Greenough's emblematic portrait celebrated Washington as a military and civilian leader who helped shape the continuation of North American destiny.

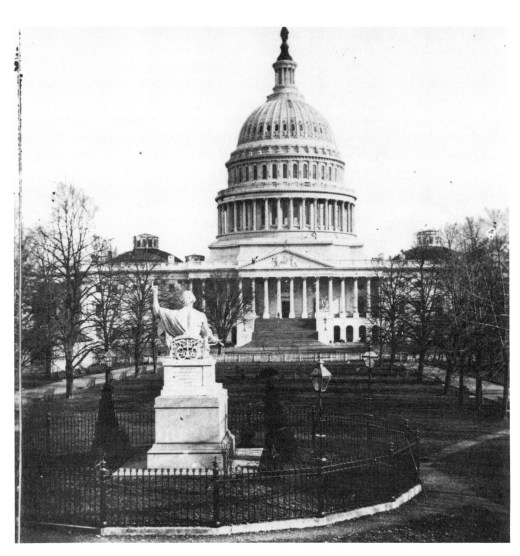

50. Horatio Greenough. *George Washington*. Photograph, taken between 1865 and 1908, showing the statue's placement outside the U.S. Capitol. Courtesy of the Architect of the Capitol.

# 4

## *Luigi Persico's* Discovery of America
## *and Horatio Greenough's* Rescue

With the placement of Horatio Greenough's *George Washington* in the center of the Rotunda in 1841, the decoration of the Capitol's central interior space had been completed, at least temporarily. Later, the ornamental scheme would be expanded: Constantino Brumidi would paint his frescoes along the base and in the canopy of the dome, and the government would add full-length busts and portraits of such prominent Americans as Abraham Lincoln, Thomas Jefferson, Ulysses S. Grant, and Alexander Hamilton. By the time these additions were made, however, the seated rendition of the founding father no longer belonged to the Rotunda's interior, having been transferred outside facing the east facade in 1843, to the Smithsonian Institution in 1908, and then to the Museum of American History in 1962.

The marble image of the first president in the Rotunda interior rendered him present as the symbol of the nation and intimated his position as the agent of civilization, creating an iconographic resonance in relation to the sculpted wall narratives. With the recontextualization of the statue on the Capitol grounds, the monument once again reiterated and expanded on established themes. Facing the east facade, Greenough's *George Washington* made the deceased man into a transcendent deity, as had Antonio Capellano's 1827 *Fame and Peace Crowning George Washington* (see fig. 82), located directly above the central portal.[1] At the same time, Greenough's monument especially related to two statues installed on the south and north sides of the main staircase: Luigi Persico's *Discovery of America* and Horatio Greenough's *Rescue.* These two sculptures exacerbate and intensify derogatory attitudes toward Indians, making them explicit and codifying them ideologically in ways that, for the first time, influenced congressmen. As the art program of the Capitol expanded image by image, commission by commission, the legislators' views began shaping the iconography that formed their environment, and the works began to strengthen their beliefs in Anglo-American continental hegemony over the land and people. As we shall see, some congressmen referred to the Capitol artworks to support their expansionist aims. In the twentieth century, the political implications of these works led to protests by Native Americans and banishment of the works to storage.

James Buchanan, a Democratic senator from Pennsylvania, first submitted a resolution for sculptural decoration to flank the main staircase of the Capitol on April 28, 1836. Once again the commission for these works did not follow a standard procedure. Rather than involving the Committee on Public Buildings, as had been the case with Greenough's *Washington*, the resolution directed the

Committee on Finance to handle the contract. Debate ensued over whether the president or Congress should be in charge of federal art patronage and what congressional committee, if any, should participate in the process. William C. Preston, from South Carolina, argued that the president should negotiate the commission, whereas Willie P. Mangum, from North Carolina, recommended that the Committee on the Library direct art expenditures and the selection of artists.[2]

Buchanan also stimulated lively debate on the propriety of supporting foreign artists when he suggested that Luigi Persico execute two groups for the eastern entrance. Preston and John C. Calhoun, also from South Carolina, objected to the congressional support of foreigners, urging instead that Americans receive federal patronage. Preston recommended the American sculptor already employed by the federal government for the Washington monument, Horatio Greenough, "a man of unquestioned genius; one calculated to do honor to his country, and whom his country should delight to honor." Noting that Greenough would soon return to the United States, Preston suggested that a competition be held so that the statues be "a lasting monument of our taste and judgement." He continued, "I should be glad to see Mr. Persico employed; he deserves to be so for his ability and industry; but, in employing him, I am unwilling that the talents of an accomplished citizen of our own country should be thrown in the back ground."[3]

Just two months before the House passed the resolution approving the Rotunda murals, the delegates were able to focus, at least temporarily, on less volatile issues than those involving party disputes and sectional discord. Whether to patronize an American as opposed to a foreign sculptor engaged national pride in American culture, which did not split along party or regional lines. Buchanan understood this and appealed to national pride in championing his Italian acquaintance, arguing that Persico was "devoted to the institutions of this country" and was dedicated to "identifying his talents with the Capitol of the Union." "He is not a native, but he intends to spend his days among us, for he loves liberty with all the enthusiasm of genius."[4] Buchanan recognized that aesthetics and craftsmanship counted less than content: statesmen wanted sculptors who understood and sympathized with national concerns.

A native of Naples who had come to the United States eighteen years earlier, in 1818, Persico first settled in Lancaster, Pennsylvania, where he befriended Buchanan, and then worked in Harrisburg and Philadelphia before moving to Washington. The Neapolitan artist earlier had demonstrated his credentials through the completion of three works for the east facade: *Genius of America* (see fig. 112), executed between 1825 and 1828 for the central tympanum, and two companion pieces, *Peace* (fig. 51) and *War* (fig. 52), completed in 1834 for the right and left niches flanking the central doorway. Persico took the initiative two years later to lobby for another commission by exhibiting in the Capitol a model in which he represented the discovery of America by Columbus. Buchanan took it upon himself to support this artist's work by submitting his recommendation.

On May 17, 1836, the Committee on Finance submitted a resolution to the

51. Luigi Persico. *Peace*. 1834. U.S. Capitol east facade, central portico. Reproduction by George Giannetti made between 1958 and 1960. Original marble figures in storage. Courtesy of the Architect of the Capitol.

52. Luigi Persico. *War*. 1834. U.S. Capitol east facade, central portico. Reproduction by George Giannetti made between 1958 and 1960. Original marble figures in storage. Courtesy of the Architect of the Capitol.

Senate that the president be authorized to "consult and advise with such artists of skill and reputation as he may think necessary and proper, with a view of procuring two marble statues . . . [for] the front entrance of the Capitol."[5] Rather than designate artists, a procedure followed in the past, the bill specified that competitors submit designs, models, and estimates for Congress's inspection. Nevertheless, it seems to have been predetermined that both Persico and Greenough be commissioned, for nine months later the Committee on Public Buildings reported a bill to enable the president to contract with Persico for the group of statues he had exhibited earlier.[6] Then on April 4, 1837, Secretary of State John Forsyth, acting on behalf of President Martin Van Buren, wrote Horatio Greenough to ask for designs, resulting in a contract in October 1838.[7]

Since the two sculptors met in Florence, first in 1839 to discuss the dimensions for the base and figures and again in 1840 to purchase marble, it is not surprising that the groups echo one another in content and composition.[8] Persico's *Discovery of America* (fig. 53) represents, in the words of Buchanan, "the great discoverer when he first bounded with ecstasy upon the shore, all his toils and perils past, presenting a hemisphere to the astonished world, with the name America inscribed upon it."[9] The massive physique, frontal position, and colum-

53. Luigi Persico. *Discovery of America*. 1837–1844. Marble. 191½ × 100½ in. Photograph taken before 1920, showing the work in situ to the left of the staircase on the east facade of the U.S. Capitol. In storage since 1958. Courtesy of the Architect of the Capitol.

54. Horatio Greenough. *Rescue*. 1837–1853. Marble. 141 × 122 in. Photograph taken
before 1920, showing the work in situ to the right of the staircase on the east facade of the U.S.
Capitol. In storage since 1958. Courtesy of the Architect of the Capitol.

*Removed from the Capitol
1958*

Discovery *and* Rescue

nar pose of the navigator contrasts with that of the crouching and hesitant female, whose bent left arm echoes the discoverer's akimbo arm, and whose outstretched right arm points downward in contrast to the European's raised arm. The complex and twisting pose of the Indian, along with the figure's uneven and broken contours, differs sharply from Columbus's solid and massive form. Persico created a chasm between the two people, one solid and arrested in motion, the other contorted and fleeing; one fully clothed with an incongruous swag of drapery flung over his right shoulder, the other nude except for the tied drapery that conceals her pudenda. With Columbus holding the globe triumphantly in his right hand and oblivious to the maiden cowering beside him, Persico's sculpture proclaims the dominance of the white man over the effeminate and, by implication, weak and vulnerable Indian. As the newcomer advances onto the soil of the New World, the native begins her retreat in the face of his power and superiority.

If *Discovery* elucidates the first meeting between discoverer and discovered, *Rescue* (fig. 54) epitomizes the result of this contact in the subsequent settlement of land. As Greenough explained to Secretary of State John Forsyth upon learning of his commission, "I know of no single fact in profane history that can balance the one so wisely chosen by Mr. Persico as the subject of his group . . . which shall commemorate the dangers and difficulty of peopling our continent."[10] (Greenough had not considered America as "peopled" before the coming of the Europeans.) The recoiling Indian maiden in Persico's statue has been replaced in Greenough's work by a muscular, militant Indian man who struggles against a settler's restricting armhold. The space that separates the people in Persico's statue has been collapsed in Greenough's *Rescue:* the two figures now form a single unit, suggesting not assimilation but subjugation in the interlocked relation between pioneer and warrior. As in the left staircase group, the explorer dominates, not only because of his towering size and physique but also because of his advantage in strength over the powerless Indian. The conqueror impedes the nearly naked Indian in order to protect his family, the frightened wife and the child she shields. Balancing this group on the right is a dog, who barks at the dramatic struggle.

As did Persico in *Discovery,* Greenough in *Rescue* contrasts the unclothed Native American with the fully dressed white man, reiterating the modest swag of classical drapery that surrounds the native's hips and the incongruous shawl-like cloth that in *Rescue* sweeps upward toward the pioneer's left shoulder. Persico placed his two figures beside each other, creating an opposition between the woman on the left, who turns to flee (but the Capitol will cut off her retreat) and the man on the right, who steps forward to claim the newly discovered land. The female's admiring and fearful gaze at the explorer enhances the lateral movement from left to right, from the New World heathen to a European Christian. Greenough, on the other hand, locates his men one in front of the other. We move from the subdued warrior in the foreground to the towering woodsman in the background.

To express in sculptural form the triumph of Anglo-Saxon civilization over the subservient native population, Greenough in his *Rescue* deliberately trans-

formed a topos from narrative discourse and the visual arts: the captivity theme. In this first indigenous narrative form in North American literature, Puritan settlers detailed their sufferings at the hands of Indians, presenting their imprisonment and subsequent rescue as a metaphor of spiritual salvation. These seventeenth-century religious works, especially those of Mary Rowlandson, John Norton, and Peter Williamson, became popular literature in the nineteenth century and established a pattern for subsequent authors. By the end of the eighteenth century, captivity narratives had become increasingly sensational, with the emphasis shifting from religious conversion to exaggerated tales of Indian cruelty. In the nineteenth century, fictionalized pulp thrillers dramatized Indian savagery, contrasting Indians' wild nature to the white captive's Christian purity. James Fenimore Cooper, for example, composed *The Last of the Mohicans* as two separate captivity narratives.[11]

This literary convention established the precedent for visual images of captivity that first appeared as illustrations for written narratives. Among the earliest is the frontispiece for *Affecting History of the Dreadful Distress of Frederick Manheim's Family*, published in 1794, in which two women are encircled by their armed captors, who dance in triumph.[12] The first painted captivity image, John Vanderlyn's *Death of Jane McCrea* (1804; fig. 55), also began as a book illustration, commissioned by Joel Barlow to provide engravings for his epic poem, *The Columbiad*.[13] Vanderlyn gave visual form to Barlow's poetic description of Jane McCrea's death: she falls to her knees, pleading unsuccessfully for her release from the Indians, who raise their axes in preparation for her brutal murder. Subsequent images continued to exploit the gender convention of the enslaved woman's innocence and the captor's cruelty. Erastus Dow Palmer's *White Captive* (1859; fig. 56), for example, epitomizes the captive female's helplessness and her virginal purity. Carved in white marble, thereby emphasizing the woman's innocence, and bound by a cloth to a tree stump, Palmer's single figure is helplessly exposed yet impervious to Indian malignity and prurient voyeurism. In George Caleb Bingham's *Captured by the Indians* (1848; fig. 57), the captivity theme is recast in a religious context, underlining the white captive's salvation from the wilderness. The sleeping Indians evoke the three Roman soldiers who guard Christ's tomb in scenes of the Resurrection; at the same time, the pyramidal grouping of mother and son and the woman's red and blue garb allude to the Madonna and child. Bingham's painting thus conforms to the eighteenth-century captivity motif of the Madonna of the Wilderness found in the earliest published narrative, *A True History of the Captivity and Restoration of Mrs. Mary Rowlandson* (1682).[14]

Although *Rescue* relates to this captivity tradition, the standard image—as represented in Vanderlyn's *Death of Jane McCrea*, Palmer's *White Captive*, and Bingham's *Captured by the Indians*—was of the *white* woman held captive, the Indian man threatening her Christian virtue before taking her life. By contrast, Greenough's group shows the *Indian* man as vulnerable and powerless, captured by the male settler. This may represent a subsequent development of events, but Greenough's inversion of a traditional image suggests a conscious alteration of a motif that had become standard in American art and literature. Clothed in a

55. John Vanderlyn. *The Death of Jane McCrea*. 1804. Oil on canvas. 32 × 26½ in.
Courtesy of the Wadsworth Atheneum, Hartford, Conn. Purchased by Subscription.

Renaissance-style flat hat and robe that resemble the clothing seen in Hans
Holbein's portraits of humanists and officials of the court of King Henry VIII,
Greenough's pioneer symbolizes enlightenment. Looking down at the subordi-
nate Indian with compassion, the colossal white settler stands for civilization: he
is a Renaissance Man taming the wilderness, protecting and preserving Chris-
tianity as represented by the frontier mother and child.

This government-sponsored monument, which once decorated the outside of
the Capitol Rotunda, qualifies as the first and perhaps only work of art that
reversed a traditional narrative theme in American literature and art. The pi-

56. Erastus Dow Palmer. *White Captive*. 1859.
Marble. Height, 66 in. Courtesy of the Metro-
politan Museum of Art, New York City. Gift of
the Hon. Hamilton Fish, 1894.

57. George Caleb Bingham. *Captured by the Indians*, or *A Captive*. 1848. Oil on canvas. 25 × 30 in.
Courtesy of the Saint Louis Art Museum. Bequest of Arthur C. Hoskins.

Discovery *and* Rescue

oneer's action of restraining the Indian interrupts such future events as the implied sexual and physical violence against women, the imprisonment of women, and the long-term separation of the mother and child from the family. Joy Kasson has shown that captivity narratives "fascinated readers partly because they raised the spectre of the disintegration" of the home and family, and that the female victim-captive existed in liminal stages of transition between virginity and sexuality, the known and unknown, domesticity and wilderness, control and loss of control.[15] In *Rescue*, a white man intervenes in this rite of passage, keeping the woman and child within his cultural and domestic sphere of influence. The family remains intact. The helplessness of the mother and child in a hostile world is placed under the control of a mythic pioneer, who interferes with any possibility of either member of his family becoming a part of, or choosing, Indian life. The woman is retained within a society where men are empowered, evidenced here by the man's gaining control over the Indian and hence over this hostile environment. The woman and child remain powerless and vulnerable, not unlike the subordinate Indian in Persico's group, a telling commentary on mid-century white male attitudes toward women in both cultures.

Although the government commissioned *Discovery* and *Rescue* in 1837, the former group did not adorn the left side of the central portico until its installation in 1844, and Greenough's *Rescue* did not stand on the right side of the staircase until 1853. These two statues consequently decorated the Rotunda exterior for the first time during the period of America's expansion westward; hence the statues must be examined in the light of these historical events and the values associated with them. As we have seen in examining the Rotunda paintings, at mid-century American popular belief held that the nation enjoyed a divine right to disseminate democracy within its continental boundaries and even beyond, and that it in fact had a preordained mission to carry civilization to unenlightened lands. At the same time, Americans were embracing the concept of manifest destiny to justify the nation's westward expansion. The phrase was first coined by John L. O'Sullivan, editor of the *United States Magazine and Democratic Review*, who argued in favor of the annexation of Texas by explaining that the nation should realize "our manifest destiny to overspread the continent allotted by Providence."[16]

As its official expression of expansionist ideology, the U.S. Congress rhetorically evoked manifest destiny to sanction war against Mexico in 1846 and to annex Texas in 1845, Oregon in 1846, and California in 1848. Robert C. Winthrop, the author of the Pilgrim address noted in relation to Robert Weir's *Embarkation of the Pilgrims*, was the first to use the term in Congress. Arguing in favor of Oregon's joint occupation by Great Britain and the United States, the Massachusetts representative maintained in 1846 that it was "the right of our manifest destiny to spread over this whole continent."[17]

During the congressional debate on the Oregon issue, some Congressmen exploited Columbus's discovery of America as the prelude to the New World's mission to absorb lands and march westward, carrying the torch of civilization

and completing the providential circle of progress from the west back to its origins, the east. William Sawyer, for example, defended the annexation of Oregon by proclaiming, "We received our rights [title to the Oregon territory] from high Heaven—from destiny." Asserting that God ordained Columbus's voyage to the New World as a means to consummate the nation's destiny, the Democratic representative from Ohio reasoned that "our fathers followed and took possession; here they established the seat of empire; here they sowed the seeds of democracy." Because Columbus was "the agent Heaven employed to place us in possession," Sawyer argued, "we have the right to every inch" of the continent.[18]

Sawyer's interpretation of history is fascinating. He perceived Columbus's arrival in the New World as a preordained event that not only led to the United States as a nation but also allowed for continental expansion. Sawyer's deliberate reinterpretation of history provided an excuse to annex additional land in spite of the international implications. By endowing Columbus with such significance, Sawyer helped set the stage for President Polk's decision to end the British-American joint occupation of Oregon.

Whether Persico intended such a broad cultural and historical ideology through his representation of Columbus's discovery is unknown. Other antebellum Americans, however, interpreted the *Discovery of America* as a statement in support of America's western expansion. The *United States Magazine and Democratic Review* published and commented on a review of Persico's statue in the *New World* that dubbed the work as "the Discoverer and Discovered of America," observing, "The artist has grouped the history of man, . . . the providential guidance which overruled his destiny, . . . whose results have changed the character and condition of the world." In Columbus, Persico embodied "the march of civilisation and Christianity." The *United States Magazine and Democratic Review* then proposed a slightly amended interpretation: "Its main point is this—that Columbus is supposed to be looking towards Europe from the New World of which he has just consummated the discovery," embodying in a symbolic spot on the Capitol's staircase "the whole idea of the destiny of the New Continent, both as to its own incalculable future and as to the reaction of its influence on the rest of the world."

The author of the article not only viewed Persico's *Discovery* as an indicator of this "great American Union's" providential mission, but furthermore identified the location of the statue on the east facade and eastern orientation of the monument as symbolic. In this analysis, Persico's Columbus stands triumphantly at the Capitol's main entrance to declare to the world and all new arrivals that the New World has been absorbed into Western civilization and declared under the white man's hegemony. The Indian prepares to flee to the Great Plains upon recognizing the white man's superiority; the navigator, on the other hand, stands immobile and imperious, symbolically taking possession of the New World in preparation for the birth of a new nation, the United States, whose government resides in the very halls of the building that Columbus, a "godlike stranger who has descended like a revelation from heaven," seems to claim and protect.[19]

At least one congressman used Persico's *Discovery* as proof of America's manifest destiny and mission in his argument for the acquisition of Texas in January 1845. James E. Belser, a representative from Alabama, stated that since the first navigators from the Old World discovered this continent "in the arrangements of Providence, Indian possession had gradually given way before the advances of civilization." Asserting that no limits existed for the American people, the Democrat predicted that the "two figures which have so recently been erected on the eastern portico of this Capitol" exhibit "an instructive lesson" that "Freedom's pure and heavenly light would continue to burn, with increasing brightness, till it had illuminated this entire continent. . . . It would go onward and onward; it would fill Oregon; it would fill Texas; it would pour like a cataract over the Rocky mountains, and, passing to the great lakes of the West, it would open the forests of that far distant wilderness to . . . the far shores of the Pacific."

It would seem from this comment that for the first time the art of the Capitol served a polemic function of legitimating congressional legislation. Belser alluded to *Discovery*'s prominent location on the Capitol's eastern portico as a predictor of American freedom to move westward away from, yet still linked to, the U.S. Capitol and the seat of the national government. He understood that the statue accurately reflected white America's perception of Anglo-American superiority over the Indians: "Gentlemen might laugh at the nudity of one of them," Belser noted, "but the artist, when he made Columbus the superior of the Indian princess in every respect, knew what he was doing." As Belser accurately observed, the female Indian's nakedness further contributed to her inferior status in relation to the discover who represented "the power of civilization."

Congressman Belser also expressed the general belief that the advance of civilization would inevitably result, under the direction of "Providence," in Indian migration and ultimate extinction. "We got their [Indian] possessions by the strong arm of power," he boasted. "We removed these tribes from their hunting-grounds, who did not cultivate the land, in order that we might accomplish the greatest amount of good to the human race." The southern congressman clearly supported the earlier Indian Removal Act of 1830, assessing the policy as appropriate for the nation's continued march westward.[20]

Within this context, Persico's *Discovery of America* seems to condone the federal government's Indian removal policy in support of westward expansion. In his group, Persico dramatized the first meeting between the Indian and the white man, savagery and civilization, heathenism and Christianity, wilderness and cultivation. Columbus stands triumphant over the Indian, who cowers in awe and fear. This is not an illustration of possible assimilation but a representation of domination: the Indian in flight must yield to white American civilization.

In its representation of a colossal pioneer with mythic associations, *Rescue*, like Persico's *Discovery of America*, referred to recent westward migration and further related to the government's official policy toward the Indians. As Senator John Elliott of Georgia had argued earlier, in favor of Indian removal, the situation between the two races was "a struggle for supremacy between savages and civilized men, between infidels and Christians."[21]

Greenough's *Rescue* illustrates Elliott's words, graphically depicting the triumph of civilization, Christianity, and culture over savagery, heathenism, and untamed wilderness. Although some asserted that Robert Mills assembled the figures in Greenough's monument incorrectly (the sculptor died three years before its placement on the Capitol stairway), the objections had to do with the positions of the dog and the mother, who some claimed should be in front of the men, in direct line of the Indian's attack.[22] Nonetheless, even if Mills's organization of the various components (mother and child, dog, Indian and pioneer) was incorrect, the meaning corresponded to the artist's intention, for according to one family member who complained about the composition, the group was to tell "its story of the peril of the American wilderness, the ferocity of our Indians, the superiority of the white man, and how and why civilization crowded the Indian from his soil, with the episode of woman and infancy and the sentiments which belong to them."[23]

That some Americans at mid-century grasped *Rescue*'s meaning is evident in an 1851 review in the *Bulletin of the American Art-Union:*

The thought embodied in the action of the group, and immediately communicated to every spectator is the natural and necessary superiority of the Anglo-Saxon to the Indian. It typifies the settlement of the American continent, and the respective destinies of the two races who here come into collision. You see the exposure and suffering of the female emigrant—the ferocious and destructive instinct of the savage, and his easy subjugation under the superior manhood of the new colonist. . . . He [the pioneer] whose destiny is to convert forests into cities; who conquers only to liberate, enlighten, and elevate; who presents himself alike at the defiles of lonely wildernesses and the gates of degraded nations, as the representative and legate of laws, and polity, and morals; he the type of your own glorious nation, stands before you. His countenance is indignant, yet dignified; . . . there is nothing vindictive or resentful in it; the cloud of passion has passed from the surface of that mirror of high thoughts and heroic feelings, and the severity of its rebuking force is a shade saddened and softened by the melancholy thought of the necessary extinction of the poor savage, whose nature is irreconcilable with society.[24]

According to this troubling interpretation, Greenough's settler will build cities and inevitably destroy the forests and the Indians. But he "conquers only to liberate, enlighten, and elevate" inferior races and does so with compassion and sadness over the necessity to destroy the "poor savage."

A few years before this remark, the acquisition of new territories under the Polk administration and the discovery of gold in California contributed to renewed conflict between white settlers and Native Americans because the government, years earlier, had moved various tribes directly into the path of renewed westward expansion along the Oregon Trail. To resolve the problem, in 1853 Congress implemented the reservation system: tribes were once again removed from their homes in the hope that they eventually could be educated and civilized

in the white man's ways.[25] Again, Persico's *Discovery of America* and Greenough's *Rescue* served to condone congressional policy, for the statues demonstrated that after the initial meeting between Indians and whites on the frontier, civilization would triumph over savagery, thereby ensuring the realization of American empire. By rendering a militant Indian in *Rescue* at a time when actual warfare had flared, Greenough supplied, in visual mythic terms, the rationale for the government's Indian policies.

The presence of these two monuments on the central staircase became exaggerated in illustrations of presidential inaugurations. Between 1829 and 1857, seven presidents took the oath of office and gave inaugural addresses on the eastern portico of the Capitol, where most of the monuments were visible. President Polk stated in his inaugural address in March 1845 that the Republic of Texas should "form a part of our Confederacy and enjoy with us the blessings of liberty secured and guaranteed by our Constitution." He reasoned that "to enlarge [the nation's] limits is to extend the dominions of peace over additional territories and increasing millions," and that the United States has a right to "our territory that lies beyond the Rocky Mountains." He announced that "the title of numerous Indian tribes to vast tracts of country has been extinguished."[26] One illustration of Polk's inauguration shows the crowd and the President dwarfed by the left staircase group of Persico's *Discovery* (fig. 58), which visually supported Polk's expansionist intentions. At James Buchanan's inaugural ceremony in 1857 on the

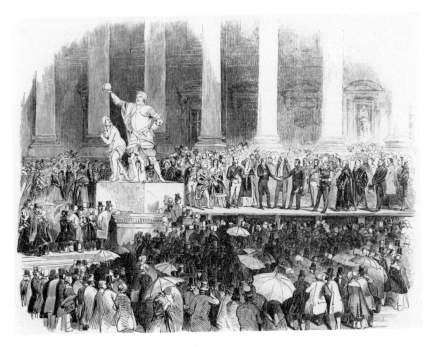

58. *Inauguration of Polk—The Oath*. 1845. Courtesy of the Architect of the Capitol.

59. *The Inauguration of James Buchanan, President of the United States, in Front of the National Capitol.* 1857. Courtesy of the Architect of the Capitol.

east facade, *Rescue* joined *Discovery* in dominating the scene (fig. 59), as larger-than-life monuments. Buchanan must have been delighted, standing framed by the two statues he had promoted as senator, as he proudly proclaimed that the United States made territorial acquisitions, through peaceful means, that brought "civil and religious liberty, as well as equal and just laws."[27]

From their original location on the left and right of the main staircase that leads to the Rotunda, Persico's *Discovery of America* and Greenough's *Rescue* announced themes found in the interior reliefs and paintings and in Greenough's *Washington.* The subject of the European discovery dominates inside the Rotunda in the portrait busts (one of which represents Columbus), in the narrative reliefs, and in the four mid-century paintings. The wall sculptures do not detail the admiral's arrival in the New World, but in their concern with discovery, conquest, and colonization the four narrative bas-reliefs parallel Persico's outside group. In particular, *Discovery* echoes Causici's *Landing of the Pilgrims* (see fig. 14) in treating the European arrival in the New World, in juxtaposing original inhabitant and alien explorer, and in implying that Western civilization will overpower the subservient Indian races. *Rescue*, on the other hand, deliberately parallels Causici's icon of conflict, *Boone and the Indians* (see fig. 19), a work Greenough saw on an earlier visit to the Capitol and mentioned when he first outlined his ideas in a letter to Forsyth in July 1837.[28] The subjugation of the Indians is more overtly demonstrated in the outside sculpture, in which the struggling native is overpowered by the settler. True, in Causici's *Boone* the vanquished Indian, over whom the two adversaries battle, portends the settler's victory, but Boone must

Discovery *and* Rescue

defeat yet another opponent. The pioneer in Greenough's *Rescue* has already overcome his enemy, indicating that the contest has ended in the white's conquest of the Indian.

The two staircase statues also relate to the second group of Rotunda paintings. In particular, Persico's *Discovery of America* corresponds to John Vanderlyn's rendition of a similar subject (see fig. 26). The Italian sculptor, however, did not convey a narrative with a multitude of figures in a landscape setting, nor did he specify a single episode from the life of Columbus. Instead, his statue intimates on a mythic level the significance of the discovery in relation to future events. By rendering only two figures—Columbus and the Indian—Persico's *Discovery of America* transcends the particular historical event to symbolize in more general terms the European triumph over the native population.

Similarly, *Discovery* and *Rescue* reiterate the themes embodied in the secondary figures that stand behind George Washington on his throne. When the marble *Washington* decorated the Capitol grounds, the small figure of Columbus faced *Discovery*. Persico's Columbus is more assertive than Greenough's contemplative, prophetlike figure. Also, the monumental and imposing president with his raised right arm in Greenough's *Washington* duplicates the pose of Persico's invader of the strange continent. Both Persico's *Discovery* and Greenough's *Washington* present historical personages as agents of civilization and as mythic symbols. In the case of Greenough's *Rescue*, the work relates to the theme of the Vanishing American, which he had earlier represented through his lamenting Indian located behind the figure of Washington. True, Greenough did not again render an Indian meditating upon his race's doom. But the sculptor nevertheless articulated his intention that the monument "serve as a memorial of the Indian race." By showing "the idea of the triumph of the whites over the savage tribes," Greenough intimated that the original inhabitants of the New World would eventually become extinct, requiring a memorial such as his *Rescue*, one in which the Indian assumes generalized features that defy ethnographic identification.[29]

In 1958, the Architect of the Capitol replaced the deteriorated sculptures on the Rotunda's facade with duplicates. Persico's *Discovery* and Greenough's *Rescue*, however, were never reinstalled on the left and right sides of the main staircase. Not only had Native Americans come to realize the works' negative implications, but some members in Congress had lobbied for their removal. As early as 1939, a joint resolution submitted to (but not passed by) the House recommended that *Rescue* be "ground into dust, and scattered to the four winds, that no more remembrance may be perpetuated of our barbaric past, and that it may not be a constant reminder to our American Indian citizens."[30] Two years later, the House considered a joint resolution suggesting that "the group [*Rescue*] now disgracing the entrance to the Capitol" be replaced with "a statue of one of the great Indian leaders famous in American history."[31] In 1952, the California Indian Rights Association objected to the demeaning imagery of their people as depicted in *Rescue*.[32] Additional correspondence from this and other In-

60. N. M. Bodecker. Cartoon. 1959. Photograph by Herbert Peck.

dian groups to various congressmen and to the Architect of the Capitol de-
manded the permanent removal of both works.[33] One letter of protest, pub-
lished in the October 1959 issue of *Harper's*, included an illustration of an Indian
proudly strutting away from two piles of stone identified by markers as "The
Discovery" and "The Rescue" (fig. 60).[34] Carrying a mallet over this shoulder
and a sign inscribed "The End," this Indian has just destroyed the two objection-
able statues. Ironically, in 1976, a crane accidentally dropped Greenough's *Rescue*
while moving the statue to a new storage area. Persico's *Discovery of America*, on
the other hand, is still intact and in storage.

By the time the statues had been banished to avoid offense, the status of
relations between Indians and whites had changed. The Indian Reorganization
Act of 1934, in fact, marked a turning point in federal policy and attitudes.
Besides encouraging tribal governments and cultures, the act rejected "the er-
roneous, yet tragic, assumption that the Indians were a dying race—to be liqui-
dated." The document furthermore acknowledged, "We took away their best
lands; broke treaties, promises; tossed them the most nearly worthless scraps of a
continent that had once been wholly theirs."[35] Ten years earlier, in 1924, the
government had granted full citizenship to Indians, but it never did terminate
federal supervision and control of tribal affairs.

Thus the demands to remove *Discovery* and *Rescue*, beginning in 1939 and
continuing until 1958, coincided with changes in Caucasian-Indian relations.
Although no one then seemed to recognize the connections between the statues,
nineteenth-century westward expansion, and the dispossession of Indians from
their ancestral lands, some twentieth-century Americans nonetheless recognized
that the imagery was inappropriate to contemporary developments.

# Part Two

## The Capitol Extension
### 1850–1860

# 5

## *Thomas Crawford's* Progress of Civilization

In September 1850, Congress legislated the expansion of the Capitol building to accommodate its increased membership and to resolve problems with heating, ventilation, and acoustics. The consequent work on the Capitol extension resulted in a number of significant changes that affected the building and its decoration. First, in 1851, President Fillmore reinstated the position of Architect of the Capitol and appointed Thomas U. Walter to fill the post after the Senate Committee on Public Buildings had sponsored a competition. Walter proposed the addition of two wings to the north and south of the old building with their exteriors having similar features, "to impart dignity to the present building rather than to interfere with its proportions or detract from its grandeur or beauty."[1] This Greek Revival architect from Philadelphia thus continued the neoclassical style of the building, reiterating the Corinthian columns, the undecorated entablature, the extensive staircase, and the central pediment on the Senate and House wings to create a stately, monumental, and unified facade. At the same time, Walter replaced Bulfinch's low dome, which had been inspired by the Roman Pantheon, with a higher, greatly articulated, cast-iron dome with its row of Corinthian columns that support an entablature, three tiers of windows, receding stages, ribbed cupula, and lantern, elements amalgamated from various buildings Walter had studied in Europe in 1838—St. Peter's in Rome, St. Paul's in London, and the Pantheon in Paris.[2] Most of these alterations were completed by the close of the Civil War in 1865.

The second significant change that occurred with the Capitol extension involved the department under which the architect operated. Since 1829, with the abolishment of the office of the Architect of the Capitol, the secretary of the interior had directed the Capitol decoration and maintenance, a situation that continued when President Fillmore reinstated the office. But in 1853, unsubstantiated charges of fraud in the employment of workmen, the method of contracting, and the quality of the materials led to President Pierce's decision to transfer the administrative responsibilities to his most powerful adviser, Secretary of War Jefferson Davis, formerly a member of the Senate Committee on Public Buildings, which made decisions about the enlargement of the Capitol, and presently in charge of the construction of forts and bridges.

Davis, a Mississippian, had attended West Point and then fought against Indians in various battles, most notably during the Black Hawk War of 1831–1832. Retiring from military service in 1835, he settled near Vicksburg and became a prosperous cotton planter. In 1845, he won a seat as a Democrat in the House of Representatives. During his short tenure as congressman, he advocated the occupation of Oregon, the acquisition of California, and the decision to go to

war with Mexico. He gave up his seat in Congress to fight in the Mexican War and then reentered politics in 1847, when the governor of Mississippi appointed him to fill a vacancy in the U.S. Senate, where he served until he became secretary of war in President Pierce's cabinet between 1853 and 1857. In this position, Davis directed the Capitol extension, organized the defense of the frontier against hostile Indian tribes, planned the removal of the Seminoles in Florida to reservations, and directed surveys for a transcontinental railroad in the South.[3]

In 1853, Davis selected Captain Montgomery Meigs from the Army Corps of Engineers as financial and engineering supervisor of the extension. The Architect of the Capitol remained subordinate to Meigs until 1859, when tension between the two and disagreements between the new secretary of war, John B. Floyd, and Meigs led to Meigs's dismissal (he was reinstated in 1860).[4] Although Davis became a senator again between 1857 and 1861, he maintained ties with those who had worked under his aegis, supporting Meigs during the engineer's disagreements with Walter and Floyd. With the transfer of supervision from the Department of War back to the Department of the Interior in April 1862, Walter once again was in charge of the Capitol extension.

Meigs, from a prominent Philadelphia family, also had attended West Point, where he took art classes, and then worked for the Corps of Engineers beginning in 1837. He directed the construction of various forts along the Atlantic coast until 1852, when he became supervisor of the Washington Aqueduct and the Post Office. As the superintendent of the Capitol extension, Meigs made some alterations in Walter's plans, locating the Senate and House chambers in the center of the north and south wings, surrounded by corridors and committee rooms. (Walter had planned to put them in the western half of the wings.) Later, during the Civil War, he became quartermaster-general in charge of transferring supplies to the Union forces.[5]

For the first time, albeit briefly, two people regulated the decoration of the Capitol, Jefferson Davis and Montgomery Meigs. Although the presidents had final say in approving or rejecting a design, they never took advantage of this power. The government thereby established its first consistent process for federal patronage, with Meigs acting as an intermediary between artists and Davis, who in only four years successfully influenced the iconography and meaning of the decoration so that it reflected his expansionist and pro-slavery stances. Meigs often took the initiative (probably with his boss's approval) to select subjects for new works that would expand on the iconography already manifest in the Rotunda decoration, and the result was a carefully thought-out and unified program. He always forwarded designs to Davis and the president for their approval.

Meigs's control over the art commission for the Capitol extension did not go unchallenged. After immigration had accelerated as a result of the Irish potato famine in 1846 and the failure of the revolutions in Europe in 1848, some people ardently opposed the federal patronage of foreign artists.[6] During this xenophobic period, in 1858, nearly one hundred American artists protested in a memorial to Congress against the hiring of foreigners like Constantino Brumidi to decorate the Capitol extension. In 1859, President Buchanan signed into law

legislation passed by Congress to appoint the Art Commission, a group of three American artists—Henry Kirke Brown, James R. Lambdin, and John F. Kensett —to direct the Capitol's embellishment, with the Joint Committee on the Library acting as final arbiter. The commission not only focused on the need to hire Americans (arguing that "patriotic hearts should perform the noble work") but also advocated the creation of a national art: "The arts afford a strong bond of national sympathy, and when they shall have fulfilled their mission here by giving expression to subjects of national interest, in which several States have been represented, it will be a crowning triumph of our civilization." The Senate and the House failed to endorse the committee's seven-page report, largely because of its grandiose and expensive schemes, and the president abolished the Art Commission.[7] What these protesting artists had not realized is that Meigs and Davis had already put their stamps on the Capitol decoration, creating and enhancing what already was a complex iconographic program that espoused national and patriotic themes.

Upon viewing Walter's plans for the Senate and House wings, Meigs determined that the American republic, "so much richer than the Athenian," should have a Capitol building that would "rival the Parthenon." The supervising engineer thus altered Walter's design, which had an entablature with a horizontal balustrade over the north and south porticos, substituting a pediment "as more beautiful and affording in its tympanum space for sculpture."[8] The supervising engineer then consulted Edward Everett, senator from Massachusetts and art connoisseur, who had earlier promoted the Pheidian Zeus as the model for Greenough's *Washington:* "Will you be kind enough to designate to me those whom you think most capable of designing and executing these works in such a manner as to reflect honor upon themselves and our country?"[9] Everett replied by recommending two expatriate American sculptors, Thomas Crawford and Hiram Powers.[10]

Powers, a renowned sculptor who earlier had earned an international reputation through his *Greek Slave* (1847), refused the potential order for two reasons. First, he objected to the requirement that he submit a design for approval, feeling it to be an affront to his reputation. At the same time, the Cincinnati-born artist reacted to what he considered an insult because Congress would not purchase his allegorical statue, *America*.[11] Consequently, the tympanum of the north wing remained undecorated until 1916, when Paul Wayland Bartlett completed his *Apotheosis of Democracy*, even though numerous sculptors submitted proposals for Meigs's consideration.

Thomas Crawford, on the other hand, submitted his concept for the Senate wing. Crawford had learned to sculpt at the age of nineteen in the studios of John Frazee and Robert E. Launitz in New York City, his birthplace, and then had gone to Rome in 1835, where he studied with the prominent Danish sculptor, Bertel Thorwaldsen. He established his reputation through his portrait busts and ideal parlor works, becoming equal in reputation to his friends Horatio Greenough and Hiram Powers, both of whom resided in Florence. While engaged on his commission for an equestrian monument of George Washington for the

Virginia Capitol grounds, Crawford received his first letter from Meigs. He subsequently became the premier sculptor for the Capitol extension, until his untimely death at the age of forty-three.[12] As Davis declared in the Senate in 1858, Crawford was "the great American genius, whose name has shed a luster upon our country . . . [and] whose early death was the nation's loss."[13]

"Our history of the struggle between civilized man and the savage, between the cultivated and the wild nature," would appeal "to the feelings of all classes," wrote Captain Meigs in August 1853 to Crawford and Powers. Realizing that the expansion of the Capitol would afford numerous locations for sculptural decoration in emulation of ancient temples, Meigs cautioned the two artists that the American public could not "appreciate too refined and intricate allegorical representations." Nor did he believe that "the naked Washington of Greenough" could be appreciated by "the less refined multitude." Consequently, in his duplicate letters to Powers and Crawford, Meigs suggested that the artists consider the theme of racial conflict for the Senate and House tympana, a subject that had been the basis for the American literary canon and could be seen elsewhere in the Capitol Rotunda.[14] Meigs's proposal also indicates that his attitudes toward the native population resembled those of many of his contemporaries, who also distinguished between savage Indians and civilized whites.

Crawford responded with enthusiasm, sending a design that followed the general theme suggested by the soldier-engineer two months after receiving his initial inquiry. Knowing that Meigs wanted the Capitol to rival the Parthenon, Crawford followed what remained of Phidias's east pediment, varying the poses of his figures so that they too would fit into the triangular architectural frame.[15] Although each figure in Crawford's relief follows the classical Greek style, the nineteenth-century version (fig. 61) nonetheless transforms the fifth-century B.C. prototype into hardened formulaic emblems. Yvonne Korshak has shown that the Pheidian composition radiates from the center toward the corners, conveying through the mythological subject matter the narrative of Athens as an imperial city.[16] The American pediment similarly moves outward from a central figure, not a representation of the deities Athena and Zeus, but a personification of America.

Entitled *Progress of Civilization*, the pediment, with its framing figures left and right, narrates the history of the nation's growth across the continent and its commerce across the Pacific and Atlantic oceans, an appropriate subject given Jefferson Davis's earlier position in Congress as a forceful advocate for expansion westward and southward into Cuba and Nicaragua.[17] It is uncertain whether Davis had suggested the topic of racial conflict to Meigs, but certainly the engineer's recommendation adhered to his boss's interests. In short, the ideology of the Senate pediment expresses Jefferson Davis's own beliefs, as well as those of other congressmen.

In Crawford's Senate pedimental design, America stands in contrapposto in the center, filling the region below the triangle's apex. Clothed in flowing classical drapery, she looks heavenward as if to acknowledge the role Providence has played in the nation's progress. Stars decorate the billowing shawl that forms a

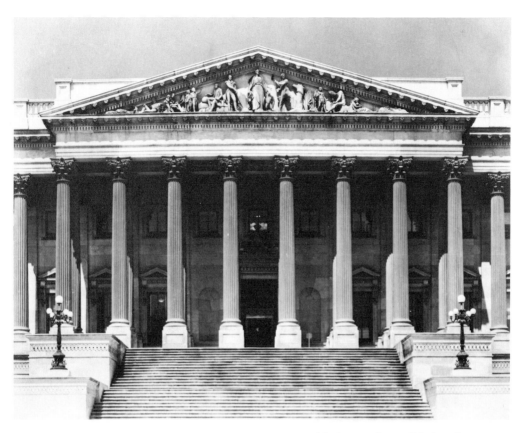

61. Thomas Crawford. *Progress of Civilization.* 1855–1863. Marble. Senate pediment, U.S. Capitol. Length, 960 in. Height at center, about 144 in. Courtesy of the Architect of the Capitol.

mantle around her shoulders and flows downward. Stars also decorate her head, as does the characteristically flipped-over Phrygian cap found in ancient Greek art, which had originally symbolized a prisoner but later referred to the idea of liberty.[18] Crawford thus represented America as Liberty, who stands, according to the artist, "upon a rock against which the waves of the ocean are beating. She is attended by the Eagle of our country." The sun rises at her feet on the left, indicating "the light accompanying the march of liberty." In one hand America holds a laurel and oak wreath, "the rewards of civic and military merit." With her outstretched left arm she "asks the protection of the Almighty" for the pioneer beside her, who clears the wilderness forest for the westward expansion of civilization.[19]

Crawford's backwoodsman (fig. 62) holds an ax in both hands as he cuts down a truncated tree. Nicolai Cikovsky, Jr., has shown that in nineteenth-century American literature and visual arts, the tree stump, ax, and woodcutter symbolized the progress of civilization, as is evident in two well-known images: Andrew Melrose's *Westward the Star of Empire Takes Its Way—Near Council Bluffs,*

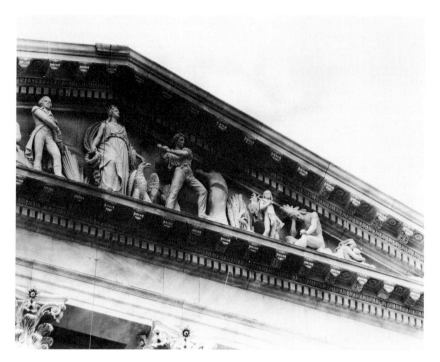

62. Thomas Crawford. *Progress of Civilization*. Detail right half.
Courtesy of the Architect of the Capitol.

*Iowa* (1867; E. William Judson Collection) and George Inness's *Lackawanna Valley* (1855; National Gallery of Art).[20] Crawford's image, in fact, resembles an 1840 frontispiece of the *Family Magazine* (fig. 63) in which a youthful woodsman leans against a tree he has been assailing. The frontispiece illustrates an article entitled "The Pioneer," whose anonymous author applauded the engraving as the suitable "graphic symbol by which [our young and growing republic's] onward progress" is indicated. Indeed, like James Fenimore Cooper, who in *The Pioneers* compared Billy Kirby, the woodcutter, to "the conqueror of some city, who, having prevailed over his adversary, applies the torch as the finishing blow to his conquest," the magazine writer describes the settler's battle with the vast wilderness as a Herculean struggle, a necessary and "mighty conquest" enabling "other pioneers to push further onward toward the sands of the great Pacific," so that truth, liberty, and justice can be transmitted to the newly settled areas in the North American continent.[21]

The article "The Pioneer" sees the Indian in the wilderness as a foe who impedes progress and must, like the forest, be conquered.[22] In the Senate pediment, Crawford conveys the same idea in the successive Indian figures of a boy, a father, and a mother and child. The boy has returned from a hunt with game flung over his right shoulder. As Crawford explained, "His looks are directed to the

63. *The Pioneer.* 1840. Engraving. Courtesy of
the Library of Congress.

pioneer whose advance he regards with surprise." Many white Americans viewed
hunting as primitive and believed that the best means to improve the Indian's
position would be their adoption of white economic practices, such as farming
and home manufacturing. The rationale for converting the Indian from hunter
to farmer, however, resided in the need for more land. Thomas Jefferson argued
that the Indians would need less acreage if they became farmers, a change that
would enable the United States to appropriate more property for the expansion
of its agrarian republic.[23] Jefferson, like most white Americans, ignored the
Indians' own agricultural practices, such as the cultivation of corn, which became
a staple in some European colonies. Instead, he focused exclusively on hunting,
defining the activity as a primitive way of life that required too much land. But
regardless of whether Indians forfeited their economic practices and adopted
those of whites, as did the Cherokees, they had to relinquish their property for
the development of the U.S. market economy. To increase cotton cultivation and
enable white settlement, the federal government relocated some seventy thou-
sand Choctaws, Creeks, Cherokees, Seminoles, and Chickasaws between 1820
and 1850. At the same time hundreds of thousands of blacks were brought into
the areas as slaves to work the land.[24] The Cherokee displacement alone resulted
in the deaths of more than four thousand Indians on the Trail of Tears.[25] The

whites' approach to the "Indian problem," then, was schizophrenic: government agents and missionaries encouraged the natives to become farmers; but even if Indians complied, they were removed from their homelands.

In *Progress of Civilization*, Thomas Crawford acknowledged the decimation of the Indians, although he did not intend a critique of white behavior or national policy. He instead provided a rationale for what he and most white Americans believed to be the sad but inevitable and necessary loss of the native population as a result of white settlement. This attitude is suggested by the hunter boy, who is involved in the very livelihood that the Indian must surrender, and his father, mother, and younger sibling, who are situated in the sloping end on the right side of the tympanum as if fading into oblivion. The father (fig. 64) is an Indian chief, with feathered headdress, who rests on a roughly hewn rock that is covered by an animal skin. This cloth wraps around the native's right leg, covering his groin as if to imply his impotence to save his race despite the tensions within his body: the man's clenched left fist and bent right leg contrast with his relaxed right arm and left leg, creating a dynamism within the static pose that is restrained within its cubic frame. His ax (not a rifle) rests against the rock, partially covered by the animal skin, a sign of the Indian's inability to employ force. (The mighty back-woodsman with ax is empowered to subdue the wilderness, in contrast to the powerless Indian chief.) It is as if he is frozen by his melancholic thoughts and therefore unable to protect his son, who becomes aware of the white settler's strength. An anonymous critic in the *Crayon* picked up these implications: the Indian chief "seems brooding over the consciousness of his destiny; the evident rigidity of the muscles of the left arm . . . with his hand resting on his knee, indicates, in its convulsive action, the impotent feeling which would prompt him to resist destiny, if resistance were of any avail."[26] Nor can he save his wife and infant child, who are seated beside a grave that is "emblematic," explained Crawford, "of the extinction of the Indian race." The imminent death of the mother and child, two generations of the tribe, refers to the inability of regeneration through birth, while the seated Indian chief embodies, as Crawford acknowledged, "all the despair and profound grief resulting from the conviction of the white man's triumph."[27] As the *Art-Journal* accurately observed, "The mother, with her prophetic fear, grabs her infant to her bosom, she reclines her cheek on its tiny face at though, in her great love, she would shroud it from the inevitable fate awaiting its race, its name, its very land; a fate sadly imaged forth by a heaped-up grave before her."[28]

Crawford's seated Indian with feathered headdress can be found in other nineteenth-century American allegorical images. The sketch in S. G. Goodrich's 1865 *Pictorial History of the United States* (fig. 65) and the right corner of the centennial stock certificate (see fig. 1), for example, each contain an Indian pondering symbols of the white civilization: a train, steamboat, city, and the Capitol building (in the book illustration), a watermill and an industrial city (in the certificate). George Catlin rendered a similar plaintive Indian in his 1857 *Letters and Notes* (fig. 66).[29] These illustrations do not promote acculturation but instead reflect the rift between so-called primitive and civilized societies, a rift that

64. Thomas Crawford. *The Indian: Dying Chief Contemplating the Progress of Civilization.* 1856. Marble. Height, 55 in. Courtesy of the New-York Historical Society, New York City.

widened because of the removal policy and reservation system. All these images imply that the Indian must leave his home to make way for the continued progress of civilization. Only Crawford's group sculpture, however, explicitly links segregation with death.

In juxtaposing the tree stump and the lamenting Indian chief, Thomas Crawford followed an established iconographic tradition in American art and literature, for the forest and the Native American shared a common fate.[30]

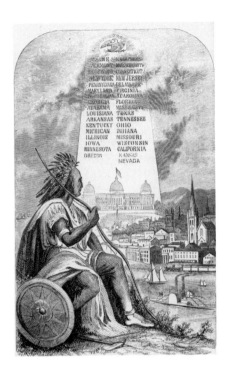

65. Engraving from S. G. Goodrich,
*A Pictorial History of the United States.*
Courtesy of the Library of Congress.

66. George Catlin. Engraving from George
Catlin, *Letters and Notes on the Manners, Customs, and Conditions of the North American Indians.* 1857. Photograph by Herbert Peck.

Horatio Greenough had used these same images in his statuette of an Indian for the Washington monument (see fig. 45), and the centennial stock certificate includes a tree stump in the foreground to underscore the shared destiny of the Indians and nature itself.[31] In John Augustus Stone's play *Metamora, or the Last of the Wampanoags*, first produced in New York City in 1829, Metamora laments, "O my people . . . the race of the red man has fallen away like trees of the forest before the axes of the palefaces."[32] The *Crayon*'s 1855 review of Crawford's pediment similarly connects the Indian's fate with that of nature via the tree stump and the dying Indian: "His tribe has disappeared, he is left alone, the solitary off-shoot of a mighty race; like the tree-stump beside him he is old and withered, already the axe of the backwoodsman disturbs his last hours; civilization and Art, and agriculture . . . have desecrated his home."[33] Both nature and the Indian must be overpowered for white civilization's unimpeded growth, especially during the expansive era in which Crawford created his design for the Senate pediment.

Crawford's lengthy explanation of the pediment's meaning (cited earlier) makes it clear that the artist depicted the seated Indian chief as the Vanishing American and that the subsidiary family members are intended to amplify this mythic type. At the request of Montgomery Meigs, Crawford consulted such ethnographic texts as Thomas L. McKenney's *Indian Tribes of North America* (1836), where a Plains Indian with feather bonnet and moccasins is featured.[34] Crawford's rendering of a Plains Indian who dwelled in the midland prairie of the North American continent further refers to the westward migration of white Americans along the Oregon Trail, during which the pioneers encountered war-bonneted Comanches, Kiowas, Blackfoots, Sioux, and Cheyennes. Crawford thereby deliberately located his allegorical westward expansion in the Midwest as an allusion to contemporary efforts to cross that region and reach the newly acquired territories along the western shore of the continent. Symbolically, then, the tightly arrayed figures in the right side of the pediment spread across half a continent. America stands at the Atlantic shore looking westward as the sun rises behind her. The backwoodsman inhabits the eastern woodlands, and the Plains Indians reside in the continent's interior.

But Crawford failed to follow the geographical and temporal continuity on the left half of the pediment (fig. 67), which should feature people of the Far West. The American soldier directly beside the central allegorical America, who mirrors the backwoodsman in his location and body posture, symbolizes the idea that "[our] freedom was obtained by the sword and must be preserved by it."[35] Although Crawford goes on to say that the man is in the act of drawing his sword to show the "readiness [and] determination of our army to protect America from insult," it is clear given the larger pedimental program that the militiaman prepares for conflict with any country or people who stand in the way of the providential mission of the United States. The soldier probably alludes not only to the Revolutionary War (especially through his uniform), but also to the War of 1812, the Mexican War, and the continuous warfare against tribes on the far frontier who resisted settlement. American leaders believed that the Mexican War would inhibit Great Britain's plan to gain sovereignty over California and

67. Thomas Crawford. Model for *Progress of Civilization*. Detail, left half. 1854.
Plaster. Courtesy of the Architect of the Capitol.

thereby "interpose," according to an article in the Whig journal *American Review: A Whig Journal*, "a barrier to growth in wealth, dominion and power of American Union and . . . the progress of republican liberty."[36] President Buchanan, defending the U.S. aggression, cast his arguments for expansion in terms of mission, noting with pride in December 1847 that "the character of our country has been illustrated by a rapid succession of brilliant and astonishing victories." He supported the Mexican War, declaring that the battle "has not been prosecuted for conquest" but rather as a means to "bestow upon" other nations "the same blessings of liberty and law, which we ourselves enjoy." The president concluded that the United States had no choice but to "fulfill the destiny which Providence may have in store for both countries."[37] And in the Senate, Jefferson Davis argued in 1848, "I hold that in a just war we conquered a larger portion of Mexico, and that to it we have a title which has been regarded as valid ever since man existed in a social condition—the title of conquest."[38]

The soldier in Crawford's *Progress of Civilization* thus matches the rhetoric of both President Buchanan and Senator Davis. This sculpted army officer—an embodiment of Davis's title of conquest—protects American civilization and

68. Augustin Dupré. Diplomatic medal. Cliché
of the obverse. 1792. White metal. $2\frac{11}{16}$ in. dia.
Courtesy of the Massachusetts Historical Society.

stands prepared to take up arms for the fulfillment of national destiny. Like
President Buchanan, Crawford advanced altruistic reasons for U.S. military ac-
tions: the amelioration of unenlightened races, the triumph of freedom over
tyranny, and the realization of the republic's westward course. Other works in the
Capitol reiterate the theme of military extension and conquest implied in
Crawford's soldier: Persico's *War* (see fig. 52), Crawford's Revolutionary War
scenes on the Senate and House bronze doors (see figs. 70 and 71), and Craw-
ford's *Statue of Freedom* (see fig. 109).[39] These works, like the soldier in Craw-
ford's pediment, represent the nation's willingness to take up arms for the fulfill-
ment of its destiny.

Seated beside the soldier is a merchant, who is surrounded, according to the
sculptor, by "emblems of commerce"—primarily packages, presumably filled
with goods—and whose "right hand rests upon the globe to indicate the extent of
our trade."[40] This image resembles an earlier representation of American mer-
cantile activity: Augustin Dupré's diplomatic medal (fig. 68). In this eighteenth-
century medal, America as the Indian princess sits among bales and barrels of
goods while receiving from Mercury, personification of commerce, a cornucopia.
The merchant on the Senate pediment, with his hand on the globe of the world,
replaces Dupré's personification of the nation and refers to trade with lands
facing both the Pacific and the Atlantic.

The themes of the two sides of the Senate pediment may seem unrelated, but
in fact they are closely tied through the mercantile notions of North American
empire. Congressmen who advocated the acquisition of new lands invoked the
concept of divine mission as a disguise for massive commercial gain. They spoke
of the need to appropriate undeveloped land beyond the Mississippi River for
farming and to build a transcontinental railroad for trade between the east and
west coasts. They hoped to establish trade routes across the Pacific with the
Orient, thereby fulfilling the old dream of a passage to India and access to its
riches. Policymakers used this theme of the Orient to induce westward migration.

Jefferson Davis, for example, argued on behalf of the forty-ninth parallel as the northwestern boundary of the United States during the debate over Oregon's joint occupation, alluding to the "bonds of commerce" that had extended around the globe as proof that expansion should be encouraged.[41] Thomas Hart Benton also supported continental expansion, believing that the U.S. advance to the Pacific would stimulate trade with the Orient and consequently free the New World from European dominance, assuring wealth and prosperity.[42] In the 1840s, the decade when Congress officially adopted manifest destiny as policy and annexed western territories, Daniel S. Dickinson espoused such a doctrine for commercial and economic gain while discussing terms of peace with Mexico. The New York senator noted that although cities and towns "have sprung up upon the shores of the Pacific," the United States has not yet fulfilled its destiny. "New territory is spread out for us to subdue and fertilize; new races are presented for us to civilize, educate, and absorb," espoused Dickinson, who noted that America was fast becoming "the commercial centre of the world" and that "the blessings of liberty" would soon be "secured to posterity."[43]

With the formal acquisition of Oregon in 1846 and of California in 1848 (actions that Jefferson Davis had advocated in Congress), the United States extended to the Pacific Ocean. Congress began to focus on the development of these new territories. Between 1848 and 1853, Benton advocated a railway to the Pacific as the basis for Asiatic trade and commercial development in the Trans-Mississippi. Benton's ideas initiated the dream of "the garden of the world," as Henry Nash Smith has explained, and the emphasis on agricultural development in these new lands. While still promoting mercantile trade, the means by which the fruit of the Trans-Mississippi world reached the Orient, the United States also concentrated on developing the Midwest (and the South).[44] Davis, as secretary of war, directed surveys for the transcontinental railroad, advocating a southern route that would be of economic benefit to his native region and cement the political alliance between South and West.[45] In the 1850s, then, two visions of American empire were realized: the mercantile and the agricultural.[46]

Whereas Crawford's merchant reflects American devotion to commerce and trade, the reclining mechanic to the far left of the tympanum symbolizes industrial and agricultural accomplishments. As Crawford detailed in his explanation of the Senate pediment to Meigs, the mechanic holds "the implements of his profession—the hammer and compass" while he rests upon a cogwheel, "without which machinery is useless."[47] The mechanization of agriculture would subdue and fertilize vast tracks of land, helping realize the agricultural notion of North American empire already embodied in Jefferson's yeoman farmer. Moreover, the pose and position of the mechanic duplicate those of the Indian mother and child on the far right. The end figures at left and right juxtapose male worker and maternal caretaker, civilization's future and the Indian's necessary destruction. Even more to the point are the corner framing elements. The sheaf of wheat on the left is, according to Thomas Crawford, "expressive of fertility, activity, and abundance," in "contradistinction to the emblem of Indian extinction" on the right side: the grave.[48] The dying Indian mother is supplanted by the fecund

69. F. F. Palmer. *Across the Continent: "Westward the Course of Empire Takes Its Way."* 1868. 22 × 30 in. Courtesy of the Museum of the City of New York. Harry T. Peters Collection.

earth, whose bounty is sown, nurtured, and harvested by white agrarians, who have replaced the Native American hunters.

Between the merchant and the mechanic are four figures divided into two groups. A schoolteacher, "emblematic of scholarship," instructs a child while two schoolmates venture forth "to the service of their country."[49] As the *New American Magazine of Literature, Science and Art* asserted, "One of the first indications of this advancing amelioration of the rude, and wild, and uncomfortable in nature, and the approach of a genial reign of better and holier influences is the early appearance of the SCHOOL HOUSE."[50] In such mid-century paintings as James M. Hart's *The Old School House* (1842; private collection) and Henry Inman's *Dismissal of School on an October Afternoon* (1845; Boston Museum of Fine Arts), tree stumps often appear beside schoolhouses as a symbol of civilization.[51] In F. F. Palmer's *Across the Continent: "Westward the Course of Empire Takes Its Way"* (1868, published by Currier and Ives; fig. 69), the schoolhouse is seen as one of the settler's first ways of establishing democratic civilization in the wilderness. As the 1840 *Family Magazine* article "The Pioneer" states, "education[,] . . . one of the strongest bulwarks of our liberty," must accompany mercantile and agricultural concerns for the advance of civilization.[52] (That all the schoolchildren are white males signals that it is men rather than women who must be educated for this purpose.)

In the Senate pediment, the two clothed, standing white schoolboys on the left occupy a position comparable to that of the naked Indian hunter boy on the right. This coupling suggests that the uneducated, uncultured, and wild native is symbolically replaced by educated, cultured, and civilized whites, who will con-

tribute to the U.S.'s realization of its industrial-mercantile goals through knowledge. The two white adults on the left who face one another, framing the standing children, are seated in poses that deliberately reiterate the Indian chief on the right, suggesting more than a compositional relationship. While the Vanishing American mourns and resigns himself to his impending death and his race's annihilation, the Anglo-Saxon merchant sits upright in anticipation of commercial transactions and the teacher concentrates on educating his pupils. The major coupling of Indian chief with white businessman and minor coupling of Indian chief with schoolteacher deliberately establish the distinction between one people's primitive way of life within a circumscribed area and the other's more sophisticated economy and culture.

Thomas Crawford's *Progress of Civilization* narrates through emblematic form the belief of the United States in its manifest destiny and mission to subdue and replace the native peoples to make way for the more enlightened and economically intricate North American empire. Yet conflict does not exist in this work. Although the soldier stands prepared to use his sword, he does not have to: the battles have been won, the Indian people defeated. The struggling warriors in Greenough's *Rescue* and Causici's *Conflict of Daniel Boone* have been subdued; the fighting spirit has become extinguished over the course of many battles in which the white man has proved his physical and moral strength. The Indians must either go along with the government's removal program, resettling on arid reservations outside the boundaries of civilization, or they must accept death as the inevitable consequence of recalcitrance.

The message conveyed in Crawford's pediment differed from the reality. Beginning in 1851, two years before Meigs contacted Crawford about the Senate pediment, the government again began acquiring western Indian lands for the protection of white travelers, for unobstructed settlement, and for the building of roads and railroads. Yet during the ensuing decades, violence once again erupted as the Sioux, Cheyennes, Modocs, and Arapahoes, among other tribes, tried to assert their independence despite their containment within reservations.[53] Jefferson Davis, as secretary of war, was cognizant of this situation, and he tried to find solutions to the "constant collision" between the two races in Texas, New Mexico, and California.[54] Crawford's suggestion that the confrontation between the Indians and whites had subsided thus reflects wishful thinking on the part of the artist and the federal government.

Given Crawford's overt message that Native Americans must be removed and extirpated, if necessary, for the continued progress of the United States, it may seem surprising that twentieth-century objections to Greenough's *Rescue* and Persico's *Discovery* have not been targeted at this work as well. This omission may be because the figures in Crawford's pediment are far above eye level and merge into the architecture. Moreover, visitors to the Capitol cannot enter directly into the Senate chamber but instead are routed from the central crypt to the upstairs chamber. Consequently, the pediment fails to capture the attention of the public despite Meigs's and Crawford's attempt to make a work that Americans could easily understand.

# Randolph Rogers's Bronze Doors
# and Constantino Brumidi's Frieze

While at work on the model for the Senate pediment, *Progress of Civilization*, Thomas Crawford was notified by Captain Montgomery Meigs about another project for the Capitol extension. "I should like to make our principle doors of bronze," Meigs wrote on December 27, 1853, "and see no reason why they should not rival those of Lorenzo Ghiberti in beauty."[1] Meigs left the choice of subject matter entirely to the sculptor, who explained that although "the life of Columbus, the landing of the Pilgrims and their efforts at civilization affords very seductive attractions," he would illustrate events from "our National History" as more appropriate for the building's entrances.[2] Crawford selected scenes from the Revolutionary War and the federal period for the Senate and House portals (figs. 70 and 71). Each set contains ten rectangular panels, following the format of Lorenzo Ghiberti's 1425 *Gates of Paradise* at the Florence baptistery mentioned by Meigs in his letter.[3] The topmost registers consist of grillwork with stars framed by a medallion and foliage. The lowest panels have allegorical subjects that divide the central registers into themes of war and peace, "for in reality," the artist explained, "all that can possibly come under the consideration of Congress must belong to either one or the other of these subjects."[4] The remaining six reliefs represent historical scenes that adhere to the thematic divisions between war and peace established by the lower medallions.[5]

Another American sculptor illustrated the life of Columbus in bronze doors for the Capitol (fig. 72): Randolph Rogers, a New York–born artist who grew up in Ann Arbor, Michigan, studied with Lorenzo Bartolini in Florence in 1848, and then opened a studio in Rome. A neighbor of Crawford while living in Rome, Rogers must have envied his friend's federal commissions. Consequently, while back in the United States in February 1855, he sent photographs of his work to Meigs.[6] The engineer in charge of the Capitol extension responded with praise and one month later invited Rogers to send a sketch for a pair of doors in bronze, asking that he not duplicate Crawford's subject of the Revolutionary War.[7]

Rogers had no trouble acceding to Meigs's request. "There is another subject which to me is quite as appropriate and far more beautiful than the one chosen by Mr. Crawford. It is the life of Columbus. Perhaps there is but one man whose name is more intimately connected with the history of this Country, or who better deserves a lasting monument to his memory than Christopher Columbus."[8] Rogers felt that the life of Columbus would enable him to capture "a variety of character, incident, drapery, and the nude, together with architectural perspective,"[9] and he intended to surpass Crawford's Senate and House doors in

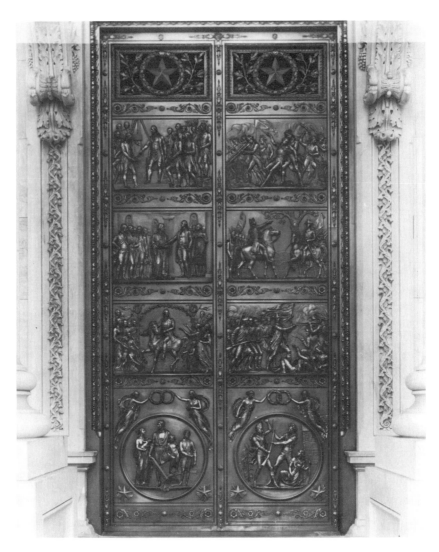

70. Thomas Crawford. Senate doors. 1855–1857. Bronze. 173½ × 88 in. Executed in bronze by William H. Rinehart. U.S. Capitol east facade, Senate. Courtesy of the Architect of the Capitol.

beauty, significance of subject matter, and narrative organization. Rogers signed a contract with the secretary of war on May 24, 1855, for eight thousand dollars, completing the models for his doors by 1858.[10] They were then cast in bronze in Munich in 1860 and installed in 1863 between Statuary Hall and the House extension. Eight years later, in 1871, the doors were moved to the entrance to the Rotunda, a location recommended by Thomas U. Walter even before the doors' completion.[11]

While Rogers worked out his ideas for the commission, Meigs again contacted him and Crawford to solicit another design.[12] "There is room in the new

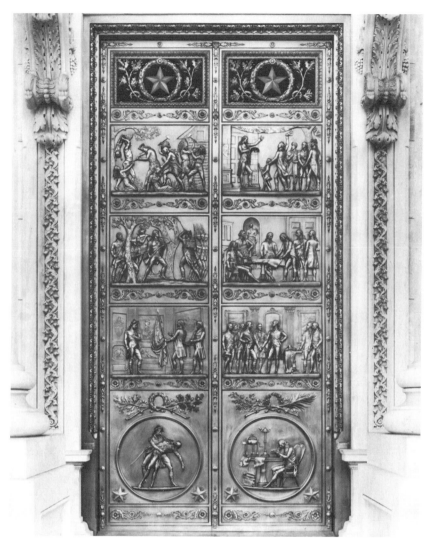

71. Thomas Crawford. House doors. 1855–1857. Bronze. 175 × 88 in. Executed in bronze by
William H. Rinehart. U.S. Capitol east facade, House. Courtesy of the Architect of the Capitol.

Dome for a frieze," Meigs wrote Crawford in May 1855, detailing the complex
series of subjects he wanted illustrated: "In this I have thought of a history of
America showing the traditional migrations of the Aztec, and other races, Co-
lumbus, the Conquest of Mexico by them, theirs by Cortez, Pizzaro, Captain
Smith, settlement of New England, the Quakers, the Puritans, Cavaliers, the
western prairies, Commanches and Buffaloes, Civilization, Lewis and Clarke,
Mexican War, California, etc. etc. etc."[13] Meigs also elaborated on this project in
his annual report to Secretary of War Jefferson Davis: "The gradual progress of a
continent from the depths of barbarism to the height of civilization; the rude and

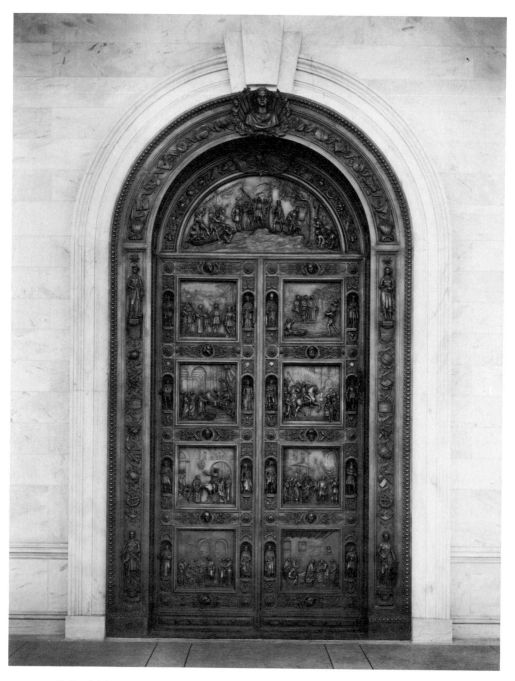

72. Randolph Rogers. Rotunda doors. 1855–1863. Bronze. 200 × 117 in. U.S. Capitol east facade, central portico. Courtesy of the Architect of the Capitol.

barbarous civilization of some of the Ante-Columbian tribes; the contests of the Aztecs with their less civilized predecessors; their own conquest by the Spanish race; the wilder state of the hunter tribes of our own regions; the discovery, settlement, wars, treaties; the gradual advance of the white, and retreat of the red races; our own revolutionary and other struggles, with the illustration of the higher achievements of our present civilization . . ."[14]

These lengthy explanations about the projected subjects for the frieze indicate that Meigs determined to solidify the iconographic program already embodied in the Rotunda murals and reliefs. He planned the sculpture inside the new dome as an American version of the Panhellenic procession in the Parthenon and apparently realized that Rogers's doors, in conjunction with the continuous frieze, would elaborate on the works already in place in the Rotunda.[15] Even more important, Meigs conceived of a complex iconographic narrative that would clarify the messages conveyed in the earlier works; historical events in the New World before the formation of the United States would clearly indicate the triumph of civilization over barbarism and the resultant "retreat of the red races."

Although Crawford intended to work on this new project, he died before executing any designs.[16] It is possible that Meigs never responded to Crawford's interest in the frieze because of the high fee the sculptor demanded—fifty thousand dollars.[17] Moreover, both Meigs and Crawford focused in their letters not only on the Senate pediment but also on the doors for the House and Senate, a statue for the pinnacle of the dome, and the figures above the Senate entrance. And the sculptor may not have had time to work on the design for the Capitol frieze before his death in 1857. By the time Meigs again contacted Rogers about this elaborate frieze, the Arts Commission had been established and Meigs realized that he no longer had the freedom to direct its completion.[18] Instead he asked another artist to execute designs for the work—Constantino Brumidi.

Born in Rome, Brumidi had been trained at the Accademia di San Luca and reportedly had studied sculpture with Canova and Thorwaldsen. He restored one of the frescoes in the Vatican by Raphael and worked for two popes, Gregory XVI and Pius IX, on other projects. Brumidi was arrested for his participation in the Italian revolution in 1849. Upon release, he went for a brief period to Mexico City, where he painted altarpieces, then emigrated to the United States. He first demonstrated his skill in fresco techniques to Meigs and Congress in *Calling of Cincinnatus from the Plow* for the House Agriculture Committee in 1855, which led to his being hired "in the capacity of Historical Artist Painter in real fresco" to decorate other areas in the Capitol extension and dome.[19] Since Brumidi was already employed by the federal government, he could work on Meigs's pet project without interference (in the opinion of the engineer) from the Arts Commission or the Library Committee of Congress, which had to approve all federal commissions.[20]

These two works at the center of the Capitol building—Rogers's bronze doors and Brumidi's frieze—reiterate and expand on the Rotunda reliefs and murals. Not surprisingly, certain subjects are repeated: the landing of Columbus, de Soto at the Mississippi, Pocahontas and John Smith, the landing of the Pil-

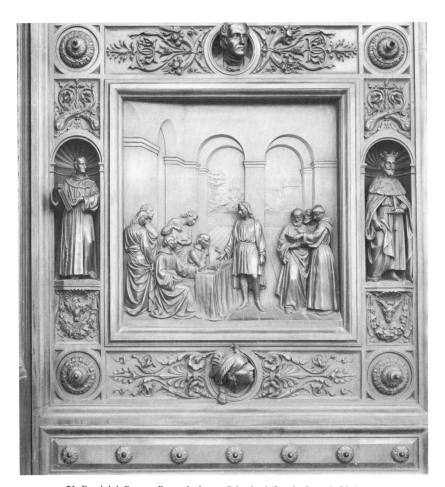

73. Randolph Rogers. Rotunda doors. *Columbus before the Council of Salamanca.*
Courtesy of the Architect of the Capitol.

grims, and Penn's treaty with the Indians. What is different is the time frame in which the artists realized their designs. Both Rogers and Brumidi conceived their elaborate narratives during the second half of the 1850s, when many congressmen advocated America's growth into areas outside its continental boundaries such as Cuba and the Dominican Republic, a "Caribbeanized Manifest Destiny."[21]

### Rogers's Bronze Doors

Instead of reiterating the single episodic image of the discovery of America by John Vanderlyn or Luigi Persico, or the portraits of Columbus by Antonio Capellano and Enrico Causici (works he saw during his visit to the Capitol in May of 1855), Rogers decided to create a sequential historical narrative in which various moments from the explorer's life are rendered in eight rectangular panels. He then

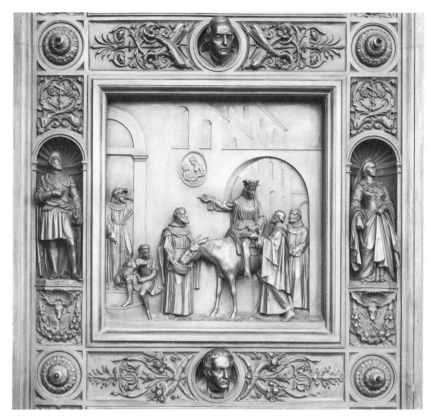

74. Randolph Rogers. Rotunda doors. *Columbus's Departure from the Convent of La Rabida.*
Courtesy of the Architect of the Capitol.

framed these episodic panels with full-length figures (in niches) and heads (in roundels), features that derive from Lorenzo Ghiberti's *Gates of Paradise* at the Florence baptistery (which Meigs declared he wanted rivaled). Departing from the Renaissance work, however, in which the portraits are interspersed between the standing figures, Rogers placed the busts in horizontal frames between the panels. He also replaced the post and lintel format found in the Renaissance prototype with a rounded arch to adhere to the frame of the inside Capitol portal.

It seems that from the outset Rogers decided to correct Thomas Crawford's failure to follow a consistent chronological arrangement; at the same time, he sought a more ambitious and complex arrangement that mixed various ways of telling stories. As in Crawford's Senate and House doors, the historical narratives in the Rotunda entrance are found in rectangular panels with multifigured compositions, spatial architectural and landscape settings, and gestures that convey stories. Rogers, however, followed a strict chronological sequence, beginning at the lower left panel and moving clockwise, upward through the left side, across the lunette at the top, and then down the right side.

The pictorial narration begins in the lower left (fig. 73) with Columbus before

*Rogers's Doors and Brumidi's Frieze*

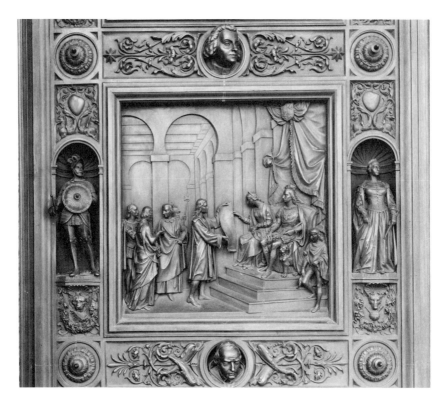

75. Randolph Rogers. Rotunda doors. *Audience at the Court of Ferdinand and Isabella.*
Courtesy of the Architect of the Capitol.

the council of Salamanca in 1487, "displaying his plans and charts and endeavouring to convince that learned body of the possibility of discovering a new world."[22] Columbus stands toward the center of the composition before a group of men appointed by King Ferdinand of Spain to evaluate the Italian's proposal to navigate a western route to India. As Columbus points to a blank scroll (presumably a map), scholars look earnestly at the parchment, while a group of clerics on the right consult an unidentified open text. (The council, incidentally, rejected Columbus's proposal.)

The next scene (fig. 74) shows Columbus embarking on a mule from the Convent of La Rabida to visit the Spanish court. Rogers explained to Meigs that Columbus had stopped at the Franciscan convent "as a mendicant begging bread and water for himself and son. It was here that he became acquainted with Juan Parez [*sic*], the learned friar who had once been confessor to the Queen. Parez, pleased with the conversation of Columbus and struck with the grandieur [*sic*] of his views, immediately wrote to the Queen begging her to reconsider his plans, which she did and ordered him to reappear at court."[23] Framed by an arched doorway, Columbus turns to a monk while pointing in the opposite direction. He is preparing to set out for the court to plead support for his voyage.

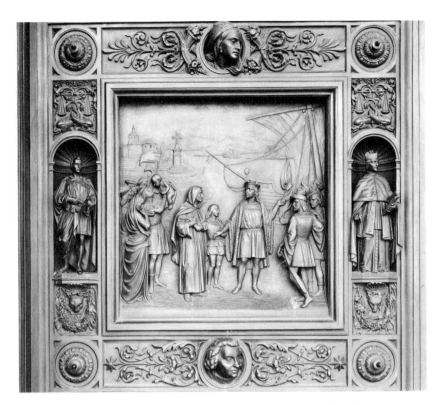

76. Randolph Rogers. Rotunda doors. *Departure of Columbus from Palos.*
Courtesy of the Architect of the Capitol.

Columbus's audience before King Ferdinand and Queen Isabella is depicted in the following relief (fig. 75). Here Columbus presents a map with incised land masses to the Spanish monarchs to explain his theories. The king appears aloof and uninterested, but the queen listens attentively and leans over to study the map. It would seem that Rogers deliberately connected the queen and the future navigator—each touches and frames the centralized map—to indicate Isabella's role as the patron who financed the voyage. The embarkation is represented in the closing panel on the left side (fig. 76). Here Columbus prepares for his departure from Palos. The city on the left and boat on the right, both in low relief, frame the protruding foreground figures. Columbus gestures to his left, the direction of the boat and the ocean, indicating that his journey away from Europe soon will begin.

The relief within the lunette (fig. 77), the largest and most important scene forming a physical and thematic transition between the two valves, represents Columbus's arrival in San Salvador on October 12, 1492, the same subject as in John Vanderlyn's Rotunda painting and Luigi Persico's exterior sculpture. As in the Vanderlyn, Columbus is shown taking possession of the newly discovered island. Standing in the center of the composition, the admiral holds a raised

77. Randolph Rogers. Rotunda doors. *Landing of Columbus*. Courtesy of the Architect of the Capitol.

sword in his right hand and the royal standard in his left. The cross behind Columbus makes it clear that he claims the land not only for his Spanish patrons but also for the Christian world.[24] The cruciform motif is reiterated (from left to right) in the mast and gaff, the two battle-axes held by men on the boat, the battle-ax behind the friar, and the standard held by Columbus.

Another feature that Rogers's relief has in common with Vanderlyn's painting is the tripartite composition. Most of the men on the left are in transition from the ocean to the newly discovered land as they disembark from the boat. The central cluster of Europeans on the island forms a semicircular group around Columbus, while the scantily clothed Indians on the right peek around the tree to observe the new arrivals. As in Vanderlyn's work, the natives are forced to the periphery, locked within the wilderness (for the tree functions as a barrier and establishes a constricted area between itself and the edge of the lunette), while the newly arrived Europeans take possession of the land, inaugurating the marginalization of the New World inhabitants. The Indians can only gaze at, but not participate in, the European activities. The movement from left to right, from ocean to land, and from Europe to the New World further emphasizes the restrictions placed on the Indians as they are pushed into the wilderness by the more numerous and dominant Europeans bringing Christian salvation to the New World.

The left and right sections of the composition, although separated by the land mass, are associated through formal means. The curvilinear pattern of waves in the water is clearly differentiated from the broader and smoother central rock but reiterates the lines in the tree trunks and leaves. The exaggeratedly minuscule size of the vessel suggests that the sailors had to struggle against the vast ocean and its numerous dangers to arrive at their destination. But the wilderness on the right also contains dangers; the woods must be cleared, the elements braved, and the Indians dealt with.

The juxtaposition of the curious newcomer, with his rifle, pike, and dog, and the Arawacks (the two groups are separated by a tree) emphasizes the military superiority of the explorers, who will eventually subdue and expel the indigenous people. One Indian holds a bow without arrows, although quivers full of arrows can be found in the outside frame beyond his reach. Unable to take the necessary weapons from the border outside their space, the Indians are powerless in the face of the powerful conquistadors; their impotence presages the many future defeats of Indian tribes in North America.

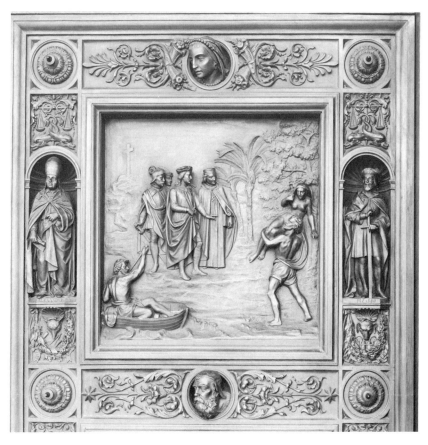

78. Randolph Rogers. Rotunda doors. *Columbus's First Encounter with the Indians.* Courtesy of the Architect of the Capitol.

79. Randolph Rogers. Rotunda doors. *Entry of Columbus into Barcelona.*
Courtesy of the Architect of the Capitol.

Rogers called the subject of the first relief on the right valve (fig. 78) "taking possession of and erecting a cross on the island of Hispaniola."[25] Although the cross is prominent on the hill to the left, the drama of the seven figures suggests a subsequent event: in December 1492, Columbus rebuked a sailor for taking an Indian prisoner. As in Greenough's *Rescue* (see fig. 54), the captivity theme is altered. Here, however, a European man abducts the same Indian woman as is rendered in the lunette's *Landing*. It would seem that Rogers deliberately cast Columbus as a righteous and high-minded Christian. (In doing so, he ignored the fact that Columbus sold many Arawacks into slavery.)[26] Indeed, a palm tree divides the composition between the right wilderness, where the captor and captive are interlocked, and the central, civilized zone, in which Columbus stands under the protection and inspiration of the cross. It is here, under the cross, that Europeans can retain their culture. When the Christian sailor ventured into the wilderness, the vignette suggests, he turned into a barbaric savage.

The next panel (fig. 79) shows Columbus's return to the city of Barcelona in April 1493. Rogers seems to have deliberately echoed the composition of the departure from the convent of La Rabida (see fig. 74), the panel below it and to the left. In both reliefs, Columbus is seated on an animal as he passes through a

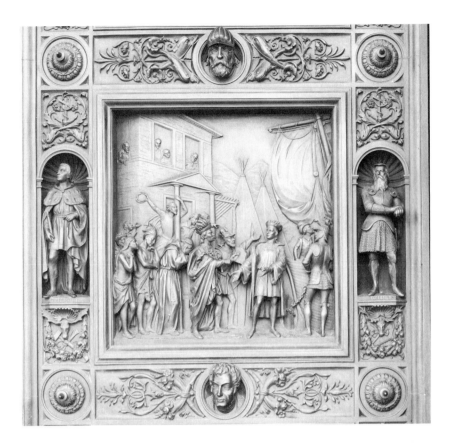

80. Randolph Rogers. Rotunda doors. *Columbus in Chains.* Courtesy of the Architect of the Capitol.

round archway. In the earlier event, Columbus is accompanied by a few Franciscans in an austere setting as he begins his venture on a mule into the unknown. In the later episode, Columbus returns to Spain on horseback in triumph. He is greeted by a crowd who celebrates his arrival, while leading the procession in front of him are New World exotica: two Indians and a parrot. (The Indian squaw's left leg merges with the horse's raised foot; she holds the parrot in her raised arm, thereby suggesting that the Indians and the animals belong to the same kingdom.)

The following relief (fig. 80) represents Columbus's imprisonment. By the end of 1499, forces against Columbus in the Spanish court had prevailed on the monarchs to send Don Francisco de Bobadilla to examine the admiral's conduct. Bobadilla imprisoned Columbus and sent him back to Spain, where eventually he was found innocent and his position and property were reinstated. In this relief, Bobadilla and Columbus face each other while a cleric and two Indians on the left lament the prisoner's fate. The juxtaposition of the building and two tepees in low relief suggests that the two races can coexist, but the permanence of the stone structure and its relative magnitude indicate that the European community will prosper at the expense of the impermanent and movable Indian village.

*Rogers's Doors and Brumidi's Frieze*

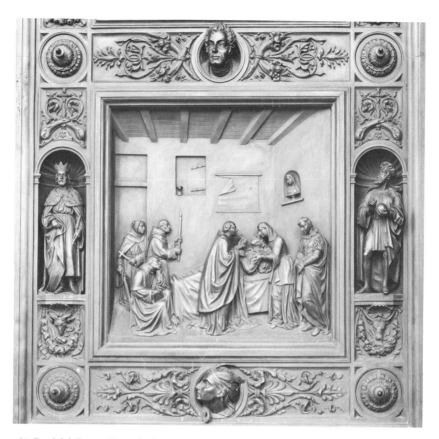

81. Randolph Rogers. Rotunda doors. *Death of Columbus*. Courtesy of the Architect of the Capitol.

The final panel (fig. 81) in the lower right shows a deathbed scene. Columbus died in 1506 after receiving the holy sacrament in a convent. "I would put upon the convent some distinctive mark," Meigs advised Rogers, saying that the setting is ambiguous and could be misinterpreted as "an inn, hotel, or caravanserai. A cross, a madonna and child or something of this kind in the niche would remedy this obscurity."[27] Rogers therefore placed a bust of the Virgin in the niche over the bed. He also depicted on the windowsill an hourglass, emblematic of death, and on the wall a torn map to indicate the passing of Columbus.

Flanking each panel left and right are full-length standing figures in niches, each identified by a name inscribed in the base. From left to right, in order of the panels, are Juan Pérez de Marchena, a Spaniard whom Columbus had met at the convent of La Rabida and who was partially responsible for the support he received from the sovereigns of Spain; Henry VII of England, who refused to finance Columbus's voyage; Hernán Cortés, conqueror of Mexico; Beatrix de Bobadilla, a lady at the Spanish court who took an interest in Columbus's endeavors and was influential in helping convince the queen to support the exploration; Don Alonzo de Ojeda, who joined Columbus on his second voyage, suc-

ceeded in capturing a warlike Carib cacique, and undertook a series of voyages after the death of Columbus; Queen Isabella, Columbus's patron; Amerigo Vespucci, the Italian navigator who sailed with Columbus on the first and second expeditions and later explored the north coast of South America; Pedro González de Mendoza, archbishop of Toledo and future grand cardinal of Spain, who contributed to the decision of the king and queen to support the voyage; the Spanish pope Alexander VI, who proclaimed the line of demarcation between Spanish and Portuguese colonial spheres in the New World; Francisco Pizarro, conqueror of Peru; King Ferdinand, who reluctantly sponsored Columbus's voyages; Vasco Núñez de Balboa, discoverer of the Pacific Ocean; Charles VIII of France, who like the English king refused to finance Columbus's explorations; Bartholomew Columbus, who joined his brother Christopher on his second voyage and governed the colony in Hispaniola in his absence; John II of Portugal, who fostered exploration but refused to assist Columbus; and Martín Alonzo Pinzón, a wealthy mariner whom Columbus met at La Rabida, who commanded the *Pinta*, and was the first to spy land on the first voyage.

Unlike the storytelling panels, these historical portraits are not placed in any particular order. At the council of La Rabida, for example, Columbus met a number of the men and women who are sculpted and placed in the niches, only one of whom (Lady Bobadilla) is situated beside the relief that represents the mariner as he departs from that sanctuary. Similarly, only the queen of Spain is rendered next to the panel in which she and the king listen to Columbus's appeal for support; Ferdinand is depicted on the left of the triumphal entry of Columbus into Barcelona.

The portrait busts in the horizontal frames of the panels do not have inscriptions, although they represent, as Rogers explained to Meigs, "distinguished men of [Columbus's] time who were connected with him, such as Las Casas—Toscanelli—Marco Polo—Diego Men[dez] . . ."[28] The bust between Columbus's departure from La Rabida and the audience at the Spanish court bears the cap and collar of a cleric, probably Bishop Bartolomé de las Casas, a historian who sailed with Columbus on his third voyage and was the first priest to be ordained in the New World. The two faces at the top of each valve are Indian maidens; those at the bottom are Indian chiefs. Three of the portraits represent Diego Méndez, the "*alguacil mayor* of Hispaniola," who saved Columbus's life in Jamaica; Marco Polo, the thirteenth-century Italian who traveled in the Far East; and Paola Toscanelli, "the Florentine philosopher and astronomer who corresponded with Columbus and gave him many very important hints in regard to discoveries."[29] Two others represent Washington Irving and William H. Prescott, nineteenth-century literary historians whose *Life of Columbus* (1828) and *History of the Reign of Ferdinand and Isabella* (1844) formed the basis for the sculptor's visual narrative.[30]

Whereas the doors themselves contain reliefs that represent the realm of history, the border holds symbols, allegories, and a portrait bust, thereby creating a distinction between center and periphery, the concrete and the ideal, and the actual and the abstract. But Rogers's scheme was even larger: "As Columbus was a benefactor of the human race, and as his genius is acknowledged by the whole

82. Antonio Capellano. *Fame and Peace Crowning George Washington.* 1827. Marble. 224 × 60¼ in. Reproduction by George Giannetti made between 1959 and 1960. Original marble figures in storage. U.S. Capitol east facade, central portico. Courtesy of the Library of Congress.

world, I have chosen to place at the corners of the doors four alegorical [*sic*] figures, representing the four quarters of the globe—Europe—Asia—Africa & America—."[31] Although personifications of the first three continents appeared in ancient and medieval art, America did not enter the pantheon until the fifteenth century, when the new land mass was discovered.[32] Rogers provided slanted eyes, jewelry, slippers, an Oriental hat, and generalized drapery for his Asia. Africa is identified by her bare feet, uncovered upper torso, Egyptian headdress and necklace, broad nose, and thick lips. Europe wears a crown and holds a sword (missing in this photograph [fig. 72, lower left] taken prior to the door's restoration in 1988), while America as Liberty has a flipped-over Phrygian cap on her head and holds in her left hand the U.S. shield and in her bent right arm the Constitution.

The largest figurative component in the door located directly beneath the keystone of the arch is a bust of Columbus (see fig. 77), which functions, according to the artist, as "the *grand finale.*"[33] Draped from the neck in a toga, this bust has undrilled eyes, symmetrical features, and a frontal visage that echo the characteristics of apotheosis found in two Capitol portraits of George Washington: Horatio Greenough's marble statue (see fig. 34) and Antonio Capellano's *Fame and Peace Crowning George Washington* (fig. 82). The composition and bust in Capellano's relief, located directly above Rogers's door, derive from ancient Roman sarcophagi in which frontal and static portraits of the deceased within a medallion are held aloft by putti.[34] It is tempting to suggest that Rogers, who visited the Capitol to study the future site of his work, emulated Capellano's bust in his rendition of Columbus. Indeed, the two busts—the larger, white granite image of Washington situated directly above the shiny, bronze image of Columbus—connect the discovery of the continent and the founding of the nation, as previously discussed with Greenough's *Washington* (see chapter 3). It must be remembered, however, that Rogers's door initially decorated the inside of the Capitol extension rather than the Rotunda door. Instead of deliberately mirroring Capellano's work, Rogers must have consulted similar sources for his

bust of Columbus, emulating the ancient Roman coffin portraits that Capellano had studied or else the late antique busts that had inspired Horatio Greenough's image of George Washington.

Rogers added other symbols to underscore the meaning of the bust. He initially had planned to frame Columbus with a figure on the left representing fame, "blowing a trumpet and about to crown him with laurels," and on the right a figure "bearing . . . the palm of victory."[35] But the sculptor instead framed the head with oak and laurel leaves on the left and right of an enclosing scallop. This scallop motif, found in early Christian sarcophagi as enclosures for portraits, symbolizes immortality, while the laurel traditionally refers to eternity and triumph. It seems that Rogers intended the viewer to move, then, from the last narrative relief, Columbus's death, to the centralized bust in which Columbus is symbolically resurrected as the "benefactor of the human race" and forefather of the United States—suggested by the eagle located directly beneath the Columbus portrait. Rogers also included dolphins above the four niches beneath the lunette, and anchors along the outside frame, both symbols of resurrection and salvation. The oak traditionally alludes to the conversion of pagans and hence echoes the cruciform shapes in the *Landing of Columbus*, located just below the bust.

The outside arch that frames the narrative panels and the area surrounding the eagle (with banners in its talons) are filled with open helmets, burgonets, shields, breastplates, rifles, gauntlets, and battle-axes—what Rogers calls "emblems of conquest." Mixed with them are tools of navigation: a globe, a telescope, a pair of compasses, and anchors. Rogers probably intended to create an arch of triumph through the display of military and explorational images. Trophies of victory had decorated Roman and Napoleonic arches; thus Rogers altered the post and lintel construction found in the Ghiberti and Crawford doors into an arch to adhere to the space inside the legislative building and to evoke the idea of triumph.

Interspersed throughout the frames of the panels, the door, and the lunette are additional objects in which "different species of deer . . . with festoons of flowers falling from the horns" clasp in their mouths various emblems.[36] Rogers had written Meigs that he intended to display "horns of plenty, and . . . emblems of the arts—sciences—history—astronomy—agriculture—commerce . . ."[37] Motifs in the frame that fit this scheme are fruit and cornucopia (agriculture), a caduceus (medicine), a plow and shovel (agriculture), a globe and eye glass (astronomy), a violin and harp (music), a palette and brushes (painting), a mallet (sculpture), and a quill and book (literature, poetry, or history).

The program of the door thus celebrates Columbus as the person who brought Christianity and civilization to the New World and triumphed over adversaries, including Native Americans and those who refused to support his endeavor. Like nineteenth-century pioneers, Columbus preservered—despite many setbacks—in opening and exploring new lands.

Constantino Brumidi also conveys a sequential narrative in his frieze—not from the life of one man, but instead from the history of the New World's "higher achievements of . . . civilization" that encompassed both North and South America. For the most part, images of discovery and settlement in the Capitol Rotunda allude to North America, although Horatio Greenough had included the struggles for freedom of various South American nations in his relief of Hercules and Iphikles on the side of the Washington throne (see fig. 47). Rogers also had preceded Brumidi in referring to other New World histories in his full-length historical figures like Cortés, Vespucci, and Pizarro. Recall that when Meigs first contacted Crawford about the new frieze in the dome, among the subjects he mentioned were the conquest of Mexico (Cortés) and the conquest of the Inca empire (Pizarro). It is possible, then, that Meigs had written Rogers about these themes (although no such letter survives) or discussed the subjects with him when the American expatriate visited the capital city. Moreover, Crawford may have relayed Meigs's ideas for the frieze to his friend Rogers. Brumidi, on the other hand, lived in Washington and hence probably learned firsthand about the engineer's ideas. Certainly, the Italian painter, who had spent time in Mexico City, would have felt comfortable with these subjects.

Brumidi executed sketches (a roll more than thirty feet long) for the grisaille frieze in 1859. He did not begin their execution, however, until 1877, owing to the Civil War, his involvement with other frescoes in the Capitol, and difficulties in getting funds. Brumidi died in 1880 before completing the cycle. (He fell from a scaffold while working on the dome fresco.) Filippo Costaggini took over, realizing Brumidi's designs by 1888 but leaving an empty space of more than thirty-two feet, which Allyn Cox filled between 1950 and 1953. Brumidi's cycle shows the beginning of America from Columbus's arrival in the New World through the discovery of gold in California. Cox added three subsequent events: the Civil War, the Spanish-American War, and the first flight of the Wright brothers.

Like Rogers's doors, in which the narrative is separated into panels, Brumidi's sketch and fresco are broken, this time by landscape and architectural markers. Nevertheless, figures often gesture into and turn their bodies toward the next scene, allowing a continuous development of the narrative, with the figures placed against a flat background in emulation of relief sculpture. The frieze begins (fig. 83) with an allegorical figure of America holding the U.S. shield in her left hand and a spear in her right. Wearing the flipped-over liberty cap and accompanied by an eagle, Brumidi's America as Liberty has affinities with Crawford's central pedimental figure in his *Progress of Civilization* in the Senate pediment (see fig. 62). Entitled *America and History*, the sketch includes a seated woman on America's right who holds a book and looks upward. This is History, and she is recording the events in the New World that unfold, almost like a scroll, in the subsequent scenes. (Brumidi added a seated, bare-breasted Indian maiden when he painted the fresco twelve years after the close of the Civil War.)

Extending out of this multifigured allegorical scene (and issuing forth without

83. Constantino Brumidi. Rotunda frieze. Sketch for *America and History* and
*Landing of Columbus.* 1859. Ink and gouache on paper. $27\frac{1}{2} \times 12\frac{3}{4}$ in. Courtesy of the
Architect of the Capitol. Donated by Myrtle Cheney Murdock, 1961.

interruption) is a historical event, the landing of Columbus, which represents the
inauguration of American history. Here Columbus stands triumphant on a plank
as he descends from a boat crowded with his comrades. Looking upward, arms
outstretched, presumably in homage to providential guidance, Columbus echoes
with slight modifications the pose, size, and frontality of America; thus the man
and allegorical woman are connected as symbols of the New World. As in other
images of the landing—Vanderlyn's Rotunda mural (see fig. 26), Persico's stair-
case group (see fig. 53), and Rogers's sculpted lunette (see fig. 77)—the native
population is portrayed as a group of cowering figures who look in surprise, fear,
and awe at the newcomer. They form a triangular mass that angles away from the
dominant figure of Columbus, whose forward motion initiates their retreat. The
curvilinear bow of the ship frames and seems to imprison the native inhabitants to
foreshadow "the final extermination of the aborigines."[38] In the completed work,
significantly, the bow forms a straight line that separates but does not enclose the
Indian group, and Columbus stands in a more static pose, which eliminates the
sense that his arrival causes their withdrawal. The stridency of the admiral's pose
in the sketch adheres to the expansionist rhetoric espoused in Congress during
the 1850s. (The cruciform halberd added to the composition provides a Christo-
logical reference found in the other Rotunda discovery images, suggesting that
the explorer brings Christianity to the heathens of the New World.)

In *Cortéz and Montezuma at the Mexican Temple* (fig. 84), Brumidi depicts the
Spanish explorer's entry into the Great Temple (Motecuhzoma) in 1519, which
preceded Montezuma's arrest and murder. According to a report on the com-
pleted fresco in the *New York Herald*, Cortéz turns away "in disgust from the
offering of human hearts before a Mexican idol."[39] In the moment he becomes
aware of the ritual heart sacrifice, he decides to establish Christianity among the

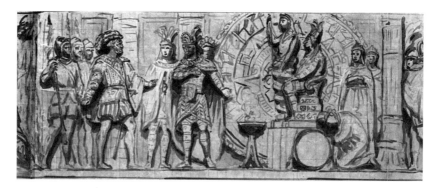

84. Constantino Brumidi. Rotunda frieze. Sketch for *Cortéz and Montezuma at the Mexican Temple*. 1859. Ink and gouache on paper. 20⅛ × 12¾ in. Courtesy of the Architect of the Capitol. Donated by Myrtle Cheney Murdock, 1961.

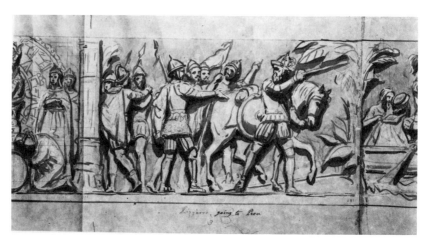

85. Constantino Brumidi. Rotunda frieze. Sketch for *Pizarro Going to Peru*. 1859. Ink and gouache on paper. 15 × 12¾ in. Courtesy of the Architect of the Capitol. Donated by Myrtle Cheney Murdock, 1961.

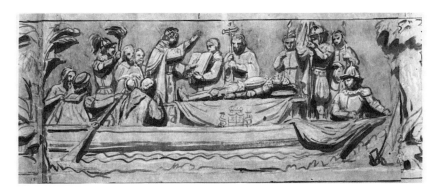

86. Constantino Brumidi. Rotunda frieze. Sketch for *De Soto's Burial in the Mississippi River.*
1859. Ink and gouache on paper. $22\frac{7}{8} \times 12\frac{3}{4}$ in. Courtesy of the Architect of the Capitol.
Donated by Myrtle Cheney Murdock, 1961.

infidels as an excuse to justify Spanish conquest, and that decision results in the establishment of the first European city in the New World. The artist incorporated various Aztec objects—such as the so-called Calendar Stone or Stone of the Sun, which was set outside in the base of the western tower of the cathedral of Mexico City, an object he would have seen while living there—and included two statues of gods on plinths, probably Tlaloc, the rain god, and Huitzilopochtli, the Aztec god of tribal war (in winged headdress).[40]

The subsequent scene, *Pizarro Going to Peru* (fig. 85), similarly alludes to a South American conquest that predates North American settlement. After having discovered the Pacific Ocean in 1513 and settling in Panama, Pizarro proceeded to conquer the Inca empire through the support of Charles I of Spain. Instead of showing a battle scene between the natives and the Europeans, Brumidi depicts the Spanish explorer standing before his horse with a sword in his right hand as he urges his men on.

With *De Soto's Burial in the Mississippi River* (fig. 86), the last scene of Spanish colonial conquest, Brumidi moves north and in doing so inaugurates the history of territory that will be part of the United States. De Soto had been a compatriot of Pizarro in the defeat of the Incas, then had led his own expedition through the southern regions of North America to the Midwest in search of another vast empire. After having discovered the Mississippi River in 1541 (the subject of Powell's Rotunda mural; see fig. 27), the Spanish explorer traveled further west into Oklahoma and northern Texas, turning back in the spring of 1542. De Soto died that same year, after having returned to the Mississippi River, and his men cast his body into the water to prevent the natives from desecrating it. In Brumidi's sketch, the dead man is laid out on a bier in a pose that emulates the deceased Christ; indeed, the cross held by one man and the benediction of

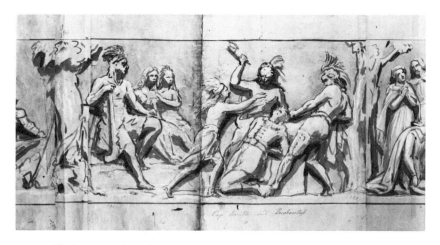

87. Constantino Brumidi. Rotunda frieze. Sketch for *Captain Smith and Pocahontas.*
1859. Ink and gouache on paper. 15½ × 12¾ in. Courtesy of the Architect of the Capitol.
Donated by Myrtle Cheney Murdock, 1961.

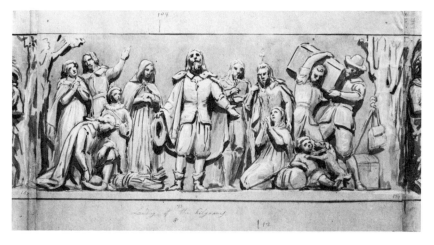

88. Constantino Brumidi. Rotunda frieze. Sketch for *Landing of the Pilgrims.*
1859. Ink and gouache on paper. 21⅜ × 12¾ in. Courtesy of the Architect of the
Capitol. Donated by Myrtle Cheney Murdock, 1961.

the priest who reads the open Bible all attest to the Christological overtones of
the scene in which De Soto is commemorated as a Christian martyr whose
hardships paved the way for the future settlement of the continent.

The next five scenes show events from the early English settlement of the
United States, some of which are found elsewhere in the Rotunda: *Captain Smith
and Pocahontas* (fig. 87), in which the rescue by the Indian princess found in
Antonio Capellano's relief is reiterated; *Landing of the Pilgrims* (fig. 88), a more

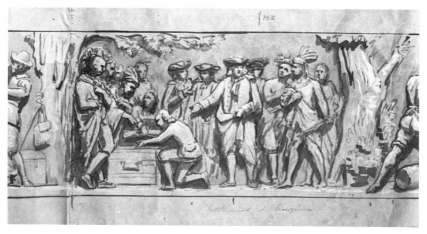

89. Constantino Brumidi. Rotunda frieze. Sketch for *Settlement of Pennsylvania*.
1859. Ink and gouache on paper. 16¼ × 12¾ in. Courtesy of the Architect of the Capitol.
Donated by Myrtle Cheney Murdock, 1961.

90. Constantino Brumidi. Rotunda frieze. Sketch for *Colonization of New England*.
1859. Ink and gouache on paper. 22½ × 12¾ in. Courtesy of the Architect of the Capitol.
Donated by Myrtle Cheney Murdock, 1961.

crowded scene than Enrico Causici's sculpted rendition and one in which the praying English men and women thank God for their safe arrival; *Settlement of Pennsylvania* (fig. 89), repeating the subject of Nicholas Gevelot's *Penn's Treaty*; *Colonization of New England* (fig. 90), a new subject in the Rotunda pantheon, in which settlers struggle against the wilderness to build a community; and *Oglethorpe and Muscagee Chief* (fig. 91), another new subject, celebrating the founding of Georgia. Here General James Oglethorpe, who had first arrived on

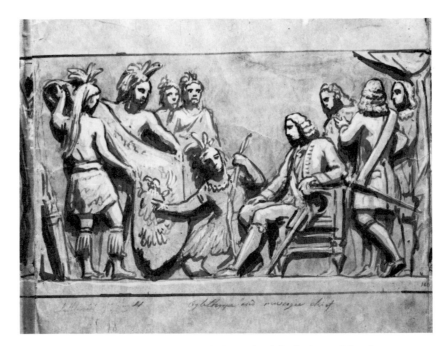

91. Constantino Brumidi. Rotunda frieze. Sketch for *Settlement of Georgia: Oglethorpe and Muscagee Chief.* 1859. Ink and gouache on paper. 15¾ × 12¾ in. Courtesy of the Architect of the Capitol. Donated by Myrtle Cheney Murdock, 1961.

92. Constantino Brumidi. Rotunda frieze. Sketch for *Lexington.* 1859. Ink and gouache on paper. 22¾ × 12¾ in. Courtesy of the Architect of the Capitol. Donated by Myrtle Cheney Murdock, 1961.

Yamacraw Bluff (Savannah) in 1732, is visited by a group of Indians who cede their lands to the colonists of the southern frontier.[41] Once again an eagle, drawn on a blanket that the natives present, presages the future existence of the United States.[42]

With the establishment of the last colony in America, the way is paved for events that would directly lead to the formation of the United States: *Lexington* (fig. 92) and *Declaration of Independence* (fig. 93). The latter subject reiterates Trumbull's painted mural, although the moment rendered is not the signing but the reading of the document. The Lexington battle, which initiated the Revolutionary War, can also be found in Crawford's House bronze doors (there all the soldiers are standing). In the Italian's rendition, the domination of the central American cavalryman on horseback suggests victory.

Brumidi's next subject, *Decatur at Tripoli* (fig. 94), shows an event of 1804 from the Tripolitan War when Stephen Decatur destroyed the frigate *Philadelphia*, which had been captured by the enemy. Costaggini replaced this event with an earlier incident from the Revolutionary War when he finished the fresco: *Surrender of Cornwallis at Yorktown*, a subject also found in one of Trumbull's Rotunda paintings. It is possible that the artist or the Architect of the Capitol, Edward Clark, realized by the 1880s that the war with Tripoli over the demands for tribute by pirates of the Barbary States had failed to capture the attention of the American public, and that a scene from that war would break the thematic continuity of Brumidi's narrative, which deals with the discovery, formation, and exploration of the New World.

93. Constantino Brumidi. Rotunda frieze. Sketch for *Declaration of Independence*.
1859. Ink and gouache on paper. $9\frac{1}{2} \times 12\frac{3}{4}$ in. Courtesy of the Architect of the Capitol.
Donated by Myrtle Cheney Murdock, 1961.

94. Constantino Brumidi. Rotunda frieze. Sketch for *Decatur at Tripoli.* 1859.
Ink and gouache on paper. 9¾ × 12¾ in. Courtesy of the Architect of the Capitol.
Donated by Myrtle Cheney Murdock, 1961.

In *Colonel Johnson and Tecumseh* (fig. 95), Brumidi includes a rare scene of conflict between the Native Americans and the colonists. When Indians are rendered in earlier episodes, they either watch in amazement while Europeans take over their land (as in *Landing of Columbus*) or they amenably sign peace treaties and forfeit their property (as in *Settlement of Pennsylvania* and *Oglethorpe and Muscagee Chief*). Only one earlier scene shows conflict, *Captain Smith and Pocahontas*, in which two Powhatans seize the Englishman at the command of their seated chieftain in preparation for his death, which the Indian princess prevents. As in Capellano's relief, Pocahontas's peaceful entreaties assuage her kinsmen's violence.

*Colonel Johnson and Tecumseh* shows a much later event (1813) when an American soldier, Richard Mentor Johnson, succeeded in defeating the Shawnee chief, who had earlier organized a tribal confederation to defer Anglo-Saxon settlement. Tecumseh had joined the British in the War of 1812, becoming a brigadier general, and subsequently died in the Battle of the Thames in October 1813. The chief's death resulted in the Indians' withdrawal from the war and the demise of their confederacy, ending a major obstacle to white colonization. In Brumidi's sketch, the American cavalrymen tower over the defeated and cowering natives, making it clear that the white man easily triumphs. This is less evident in the painted fresco, in which Johnson's horse seems to be falling and an Indian with a tomahawk (on the left) stands over a kneeling and frightened settler. It appears that Brumidi initially felt compelled to show that the Native Americans fell to Johnson and his comrades without much struggle, probably because conflicts between the two races during the period of expansion still flared. It was only later, when the Indians indeed appeared to be vanquished and safely isolated on reservations, that the artist felt he could dramatize the earlier struggles.

*The American Army Going in the City of Mexico* (fig. 96) and *A Laborer in the Employ of Captain Sutter* (fig. 97) close Brumidi's cycle by showing recent events in the nation's successful move into the West and the Southwest. In the Mexican

95. Constantino Brumidi. Rotunda frieze. Sketch for *Colonel Johnson and Tecumseh*. 1859. Ink and gouache on paper. 13¾ × 12¾ in. Courtesy of the Architect of the Capitol. Donated by Myrtle Cheney Murdock, 1961.

96. Constantino Brumidi. Rotunda frieze. Sketch for *The American Army Going in the City of Mexico*. 1859. Ink and gouache on paper. 17¼ × 12¾ in. Courtesy of the Architect of the Capitol. Donated by Myrtle Cheney Murdock, 1961.

War scene, instead of depicting a battle or acknowledging the vast casualties suffered by the Americans in the controversial War, Brumidi has the enemy surrender without resistance to General Scott and his troops (represented by an upright row of rifles and hats). The final episode shows the discovery of gold in 1848 by James W. Marshall while at work building a sawmill for Johann Augustus Sutter—the start of the California Gold Rush.

### Caribbeanized Manifest Destiny

For nineteenth-century romantic historians such as George Bancroft, Francis Parkman, Washington Irving, and William H. Prescott, history consisted of an unfolding of a divine plan for progress to proceed westward from Europe through South America to North America, where civilization prospered with the formation of a new nation.[43] Rogers read Irving's *Life of Columbus* and Prescott's *History of Ferdinand and Isabella*, and it is possible that Brumidi and Meigs consulted these books as well as Prescott's *History of the Conquest of Mexico* (1843) and *History of the Conquest of Peru* (1847). Hence it is not surprising that Brumidi and Rogers included Mexico and Peru in the Capitol program. But the addition of the Spanish conquest to the Capitol pantheon also reflects the congressional debate during the 1850s over whether the nation should expand into Cuba and Central America.

As early as 1848, President James K. Polk had attempted to purchase Cuba, a bid repeated by President Franklin Pierce in 1854 and 1859. These Democratic

presidents, along with their successor, James Buchanan, worked toward establishing a physical link between North and South America in Mexico (at Tehuantepec), Panama, and Nicaragua.[44] At the same time, American filibusters attempted to take over Cuba for the United States, while other adventurers moved into Central America. Most notable was William Walker, a former journalist from Tennessee who attempted to establish a republic in Lower California and participated in a civil war in Nicaragua, where he became dictator for about ten months in 1856 and 1857.[45]

After 1850, the earlier division between Whigs, who generally opposed American expansion, and Democrats, who generally favored it, became sectionalized. Southerners especially advocated movement into Central America and Cuba as a means to maintain sectional balance after their failure (with the passage of the Kansas-Nebraska Act in 1854) to make Kansas a slave state, but some northerners also supported American expansion into these regions. Among the southern promoters of the hegemony of the U.S. in the tropics was Jefferson Davis, President Pierce's secretary of war, who endorsed Pierce's attempt to purchase Cuba in 1854 and supported Walker's Nicaraguan government.[46] Earlier, in the Senate, Davis had championed the Mexican War and had advocated the acquisition of the entire nation of Mexico through what he termed "title of conquest."[47] Later, as secretary of war and again as senator, he supported various filibustering efforts by Walker in Nicaragua and by the Cuban Narciso Lopez and the Mississippian John A. Quitman in Cuba, and he encouraged the official purchase of the island from Spain, writing in 1855 that "the acquisition of Cuba is essential to our prosperity and security."[48] Besides advocating the purchase of that island from Spain, he also promoted the annexation of Central America through "a system of colonization."[49]

97. Constantino Brumidi. Rotunda frieze. Sketch for *A Laborer in the Employ of Captain Sutter.* 1859. Ink and gouache on paper. $23\frac{1}{2} \times 12\frac{3}{4}$ in. Courtesy of the Architect of the Capitol. Donated by Myrtle Cheney Murdock, 1961.

Although Davis and other southerners supported the acquisition of Cuba for slaveholders, they nevertheless also believed in the nation's manifest destiny to spread democracy to unenlightened lands. As Davis exhorted in the House on behalf of sole U.S. possession of Oregon, "the immigration of U.S. citizens into the Oregon territory is the onward progress of our people towards the Pacific, which alone can arrest their westward march."[50] Furthermore, many Americans viewed Spain as a nation in decline and felt that Cuba, its sole possession in the New World, should be relinquished to allow for civilization's continued progress. As one person declared in 1853, "Spain, poor old Spain, who once covered the surface of the great deep with her Armada, once the seat of pomp and power and grandeur, finds herself stripped of all her jewels, save one, which nought but '*family*' pride prevents her parting with. Our destiny is onwards."[51] The Ostend Manifesto of 1854 expressed similar sentiments, proclaiming that "Cuba is as necessary to the North American republic as any of its present members, and . . . it belongs naturally to that great family of states of which the Union is the Providential Nursery."[52]

Both Rogers's bronze doors and Brumidi's frieze include the history of the Spanish conquest in the New World as steps that led to the fulfillment of the destiny of the North American continent. Certainly Meigs must have had this in mind when he suggested his ideas for the decoration in the dome to Crawford, but he also liked Rogers's selection of subject matter, in which Columbus is shown, in his assessment, as "the instrument by which this Western Empire was begun."[53] He must have realized the implications of these works in relation to contemporary efforts to move into Central America and Cuba, and to his superior's strident advocacy of the acquisition of Cuba and support for Walker's Nicaraguan regime. In fact, the promotion in both works of the southern agenda for spreading U.S. democracy into the Caribbean reveals Jefferson Davis's success in influencing the iconography of the Capitol extension artworks.

## Part Three

*The Politics of Exclusions*

# 7

## *Ethnographic Exclusions*

The Native American is a prominent motif in the mid-nineteenth-century Capitol decoration. Literature and the visual arts in this period were answering the call that began in the 1820s for a distinctive American culture. To a country newly aware of its uniqueness, strength, and nationhood, James Fenimore Cooper's mythologizing of the American frontier as the site of racial war in his best-selling Leatherstocking novels seemed to fill the perceived vacuum of national fiction, as did the forty novels published between 1824 and 1834 that included Indian episodes.[1] To a country in search of a past separate from Europe, the North American Indians—like the untamed wilderness—seemed a fitting subject for the arts. It validated the distinctive cultural heritage of the United States and ironically, as Carolyn Karcher has observed, enabled a particular identity to arise through the exploitation of the very race that was being extinguished.[2]

But the call for a national art form does not explain fully why the Indian appears in so many works in the Capitol building—the Rotunda paintings and reliefs, the exterior staircase groups, the Senate pediment, the Rotunda bronze doors, the frieze in the dome, and the Washington monument. In these paintings and statues, Indians are relegated to shadows and borders, to circumstances of less power than Europeans and settlers, and to positions that augur their diminishment and disappearance. This marginalization adheres to white America's attitudes and the federal government's official policies toward the native population.

As Brian Dippie has demonstrated, the myth of the Vanishing American had fully entered the consciousness of white citizens by the close of the War of 1812. The myth corresponded to reality, for many tribes had indeed been decimated by disease, interracial and intraracial warfare, and liquor.[3] All this seemed to corroborate white America's conviction that the interaction between the two races contributed to the indigenous people's demise. According to this belief, the Indians had forfeited whatever innate good qualities they possessed and, regrettably, had acquired the whites' worst habits. George Catlin's double portrait, *Pigeon's Egg Head Going to and Returning from Washington* (fig. 98; 1837–1839), parodied this situation: the brave, dignified, and proud chieftain enters the capital city dressed in his tribal uniform, only to return to his people as a pompous dandy in high-heeled boots and a colonel's uniform with white gloves, smoking a cigar and holding a fan and parasol. In this double portrait of Wi-Jun-Jon, Catlin wished to show the gulf that he believed existed between Native American culture and white civilization,[4] and he correctly identified liquor as one cause of the Indian's diminished status, placing whiskey bottles in the Assiniboin's back pockets. As Jedidiah Morse, a representative of the Northern Missionary Society

98. George Catlin. *Pigeon's Egg Head (The Light) Going to and Returning from Washington.*
1837–1839. Oil on canvas. 29 × 24 in. Courtesy of the National Museum of American Art,
Smithsonian Institution. Gift of Mrs. Joseph Harrison, Jr.

of New York and father of Samuel F. B. Morse, reported in his 1822 recommendations for federal Indian policy to the secretary of war, "Except when intoxicated, they are not vociferous, noisy, or quarrelsome, in their common intercourse, but mild and obliging."[5] The white man's liquor poisoned the Indian's way of life, implied Morse, and resulted in drunken stupors, increased laziness, and troublesome behavior. The *Niles' Weekly Register* concurred, declaring that the Indians suffer "a daily depreciation" through their association with whites. "By mixing with us, they imbibe all our vices, without emulating our virtues— and our intercourse with them is decisively disadvantageous to them."[6]

Already in the 1820s, when the Rotunda reliefs were created, many Americans believed the Indians would become extinct because of disease, warfare, and the influence of the transplanted European culture. William Cullen Bryant's 1824 poem "An Indian at the Burying-Place of His Fathers" summarized white assumptions. Taking on the persona of an Indian, Bryant eulogized the passing away of the tribal societies:

> They waste use—aye—like April snow
>   In the warm noon, we shrink away;
> And fast they follow, as we go
>   Towards the setting day,—
> Till they shall fill the land, and we
>   Are driven into the western sea.[7]

An Independence Day address given in 1825, the year Causici carved his *Landing of the Pilgrims* in the Capitol wall, also summarized the beliefs of white America. In his speech, Charles Sprague identified the arrival of "the pilgrim bark" as the cause of the eventual blotting "forever" from the continent of "a whole particular people." The Boston banker and amateur poet concluded, "As a race [the Indians] have withered from the land. . . . They are shrinking before the mighty tide which is pressing them away; they must soon hear the roar of the last wave, which will settle over them forever." The European invasion of the Atlantic seaboard constituted "the mighty tide" of "civilization" to which the native race would succumb.[8]

Later, in the 1840s, when the United States engaged in its aggressive annexation of western lands, the *Southern Literary Messenger* published a poem, "The Lament of the Last of the Tribes," that connected the pilgrim's arrival with the more recent emigration across "Oregon's plain" and the "Rocky Mountain's chain," which led to the Indians' "Sinking, wearied, in their grave, / By the blue Pacific's wave!" In a foreword, the author of the poem proclaimed, "the tribes of the red men will doubtless wither and fade away, as if by some resistless ordinance of nature."[9]

The elegiac myth of the disappearing race, which denoted the Indian as "part of the past, futilely resisting progress in the present, doomed to extinction in the near future," is found not only in poetry and literature but also in books by nineteenth-century historians.[10] Francis Parkman, for example, explained in the preface to *The Conspiracy of Pontiac* (1851) that he wanted to rescue from oblivion the events detailed in his book especially because the Indians "were destined to melt and vanish before the advancing waves of Anglo-American power, which now rolled westward unchecked and unopposed."[11] This romantic, New England historian contributed to the image of Indians as beasts and devils who must be displaced by a more civilized race.[12]

Within this context, policymakers employed the myth of the Vanishing American in their discourses promoting the Indian removal policy. "Humanity has often wept over the fate of the aborigines in this country," observed Andrew Jackson, victor of the Creek War at Horse Shoe Bend, in his second annual

message in 1830. "Its progress has never for a moment been arrested, and one by one have many powerful tribes disappeared from the earth." This advocate of the Indian removal acknowledged that "to tread on the graves of extinct nations excite[s] melancholic reflections." But in Jackson's paternalistic thinking, the Indian removal policy, like the race wars in which he participated, resulted from the natural state of things: one culture must die for the other's survival. The Indian Removal Act thereby enforced the dispossession and segregation of "his children," as Jackson called the Indians (at other times he referred to them as "savage bloodhounds"), in order to protect them from further damage and enable whites to own and cultivate land.[13]

John Elliott, a member of the Committee on Indian Affairs, who during the Senate's debate over the Indian removal bill identified the contest as being between "civilized" people and "savage infidels," employed similar reasoning. Making an analogy between "the ceaseless encroachments of the ocean" upon the sand and the effects of white civilization on the Indians, "who have been gradually wasting away before the current of the white population," the senator from Georgia argued that unless the tribes were "speedily removed . . . a remnant will not long be found to point you to the graves of their ancestors, or to relate the sad story of their misfortunes!"[14] Both Jackson and Elliott provided moral justification for U.S. mistreatment of the Indian, disguising their metaphysics of genocide as philosophical reflections.

Statesmen used similar arguments in their support of land acquisition during the 1840s. Missouri senator Thomas Hart Benton, for example, an expansionist, spoke in 1846 on behalf of annexing Oregon, asserting that he could not feel bad about "what seems to be the effect of divine law." In this case, divine law dictated that the Capitol building replace wigwams, that Christian people replace "savages," and that great statesmen like Washington, Franklin, and Jefferson replace Powhatan, Opechancanough, and "other red men." Benton concluded, "Civilization or extinction, has been the fate of all people who have found themselves in the track of the advancing Whites, and civilization . . . has been pressed as an object, while extinction has followed as a consequence of resistance."[15]

Civilization and extinction seemed to be the only choices available to the native population according to such men as Jefferson, Jackson, and Benton. Of course, civilization meant assimilation and thus the abandonment of the rich and varied tribal heritage and traditions. Whether the Native Americans followed the example of Pocahontas and became civilized through assimilation, or fought against white encroachment on their land like the warriors in the *Boone* relief, they would eventually disappear from North America. As Davis lamented in his melodramatic 1817 novel about Pocahontas, "The race of Indians have been destroyed by the inroads of the whites!" Indiana legislator Robert Dale Owen also wrote a fictionalized account of Pocahontas's life. In the introduction to his *Pocahontas: A Historical Drama* he noted, "The story of my heroine . . . is intimately connected with the very first successful effort to colonize Northern America from Europe, a marked epoch in our history. It is connected, too, with the fates of a noble race, which is fast fading away from the earth."[16]

The pervasiveness of white America's belief in the ultimate demise of the Indian race is manifest not only in poetry, fiction, drama, and the rhetoric of statesmen, but also in art magazines and among artists. The *Crayon*, for example, proclaimed in 1856, "It should be held in dutiful remembrance that [the Indian] is fast passing away from the face of the earth," and concluded that artists have a duty to record "his habits and appearance" for posterity.[17] This statement, written twenty-six years after the enactment of Indian removal and three years after the establishment of the reservation system, makes it clear that white Americans believed that their "safekeeping" efforts could at best only lessen the pace of cultural genocide.

Not surprisingly, the Indians depicted in the national legislative building correspond to white America's assumptions and adhere to two mythic stereotypes found in antebellum literature and art: the unremitting savage who poses such a threat that he must be vanquished, and the abject creature who will vanish.[18] Both the fearsome and the timorous Indians would nevertheless become extinct. Whether the noble savage, whose innate virtues motivate good acts—the offering of corn to the new immigrants in Causici's *Landing of the Pilgrims* and the agreement of the Delawares to surrender control over extensive acreage in Gevelot's *Penn's Treaty* and Brumidi's *Settlement of Pennsylvania*—or the ignoble savage of Capellano's *Preservation of Captain Smith*, Causici's *Boone's Conflict*, and Brumidi's *Colonel Johnson and Tecumseh*, who symbolizes savagery, heathenism, and wilderness, these Indians are destined (the compositions suggest) to disappear into the shadows of history.[19]

Yet another work in the Capitol that represents an archetypal image of the soon-to-be-extinct noble Indian is William H. Rinehart's 1858 House of Representatives clock (fig. 99).[20] The Indian and the pioneer who frame the clock strike almost identical poses: both are men with muscular physiques and stand on one leg with the other crossed, holding a weapon and looking down. Only the clothing, weapons, and hair distinguish the two figures, but the fact that the man on the right is an Indian, indicated by his buffalo hide robe (worn like a Roman toga), bare feet, shaven head, bow, and roche (the adornment on his head), adds significance to his downcast, meditative pose. The pioneer leans against a rifle, a weapon superior to the Indian's bow, and holds in his taut left fist a knife ready for attack. The Native American, by contrast, stands with his slackened hand resting against the bow; the absence of an arrow to go with the bow indicates that the Indian meditates in repose. Clearly, Rinehart intended to convey the same idea as found in Thomas Crawford's Indian chief in the Senate pediment (see fig. 64), where the Native American ponders his people's inevitable demise.

The noble savage, seen as living in a virtuous state of primeval innocence, often appeared in the visual arts in the guise of an ancient Greek god. Best embodied in Benjamin West's supposed identification of the Apollo Belvedere as a Mohawk warrior, this typology codified the noble savage as an athletic man with bulging muscles and perfect proportions.[21] Crawford's lamenting chief, for example, displays the muscular physiognomy, proportions, and pose of the Hellenistic Torso Belvedere by Apollonios of Athens.[22] Similarly, Rinehart's Indian

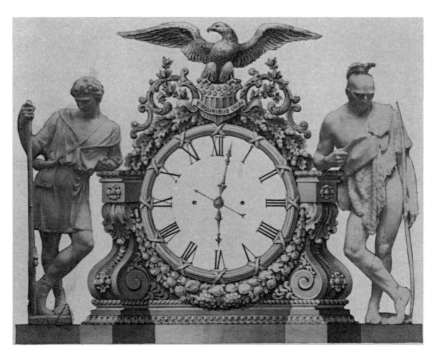

99. William H. Rinehart. Design for clock for the Hall of Representatives. 1858.
Photograph of a drawing by Montgomery C. Meigs and Thomas U. Walter. $18\frac{1}{2} \times 23\frac{3}{4}$ in.
Courtesy of the Architect of the Capitol.

evolves from the classical Doryphorus, although the leg positions and lowered head depart from this ancient prototype. Greenough's Indian in his Washington monument (see fig. 45), on the other hand, conflates the ancient philosopher type and the more athletic and idealized proportions of the Doryphorus. In each of these statues, the figure becomes Indianized through the clothing and head-dresses and Americanized through its codified meaning.

The literary writers of the nineteenth century used terms borrowed from the fine arts in their evocation of the threatening barbarian and the vanquished and vanishing children of nature. In *Hobomok* (1824), for example, the reformer and abolitionist Lydia Maria Child distinguished between the benign "tall, athletic" Hobomok, who represented "one of the finest specimens of elastic vigorous elegance of proportion," and the "dark, lowering looking savage," Corbitant, Hobomok's enemy.[23] In James Fenimore Cooper's *Last of the Mohicans* (1826), Magua is a fierce man with an "expression of ferocious joy," who as "the Prince of Darkness" prepares evil plots, exults in victory over a defeated enemy, and captures innocent women. On the other hand, Uncas, described by blond-haired Alice as "some precious relic of the Grecian chisel," appears to Hayward as "an unblemished specimen of the noblest proportions of man."[24]

Although by the 1850s Indians in general and the type of the noble savage in particular had run their course,[25] the stereotypical image of the Indian as a

vanishing race to be pitied and censured had achieved its best known and perhaps most successful form in Crawford's marble chief in the Senate pediment.[26] This is clearly the doomed noble savage, who realizes, like Chingachgook in Cooper's *The Pioneers*, that his people will no longer inhabit the land because of the inevitable progress of civilization. He acquiesces without a fight, expressing nobility, sadness, and honor while evoking sympathy for the plight of him and his family.

Besides the noble and ignoble Vanishing American that prevailed in nineteenth-century American literature, visual arts, and rhetoric, there was yet a third, seemingly ethnographic Indian who is not evident in the Capitol decoration. That the omission of this type was not accidental is clear from the cases of three artists—George Catlin, Seth Eastman, and John Mix Stanley—who attempted to sell their works to the federal government (only Eastman succeeded). These artist-naturalists traveled throughout the western frontier in order to capture on canvas the first Americans in their untainted environments. They documented for posterity the traditions, clothing, likenesses, and rituals of what they perceived as a doomed race, making slight adjustments to appeal to white urban audiences.[27] But these works failed to promote the same ideas as those found inside the Capitol building. And statesmen succeeded in suppressing this third type because it failed to promote racial conflict and the promise of white hegemony.

### George Catlin's Indian Gallery

Vanderlyn, Greenough, and Crawford all went to Italy to study ancient art. They probably never saw an Indian, relying on stock images and ethnographic books for their models. George Catlin, on the other hand, wanted to explore the American wilderness in the Great Plains in search of the native people, who afforded, in his opinion, models equal to those in Greek sculpture. He shared the white conviction that "whiskey and its concomitant vices" corrupted the bewildered natives but felt motivated to document for posterity those who "are yet unroused and unenticed from their wild haunts or their primitive modes, by the dread or love of white man and his allurements."[28]

Cooper's Leatherstocking tales may have influenced Catlin to abandon his career as a portrait painter of miniatures in Philadelphia and dedicate himself to recording Native Americans in their pristine homelands.[29] Certainly his awareness of a delegation of Plains Indians in Philadelphia in 1824 contributed to his decision. Catlin made his first trip into the frontier in 1830 through the financial support of a New York publisher, Colonel William F. Stone, who himself became a historian of Indians through his biographies of Joseph Brant and Red Jacket.[30] During the next seven years, Catlin explored the wilderness between the Mississippi and the Rockies, making sketches and oils of the native people he observed. From 1837 to 1852, Catlin exhibited this "Indian Gallery"—a collection of artifacts, more than four hundred paintings, and thousands of sketches—which opened to large audiences both in this country and abroad.

Catlin departed from the norm in presenting the Indians as having their own culture and in ignoring the stereotypes that prevailed in American literature and

100. George Catlin. *Black Hawk, a Prominent Sauk Chief.* 1832. Oil on canvas. 29 × 24 in. Courtesy of the National Museum of American Art, Smithsonian Institution. Gift of Mrs. Joseph Harrison, Jr.

101. George Catlin. *Osceola, the Black Drink, a Warrior of Great Distinction.* 1838. Oil on canvas. 30⅞ × 25⅞ in. Courtesy of the National Museum of American Art, Smithsonian Institution. Gift of Mrs. Joseph Harrison, Jr.

art.[31] He believed that the Indians would serve as "models equal to those from which the Grecian sculptors transferred to the marble" and consequently imposed classical ideals on the proportions, physiques, and poses of his figures.[32] Instead of representing the typology of the Vanishing American found in Greenough's Washington monument and Crawford's Senate pediment, however, Catlin painted full-length or bust portraits of what he called "these knights of the forest"[33] dressed in their tribal clothing and surrounded by indigenous accoutrements. He often portrayed them with painted faces and bodies, jewelry, and costumes to enhance their exotic appeal to urban audiences in the East and in Europe. He also depicted various rituals and customs, such as the buffalo hunt or the then-controversial Mandan O-Kee-Pa rite of passage, which Catlin recorded in four paintings in 1832. Probably most telling are his portraits of the imprisoned Black Hawk (1832; fig. 100) and Osceola (1838; fig. 101), both of whom led unsuccessful attempts to resist the forced removal of their tribes. What Catlin presents in his renderings of these militant chiefs are images of aloof yet proud and saddened men who do not differ in demeanor or expression from their unfettered counterparts whom Catlin observed in their tribal homelands. The artist does not emphasize that the leader of the Seminoles, Osceola, is defeated and imprisoned, nor that he is a dying man. Instead, the chief is portrayed in his prime.[34] The Black Hawk leader, on the other hand, seems to resemble Catlin's other images of Indian chiefs in being dignified, but the dead bird of prey (a black hawk) held in the chief's arms metaphorically emphasizes his confinement and

impending death. Catlin nevertheless fails to show why white Americans responded in "a sort of terror" to Black Hawk, for Catlin saw this Sauk as a distinguished speaker and counselor rather than as a bloodthirsty menace who had to be subdued.[35]

The artworks themselves, in combination with the artifacts that Catlin collected, document the culture, customs, clothing, rituals, and likenesses of forty-eight tribes. His works vary between two types. *Osceola* and *Ju-ah-kis-gaw, Woman with Her Child in a Cradle* (1835; National Museum of American Art) show portraits of figures who are sculpturally defined with distinct contours that separate them from the background. *The Last Race, Mandan O-kee-pa Ceremony* (1832; fig. 102) and *Bird's Eye View of the Mandan Village* (1835–1839; National Museum of American Art), on the other hand, are panoramic views of rituals in which a number of small figures are painted with daubs of loosely applied pigment. Whether portraits or ritual scenes, Catlin's paintings depict actual people (often embellished via costumes and paraphernalia) as "stain[s] on a painter's palette" so that they could emerge, as Catlin explained, "phoenix-like . . . and live again upon canvass and stand forth for centuries yet to come, the living monuments of a noble race."[36]

102. George Catlin. *The Last Race, Mandan O-kee-pa Ceremony.* 1832. Oil on canvas. 23⅜ × 26⅛ in. Courtesy of the National Museum of American Art, Smithsonian Institution. Gift of Mrs. Joseph Harrison, Jr.

*Ethnographic Exclusions*

The impetus for the artist's career as a chronicler of Native American life derived from the whites' conviction that the first Americans would eventually become extinct. Although Catlin's paintings and drawings do not by themselves perpetuate the myth, the reason for the existence of the works evolves from that myth.[37] As Catlin stated, he wanted to be a "historian" of "the noble races of red men . . . melting away at the approach of civilization" who were "'*doomed*' and must perish" because their "rights [had been] invaded, their morals corrupted, their lands wrested from them, their customs changed, and therefore lost to the world; and they at last sunk into the earth, and the ploughshare turn[s] the sod over their graves."[38]

Catlin looked to Native Americans for his subject matter not only out of a paternalistic wish to leave a record of lost cultures. Business, too, provided a major motive. In dedicating himself to the preservation of the manners and customs of the North American Indians, as art historian William H. Truettner has observed, Catlin removed himself from the stiff competition among portrait painters in the United States (calling portrait painting a "limited and slavish branch of the arts") and worked instead in the more academically privileged field of history painting—but with a twist.[39] Instead of depicting historical events from mainstream Western culture, be it scenes from the Bible, classical antiquity, or U.S. history, Catlin followed the lead of American literature in emphasizing the wilderness environment when he decided to focus on an aspect of the nation's past and present that distinguished it from Europe. He became a history painter in a new tradition, turning to "these lords of the forest," as he called the Indians. As a traveling artist-naturalist in the tradition of the Philadelphia scientific community still dominated by the Peale family, he collected, classified, and recorded the Native Americans in their original environment.[40] He also realized that his pictures of soon-to-be-extinct tribes such as the Mandans would eventually become profitable as the only vestiges of a people who once had inhabited North America. Catlin's father noted that although his son "mourns the dreadful destiny of the indian tribes by the small pox," the "shocking calamity will greatly increase the value of his enterprize & his works."[41]

Catlin thus turned to the Native American for his subject matter in part because he believed he could establish his reputation and make a good living. Yet financial difficulties, which loomed throughout the artist's life, led to his numerous abortive efforts over a period of forty-five years to secure the federal government as his patron. In this, Catlin was influenced by the example set by Charles Bird King, whose portraits of Indians had been commissioned by Thomas L. McKenney, superintendent of the Indian Trade Bureau (1816–1822) and head of the Bureau of Indian Affairs (1824–1830), to decorate his office. Catlin probably thought his collection could supplement McKenney's "archives," as the agent called his collection,[42] and hence petitioned the federal government for the first time, between 1837 and 1840, for a commission. Again in the mid-1840s, in 1852, and in 1869, Catlin lobbied for a commission, as did his family (after the artist's death) in 1872 and 1873.[43]

The reasons why Catlin could not garner a commission are manifold. Al-

though secretaries of war John C. Calhoun and James Barbour supported Mc-Kenney's purchases, Congress considered such expenditures frivolous and hence ceased the appropriations following McKenney's removal from office in 1830.[44] Catlin probably made a mistake in his asking price, even though he lowered the cost of his collection from sixty-five thousand to twenty-five thousand dollars. The artist-traveler expected more money than Congress had paid for the four Rotunda paintings executed in the 1840s and 1850s, which cost less together (forty thousand dollars) than Catlin's initial asking price.[45] The divergence between Catlin's perceived historical accuracies, sympathetic renditions, and heroic yet generally non-idealized images, on the one hand, and the codified noble and ignoble savages found in the Capitol building, on the other, also may have contributed to Congress's failure to act decisively in acquiring the collection—even though at one point, in 1846, William Campbell from the Joint Committee on the Library had suggested that the House bill for the establishment of the Smithsonian Institution be amended to provide for the purchase of Catlin's gallery.[46] In other words, while considering acquiring these ethnographically sympathetic records, Congress did not necessarily envision the works' placement in the Capitol building, where they would have clashed with the more acceptable stereotypical conceptions found in the Rotunda paintings and sculptures.

At the same time, Catlin failed to get the backing of a single government official. No procedures existed for federal patronage until the Capitol extension, at which time Meigs could commission artists for frescoes and sculptures attached to the walls, while Congress controlled the purchase of free-standing statues and framed canvases.[47] As a result, various congressmen submitted resolutions that directed different committees (an issue of debate throughout) to acquire Catlin's collection, beginning on May 28, 1838, when George Nixon Briggs, a Whig from Massachusetts, introduced a resolution in the House ordering the Committee on the Library to consider acquiring Catlin's Indian portraits. During the next session, Briggs moved in the House a second resolution for the purchase of Catlin's collection. It was referred to the Committee on Indian Affairs, which reported unanimously in favor of the proposal, but again Congress took no action. A third resolution, similar to the second but directed to the Committee on the Library, died in the House in 1840.[48]

Because of the failure of Congress to act on acquiring his works, Catlin sailed to Europe on November 25, 1839, four months before this last abortive attempt in Congress to purchase his collection. He went to England and then France, hoping to find a patron abroad. At the same time, Catlin calculated that a trans-Atlantic reputation might get Congress to reverse its decision. The artist later capitalized on the threat of finding a European patron, petitioning Congress in 1846 to purchase his collection of "Indian portraits and curiosities" and garnering testimonials from American artists in Paris, London, and the United States.[49] Even Lewis Cass—governor of the Michigan Territory from 1813 to 1831, secretary of war under Andrew Jackson, self-proclaimed expert on the subject of the North American Indians, and, in 1846, Democratic senator from Michigan—supported Catlin's case, arguing that the natives "are receding before the advanc-

ing tide of our population, and are probably destined, at no distant day, wholly to disappear; but [Catlin's] collection will preserve them . . . and will form the most perfect monument of an extinguished race that the world has ever seen."[50] The Joint Committee on the Library reiterated Cass's sentiments, noting that the collection would serve "as a monument to a race once sole proprietors of this country, but who will have yielded it up, and with it probably their existence also, to civilized man."[51] Despite these arguments, which drew on the myth of the Vanishing American, Congress failed to act, perhaps because its attention focused on the recent outbreak of war with Mexico.[52]

In the following session of Congress, Senator John M. Clayton of Delaware attempted to convince Congress to purchase Catlin's Indian gallery, claiming that it would probably be the last opportunity to perpetuate "the lineaments of these aborigines."[53] James D. Westcott, Jr., of Florida, however, opposed the amendment, objecting to Catlin's representation of "savages," who had killed numerous citizens during the Seminole War in his state, and explaining that he would prefer portraits of the white citizens whom the Indians had ruthlessly murdered.[54] The Senate voted against the amendment. Although the Committee on the Library recommended again in 1848 that the government purchase Catlin's collection, by a narrow margin of four votes Congress rejected the proposal despite the committee's argument that "the advance of civilization, even so far as it does not immediately involve the disappearance and extinction of the Indian races, effaces the existence, and before long the memory, of all that was most distinctive in their character and habits; our children will know nothing of those once numerous families of men except by means of what we of this age may rescue from the wreck and preserve for their instruction."[55]

During the next year, the House and Senate once again considered the issue. Daniel Webster made an impassioned plea that his colleagues purchase what belongs "to our history, to the race whose lands we till, and over whose obscure graves and bones we tread everyday." He asserted that these pictures, like those in the Rotunda, illustrate American history and hence should be preserved by Congress.[56] Henry S. Foote of Mississippi concurred, contending that since "the Federal Government . . . controls" the Indians, it is in the national interest and honor to purchase the collection as "testimonials of the peculiar characteristics of the people to whom we act the part of parent."[57] In 1852, Catlin's imprisonment for debt in London spurred on his supporters, who argued that the artist might be forced to sell his collection abroad.[58] Despite such appeals to patriotic sentiments that the nation should own this uniquely American collection, the Senate tabled the bill by only six votes.[59]

Catlin's frenetic attempt to avert financial ruin in 1852 failed in part because of the slavery question in new territories, which fractured political parties during a presidential election year, contributing to the vote against the resolution along sectional and party lines.[60] Catlin himself interpreted Congress's failure to purchase his Indian collection earlier, in the 1830s, as part of what he considered the Jackson administration's conspiracy against the Indians, which removed "all the southern tribes of Indians west of the Mississippi River, that their two hundred

and fifty millions of rich cotton lands might be covered with slave labourers." He argued in his 1867 publication, *Last Rambles*, that successive administrations continued to link slavery and Indian removal and that the extension of slavery fueled southern opposition to Indian rights. Catlin derived this last conclusion from his interpretation of Jefferson Davis's explanation in 1849 that although he applauded the artist's accurate records of the "wild man of the forest," he opposed federal patronage of the arts for such a vast collection, which would require "a gallery, an Institution for fine arts." Republican simplicity required fiscal restraint, argued Davis; hence his regretful vote against congressional acquisition of the Catlin gallery.[61]

Instead of supporting his friend, with whom he had traveled in the spring of 1834 to Indian territory, Davis, later as the secretary of war, approved Brumidi's few images of Native Americans that he painted in fresco on the walls of the Capitol extension. In room H-144, formerly used by the Committee on Agriculture and in which Constantino Brumidi first demonstrated his abilities as a fresco painter, allegories flank grisaille medallions of Washington and Jefferson, while fruit and putti surround these cartouches. The women beside the bust of the first president represent America (fig. 103); the one on the left wears classical drapery and holds an American flag, and the one of the right wears similar drapery although her right shoulder is bare. This figure also has a leopard skin belt, holds a bow in her left hand and a quiver full of arrows in her right, and wears an Indian headdress. These details—headdress, bow, arrow, and animal skin belt—identify the woman as an Indian princess, a typical personification of the American continent.[62] She does not represent a generic Native American but instead the United States, as is made clear through her red, white, and blue feathered headdress.

103. Constantino Brumidi. 1855–1856.
Fresco. U.S. Capitol, Room H-144, formerly the
Committee on Agriculture Room. Courtesy of the
Architect of the Capitol.

104. Constantino Brumidi. *America.* 1871.
Fresco. U.S. Capitol, Room S-127, formerly the
Senate Naval Appropriations Committee Room.
Courtesy of the Architect of the Capitol.

Room S-127, formerly the Senate Naval Appropriations Committee Room, also contains a personification of America as an Indian princess (fig. 104). Here she wears a beige deerskin dress with a red and blue design; in her headdress are three feathers, one white, one blue, and one red, and the blue headband holds white stars. The Native American has lost her own identity in these personifications. All indigenous objects are appropriated as American symbols; Indian history and culture are sifted out, leaving only objects that the United States could claim as its own identifying features. Obviously, Davis and Meigs preferred these works over what they perceived as ethnographically correct representations in Catlin's collection and those by Eastman and Stanley, who also hoped for federal patronage.[63]

Nevertheless, two fairly accurate portraits of Indian chiefs were commissioned and completed during this period for the Senate Indian Committee room. *Aysh-Ke-Bah-Ke-Ko-Zhay* (fig. 105) and *Beeshekee* (fig. 106), by the Italian artist Francis Vincenti, represent two Pillager Chippewas who went to Washington to sign treaties with the commissioner of Indian affairs, forfeiting lands in Wisconsin and Minnesota and agreeing to move onto reservations. These two busts slipped through congressional opposition to ethnographic Indian renditions because Meigs asked Vincenti to render the two busts in preparation for his work in carving Crawford's pediment. Consequently, Meigs did not view these busts as works of art in their own right but as models for Crawford's more negative Indian renditions.[64]

105. Francis Vincenti. *Aysh-Ke-Bah-Ke-Ko-Zhay*. 1858. Marble. 24 in. U.S. Capitol, Senate wing, third floor, east corridor. Courtesy of the Architect of the Capitol.

106. Francis Vincenti. *Beeshekee*. 1854. Marble. 33 in. U.S. Capitol, Senate wing, third floor, east corridor. Courtesy of the Architect of the Capitol.

Jefferson Davis's remarks about Catlin's works in the Senate in 1849 closed debate on William Lewis Dayton's amendment to the civil and diplomatic appropriation bill, which called for the purchase of Catlin's collection for fifty thousand dollars. The Mississippi senator did not stand alone in his opposition, however, although Catlin was incorrect in believing that all southerners opposed the bill. Henry S. Foote, for example, a democrat from Mississippi, joined John M. Berrien, a Whig from Georgia, in acknowledging the government's culpability in the rapid disappearance of the Indian "from the face of the earth"; but instead of advocating that the Indian people themselves be saved, they argued that the federal government had an obligation to perpetuate their memory through works of art. Robert M. T. Hunter, on the other hand, a States' Rights Whig from Virginia, joined the Democrat Davis in arguing against national patronage of the arts.[65]

Solon Borland, a Democrat from Arkansas, concurred with some of his southern colleagues in promoting fiscal restraint. But he felt that Congress could both record the vanishing race and save money by purchasing at a lower price a "more extensive" collection, that of Seth Eastman, a captain in the army and "a very distinguished artist," who was furnishing illustrations for Henry R. Schoolcraft's *Historical and Statistical Information Respecting the History, Condition, and Prospects of the Indian Tribes of the United States* (1851–1857).[66] Again in June and July 1852, Borland championed Seth Eastman, "whose knowledge of Indian character, and familiarity with scenes among the Indians," qualified him to provide reasonably priced works to adorn the Capitol.[67] James Cooper of Pennsylvania immediately countered that Catlin's paintings of "chiefs and braves of those tribes who were once lords of the soil, and who have almost entirely disappeared from the world," rank him as a superior artist and an "original in this field." He recommended that Congress purchase works not only by Catlin but also by Eastman and another Indian memorialist, John Mix Stanley. In Senator Cooper's opinion, the records made by these three artists should be placed in the "halls which are about to be erected for the deliberations of future Congresses" (the Capitol extension) so that "posterity may see the faces of the race of men that occupied this soil when it was a wilderness, and previous to their time."[68]

Seth Eastman's oil paintings, watercolors, and pencil sketches of the Chippewas and Sioux especially appealed to Borland, a states' rights advocate, because the collection would not cost the government any money; Eastman had executed the works while serving as an army officer.[69] Trained as a topographical draftsman in the U.S. Military Academy, this "American soldier-artist of the wilderness" served for seven years as the assistant teacher of drawing at West Point under Robert Weir.[70] Eastman then spent one year in Florida before returning to Fort Snelling, Minnesota, where he had earlier served, and where he returned to perform diplomatic services with the frontier Indians. (He supervised the removal of the Winnebagos and Sioux at Wabasha's Prairie in June 1848.) During his tenure at Fort Snelling, Eastman also learned a number of Dakota languages

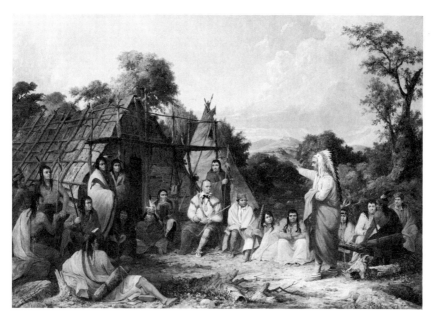

107. Seth Eastman. *Indian Council.* 1868. Oil on canvas. 31 × 44 in. Formerly in the U.S. Capitol, now in the Longworth House Office Building. Courtesy of the Architect of the Capitol.

and devoted his free time to sketching Chippewa and Sioux activities, completing by 1846 more than four hundred oils, watercolors, and drawings. After a brief time in Texas, he moved to Washington, D.C., in 1850 to work on his illustrations of maps, Indian weapons, musical instruments, tools, clothing, artifacts, and tribal rituals for Schoolcraft's ethnographic study of the natives commissioned by the Office of Indian Affairs through the authorization of Congress. These lithographic prints derived from Eastman's earlier works executed while he was at Fort Snelling. Eastman also created some new compositions and made copies of other artists' renditions.[71]

Despite the efforts of some congressmen to purchase works by the soldier-artist, especially during Catlin's imprisonment in Great Britain, Brigadier General Eastman finally received a commission in 1867 to decorate the House Indian Affairs Committee room in the Capitol with nine paintings and in 1870 to execute seventeen paintings of U.S. military forts for the House Committee on Military Affairs.[72] The works Eastman produced for the first of these commissions were based on watercolors and engravings he had made for Schoolcraft's book between 1850 and 1855 (within the period I am considering), and they contain renderings of Native Americans. Eastman's images combine fairly accurate accounts of Indian domestic, religious, and hunting life evident in his genre scenes—*Buffalo Chase* (1868), *Indian Council* (1868; fig. 107), and *Indian Woman Dressing a Deer Skin* (n.d.)—with one stereotypical image, *Death Whoop* (1868; fig. 108), in which an ignoble savage cries out in victory after murdering his white opponent. The

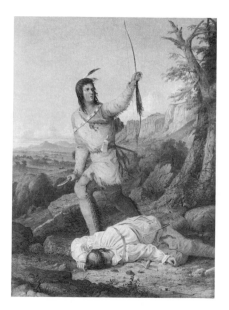

108. Seth Eastman. *Death Whoop.* 1868.
Oil on canvas. 38½ × 28 in. Formerly
in the U.S. Capitol and the Longworth
House Office Building, now in storage.
Courtesy of the Architect of the Capitol.

dead man, with his bald head, an arrow protruding from his side, and his haphazard pose, contrasts with the triumphant Indian, who holds a bow and scalp in his raised left hand and a knife in his right. (This painting, like Greenough's *Rescue*, was quietly removed in 1951 and put back into place in 1953, then removed again in 1987, because people objected to its offensive racism.)[73]

On July 20, 1852, while the Senate considered the purchase of Catlin's Indian gallery, Jeremiah Clemens of Alabama submitted a testimonial from Eastman on behalf of New York artist John Mix Stanley, who had spent three years between 1842 and 1845 recording likenesses of the Creeks, Cherokees, Choctaws, Chickasaws, and Seminoles, tribes removed to portions of Oklahoma and Texas. Eastman thought that Stanley's Indian pictures currently on exhibit in the Smithsonian Institution were superior to Catlin's.[74] Five months later, John B. Weller, a Democrat from California, submitted a memorial by Stanley in which the artist offered his Indian gallery of forty-two tribes, who had lived "in their greatest purity and originality, because least modified by intercourse with the conquerors of their land" in the Indian territory west of the Mississippi. "He has beheld them silently retreating or melting away from before the face of civilization, like the exhalations from the sunlight," Stanley wrote about himself in the memorial, "and he conceived the ambition of illustrating their fading history by the pencil and the canvas." Because "destiny and our immeasurable superiority have made us lords of the magnificent country which was once their own,"

Stanley reasoned, "justice to their memory demand[s] of us that we assign to them a niche in its history" by capturing their likenesses in paint and pencil on the U.S. Capitol walls. Stanley expressed his hope that chiefs would occasionally visit the capital city and view his images of departed men so that they may realize "the paternal attachment of the Government for their race."[75]

Isaac Pigeon Walker, a Democrat from Wisconsin, reported an amendment on March 3, 1853, on behalf of the Committee on Indian Affairs, proposing the purchase of Stanley's gallery for a little over nineteen thousand dollars. Although James Cooper, the Pennsylvania Whig who had supported Catlin's gallery the previous July, urged on behalf of the Committee on Indian Affairs that the Senate vote in favor of purchasing Stanley's portraits of Indian chiefs, "most of whom are now dead"; the Senate voted against the amendment, twenty-seven to fourteen.[76] The voting followed sectional rather than party lines, although Whigs tended to support federal patronage more than Democrats did, with southerners consistently opposing congressional involvement in the arts.[77]

Stanley petitioned Congress two more times, in 1856 and again in 1863, in an attempt to sell his collection to Congress.[78] The final memorial, which Stanley submitted in the midst of the Civil War, contained the same statement he had presented eleven years earlier. This time, however, the artist also submitted declarations by various Indian experts attesting to the accuracy of his likenesses and the significance of the collection. Thomas L. McKenney, former head of the Office of Indian Affairs, patron of Charles Bird King's Indian paintings, and coauthor of a book on North American Indian tribes (1836–1844), verified the authenticity of the lifelike portraits and costumes and stated with a sense of urgency that Stanley's collection constituted "the last and best offering" of a race whose "destiny . . . is sealed." They would "soon be lost to our sight forever," McKenney concluded, implying that Stanley's paintings and drawings in the Capitol would at least keep their images in white Americans' sight and memory.[79]

One newspaper applauded that the "children of the forest . . . will not wholly die" because Stanley had "arrested and fixed" the "vanishing forms" of the Indians on canvas.[80] Unfortunately, in 1865, fire almost entirely destroyed Stanley's Indian collection, which had been in storage in the Smithsonian Institution since 1852. The calamity demolished all but five of Stanley's 152 Indian portraits and scenes of Indian life.

The ruin of Stanley's works must have seemed a blow to the artist, who had tried to keep the Indians alive through his renderings. Not to be deterred by his loss, Stanley once again tried to get a commission in 1865, submitting a petition signed by about ninety citizens asking Congress to have him create "two or more historic scenes commemorative of the Indian race and of our relations to that race."[81] The Committee on the Library drafted a joint resolution that called for commissioning a picture from Stanley for one of the grand staircases in the Capitol "illustrative of some scene in the history of the intercourse of our race with the aborigines of the country."[82]

This resolution, preserved in the National Archives, was never printed or even considered by Congress, which became preoccupied with Reconstruction

after the Civil War. The preamble that preceded it, however, expressed white America's convictions concerning the reasons for the Indian's disappearance from the continent. It was imperative to preserve on canvas "the most perfect representations and records of that race and of our relations to its tribes and people in attestation of our compassion for them in their impracticable resistance to the advancement of the white race, and in their suicidal repugnance to the light of civilization—as well as of our unwearying humane and fostering policy toward them."[83] The Indian resistance to civilization, in short, resulted in their destruction despite the government's "humane and fostering policy."

George Catlin, Seth Eastman, and John Mix Stanley each attempted, with little or no success, to immortalize the Indians they observed on the frontier in artworks on the Capitol walls. The curators and specialists in the natural history section of the Smithsonian Institution today are devoted to the ethnographic and anthropological study of the first Americans. The Smithsonian houses the kinds of objects that Catlin and Stanley included in their exhibitions and preserves paintings and photographs that record Native Americans, as well as their ceremonies and way of life. The Capitol building, on the other hand, contains numerous stereotypical images that present the negative attitudes of nineteenth-century white Americans toward the Indians.

The taking down of Greenough's *Rescue*, Persico's *Discovery of America*, and Eastman's *Death Whoop* indicates that some twentieth-century congressmen realized the derogatory implications of these works. But instead of removing the art and thereby erasing a part of history from the Capitol, Americans should see these objects in their original settings and understand how they embodied and promoted an ideology that fostered the continued relocation of Indian tribes. It is important also to understand that the contrasting images of good and bad Indians proved useful to policymakers and others who wished to exploit Native Americans for their resources. If the stereotype of Indian goodness suggested that the first Americans could be controlled by whites to enable settlement, conversion, and exploitation, that of Indian malevolence and savagery allowed whites to rationalize military conquest as the only means to get the natives to adopt civilized manners. It should not be surprising, then, that these two images prevail in the Capitol decoration.

# *Liberty, Justice, and Slavery*

Almost twenty feet in height, the colossal bronze *Statue of Freedom*, by Thomas Crawford (1863; fig. 109), stands atop the Capitol and dominates the city of Washington. It competes for attention only with the Washington Monument at the opposite end of the Mall. The obelisk serves as an abstract symbol of the founding father and represents the rule of one man, the president, whereas the Capitol and its pinnacle, Crawford's *Freedom*, refer to republican democracy and the rule of the people.[1]

Yet this symbol of freedom contains contradictions. Freedom obviously did not apply to black slaves until 1863, nor did equal rights apply to the disen-franchised Native Americans, African Americans, and women. Justice is also a prominent allegory and is, like the allegories of freedom, located in conspicuous places in the Capitol, often in the same room as the more prolific images of Native Americans that are usually stereotypical noble or ignoble savages destined to become extinct and who, like blacks and women, could not vote. African Americans, on the other hand, are mostly absent from the building's artistic program prior to the Civil War.

Why is the Indian such a prevalent subject in the mid-century Capitol deco-ration whereas other peoples, most notably those of African descent, are almost entirely missing? Artists as diverse as Eastman Johnson, William Sidney Mount, Edmonia Lewis, and John Rogers made African Americans the subject of their art.[2] Why, then, are such subjects not found in the paintings and sculpture of the Capitol? Why did the government condone Indian stereotypes but not black stereotypes in the Capitol decoration? Certainly, in literature and art, racist stereotypes of blacks abounded, so why not in the Capitol?

To answer these questions, we must first uncover the attempts made by those in charge of the artworks to reject all references to what nineteenth-century Americans called the "peculiar institution," that is, slavery. The virtual absence of blacks and slavery in the Capitol decoration before the Civil War is no acci-dent, but instead resulted from conscious efforts to avoid the very issue that threatened national unity. Ironically, attempts to keep references to slavery out of the Capitol are often connected to images of justice and liberty, which embellish the building.[3]

## *Justice*

Allegories of justice adorn three prominent places in the national Capitol: the old Supreme Court, the exterior of the Rotunda, and the Senate doorway. The concepts of law and justice first appeared during the early Middle Ages in scenes of the Last Judgment, but by the twelfth century these Last Judgments had

109. Thomas Crawford. *Statue of Freedom*. 1863. Bronze. 234 in. Cast by Robert Mills. U.S. Capitol dome. Courtesy of the Architect of the Capitol.

110. George Richardson. *Justice*. 1789. Engraving.
Courtesy of the Library of Congress.

become associated with secular law, in which Jesus acts as judge of the defendants, mankind. At the same time, the concept of justice came to be represented by two symbols: the book, which referred to the canon law of the church, and the sword, which alluded to the temporal power of secular governments. During the Renaissance, justice became personified as a woman holding a set of scales as in Ambrogio Lorenzetti's *Allegory of Good Government* (1337–1339; Palazzo Pubblico, Siena) and Giotto's *Iusticia* (c. 1306; Arena Chapel, Padua). These Trecento frescoes designate various concepts of justice derived from ancient, medieval, and Renaissance scholars. The complex theological distinctions inherent in them merged into a single type in such seventeenth-century emblem books as Cesare Ripa's *Iconologie* (1758–1760) and George Richardson's *Iconology* (1789; fig. 110), in which Justice wields a sword as an emblem of power; the blindfold and scales betoken impartiality and equal treatment. Richardson elaborated: "The white robes and bandage over her eyes, allude to incorrupt justice, disregarding every interested view, by distributing of justice with rectitude and purity of mind, and protecting the innocent. The scales on the balance denote that this virtue directs to equity and upright judgement; and the sword is allusive to the punishment of a delinquent."[4]

The images of Justice in the U.S. Capitol employ one or more of the symbols found in these antecedents: the book, the sword, and the scales. Only the book undergoes a radical transformation in its meaning, for the sacred book of canon law from the Middle Ages and the Renaissance becomes the secular U.S. Constitution, with America's courts of law replacing Christ as judge.

Carlo Franzoni's *Justice* of 1817 (fig. 111)—located in a lunette of the old Supreme Court—is one of the earliest works completed after the destruction of the Capitol during the War of 1812. Franzoni (1789–1819), who arrived in the United States one year before receiving a government commission, reversed Richardson's emblem for his central figure of Justice, a goddess in classical garb who holds the scales of justice in her left hand and a sword in her right. As in all the Capitol renderings of Justice, the blindfold is absent, perhaps to show, as William Force surmised about Luigi Persico's central pedimental figure, "that with us justice is clear-sighted respecting the rights of all."[5] Decorating Justice's throne is an eagle, ancient personification of Zeus and symbol of supreme authority, unity, and wisdom. On the right is another eagle, perched beside law books, and on the left is a winged boy, purportedly the Young Nation, crowned by the rising sun and pointing to a tablet inscribed "The Constitution of the U.S."[6] Franzoni's *Justice* thus makes an appropriate subject for the room in which Supreme Court justices once decided the constitutionality of laws and acted as the court of final appeal (they moved out of the Capitol to their own building in 1935).

The allegory of Justice also figures prominently in Luigi Persico's *Genius of America* (fig. 112), located in the central pediment on the Capitol's east facade. Charles Bulfinch had first conceived of sculptural ornamentation for the Rotunda tympanum in 1822 and had requested a design from Enrico Causici at the same time that he had informed the sculptor about his plans for the Rotunda reliefs. Although Causici submitted a design for the pediment, the project remained unrealized until two years later, when President John Quincy Adams approved a

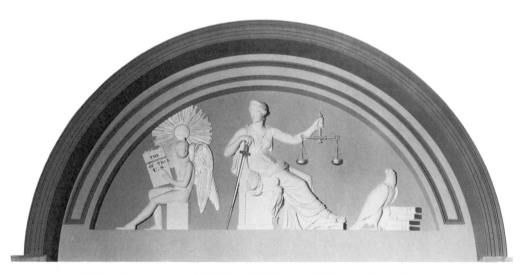

111. Carlo Franzoni. *Justice*. 1817. Plaster. U.S. Capitol, Old Supreme Court Chamber.
Courtesy of the Architect of the Capitol.

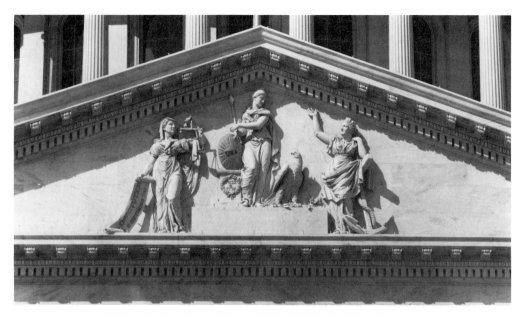

112. Luigi Persico. *Genius of America*. 1825–1828. Marble. 972 in. Copy by
Bruno Mankowski done between 1959 and 1960. U.S. Capitol east facade, central
portico. Courtesy of the Architect of the Capitol.

competition and appointed three commissioners to judge the designs: William
Thornton, an amateur architect and first-prize winner of the 1792 competition
for the Capitol's architectural plans, who served as commissioner of public build-
ings; George Bomford, lieutenant-colonel of the Army Ordinance Department
in Washington and an acquaintance of the architect, Benjamin Latrobe; and
Charles Bird King, the painter who executed Indian portraits for the War De-
partment. This procedure of having a presidential panel select the winner of a
competition derives from the format followed for the architectural plans of the
Capitol building and was not followed for subsequent art commissions.

The president involved himself in the selection process and concluded that
each of the thirty-six submissions failed to express adequately a new national
mythology. According to Bulfinch, Adams "disclaimed all wish to exhibit tri-
umphal cars and emblems of Victory, and all allusions to heathen mythology, and
thought that the duties of the Nation or its Legislators should be expressed in an
obvious and intelligible manner."[7]

Although none of the competitors had satisfied Adams, he did approve of
Persico's model for *Genius of America* when it was exhibited in the White House
for his inspection. The only record of Persico's design can be found in the
president's diary, in which he explains that Persico had depicted a "personifica-
tion of the United States standing on a throne, leaning upon the Roman fasces,
surmounted by the cap of liberty, with Justice at her right hand, blindfolded,

*Liberty, Justice, and Slavery*

holding a suspended balance, and in the other hand an open scroll." Hercules sat at the left corner of the throne, embracing the fasces "emblematical of strength," while Plenty with her cornucopia stood in one corner. And Peace, "a flying angel," extended a garland of victory toward America.[8]

Adams proposed a different composition. "Hercules had too much of the heathen mythology for my taste," the president explained, recommending that the "Scriptural image" of Hope with an anchor replace the mythological figure. Instead of the fasces, Adams proposed a pedestal with "4th of July, 1776" inscribed on its base and "4th March, 1789" on its upper cornice. He accepted the figure of Justice, however, allowing Persico to sculpt the personification with scales and a scroll. "The whole design," Adams concluded, would thus "represent the American Union founded on the Declaration of Independence and consummated by the organization of the General Government under the Federal Constitution, supported by Justice in the past, and relying upon Hope in Providence for the future."[9]

Persico's final composition incorporated some of the president's suggestions and reflects the meaning that Adams envisioned. In the tympanum, America stands on a broad pedestal and holds a shield inscribed "U.S.A." This shield rests on an altar emblazoned with the date July 4, 1776; behind the altar is a spear indicating the willingness of the United States to fight for independence and liberties. Beside America perches an eagle, who looks toward her. Hope stands on the right side of the composition, leaning on an anchor, looking toward America, and raising her right arm in greeting. Justice, on the left, holds balanced scales in her raised left hand while in her right she carries an open scroll inscribed "Constitution, 17 September 1787," the date the document was signed. (The figure is without the blindfold originally intended by the sculptor.)

In the composition, then, Persico followed the president's advice by eliminating the liberty cap, fasces, Hercules, Plenty, and Peace, and by adding Hope. As a result the central tympanum celebrates the Declaration of Independence and the Constitution for establishing justice in the United States and points, by way of the figure of Hope, to divine guidance in this achievement.

It might appear that Adams's opposition to Greco-Roman mythology for national art is the sole reason for his suggestions. But Adams's iconographic program for the central tympanum espouses a specific ideology that reflects his political beliefs. As commander in chief, the National Republican president refused to force the removal of the Creeks and Cherokees from Georgia, advocated a federal program of internal improvements without a constitutional amendment, and promoted protective tariffs to stimulate manufacturing. More to the point, however, is President Adams's agreement with Chief Justice Marshall that the Supreme Court, not the states, should remain the final arbiter of constitutionality, and that the Constitution had been created by the people, not the states, which hence are subordinate to the federal government.[10] The concept of justice as conveyed in Persico's relief thus advocates majority rule over decentralized authority. The personification of America must also be seen, then, as a projection of the nationalist policy. This centralized female personification

flanked by two symbols of the United States—the eagle and the shield—proclaims the leadership of the federal government over that of the states, and locates the Declaration of Independence and the Constitution as crucial for the equal rights of white men.

Besides the pediment's association with the particularist-versus-nationalist debate, which had contributed to Horatio Greenough's commission for a portrait of George Washington (see fig. 34) and especially had surfaced during the nullification crisis of the late 1820s, the work also must be understood within the context of that decade's burgeoning patriotism. Following the success of the War of 1812, Americans became increasingly aware of their historical past and began to reassess their national accomplishments, especially in response to a series of events: the completion of the Erie Canal in October 1825; General Lafayette's tour of the United States in 1824 and 1825; the fiftieth anniversary of the signing of the Declaration of Independence, in 1826; and the deaths of John Adams and Thomas Jefferson on July 4, 1826. Daniel Webster's address of 1825 at the laying of the cornerstone of the Bunker Hill Monument and Edward Everett's July 4, 1826, oration, "The Principle of the American Constitution," further idealized the recent historical past.[11] Both statesmen emphasized that the Declaration of Independence (eulogized by Everett as "that sacred charter")[12] and the Constitution distinguished the United States from all other countries past and present, and argued that the federal government took precedence over the authority of states.

Although commissioned thirty years after *Genius of America*, Thomas Crawford's *Justice and History* (fig. 113), on the cornice above the Senate door, similarly glorifies justice and its basis in the Constitution. Yet Crawford's work also refers to the nation's territorial expansion and becomes a harbinger of later objections to any implied references to the southern institution of slavery. The

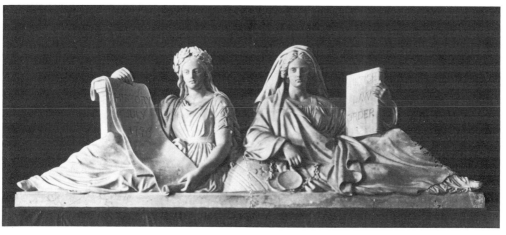

113. Thomas Crawford. *Justice and History.* 1855–1863. Marble. Length, 134 in. Height, 46 in.
U.S. Capitol east facade, Senate portico. Courtesy of the Architect of the Capitol.

*Liberty, Justice, and Slavery*

idea for sculpture above the Senate doorway coincided with plans for the pediment decoration on both the Senate and House wings of the Capitol extension. When Captain Meigs wrote Crawford and Hiram Powers concerning the tympanum sculpture, he also requested statuary for the areas immediately above the doorways.[13] Crawford forwarded his drawings for the cornice design on January 17, 1853, suggesting "Liberty and Justice" as the subject.[14] The artist intended both female personifications to be reclining figures, with Liberty identified by the pileus (the "liberty cap" worn by freed slaves in ancient Rome) and Justice by the lictor rods, a pen, and a palm branch.

The secretary of war, Jefferson Davis, reviewed Crawford's proposal, recommending that the fasces be replaced by scales and that the liberty cap be eliminated. Davis objected that the lictor rods and ax, which in ancient Rome stood for the power to summon, arrest, or execute citizens, were an inappropriate symbol for the U.S. system of justice.[15] Meigs concurred: although the artist meant the fasces to show that "in Union is strength," the original Roman meaning would intrude.[16] Together, the secretary of war and the engineer convinced Crawford of the object's impropriety for the United States, as the artist replaced the fasces with the more traditional image of scales and added a book inscribed "Justice, Law, Order." He furthermore transformed Liberty into History, avoiding the objectionable liberty cap that became associated with bondage in the South.

In the final composition, History is seated on the left, wearing a laurel wreath and holding a scroll inscribed "History, July 1776." Justice reclines on the right and leans on a globe, against which rest the scales. As in Persico's *Genius of America*, located to the left of the Senate cornice, both the Declaration of Independence and the Constitution (represented by the tablet) are glorified as the culminating documents of civilization's westward course. The globe is a significant additional element, for it means that an American system of justice will be spread throughout the entire world. The work thus signals mid-century adherence to a mission of destiny.

More to the point for the work's placement on the Senate extension, the sculpture relates to the pediment above the doorway on which the cornice figures recline. Crawford's *Progress of Civilization* (see fig. 61) locates the nation's expansion on its westering course and acknowledges the Indians' concomitant imperilment. His *Justice and History* suggests that the North American empire will expand beyond the continental boundaries and extend its society and republican government to cultures in other areas of the world. Whether Crawford consciously created the thematic relationship between these two works is unknown, for he never alluded to their analogies in his letters to Meigs and Davis. It would be odd, however, if the sculptor had not considered the correspondence between his sculpture for the Senate pediment and that for the doorway. Crawford seems to have intended the two works to relate thematically to form the ideological summation of the mission and manifest destiny of the United States.

114. Edward Savage. *Liberty, in the Form of the Goddess of Youth, Giving Support to the Bald Eagle*. 1796. Stipple Engraving. 24¾ × 15 in. Courtesy of the Library of Congress.

### *Liberty*

Liberty as a subject in the Capitol belongs to the first phase of the building's artistic decoration, under Benjamin Latrobe, who determined to have a sitting figure of Liberty in the House of Representatives. The architect immediately contacted Philip Mazzei, who recommended Giuseppe Franzoni. (Giuseppe worked on the Capitol embellishment before his brother, Carlo.) Franzoni's *Liberty* held a liberty cap in her left hand and the scroll of the Constitution in her right, while her "foot treads upon a reversed crown as a footstool and upon other emblems of monarchy and bondage."[17]

The plaster cast, which stood behind the speaker's chair in the Hall of Representatives and was destroyed in the fire of 1814, followed the iconographic tradition that had been established in this country after the Revolutionary War. Found in such precedents as Edward Savage's 1796 *Liberty* (fig. 114) and Samuel Jennings's 1792 *Liberty Displaying the Arts & Sciences* (fig. 115), the ubiquitous pileus and pole are either held by the woman or located behind her, while the figures stand triumphantly over emblems of despotism.[18] Savage's popular print, reproduced on embroidery, in amateur paintings, and on Chinese porcelain, features Liberty stepping on various regalia: a broken scepter, a hammer, and a medal. At

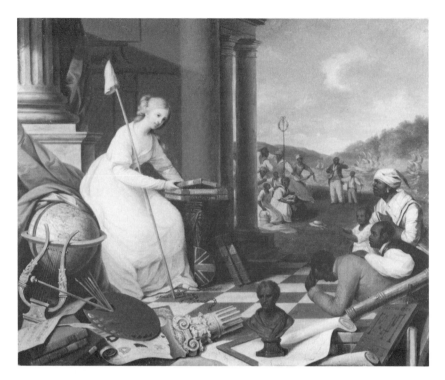

115. Samuel Jennings. *Liberty Displaying the Arts & Sciences.* 1792. Oil on canvas. 15 × 18 in.
Courtesy of the Henry Francis du Pont Winterthur Museum.

the request of the directors of the Library Company of Philadelphia, who commissioned *Liberty Displaying the Arts & Sciences*, Jennings positioned a broken chain beneath Liberty's left foot, betokening the abolitionist sentiments of those Quakers who belonged to the society and had specified the work's symbolism.[19] In both images, as in Franzoni's destroyed work, Liberty is conflated with Victory to demonstrate the triumph of freedom over tyranny and, in the case of Jennings's painting, over slavery.

Two points concerning the personification of Liberty and its association with southern slavery must be made. First, although objections to the cap would be raised during periods of sectional strife in the United States, it seems that no one opposed the presence of this object in Franzoni's *Liberty*. Second, the personification of liberty derives from ancient Rome, where the figure, Libertas, first stood for personal freedom in relation to manumission and later, in the Roman Empire, referred to both political liberty and constitutional government. It is the association between Libertas and manumission in ancient Rome that provoked opposition to the pileus during the 1840s and 1850s.

Benjamin Latrobe had not made this connection. Instead, the architect intended Liberty in the Capitol to denote only the meaning that had evolved in the Roman Empire, namely, constitutional freedom. In a long aside concerning

116. Enrico Causici. *Genius of Constitution.*
1817–1819. Plaster. 163 in. U.S. Capitol, Statuary
Hall. Courtesy of the Architect of the Capitol.

"the welfare of our country," Latrobe wrote to Mazzei, "After the adoption of the federal constitution, the extension of the right of Suffrage in all the states to the majority of all the adult male citizens, planted a germ which has gradually evolved, and has spread actual and practical democracy and political equality over the whole union."[20] Probably not intending to criticize his adopted country, the English-born Benjamin Latrobe's assessment in fact summarized America's limitations in defining its political equality and suffrage. At the outset of the nineteenth century, these ideals, as promoted by the founding fathers, applied not to all "adult male citizens" but just to Caucasian men. This distinction influenced later discussions over the meaning of the liberty cap and whether the symbol was appropriate given slavery in the United States.

With the destruction of the Capitol and Franzoni's plaster cast in 1814, Latrobe's desire to have a figure of Liberty embellish the House of Representatives failed to be realized. Yet most nineteenth-century guidebooks to the Capitol and twentieth-century texts suggest that Enrico Causici's plaster figure, set in the niche above the entablature in the old House of Representatives between 1817 and 1819, had replaced Franzoni's work.[21] The misattribution of Causici's *Genius of the Constitution* (fig. 116), incorrectly identified as *Liberty and the Eagle*, indicates a desire to interpret the image as Liberty even when her traditional symbols—the cat, pileus, pole, scepter, and flying bird—are noticeably absent. Perhaps the confusion was because no iconographic tradition existed for *Genius of the Constitution*, and because the small scroll held by the goddess in her outstretched right hand is untitled. (The scroll in Franzoni's *Liberty* is identified by Latrobe as the Constitution.)[22] That the emblem to the left of Causici's standing Greek goddess is also misidentified by nineteenth- and twentieth-century observers as "the frustum of a column," as "the stump of a tree," and as "an altar" rather than the fasces, further indicates the sculptor's failure to create clearly

identifiable symbols.[23] Only the eagle to the left, in its aggressive pose of readiness, and the rattlesnake around the fasces are clear references to the United States.[24]

What is important is *how* nineteenth-century Americans interpreted the work rather than the fact that they misunderstood its symbolism. Robert Mills's explanation of the sculpture's message shows that regardless of whether Americans were correct or incorrect in their identification of the allegory, they associated Liberty with the Constitution, indicating the direction later images in the Capitol would take. "'Be careful, my sons, to preserve inviolate the high trust committed to your charge,'" the Architect of Public Buildings envisions Liberty saying: "'be true to the principles of the glorious constitution established by your fathers, under my auspices.'" Going beyond an understanding of liberty as the umbrella under which the Constitution exists, Mills concludes this imaginary oration by having Liberty assert that Americans will "'be handed down to a grateful posterity as the firm upholders and preservers of the last hope of an oppressed world.'"[25]

To Mills in 1834, like Latrobe nearly thirty years earlier, the contradiction between the view of the United States as bastion of freedom and beacon of hope for oppressed people and the reality of southern bondage was no dilemma. Even though William Lloyd Garrison began publishing the *Liberator* three years before Mills wrote his guidebook to the Capitol, and though the abolitionist movement gained momentum during this decade, the sectional dispute over slavery would not fully erupt until the 1840s, when the Texas question and the Mexican War brought the issue to the forefront of national consciousness. It was during this period of intense North-South disagreement over slavery in the newly acquired southwestern territories that objections to the pileus for images of Liberty in the Capitol arose, as already evidenced in Crawford's *Justice and History*.

Jefferson Davis's rejection of the pileus for Liberty in this cornice design resulted in Crawford's transformation of the figural personification to History, a more innocuous allegory that avoided any associations with the "peculiar institution." As Captain Meigs explained to the artist, "Mr. Davis says that he does not like the cap of Liberty introduced into the composition. That American Liberty is original & not the liberty of the freed slave—that the cap so universally adopted & especially in France during its spasmodic struggles for freedom is desired from the Roman custom of liberating slaves thence called freedmen & allowed to wear this cap."[26]

In Meigs's account, the slaveowner and future president of the Confederacy expressed knowledge of the practice of manumission in ancient Rome. During the Roman ceremony, freed slaves covered their newly shorn heads with the cap while magistrates touched them with a rod (the vindicta).[27] Before the Roman Empire the cap symbolized emancipation from personal servitude rather than constitutional political liberty. Edward Everett also understood the meaning of the pileus, which he explained in a letter to Hiram Powers as the reason why Powers's intention to have his statue *America* (see fig. 129) hold the cap aloft constituted an inconsistency. This statesman had encouraged Horatio Green-

ough to base the composition for his statue of George Washington on the Pheidian Zeus and had earlier served as the chairman of the Department of Greek Literature at Harvard. Everett thus had studied antiquity and knew well the original meaning of the liberty cap. In his reconstruction of the pileus's origin, Everett explained that emancipated slaves in Rome wore a cap in order to hide their shaved heads, "hence 'to call a slave to the cap' was tantamount to liberating him or declaring him free."[28]

Although both Edward Everett and Jefferson Davis provided accurate explanations for the original function and meaning of the liberty cap in ancient Rome, eighteenth-century emblem books had codified Libertas as a female personification who holds a pole surmounted by the pileus. Paul Revere employed the figure with a cap on the pike, possibly for the first time in the American colonies, in 1766 on the obelisk for the celebration of the repeal of the Stamp Act.[29] Twenty-four years later, Samuel Jennings used Libertas in *Liberty Displaying the Arts & Sciences* not as a symbol of political freedom but as a reference to the possible emancipation of blacks in the United States, an appropriate meaning given that Jennings executed this painting for the Library Company of Philadelphia in support of the directors' abolitionist activities. In the work, Jennings juxtaposes a benign and beautiful white woman as Liberty with the slaves in the lower right-hand corner. In the background, a group of African Americans dance around the liberty pole in celebration of their freedom.

This first abolitionist painting emphasizes the meaning of the liberty cap in the United States. Because it had referred to manumission in ancient Rome, the pileus in the United States resonated with tacit implications in regard to the slaveholding South. Consequently, the liberty cap and staff that Augustin Dupré depicted on the coin *Libertas Americana* (fig. 117) in 1781 disappeared from the first American pattern dime of 1792.[30] For the newly established country, which depended upon the link between the North and South for its existence, some Americans considered the symbols of Roman manumission too loaded in content for their inclusion on American coins.

Abolitionist organizations like the ones that the directors of the Library Company had founded in the eighteenth century became revitalized in the 1830s and again in the 1840s, when newly acquired Mexican territories exacerbated the differences between North and South. In 1846, Pennsylvania Democrat David Wilmot attached to an appropriation bill a proviso prohibiting slavery in all new territories acquired from Mexico. Although this measure failed to pass both houses, debate over slavery extension further hardened differences between northerners and southerners, eventually leading to the threat of secession by South Carolina and other southern states in 1849. After eight months of acrimonious debate, the Compromise of 1850 temporarily allayed dissension.

We can now understand why Jefferson Davis opposed the use of the liberty cap in Crawford's cornice figures. Davis used his position as the person in charge of the Capitol extension between 1853 and 1857 to reject any potential antislavery implications. At the same time, Montgomery Meigs, although a northerner who considered slavery an "eternal blot" on the concept of liberty in the

117. Augustin Dupré. *Libertas Americana.*
Obverse. 1781. Bronze. 1⅞ in. dia. Courtesy of
the Massachusetts Historical Society.

United States, communicated Davis's opinions and acted as an intercessor on behalf of southern concerns by making sure that the liberty cap and slavery remained out of sight in the Capitol artworks. This army officer had befriended a number of powerful southern politicians, among them Robert Toombs of Georgia and R. M. T. Hunter of Virginia, and he needed their support, as well as that of his boss, during the times when Thomas U. Walter and, later, Secretary of War Floyd challenged his position as supervisor of the Capitol extension.[31]

Jefferson Davis's rejection of the liberty cap as an anti-slavery symbol and Montgomery Meigs's adherence to his superior's desires are apparent not only in Crawford's doorway figures but also in his more conspicuous *Statue of Freedom*, which overlooks the mall. The idea for a statue on the pinnacle of the newly designed dome first arose in a drawing by Thomas U. Walter (fig. 118). The Philadelphia architect had conceived of a colossal statue of Liberty with the pileus on the end of a pike held by the woman.[32] Upon learning about the plans for sculpture on the new dome, Meigs first asked Randolph Rogers for proposals.[33] Rogers, occupied with his bronze doors for the Capital Rotunda, pleaded that he did not have time for additional work. Meigs next contacted Thomas Crawford in May 1855. "We have too many Washingtons, we have America in the pediment," Meigs reasoned in a letter to Crawford, noting also that "Victories and Liberties are rather pagan emblems." Nevertheless, the engineer concluded, "Liberty I fear is the best we can get. A statue of some kind it must be."[34]

Crawford followed the engineer's advice and proposed "Freedom triumphant in Peace and War." In this first design (fig. 119), Freedom does not have the pole, cap, or any other symbols associated with Liberty. Instead the modest, softly rounded female figure wears on her head a wreath composed of wheat sprigs and laurel. "In her left hand," Crawford elaborated, "she holds the olive branch, while

118. Thomas U. Walter. *Original Sketch for Statue and U.S. Capitol Elevation.* 1855.
Salted paper photo print. Courtesy of the Library of Congress.

119. Thomas Crawford. *Freedom Triumphant
in War and Peace.* 1855. Engraving. Courtesy
of the Library of Congress.

her right hand rests on the sword which sustains the shield of the United States." The sculptor also placed wreaths on the base, "indicative of the rewards Freedom is ready to bestow upon the distinction in the arts and sciences."[35] Crawford thus merged Peace (identified by the olive branch) with Victory (identified by the laurel leaves) and Liberty in his drawing, creating an iconographic synthomorphosis (fusion of stock allegorical imagery) that would undergo additional metamorphoses based on Jefferson Davis's suggestions.[36]

Four months later, Crawford submitted an altered design in which he abandoned the theme of peace and established more clearly the work's reference to Libertas. In the final model, which included some further, crucial modifications, the sculptor positioned what he now identified as "armed Liberty" on a globe that is surrounded by wreaths placed below "emblems of Justice" (the fasces). Crawford added three emblems (fig. 120): "a circlet of stars around the Cap of Liberty"; the shield of the United States, "the triumph of which is made apparent by the wreath held in the same hand which grasps the shield"; and a sword held in her right hand, "ready for use whenever required." Crawford finished the statue by placing stars upon her brow "to indicate her Heavenly origin" and by locating the figure above a globe to represent "her protection of the *America[n]* world."[37]

In Crawford's second design, the artist added the liberty cap, eliminated the olive branch and its reference to peace, and retained the sword. The addition of the globe as the "American world" corresponded to the vision of America as a great empire that would influence other nations to adopt its republican form of government. The orb also suggests an association with the nation's expanded view of manifest destiny as encompassing Cuba and the Caribbean. Like his *Justice and History* above the Senate door, Crawford's "armed Liberty" thus reflects the militaristic rhetoric of the 1850s and matches the administrative responsibilities of Jefferson Davis as the secretary of war who advocated the purchase of Cuba and Nicaragua.

Jefferson Davis once again objected to the pileus, arguing that "its history renders it inappropriate to a people who were born free and would not be enslaved"—quite an assertion from a slaveowner who argued vehemently on behalf of the slave system and its extension into newly acquired lands. This southerner's refusal to acknowledge that blacks in the South and on his own plantation were *not* born free indicates a dangerous racism implicit in the reasoning of the future president of the Confederacy. Davis suggested that "armed Liberty wear a helmet" instead of the liberty cap since "her conflict [is] over, her cause triumphant."[38] Consequently, Thomas Crawford dispensed with the objectionable object, putting in its place "a Helmet the crest [of] which is composed of an Eagles head and a bold arrangement of feathers suggested by the costume of our Indian tribes."[39] Crawford furthermore placed the initials "U.S.A." on armed Liberty's chest, with rays of light issuing forth from the letters.

This third and final version of the dome statue of Liberty addresses concerns about Indians and slavery. Freedom, according to the artist, remains the focus of the statue, whether in the official title, *Statue of Freedom*, preferred by the current (1991) Architect of the Capitol, or the more accurate title given by Crawford and

120. Thomas Crawford. Model for *Statue of Freedom*. 1858. Plaster. 234 in. In storage.
Courtesy of the Architect of the Capitol.

used by Jefferson Davis, *Armed Liberty*, which accurately conflates the two ideas
manifest in this combined rendering of Minerva and Liberty. As Marvin Trach-
tenberg has demonstrated, after 1830 in France the personification of liberty had
undergone a process of synthomorphosis in which artists fused iconographic
traditions, as in Augustin-Alexandre Dumont's *Genius of Liberty* (c. 1840), where
Giovanni Bologna's *Mercury* holds a flaming torch and a broken chain. Eugène
Delacroix's 1830 *Liberty Leading the People*, executed to commemorate the July 30
uprising in Paris, also exemplifies the iconographic transition of Libertas. Instead
of representing a classical goddess, Delacroix rendered a French revolutionary
woman who holds the tricolor flag and rifle while wearing on her head the

ɡ observes, "At her feet are heaped the corpses
of a neatly set cat and broken jug." These two
r Frédéric-Auguste Bartholdi's famous *Liberty*
ɛr known as the Statue of Liberty. The French
ɔroach, uniting Faith, Truth, Eternal Felicity,
ɔnal allegories, to provide the ancient goddess
iations that evoke its intended meaning: the

ɾawford's *Statue of Freedom* was first set atop the
provides a basis for recognizing the process of
York harbor statue, Crawford's work discards
with Liberty, making the title (*Statue of Free-*
ɾr our identifying the personification. Albert
ɛ monument dispenses with the Phrygian bon-
ɩwer of reason rather than . . . a fervent call to
ɩis American icon was created by a Frenchman
who had opposed the Commune, the omission
ɛ bloody civil war in Paris than with concern in
the South and its threat to national cohesion.
ɩcid image in his *Armed Liberty*, in part to show
von in North America, enabling her to stand
ɔrld to enforce her rule by the sword wherever

the liberty cap and his recommendation of a
lation of three traditional allegories: Liberty,
will take on special implications because of the
statue's location over the globe of the world.) As a result, Crawford created an
image that loses its power rather than retaining its sharp iconographic focus. An
examination of how Crawford's *Statue of Freedom* fuses three traditional allegories
in a synthomorphic process will expose the monument as a study in compromise
and the erosion of a sculptural goal.

America, as a female personification of a geographic location, came to sym-
bolize the New World in the form of an Indian queen. Wearing a feathered skirt
and a headdress, this America often held a club or a bow and arrow. The United
States adopted this iconographic type as its own on three Congressional medals
commissioned between 1787 and 1791 and on Augustin Dupré's diplomatic
medal of 1792 (see fig. 68).[42] Before and during the Revolutionary War, America
and Liberty combined to become America as Liberty, in which the Indian
princess with tobacco leaf skirt and headdress held the cap and pole, as in Paul
Revere's masthead for the *Massachusetts Spy* (fig. 121). (Randolph Rogers followed
this tradition in his personification of America in the Rotunda bronze doors, as
did Constantino Brumidi in his frescoes).[43]

That Crawford added eagle feathers to the helmet indicates that the sculptor
knew the tradition of associating America with Liberty and intended to combine
the two allegories in his statue. In doing so, he created a figure that is often

121. Paul Revere. Masthead for the *Massachusetts Spy*. Engraving. 1781.
Courtesy of the American Antiquarian Society.

misidentified as an Indian, an ironic mistake given the stereotypical aboriginal images that decorate the Capitol and their evocation of the Vanishing American myth that advocated the Indian's destruction. Indeed, aside from the headdress, nothing on the statue, least of all its physiognomy and clothing, resembles the other Indian images at the Capitol nor in the history of American art. The figure is neither the ignoble nor the noble savage, but instead a substantial woman swathed in classically inspired clothing who stands proudly and triumphantly over the globe of the world. If the statue indeed represented an Indian, the work would indicate the original inhabitants' triumph over white Americans and their rule of the continent, suggesting a different mythicohistorical ideology from that which pervaded and still pervades the American consciousness and the iconographic program of the Capitol.

Crawford's synthomorphic approach is further evident in the work's association with Minerva, the ancient Roman goddess of war and of the city, protector of civilized life, and embodiment of wisdom and reason. A majestic and robust female figure, *Statue of Freedom* in fact emulates Phidias's fabled Athena Parthenos (fig. 122), a work reconstructed by Quatrèmere de Quincy (and entitled *Minerve du Parthénon*) in *Restitution de la Minerve en or et ivoire, de Phidias, au Parthénon* (1825), which Crawford must have consulted.[44] Phidias's Athena Parthenos was the guardian deity over that earliest and most archetypal democracy, Athens, and hence an appropriate prototype for the American female colossus who stands guard over the United States. Although Crawford's image is less complex, both the ancient and modern works include the helmet, the breast medallion, and the shield along the side. (Crawford replaced the image of Medusa found in Minerva's breastplate with the initials "U.S.A.") Even the fluted cloak that gathers from the lower right to the upper left shoulder corresponds in these two matron types, whose immobility, severity of facial expression, military accoutrements, and colossal size express sternness and control, very different from the serenity and suppleness of Crawford's first design, *Freedom Triumphant in War and Peace*. (Crawford's final militant, motionless, and massive female resembles

MINERVE DU PARTHENON

122. Antoine-Chrysostome Quatremère de Quincy. Reconstruction of Phidias's *Minerve du Parthénon*. 1825. Engraving. Fine Arts Department, Boston Public Library; reproduced courtesy of the Trustees of the Boston Public Library.

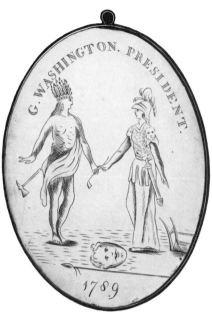

123. Jefferson Davis. *Minerva*. 1828.
Drawing. Courtesy of the West Point Museum,
United States Military Academy.

124. Joseph Richardson, Jr. Washington
Peace Medal. Obverse. 1789. Silver.
$4\frac{1}{8} \times 5\frac{1}{2}$ in. Courtesy of the Henry
Francis du Pont Winterthur Museum.

Luigi Persico's *War* [see fig. 52], located in the left niche of the central doorway of the Capitol portico.)

Jefferson Davis probably intended *Statue of Freedom* to be interchangeable with Minerva and thereby echo Persico's statue when he suggested the helmet, for the secretary of war knew the goddess's iconography, evident in his 1828 detailed drawing of a profile bust of Minerva with a helmet while a student at West Point (fig. 123). Furthermore, Crawford, Meigs, and Davis must have been familiar with the traditional association between America and Minerva seen in such images as the Washington peace medal (1789; fig. 124), the frontispiece for the Reverend Samuel Cooper's *History of North America* (1789), and John J. Barralet's *America Guided by Wisdom* (c. 1815; fig. 125). (Statesmen used the Washington peace medal in treaties of friendship with the Indians until a new image replaced the one minted in the year of the first president's inauguration; in the later medals, Washington replaced Minerva.)[45] In Barralet's popular engraving, the two personifications are separate figures in close association. The other two images—the Washington peace medal and the frontispiece to Cooper's book—fuse America and Minerva into one allegory.

Although Thomas Crawford managed to complete the model for *Statue of Freedom* before his death in 1857, the workers did not erect the statue until 1863,

the year of the Emancipation Proclamation and the Battle of Gettysburg.[46] The outbreak of the Civil War resulted in the cessation of work on the Capitol extension and the temporary interruption of the statue's molding into bronze under the direction of Clark Mills. President Lincoln ordered the work resumed, however, despite some arguments that troops needed the bronze for munitions.[47] "If people see the Capitol going on," Lincoln argued, "it is a sign we intend the Union shall go on."[48]

Thomas U. Walter and the secretary of the interior, John Palmer Usher, orchestrated a ceremonial installation of the statue on December 2, 1863.[49] Instead of having prominent statesmen and orators deliver speeches, the organizers arranged for a battery of artillery to be placed on the grounds east of the Capitol; it fired a salute of thirty-five rounds, one for each state, while an American flag, hoisted at the outset of the celebration, waved above the work. The government thereby coordinated a ceremonial military ritual to symbolize the nation's reunification under northern hegemony. As a writer in the *New York Tribune* asserted, *Statue of Freedom* stood triumphantly over the Capitol "now that victory crowns our advances, and the conspirators are being hedged in and vanquished everywhere, and the bonds are being freed." Freedom now turned, according to the article, "rebukingly toward Virginia," with an outstretched hand to guarantee "National Unity and Personal Freedom."[50]

Thus by the time Crawford's *Statue of Freedom* surmounted the Capitol dome, the fasces—which Crawford identified as "the emblems of Justice triumphant"— and the wreaths that uphold the circular globe assumed new connotations. In the

125. John J. Barralet. *America Guided by Wisdom.* 1815. Graphic on wove paper by B. Tanner. 17¼ × 23½ in.
Courtesy of the Henry Francis du Pont Winterthur Museum.

*Liberty, Justice, and Slavery*

1850s, when Crawford completed the plaster cast, armed Liberty's position above the "American world" alluded to the nation's vision of its great republic as empire in the western hemisphere. By the time of the Civil War, however, the statue's external symbols deflected attention from internal sectional differences and predicted the triumph of the North over the Confederacy. Justice triumphed in the New World with the freeing of the slaves and the Northern victory, enabling armed Liberty to stand even more proudly over the globe in anticipation of enforcing republican democracy throughout the world.

The elimination of the traditional liberty cap from Crawford's monument did not go unnoticed by some northerners, who commented on the implicit racism involved in Jefferson Davis's rejection of "the grand old Cap of Liberty," as an 1863 article in the *New York Times* fondly called the emblem that "our grandfathers [loved]." The anonymous author attributed Davis's decision to replace the cap with "the barbarous device" of the helmet to his "worshipping slavery."[51] By this time, Davis had become the president of the Confederacy and was thus identified as the arch-defender of slavery.

Other northerners viewed the statue's symbolic content as significant. The *New York Tribune* reported on December 10, 1863, that the superintendent had gone on strike in Mills's foundry, in Bladensburg, Virginia, demanding an increase in wages. In the midst of this crisis, one black man offered to take the striker's place. "The black master-builder lifted the ponderous uncouth masses and bolted them together . . . til they blended into the majestic 'Freedom,' who to-day lifts her head in the blue clouds above Washington, invoking a benediction on the imperiled Republic!" The article concluded with the question, "Was there a prophecy in that moment when the slave became the artist, and with rare poetic justice, reconstructed the beautiful symbol of freedom for America?"[52] If Jefferson Davis knew that a soon-to-be-emancipated slave had molded Crawford's statue, he did not acknowledge the irony.

### The Absence of African Americans

Fifteen years after Lincoln's manumission of American slaves and the erection of Crawford's *Statue of Freedom* on the Capitol dome, an American citizen donated *First Reading of the Emancipation Proclamation*, by Francis Bicknell Carpenter (1864; fig. 126), to Congress.[53] The painting inhabited the east stairwell of the House wing between 1878 and 1941, the Old Senate Chamber between 1941 and 1961, and since 1961 the west stairwell of the Senate wing. This first recognition of slavery in a Capitol artwork glorifies Lincoln and, in a framed drawing in the background, Washington for their roles in the evolution of American freedom. The first commander in chief, who had led his countrymen in arms against British rule—like his fellow Virginian, Thomas Jefferson, author of the Declaration of Independence – owned slaves. Edmund Morgan has shown that these founding fathers did not recognize the hypocrisy of holding slaves while promulgating freedom in the new nation, and that the rise of liberty and equality in America coincided with the rise of slavery, thereby enabling Washington, Jefferson, and others to recognize unconsciously the importance of freedom to a society.[54]

126. Francis Bicknell Carpenter. *First Reading of the Emancipation Proclamation.* 1864. Oil on canvas. 108 × 174 in. U.S. Capitol, Senate wing, west staircase. Courtesy of the Architect of the Capitol.

What is interesting about Carpenter's *First Reading* is not only that Washington the slaveowner is included in this commemoration of the Emancipation Proclamation—other artists, such as Thomas Ball in the *Emancipation Group* (1874), also unite Lincoln and Washington to celebrate black emancipation—but that those who benefited from this declaration, the enslaved African Americans, are not represented in this large history painting. The virtual absence of blacks from the Capitol decoration throughout the nineteenth and twentieth centuries suggests that those in power have never felt comfortable acknowledging the reality of slavery in the United States. This becomes evident when we turn to a work submitted for the Capitol decoration before 1860 that included a chattel figure: the House pediment design by Henry Kirke Brown, a sculptor who lived in Florence and Rome between 1842 and 1846 and then returned to New York City to promote national artistic expression.

Learning about Captain Meigs's intention to have pedimental sculpture on both the new Senate and House wings, Brown submitted an unsolicited design in 1855. (It should be recalled that Meigs anticipated that Powers and Crawford would decorate the two tympana.) The sculptor recorded in his notebook that the captain of engineers immediately focused on the black man on the left seated on a bale of cotton to represent industry in the South (fig. 127):

> The Capt. [Meigs] on looking at my design for some monuments placed his finger on the (figure) of the slave. I felt its significance at once and saw

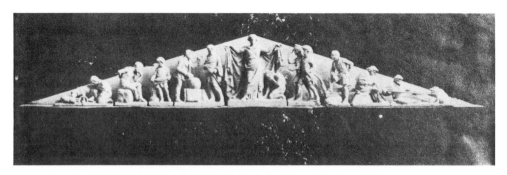

127. Henry Kirke Brown. First design for the House pediment. 1855. Photograph
of plaster model. Courtesy of the Library of Congress.

that my hopes of introducing him into the composition was vain.

After long and careful looking he said: I do not think it would do to
represent a slave in the pediment, it is a sore subject and upon which there
is a good deal of feeling. I think no southerner would consent to it—but I
[Brown] interposed—that it is an institution of the country. How else can
it be represented? He [Meigs] said the South talked of it as the greatest
blessing both for slave and master, but that they did not like to have it
alluded to, and I was advised to avoid so fruitful a subject of contention,
and yet he could not see how else the south could be represented.[55]

Meigs earmarked the slave as a potential problem for southern statesmen, whose
support and friendship he needed in order to retain his position and influence,
which were already being threatened. He also realized that Davis would be
offended by a representation of a slave.

As a consequence of Meigs's disapproval, the sculptor replaced the objection-
able slave with a miner (fig. 128).[56] Intending to represent America's equal bless-
ing to all trades and professions, Brown conceived of an elaborate and potentially
confusing pediment composition in which America "occupies the central posi-
tion in the group extending her blessing and protection alike to all, not merely to
her own citizens, but to the poor and distressed foreigner who kneels at her feet
on the left." Beside the immigrant stood a citizen who deposits his vote in a ballot
box, "a very distinguishing feature of our country and symbol of equal rights." A
farmer with his plow, a fisherman, and a "brave and athletic hunter combating
the wild animals upon the outskirts of civilization" complete the right portion of
the composition.

To America's right Brown placed an anvil, a wheel, and a hammer to represent
"the mechanic arts." Beside these mechanical symbols stood a statesman con-
sidering the propositions presented by "the old weather-beaten navigator and
discoverer," who holds a globe and maps. Playing with a boat was an American
boy, "the promise of commerce and navigation, the perpetual renewal of hope of

all," whereas the miner represented "a gold seeker of California." An Indian trapper, who stood for the interests of fur trade, ended the left portion of the composition.[57]

Brown had intended to show the United States as a pluralistic society composed of numerous classes and types of people—freemen, immigrants, and slaves—all of whom toil under America's guidance. (That no women are shown involved in a professional activity denied the reality of working women slaves and working free white and black women.) As Brown summarized, "In this specific idea of America I have represented my country as showing favoritism to no class, she holds out no prizes to any, but distributes equal blessing to all trades and professions."[58]

Brown's pedimental sculpture would have reflected the stratification of American society, a danger even without the figure of the slave, which he omitted in order to appease southern opposition to his design. The sculptor did not need to eliminate the bondsman, however, for Meigs rejected the work as a whole anyway, with the excuse that he still hoped Hiram Powers would submit a proposal for the House pediment. Although the army officer told the truth—negotiations continued between Powers and Meigs for a number of years—Brown's work nevertheless failed to promote a mythic version of American history that would ignore the realities of class distinctions, immigrant workers, and southern slavery.

Brown recognized the complex reasons why Meigs did not accept his design. Surmising that Meigs "was acting under [the] restraint" of his boss, Jefferson Davis, Brown expressed hope that soon "the gag may be taken from the mouths of all men." He then astutely predicted that the ballot box "will alarm our brethren of the South more than my poor sleeping Slave."[59] In short, the sculptor who had visited Mackinac Island to study various tribes in preparation for marble renditions of aborigines, and who acknowledged that the adoption of a "civilized life" by the Indians led to their degradation, wanted his work for the Capitol to raise legitimate concerns about equal rights.[60] Whether Brown himself intended the viewer to reason that blacks, Indians, and women could not go to the ballot box pictured in his relief is debatable.

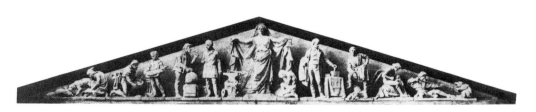

128. Henry Kirke Brown. Second design for the House pediment. 1855. Photograph of plaster model. Courtesy of the Library of Congress.

*Liberty, Justice, and Slavery*

Henry Kirke Brown's dissatisfaction with Meigs's rejection of his proposal resulted in the artist's aggressive campaign to remove the engineer from his position in charge of the Capitol extension. He helped arouse congressional concern about the soldier's use of federal funds for artworks, and he helped form the Arts Commission, whose report damned Meigs's patronage of foreign artists, most notably Constantino Brumidi. The friction between the architect, Thomas U. Walter, and the engineer, Montgomery Meigs, which had existed from the beginning of Meigs's tenure as chief of the Capitol extension, contributed to the decision in 1859 of the next secretary of war, John Floyd, to replace Meigs with a new army officer, W. B. Franklin. Despite these intrigues, which involved numerous debates in Congress over Meigs's stewardship and Brown's active campaign to remove him, Captain Montgomery Meigs together with Jefferson Davis

129. Hiram Powers. *America*. 1848–1850.
Plaster. Height, 89⅛ in. Courtesy of the
National Museum of American Art,
Smithsonian Institution. Museum purchase
in memory of Ralph Cross Johnson.

130. Hiram Powers. *Benjamin Franklin.*
1859–1862. Marble. Height, 95 in. U.S. Capitol,
Senate wing, second floor, east corridor.
Courtesy of the Architect of the Capitol.

131. Hiram Powers. *Thomas Jefferson.*
1859–1863. Marble. Height, 96 in. U.S. Capitol,
House wing, second floor, east corridor.
Courtesy of the Architect of the Capitol.

controlled the meaning of Thomas Crawford's sculpture for the extension and successfully kept out nearly all references or allusions to black bondage under white masters.[61]

Hiram Powers's *America* (fig. 129) further reveals how much the North-South conflict over bondage affected the Capitol decoration. The conflict affected works such as Crawford's *Justice and History* and *Progress of Civilization*, which espouse the concept of manifest destiny, and Powers's *Benjamin Franklin* (fig. 130) and *Thomas Jefferson* (fig. 131), which celebrate the founding fathers. Both categories exclude the issue of southern slavery. As we have seen, Jefferson Davis used his position as the cabinet member in charge of the Capitol extension to manipulate the meaning of the artworks so that none could be interpreted as condoning abolitionist sentiments. But the secretary of war was not alone in influencing the meaning of the painting and sculpture in the Capitol. In fact, northern statesmen affected the iconography of Powers's *America* in ways that would appease sectional strife, and they encouraged the artist to replace his personification with the more innocuous portraits of Jefferson and Franklin. Edward Everett especially urged Powers to eliminate the liberty cap, which the sculptor had intended to place in the uplifted left hand of *America*. It may be recalled that the former representative from Massachusetts followed the same scholarly reasoning as

Davis in explaining the inappropriateness of the pileus for American freedom. Articulated in 1849, one year before the compromise that temporarily resolved the conflict between North and South, Everett's argument arose because the statesman supported Powers's intention to house *America* as a national monument in the Capitol building. He recognized that southerners would never accept this covert condemnation of slavery.

Although Powers followed Everett's advice and got rid of the objectionable symbol, he nevertheless chose another and more overt emblem of emancipation when in 1855 he placed manacles beneath America's left foot.[62] It is not surprising that President Pierce hesitated to order the statue without seeing a photograph or having committee approval because, according to Everett, he feared that southerners would regard it as an anti-slavery statement. As Powers's friend explained, the president "is excessively guarded as to everything that concerns the 'peculiar institution,' & he may be afraid, that Southern members of Congress will misinterpret the meaning of the chains under the feet of 'America' and regard her as an abolitionist."[63] Acting as a lobbyist on Powers's behalf during the 1850s, when he also served as secretary of state and as a senator, Everett anticipated Pierce's potential aversion to *America*'s meaning, arguing that the marble figure is "the embodiment of the idea of free, popular, constitutional government."[64]

But Powers blamed Meigs for the president's rejection of the statue. The sculptor felt that he deserved the commission that Meigs had awarded Crawford for the statue on the Capitol dome, and he believed that "the armed figure's" bellicose and imperialistic statement appealed more to Meigs than did Powers's own "peaceful" conception.[65] "I regard 'America' rather the apostle of Liberty and self government—than the armed champion," Powers asserted. "Our business is to persuade and lead mankind, not to coerce them."[66]

It is difficult to determine whether Hiram Powers or Edward Everett was correct in assessing why the government failed to purchase Powers's *America*. At one point, Meigs confessed to Davis, "It is hoped that his statue of America will be one of the decorations . . . for the new Halls of the Legislature."[67] When Meigs wrote this letter, he probably did not know of Powers's insertion of the manacles under America's foot. But the charged disagreements over slavery led to extreme caution on the part of such northerners as Everett and Pierce, who shared with Davis a concern over anti-slavery implications in artworks in the Capitol. Northerners did not want to agitate southerners, and Davis did not want any acknowledgment of bondage. Consequently, in the case of Powers, rather than have his potentially dangerous *America* housed in the legislative building, President Buchanan finally granted the artist a commission for two portraits, one of Thomas Jefferson (1863) and one of Benjamin Franklin (1862), for the House and Senate wings, respectively. By the time Powers completed the Jefferson statue, however, the slavery issue had at least on the surface been resolved, even though the war continued, enabling one relatively small figure of a black man to inhabit the mural in the same stairway as Powers's *Benjamin Franklin*. (In the Epilogue, I consider this mural, Emanuel Leutze's *Westward the Course of Empire*).

Nevertheless, none of the statesmen, northerners nor southerners, succeeded

132. Constantino Brumidi. *Cornwallis Sues for Cessation of Hostilities under the Flag of Truce*. 1857. Fresco. 95½ × 130 in. U.S. Capitol, H-177, Members' Private Dining Room. Courtesy of the Architect of the Capitol.

in entirely banishing the dangerous symbols and images of blacks from the Capitol decoration. Constantino Brumidi placed an African American in his 1857 fresco on the south wall of the House chamber. (The fresco was moved into the House members' private dining room in 1961.) Located on the far right of *Cornwallis Sues for Cessation of Hostilities under the Flag of Truce* (fig. 132) is a black youth whose face, partially obscured by the soldier's broad hat and epaulet, recedes into the background tent of similar hues. It is as if this figure (who wears an earring and whose curly black hair, thick lips, and dark skin contrast with the features of the other people) is being pushed out of the composition, as he is wedged behind the two seated men and the Windsor chair and the tent. The figure is barely visible given the prominence of the white soldiers with their bright-colored clothing, the triangular focus of the three central figures, and the importance of Washington in this ceremonial painting celebrating the general's astute ploy to force the British surrender.

Neither Meigs nor Davis objected to the presence of a black man in this mural, which was an experiment to show the members of the House what such a wall painting would look like in the Capitol.[68] Consequently, it makes sense that Davis in particular did not object to the obscure presence of the black in the

picture, especially because its location in a corner at the far end of the room further camouflaged the black's innocuous and nonthreatening presence.

The ceiling in the House of Representatives, which had once contained each of the state seals in glass, also included potentially objectionable motifs. Installed two years before the outbreak of the Civil War, many of the thirty-one glass seals by Johannes Adam Oertel contained the pileus and pole, the very emblem that had hampered Powers's efforts to sell his *America* to the federal government and that Jefferson Davis had rejected. Perhaps the tiny scale of these state seals, located high in the House of Representatives ceiling, accounted for their presence in the building. More likely, no one wanted to tangle so overtly with the dangerous issue of states' rights by suggesting that one or more of the seals be removed.

It should be recalled that a Negro decorates the top right portion of Randolph Rogers's bronze doors. Yet because this ethnic figure clearly represents Africa as one of the four continents, neither Davis nor Meigs suggested that the personification could be linked to American slavery. Hence, Rogers faced no opposition in the representation of this safe allegory.[69]

To return to the series of questions raised at the beginning of the chapter: why are blacks almost entirely absent from the Capitol decoration when Indians figure prominently? It is possible that because of the continuous threat of disunion from slavery, both northerners and southerners felt that they needed to banish blacks from the artworks. This is certainly the case with Jefferson Davis, Edward Everett, and Franklin Pierce, each of whom had input about the works to be executed for the Capitol building. Undoubtedly, some Americans, such as Henry Kirke Brown, recognized the hypocrisy inherent in the contradictions between American freedom and southern captivity. White Americans may have come to terms with the extermination or banishment of the Indians from white territory, whereas African Americans continued to pose a problem, for whether free or enslaved, they would live among whites even if excluded from full participation in mainstream society. By dislocating the indigenous Indians and removing them to reservations, white Americans thought they could forget their existence. But African Americans always would be visible, especially as bondsmen and bondswomen in the South, and their presence in the country would force some statesmen to ensure their absence from the Capitol decoration. Furthermore, although the North and South were divided over slavery, nineteenth-century white Americans basically agreed about the Indians, for whether they would be assimilated, civilized, dislocated, or exterminated, the Indian culture would be destroyed. The Capitol artworks that featured Native Americans could serve as memorials of an extinct race and culture. Blacks, however, would not become extinct, especially because of their service in the South as chattel labor before emancipation. For these reasons, Indians could constitute a major motif in the antebellum Capitol decoration and take on mythicohistorical associations, unlike blacks, who reminded Americans of the volatile pro-slavery and anti-slavery arguments and hence could not enter the mythic realm of America's consciousness.

# Epilogue

## *Emanuel Leutze's* Westward the Course of Empire Takes Its Way

> Westward the Course of Empire takes its way;
>     The four first Acts already past
> A fifth shall close the Drama with the Day;
>     Time's noblest Offspring in the last.

Thus ends Bishop George Berkeley's "Verses . . . on the prospect of Planting Arts and Learning in America" (1752), in which he correctly predicted the focus of the nation's energies a century later.[1] Emanuel Leutze, the German-born painter who had moved with his family to the United States during his childhood and returned to Düsseldorf to study art, adopted the first line of Berkeley's final stanza as the title for his illustration of the emigration to the West (fig. 133), commissioned by Montgomery Meigs and approved by Secretary of War Simon Cameron for twenty thousand dollars in 1861 for the west stairway of the new House wing.[2] Begun one year after the start of the Civil War and completed in 1862, the mural summarizes the iconographic program that some works in the Capitol outline with slight, albeit significant, alterations that involve Native Americans and African Americans.

Meigs had first contacted Leutze in Düsseldorf in January 1854, informing him of his intention to hire American artists to fill the myriad wall spaces available for decoration "by the hand of the painter."[3] The artist replied that "the scenes that rise before an historical eye are vast [and] grand," indicating his willingness to "adorn the walls of the Capitol with pictures of the history of our country arranged in chronological order."[4] Meigs again contacted Leutze in February 1857, when the artist had returned to New York after having lived and studied abroad. This time Leutze replied with a more elaborate plan to illustrate events ranging from Columbus's discovery of America to the arrival of the Pilgrims, the Revolutionary War, and the storming of Chapultepec during the Mexican War. Interspersed amid this catalog of American historical events is the emigration to the West, the subject of a single commission for the House staircase, which Meigs instigated in March 1861 when he asked Leutze for a design for one of the "great stairways of the Capitol" that looks "bald without pictures."[5]

Condensing America's belief in its topological mission and manifest destiny into a large stereochromed wall painting—a German technique combining pigments, minerals, and waterglass—Leutze's work, also known as *Westward Ho!* does not depict the European discovery of the Atlantic coast, as do some of the Rotunda paintings and sculptures, but instead shows the pioneers' westward

133. Emanuel Leutze. *Westward the Course of Empire Takes Its Way (Westward Ho!)*. 1861–1862. Fresco. 240 × 360 in. U.S. Capitol, House wing, west stairway. Courtesy of the Architect of the Capitol.

emigration to the Pacific. The predella below the mural designates this final destination, for it illustrates the Golden Gate of San Francisco harbor.[6] "The drama of the Pacific ocean closes our Emigration to the West," explained the artist, who probably selected this site because of its associations with Eldorado, the land of gold, which represented the "promised land."[7]

The German-trained Leutze emphasized the hardships experienced by these travelers, explaining in his notes that the "suffering wife" clothed in red and blue in a Madonna motif "with her infant in her arms . . . has folded her hands thanking [God] for escape from dangers past." Despite the toil of these weary emigrants, Leutze nevertheless infused the work with hope, evident in the golden sky and the Pacific slope, which contrast with the treacherous mountains on the right, identified by the artist as "the valley of darkness." Leutze also has included numerous optimistic and sanguine figures, whose strategic placement in the composition catch the viewer's attention: "a frontiere farmer (Tenneseeian)," whose outstretched arm echoes that of the "old trapper, clad complete in buckskin," who points the way to the promised land while protecting the mother and her children in front of him; the eager "young adventurer" on horseback, in the foreground, who rises in his stirrups "to catch his first glimpse of the distant land"; and the young man, tiny in scale, standing on the pinnacle of a rock, who plants "the American banner" and raises his left arm in celebration and triumph.[8] This figure, who signifies conquest, forms the apex of a pyramidal composition in

which the exuberant and weary men and women lead the viewer's eye along the base to the summit through gestures, body positions, and glances.

Unlike the works created earlier for the Capitol, this "noble Epic in colors," as the *National Intelligencer* dubbed the mural,[9] does not represent explicitly the struggles between the homesteaders and the native population, although such conflict had occurred, as indicated in the foreground by the elderly "hunter of the border," with two rifles over his right shoulder and a feather in his cap, who assists a younger "lad" who, according to the artist, "has been wounded, probably in a fight with the Indians." Located behind these two figures and to the right is a team of oxen, driven by a boy holding what Leutze identified as "Indian arrows and a bow," suggesting that some Native Americans had been defeated during the pioneers' long trek across the continent.[10] There are also pioneers toiling with their wagons up the Great Divide, and nestled in a grassy, green island are animal skulls from deceased livestock, a broken wheel, and a damaged Conestoga wagon. The route to Eldorado had not been easy, but the pioneers nevertheless have triumphed over the arduous landscape and recalcitrant tribes. (Leutze made a trip to the west as far as the Colorado Territory in preparation for this painting, but unlike Catlin, Eastman, and Stanley, he went to view the landscape rather than document various tribes and customs.)[11]

Although the subject of conflict between the indigenous people and the emigrants—so prevalent inside and outside the Rotunda—remains absent in the mural, Leutze nevertheless placed the Native Americans in the upper margin, the locus of mythic vignettes and the mythic text. (The "arabesque" scroll in blue and gold with the motto "Westward the Course of Empire Takes Its Way" decorates this area.) Situated in this horizontal upper border are three figures of Indians, all difficult to discern: one, according to the artist, "creeping and flying" away from a central eagle, who "shields union and liberty under his wings" (represented by putti-like figures); another "creeping, discharging an arrow at the hunter" along the left; and a third, on the right, "covering himself with his robe sneaking away from the light of knowledge."[12] Leutze removes these references to frontier conflict from the major scene to a subsidiary location, displacing the dispossessed Indian onto the perimeter of his mural and indicating that triumphant U.S. emigration to the Pacific coast resulted in its final conquest of the land and the Indians. Confrontation had receded into the past, Leutze suggests, allowing America's final realization of its manifest destiny in the New World Eden, although three columns of smoke in the left valley indicate additional tribal villages and, possibly, further battles. With the Euro-Americans' final thrust to the western coast, the Native Americans will be successfully defeated, Leutze's mural implies, enabling the fulfillment of civilization's providential progress from east to west.

In the left and right frames, faint grisaille vignettes against a brown background make it clear that the work refers to America's millennial typology. "Moses leading the Israelites through the desert" and "the spies of Escholl bearing the fruits from Canaan" join with such mythological scenes as "Hercules dividing the pillars of Gibraltar" as a means emblematically to refer to the preor-

dained mission of the United States in heralding the millennium on earth.[13] The Chosen People underwent special trials along their passage westward as a means to fulfill their goal, not from earth to heaven, as Sacvan Bercovitch has explained, but from "lesser to greater glories on the American strand."[14] Eldorado was the promised land sought after by nineteenth-century Americans who followed the path first blazed by such hunter-adventurers as William Clark and Daniel Boone, who are depicted in the medallions in the center of the two vertical frames. Flanking the bottom panel of San Francisco Bay are two inscriptions: on the right, "The Spirit grows with its allotted Spaces / The Mind is narrow'd in a narrow Sphere," and on the left, "No pent up Utica Contrasts our Powers but the whole boundles[s] Continent is ours." These indicate that the nation will succeed in its mission, led by such people as the colossal frontiersman in the mural, who protects the mother and her children and replaces the earlier trappers, taking on mythic proportions in scale.

The mural with its framing margins and predella combines secular and sacred history into a religious altarpiece that eulogizes the nation's accomplishment of its mission and manifest destiny. America had succeeded in fulfilling its God-ordained errand into the wilderness to the Pacific shore, overcoming the Indian threat, which had failed to arrest the nation's compelled migration westward. "Without a wish to date or localize, or to represent a particular event," Leutze wrote, "it is intended to give in a condensed form a picture of western emigration, the conquest of the Pacific Slope."[15]

Leutze's *Westward Ho!* not only demarcates the purported end of white-Indian conflict (wishful thinking) but also marks the beginning of the improved status of African Americans. Located toward the center of the composition in the foreground stands a black boy, a figure Leutze had not included in his two oil sketches.[16] Leutze probably added the figure after he learned of Lincoln's Emancipation Proclamation, at which point he must have felt comfortable including the African American even though the war over slavery continued.[17] Since Davis no longer controlled the Capitol decoration, it is not surprising that Meigs did not object to the figure.

The black youth stands before an Irish woman who, seated on a donkey and holding her child, represents the "new Madonna," according to Anne Brewster, who published an interview with the artist in *Lippincott's Magazine* in 1868.[18] In this Holy Family archetypal motif, the former slave replaces Joseph to form an integrated, pluralistic community in the west. The emigrant and the freedman teach "a new gospel to this continent," Brewster explained, forming "the two great elements which are to be reconciled and worked with" in post–Civil War America.[19] The two elements of Brown's House pediment design that had resulted in its rejection for the Capitol extension—the slave and the immigrant—are now integrated in Leutze's mural, signaling a change in society that continues today.

"Nothing more clearly indicates the vigorous power of this young and growing nation," proclaimed the *National Intelligencer* in 1862 about Leutze's *Westward*

*Ho!* Noting that a war "of unequalled magnitude is raging in [the nation's] midst," the journal congratulated the government for "calmly" supporting the "peaceful arts" and providing for "the future of a united nation as if the war were but a momentary impediment."[20] Nathaniel Hawthorne also interpreted the creation of the mural in the midst of war as a positive sign, noting that the painting "looked full of energy, hope, progress, irrepressible movement onward," in spite of "this dismal time, when our country might seem to have arrived at such a deadly stand-still." For Hawthorne, Leutze's perseverance indicated his belief in "a more enduring existence" of unity.[21] A speaker at the New-York Historical Society on January 6, 1863, concurred: "While the grapes of Eschol, the dove with the olive branch . . . and those other beautiful symbols of Peace and prosperity were springing up silently on the wall beneath the cunning pencil of the artist, the drums were rattling through the Senate Chamber and the litters of the wounded from the Peninsula were borne along the corridors. . . . Let us hope that even a fratricidal war will not fatally interrupt the glorious progress of the Nation."[22] That the government financed the painting during the Civil War shows that these assessments contained a kernel of truth, for the secretary of war had initially stopped all expenditures except for defense.[23]

Meigs recognized the symbolic significance of the mural's completion in the midst of the North-South conflict and convinced Secretary of War Simon Cameron that Leutze needed to continue working on his mural despite the war.[24] As a result, Leutze's painting memorializes not only westward expansion but also nationhood itself, which survived, as Angela Miller eloquently put it, "the challenges of geography, sectionalism, and slavery to affirm the republican promise in the enlarged sphere of empire."[25] Leutze's mural thus became a symbol of the nation's triumph over the ensuing sectional conflict, suggesting that the long-prophesied millennium would be an outcome of the war.

*Westward Ho!* was not the only artwork for the Capitol that accrued symbolic meaning in the midst of the Civil War. Laborers hoisted Thomas Crawford's *Statue of Freedom* on top of the newly renovated dome one year after the mural's completion. It now seems propitious that the completion of Leutze's *Westward the Course of Empire* and Crawford's *Statue of Freedom* occurred in the midst of the Civil War. These two prominent works proclaimed the nation's providential mission as having reached its apogee despite the war, setting the stage for the nation's movement outward to other hemispheres. *Statue of Freedom* still stands triumphant atop the U.S. Capitol, proclaiming the nation's expansionist ideology of the nineteenth century as the continued focus in the twentieth. Whether or not Americans and their representatives agree with this vision, the Minerva-like statue nevertheless asserts such global aspirations. Leutze's *Westward Ho!* continues to decorate the House staircase that thousands of Americans climb every year to observe the legislature in session. Few stop to look at the mural, but it remains a vivid, colorful panorama that documents and mythologizes the nation's drive westward, a secular altarpiece that unites the diverse iconography of the nineteenth-century Capitol decoration in a single work of art.

# Notes

## Introduction

1. Charles L. Griswold, "The Vietnam Veterans Memorial and the Washington Mall," 692–693.

2. Neil Harris, *The Artist in American Society*, has examined American fears about the arts as too ostentatious for a republic that should express simplicity.

3. For further discussion of the Vanishing American, see Dippie, *Vanishing American*.

4. For a useful introduction to the various definitions of the term *ideology*, see Eagleton, *Ideology*.

5. For an analysis of other themes, see Fryd, "Sculpture as History."

6. Public art has recently been the focus of scholarly attention, possibly, as Michele Bogart has pointed out, because of the controversies that have erupted over such notorious works as Richard Serra's *Tilted Arc*, commissioned in 1979 for the Federal Plaza in Lower Manhattan, installed in 1981, and removed in 1988. (See Bogart, *Public Sculpture and the Civic Ideal*, 1–2). Bogart's study is among the first to focus on issues surrounding public art. See also Gurney, *Sculpture and the Federal Triangle*; Garvey, *Public Sculptor*; and Senie and Webster, eds., "Critical Issues in Public Art." Conferences and symposia have also highlighted this topic, most notably "Decorating Our Nation," Delaware Symposium on American Art, April 1989; and "Public Art in America since 1776," College Art Association, New York, February 1990.

7. Many art historians in the past few years have studied the interrelationship between art and politics, mostly in nineteenth-century European art. See Herbert, *David, Voltaire, "Brutus," and the French Revolution*; Clark, *Image of the People: Gustave Courbet and the 1848 Revolution*; Millon and Nochlin, eds., *Art and Architecture in the Service of Politics*; Boime, *Art in an Age of Revolution, 1750–1800*; Marrinan, *Painting Politics for Louis-Philippe*; and Nochlin, *The Politics of Vision: Essays on Nineteenth-Century Art and Society*. For explorations in twentieth-century art, see Guilbaut, *How New York Stole the Idea of Modern Art*; Folgarait, *So Far From Heaven: Siqueiros' "The March of Humanity"*; Whiting, *Antifacism in American Art*; and Pohl, *Ben Shahn*.

8. The few scholars who have analyzed the image of the Indian in the visual arts are Ellwood Parry, *Image of the Indian and the Black Man*; Hugh Honour, *New Golden Land*; Robert F. Berkhofer, Jr., *White Man's Indian*; Lee Clark Mitchell, *Witnesses to a Vanishing America*; Kathryn Sweeney Hight, "Frontier Indian in White Art"; and Julie Schimmel, "Inventing 'the Indian,'" in *The West as America*, 149–189.

9. Groseclose, "American Genesis: The Landing of Christopher Columbus."

10. For the status of women artists in nineteenth-century America, see Harris and Nochlin, *Women Artists, 1550–1950*, 50–58. See also Gerdts, *White Marmoreal Flock*.

11. Prioli, "Wonder Girl from the West."

12. Kolodny, *The Land Before Her: Fantasy and Experience of the American Frontiers, 1630–1860*.

13. Slotkin, *Regeneration through Violence: The Mythology of the American Frontier, 1600–1860*.

14. Roger S. Stein uses this triad of verbs—*embody*, *crystallize*, and *reinforce*—in "Thomas Smith's Self-Portrait," 320.

15. Edmundo O'Gorman, *Invention of America*, asserts that historians have made Columbus into the founder of the United States.

*Chapter 1*
*The Rotunda Reliefs*

Portions of this chapter were published earlier in "The Italian Presence in the United States Capitol," in Irma B. Jaffe, ed., *The Italian Presence in American Art, 1760–1860* (New York: Fordham University Press; Rome: Istituto della Enciclopedia Italiana, 1989).

1. Elliot, *Historical Sketches*, 35.
2. I have adapted Louis Marin's term *representational screen* to describe the picture surface. See Marin, "Towards a Theory of Reading in the Visual Arts," in Bryson, ed., *Calligram*, 63–90.
3. Norton, *Latrobe, Jefferson and the National Capitol*, 2. See also Hodgkins, "Naming the Capitol and the Capital."
4. Frary, *They Built the Capitol*, 33.
5. Scott, "Building the Original Capitol."
6. For Benjamin Latrobe's report in which the Architect of the Capitol detailed the building's destruction (in preparation for its construction), see Latrobe to Thomas Jefferson, n.d., in Padover, ed., *Thomas Jefferson and the National Capitol*, 473–476. See also *Documentary History of the Construction and Development of the United States Capitol Building and Grounds*.
7. Miller, *Patrons and Patriotism*, 44. For details concerning the dispute between Lane and Latrobe, see Brownell, "Latrobe, His Craftsmen, and the Corinthian Order," in Quimby, ed., *The Craftsman in Early America*, 247–272.
8. Information on the architecture of the Capitol is surprisingly scarce. The best summaries can be found in Frary, *They Built the Capitol*, and Brown, *History of the United States Capitol*. See also Harris, "The Significance of William Thornton's Design for the U.S. Capitol"; Butler, "Competition 1792"; and Campioli, "The Original East Central Portico of the Capitol." A detailed discussion of the political friction involved in the establishment of a new federal city can be found in Bowling, *Creating the Federal City, 1774–1800*.
9. Mazzei, an Italian physician, merchant, and horticulturist, acted as Virginia's agent in Europe during the last years of the American Revolution. He had visited Virginia in 1773, buying land adjacent to Monticello, where he and his family resided while his house was being built. In June 1779 he lived in London, acting on behalf of the state of Virginia. He returned to the United States in 1784, but shortly thereafter resettled in various European cities. When Latrobe considered decorating the Capitol with sculptural ornamentation, Jefferson recommended he contact his friend Mazzei for assistance. For Mazzei's biography, letters, and association with Jefferson and other American statesmen, see Garlick, *Philip Mazzei*.
10. Latrobe to Mazzei, March 6, 1805, in Padover, ed., *Thomas Jefferson and the National Capitol*, 355.
11. Jefferson to Governor William Miller, January 22, 1816, in Gardner, *Yankee Stonecutters*, 7.
12. Latrobe to Mazzei, March 6, 1805, in *Thomas Jefferson and the National Capitol*, 357.
13. Garlick, *Philip Mazzei*, 151. Mazzei elaborated that Andrei and Franzoni are "republicans in their heart . . . and so contented to go to the United States, that (according to my opinion) they will never think of returning to Europe. . . . They are able to model and make excellent statues in marble" (150–151). Mazzei furthermore recommended Thorwaldsen, the "most eminent among" the artists in Italy and the most qualified to execute the figure of Liberty. Latrobe explained in a letter to Mazzei of December 19, 1806, that the president did not wish to incur the expense of hiring the Danish sculptor and that Franzoni would execute the statue even though "Canova & probably Thorwaldsen & Flaxman are his superiors in a great degree." Fairman, *Art and Artists of the Capitol*, 11.
14. For piecemeal information on these works, see Fairman, *Art and Artists of the Capitol*, 1–22, and Frary, *They Built the Capitol*, 107–112. Charles E. Brownell, "Latrobe

and Programs of Ornamentation," discusses Latrobe's role in the architectural decoration of the Capitol before 1814.

15. Jaffe, *Trumbull: The Declaration of Independence*, 93. For more information about Trumbull's career, see Jaffe, *John Trumbull: Patriot–Artist of the American Revolution.*

16. Trumbull also brought along three other oil sketches: *The Capture of the Hessians at Trenton* (1786), *The Death of General Mercer at the Battle of Princeton* (1786), and *The Surrender of Lord Cornwallis at Yorktown* (1787). Prown, "John Trumbull as History Painter," in Cooper, ed., *John Trumbull: The Hand and Spirit of a Painter*, 22–41.

17. For a discussion of the debates in Congress over Trumbull's commission and the subsequent criticisms of his murals, see Miller, *Patrons and Patriotism*, 45–48. See also *Annals of Congress*, Senate, 14th Cong., 2d sess., January 13, 1814, 64; House, *Annals of Congress*, 14th Cong., 2d sess., January 22, 1817, 704; January 27, 1817, 761–763; February 28, 1817, 1041; House, 15th Cong., 2d sess., February 9, 1819, 1142–1145.

18. Trumbull, *Autobiography*, 257–258.

19. Trumbull, *Description of the Four Pictures*, iii.

20. Ibid., vi.

21. John Trumbull to Charles Bulfinch, January 28, 1818, in Trumbull, *Autobiography*, 266.

22. For a more detailed explanation of the collaboration among Trumbull and the two architects, see Egon Verheyen, "John Trumbull and the U.S. Capitol: Reconsidering the Evidence," in Cooper, ed., *John Trumbull*, 260–271, and Jaffe, *John Trumbull: The Declaration of Independence*, 101–106. Verheyen accurately perceived that Trumbull had wanted to create a panorama (269).

23. Trumbull to Bulfinch, January 28, 1818, in Trumbull, *Autobiography*, 266.

24. Bulfinch to Henry Couceci [*sic*], July 8, 1822, Commissioner of Public Buildings, Record Group 42, National Archives. In the same letter, Bulfinch solicited a design of "an allegorical or historical subject" for the central tympanum, cautioning the Italian that his grandiose ideas would not be commissioned by the commissioner of public buildings because of the expense and length of time needed for production. Bulfinch then suggested Causici work on "a group in sculpture, to accompany a clock in the Senate chamber, to stand over the principal door frame. . . . I leave it to your taste to introduce the figure of *Time* or any emblems that may be suitable . . ." Earlier, in 1819, another Italian, Carlo Franzoni, whose brother Giuseppe had arrived in the United States sometime after mid-July 1816, created *Car of History* for the clock in the old House of Representatives (now Statuary Hall). *Niles' Weekly Register* 45 (September 21, 1833): 53, reported that Causici had died in Havana, Cuba, of Asiatic cholera.

25. As Trumbull himself explained in his guidebook to the Rotunda paintings, "This Revolution has not only produced the establishment of a new and mighty empire, but an empire founded on a new principle, the principle that man, under the guidance of the representative system, is capable of governing himself, without the aid of autocracy, oligarchy, or aristocracy." Trumbull, *Description of the Four Pictures*, 7.

26. *Niles' Weekly Register* 23 (March 1, 1823): 415.

27. Antonio Capellano to Joseph Elgar, January 29, 1824, and Capellano to Elgar, February 28, 1824, Commissioner of Public Buildings, Record Group 42, National Archives. Capellano requested five thousand dollars for the outset of the work's creation and two thousand dollars a year while executing the reliefs. Elgar replied, "I am sure the compensation you require is by no means greater than your talents might fairly claim, but it is so much beyond anything I could feel authorized to offer, that I begin to despair of accomplishing what I much desired, the securing to the public some specimen of your distinguished abilities." Elgar to Capellano, March 4, 1824, Commissioner of Public Buildings, Record Group 42, National Archives.

28. Bulfinch to Elgar, January 29, 1829, House Committee on Public Buildings, 20 AG 16.1, National Archives.

29. Castiello, "The Italian Sculptors of the United States Capitol, 1806–1834," attributes to Iardella the carving of all four reliefs because he was listed in payment

vouchers as the carver. Certainly Causici and Capellano came up with the compositions, although Iardella may have then helped carve them. See Castiello, "Italian Sculptors," 48 and 53 and Accounts J. Elgar nos. 48,592; 49,157; 49,538; 50,841; 51,887; 52,036; 52,317; 53,676; 55,024; 55,475, National Archives.

30. Woodward, *Pocahontas*, 48. Other sources that detail the Pocahontas-Smith legend are Young, "Mother of Us All"; Barbour, *Pocahontas and Her World*; Green, "Pocahontas Perplex"; Mossiker, *Pocahontas;* and Anderson, "Best of Two Worlds."

31. The date of 1606 inscribed on the relief is thus incorrect. In Rembrandt Peale's reminiscences of Capellano, whom he knew in the 1830s, the painter reported that the Italian "was a most industrious man—and so devoted to his marble that he could not spare an hour to learn either French or English." Peale, "Reminiscences," 6. Since Capellano's letters to the commissioner of public buildings are in English, the sculptor either knew the language or asked someone to translate his correspondence. If the latter, then Capellano could not have read the books on Pocahontas. This does not negate my argument, however, for someone could have conveyed the content of the texts to the artist and, in so doing, made revisions or simplifications, which would account for his departure from Smith's version and the mistake in the date, 1606, inscribed in the lower left-hand corner of the relief.

32. This passage is published in full in *Captain John Smith: A Select Edition of His Writings*, 64. Francis Mossiker, in *Pocahontas*, theorizes that the Indian princess's rescue of Smith constituted a portion of the adoption ceremony characteristic among northeast woodlands tribes in the seventeenth and eighteenth centuries (81). Francis Jennings, *Invasion of America*, 152, suggests that the act derived from an Indian custom that allowed a widowed woman to adopt a prisoner to replace her deceased husband. Helen C. Roundtree, on the other hand, rejects these suggestions, arguing that Smith did not write the event as if it belonged to a ritual sequence and that only the Iroquois are known to have such adoption ceremonies (*Pocahontas's People*, 39).

33. Among the nineteenth-century poems, plays, and books about Pocahontas are John Davis, *Captain Smith and Princess Pocahontas: an Indian Tale* (1817); *Virginia, or the Fatal Patent: A Metrical Romance* (1825); Samuel Griswold Goodrich, *Stories about Captain Smith, of Virginia* (1829); George Washington Custis, *Pocahontas, or the Settlers of Virginia* (1830); Robert Owen, *Pocahontas: A Historical Drama in Five Acts* (1837); and Seba Smith, *Powhatan: a Metrical Romance in Seven Cantos* (1841). Both Elliot, *Historical Sketches*, 114, and Mills, *Guide to the Capitol*, 26, quote Smith's account of Pocahontas's rescue.

34. Elliot, *Historical Sketches*, 114.

35. John Davis suggested this interpretation in his 1817 biography of Smith, in which he recognizes that "the race of Indians have been destroyed by the inroads of the whites" (65).

36. Brilliant, *Visual Narratives*, 23.

37. Ibid.

38. For Adams's speech, see *An Oration, Delivered at "Plymouth," December 22, 1802*. Robert Arner, in "Plymouth Rock Revisited," identifies Adams's speech as the beginning of the Plymouth Rock mythology, analyzes the pilgrimage as a symbolic rite of passage, and discusses Webster's oration. The rock's mythic significance is suggested by Elliot, who in discussing Causici's relief concluded, "The identical rock on which the Pilgrims first landed, has been broken up into fragments, and one part of it placed in the centre of the town of Plymouth, where it is known by the name of 'Forefather's Rock,' and is visited with a degree of veneration by all New Englanders" (*Historical Sketches*, 117). See also Watterston, *New Guide to Washington*, 38, for another reference to the rock's meaning.

39. Force, *Picture of Washington*, 62.

40. Historians have identified Squanto as the Indian who taught the emigrants in the Plymouth colony to plant corn. It is unlikely, however, that Causici intended to portray this Patuxet Indian or to record his crucial role in helping the settlers survive. For information about Squanto, see Adolf, "Squanto's Role in Pilgrim Diplomacy."

41. Winthrop, "Pilgrim Fathers," in *Addresses and Speeches on Various Occasions*, 10.

42. Berkhofer, *White Man's Indian*, 130.

43. Clarkson, *Memoirs of the Private and Public Life of William Penn* (1813), 1:338–339; *Niles' Weekly Register* 28 (June 11, 1825): 226. For discussions about the other treaties, see Clarkson, *Memoirs of Penn*, 1:240–256; Weems, *The Life of William Penn, the Settler of Pennsylvania* (1836), 146–156. When Clarkson's book, first published in 1813, was revised in 1849, illustrations were added, including an engraving of West's famed painting of the treaty.

44. Abrams, "Benjamin West's Documentation of Colonial History," discusses these medals.

45. Prucha, *Indian Peace Medals in American History*, 3.

46. Abrams, "Benjamin West," 70.

47. Clarkson, *Memoirs of Penn* (1813), 1:338.

48. The pointing finger literally acts as an indexical sign that points to the treaty. The relationship among the figures merely underscores the importance of the document as the beginning of peace between the two races. The semiotic term *indexical sign* was coined by C. S. Peirce and explained by Wendy Steiner, *Exact Resemblance to Exact Resemblance*, 6.

49. Clarkson's relatively factual biography of Penn never mentions such a ritual. Parson Weems's anecdotal biography, however, has the handshake occurring more than once during the meeting between the Quakers and the Delawares. Upon Penn's finishing his speech to the Indians, they "cordially [shook] hands all around" and then smoked a peace pipe (154). According to Weems, the two parties shook hands earlier in the ceremony as well (148).

50. According to Francis Jennings ("Brother Miquon: Good Lord!" in Dunn and Dunn, eds., *World of William Penn*, 200), in Indian diplomacy a chain of friendship was a political bond created by a treaty. I wonder if the handshake on the peace medals intentionally referred to the native tradition or was merely a coincidence.

51. Slotkin (*Regeneration through Violence*, 204) identifies the French symbolic figures of the good savage and good Quaker as originating in Voltaire.

52. Galt, *Benjamin West*, 14–15.

53. Jennings, *World of William Penn*, 195–214.

54. Rogin, "Political Repression in the United States," in *Ronald Reagan, the Movie*, 47. "Treaties presented a fiction of Indian freedom to disguise the realities of coerced consent, bribery, deception about boundaries, agreements with one faction enforced on an entire tribe, and the encouragement of tribal debts—real and inflated—to be paid off by the cession of land" (46).

55. Filson, *Discovery of Kentucke and the Adventures of Daniel Boone*, 53.

56. Bryan, *Mountain Muse*; and Timothy Flint, *Biographical Memoir of Daniel Boone*.

57. Mills, *Guide to the Capitol*, 28; Paulding, *Westward Ho!* 1:70, 55.

58. Filson, *Discovery of Kentucke*, 57.

59. Force, *Picture of Washington*, 61.

60. *Niles' Weekly Register* 62 (May 21, 1842): 180.

61. Force, *Picture of Washington*, 61; Haas, *Public Building and Statuary of the Government*, 19.

62. Mills, *Guide to the Capitol*, 28; Haas, *Public Building and Statuary*, 18.

63. Haas, *Public Building and Statuary*, 20; Elliot, *Historical Sketches*, 120. Mills thought that "in the neighborhood of the subjects previously described [*Smith* and *Pilgrims*] it loses its interest" (27).

64. Knapp, *History and Topography of the United States of North America*, 2:427. For disparaging remarks about Penn's hat, see U.S. Congress, *Register of Debates*, House, 19th Cong., 1st sess., March 18, 1826, 2657, and House, 19th Cong., 2d sess., February 23, 1827, 1364.

65. U.S. Congress, *Register of Debates*, House, 19th Cong., 1st sess., May 18, 1826, 2657.

66. Knapp, *History and Topography of the United States*, 2:426. Elliot, *Historical Sketches*, 115.

Elliot perceived the face and headdress of Pocahontas as Grecian and the features of Powhatan as "less like an Indian than an European" (119).

67. U.S. Congress, *Register of Debates*, Senate, 18th Cong., 2d sess., February 22, 1825, 639–640.

68. For more information on Jefferson's attitudes and policy, see Sheehan, *Seeds of Extinction*.

69. Thomas Jefferson to Benjamin Hawkins, February 18, 1803, in *Writings of Thomas Jefferson*, 8:214. Three books are especially helpful in understanding Jefferson's attitudes toward the Indians: Dippie, *Vanishing American*; Rogin, *Fathers and Children: Andrew Jackson and the Subjugation of the American Indian*; Takaki, *Iron Cages: Race and Culture in Nineteenth-Century America*. For the relationship between the U.S. market economy and Indian policy, see Takaki, *Iron Cages*, 57–60.

70. Information about the relations between Indians and whites during this period is extensive, but most helpful are Dippie, *Vanishing American*; Drinnon, *Facing West*; Horsman, *Race and Manifest Destiny*; Prucha, *American Indian Policy in the Formative Years*; and Sheehan, *Seeds of Extinction*.

71. Quoted in Dippie, *Vanishing American*, 48.

72. The exact number of deaths is disputed. See Prucha, "Doing Indian History," 7–8. In addition to the sources cited previously, Philip Borden, "Found Cumbering the Soil," 71–97, provides a succinct summary of the Indian removal policy, linking it with the ideology of manifest destiny.

73. For Jackson's degrading nickname for the Indians, see Takaki, *Iron Cages*, 96. Takaki analyzes the relationship between racial domination and the development of capitalism in nineteenth-century American society, providing the basis for my references to what Takaki calls the "market revolution" and the importation of slaves into former Indian territory (110).

74. Jaffe, *John Trumbull*, 16.

*Chapter 2*
*The Rotunda Paintings*

1. The contract for the murals stipulated that the vice president and Speaker of the House would decide the location of each picture. See Fiscal Branch, Acct. 81.296, National Archives. For my analysis of the visual narratives explicated in these reliefs, I am using as my theoretical model Brilliant's study of ancient serialized images in *Visual Narratives*. The places of Powell's *Discovery of the Mississippi* and Weir's *Embarkation of the Pilgrims* were switched in 1979, following a proposal of November 1, 1978, by the Joint Committee on the Library. David Sellin, curator of the Capitol, explained, "Now the diagonal groupings, massing, and tonality of the Vanderlyn and Weir form a monumental pyramidal focus at the East portal, with an iconographic emphasis on the discovery of Columbus and the Pilgrim settlement, two of the events in American history known to all American children. The Powell and Chapman compliment them, and each other in the new arrangement." Memorandum from David Sellin to George M. White, August 27, 1979, Records of the Architect of the Capitol. I am analyzing the works' locations prior to the change.

2. For the divisiveness over slavery, see Potter, *Impending Crisis, 1848–1861*, 4.

3. Todorov, *Conquest of America*, 44.

4. *New-York Mirror*, July 16, 1836, 23.

5. John Quincy Adams recorded in his diary that three sketches had been placed beneath Trumbull's murals: the deaths of Warren, Montgomery, and Mercer. Adams, *Memoirs*, 7:188–189. Egon Verheyen has identified the fourth sketch, described by Adams as "another battle," as *The Capture of the Hessians at Trenton*. Verheyen, "John Trumbull and the U.S. Capitol," 271. These sketches are discussed in greater detail in Jaffe, *John Trumbull: Patriot-Artist*, and in Prown, "Trumbull as History Painter."

6. John Trumbull to Wilkes, January 28, 1827, quoted in Jaffe, *John Trumbull: Patriot-Artist*, 257.

7. Report of the Architect of the Capitol, December 27, 1827. *Message from the President*, 20th Cong., 1st sess., January 4, 1828.

8. *Annals of Congress*, House, 14th Cong., 2d sess., February 28, 1817, 1041.

9. Miller, *Patrons and Patriotism*, 46–47.

10. *Register of Debates*, House, 20th Cong., 1st sess., January 9, 1828, 942.

11. John King of New York presented the first memorial, which was referred to the Committee on the District of Columbia. *Register of Debates*, Senate, 18th Cong., 1st sess., March 3, 1824, 314. On April 27, Edward Lloyd of Maryland, also on the committee, reported a bill to authorize the painting. The resolution was read and passed to a second reading. Ibid., 581. Later that month, the bill was read a second time and referred to the Committee on Public Lands. Ibid., April 29, 1824, 592–593. In May, the Senate tabled the resolution. Ibid., May 21, 1824, 769.

12. House, "Designs of Paintings," 19th Cong., 2d sess., December 19, 1826, H. Rpt. 8. For the original document, see House Committee of the Library, Record Group 233, HR 19A-D11.2, National Archives.

13. *Register of Debates*, House, 20th Cong., 1st sess., January 8, 1828, 929. Ralph I. Ingersoll of Connecticut and Henry W. Dwight of Massachusetts both submitted amendments to promote John Trumbull in lieu of South Carolina's favorite son. Ingersoll suggested Allston's name be replaced with either Trumbull's or that of "some suitable artist," whereas Dwight proposed four Revolutionary War subjects, most of which Trumbull had already sketched: the battles of Bunker Hill, Quebec, and Monmouth, and the attack on Quebec. (Trumbull never drew Monmouth. For a list of the subjects considered and executed by the artist, see Jaffe, *John Trumbull: Patriot-Artist*, 154.)

14. This last conflict in the War of 1812 "so brilliantly closed our second contest" (Hamilton) and hence as a subject was an appropriate companion to Trumbull's *Surrender of Yorktown*, which celebrated the end of the first war with Great Britain. *Register of Debates*, House, 20th Cong., 1st sess., January 8, 1828, 929. For references of party affiliation in Congress, I have relied on *Biographical Dictionary of the United States Congress 1774–1989*; 100th Cong., 2d sess., Senate Doc. 100-34.

15. Hall, *Travels in North America*, 3:49–67. Others have discussed the partisan implications of this debate: Jaffe, *John Trumbull: Patriot–Artist*, 257; Miller, *Patrons and Patriotism*, 48–49; Frese, "Federal Patronage of Painting to 1860"; Nielson, "Paintings and Politics in Jacksonian America"; and Warren, *Odd Byways in American History*. For the debate itself, see *Register of Debates*, House, January 9, 1828, 941.

16. *Register of Debates*, House, January 8, 1828, 932. Henry Storrs of New York further clouded the discussion by introducing a new topic. Naval victories deserved as much consideration as military exploits, asserted the former Federalist, proposing that "chivalrous triumphs of the Navy" be selected "for such national commemoration." The following day the National Republicans confounded the issue by elaborating on Storrs's proposal for naval subjects. The congressman from New York continued his arguments by admonishing that "our seamen seem to have been . . . overlooked." Promoting the battles of Lake Erie and Lake Champlain, Storrs explained that "while the one saved New Orleans, and protected the Southwestern portion of the Union, the others gave security to the Northwestern States, the Western and Northern frontiers of New York and Vermont." Other members offered additional measures, calling innocuously for "a series of historical paintings" instead of specifying the New Orleans battle, and offering additional subjects as varied as the battles of Bridgewater and of Lake Champlain, Penn's treaty, and the landing of the Pilgrims. *Register of Debates*, January 9, 1828, 935, 941, and 946. John Randolph offered a resolution for a gold medal to commemorate the Battle of New Orleans, and one of the future founders of the Whig party, Elisha Whittlesey of Ohio, suggested Perry be celebrated in a similar manner. Randolph's proposal was the final attempt to heroicize the last conflict in the War of 1812. Ibid., 947–948.

17. Allston expressed his preference for religious subjects: "the three Marys at the tomb

of the Saviour." Allston to Verplanck, March 1, 1830, in Flagg, *Life and Letters of Washington Allston*, 233. Verplanck correctly discouraged this as inappropriate for the Capitol, recommending instead the landing of the Pilgrims, a subject Allston rejected because his friend Henry Sargent had already painted the subject on canvas. Allston then proposed a scene from Washington Irving's fairly recent *Life and Voyages of Christopher Columbus* (1828). See Verplanck to Allston, March 9, 1830, Flagg, *Life and Letters of Allston*, 235; Allston to Verplanck, March 29, 1830, ibid., 236–237; "Some Unpublished Correspondence of Washington Allston," 79–80; and Gerdts and Stebbins, *Man of Genius*, 150. Allston had declined the commission even before it failed to be passed, recommending instead John Vanderlyn, Thomas Sully, and Samuel F. B. Morse. David Bjelajac has suggested that Allston recognized that his sacred subject would not appeal to the Democrats, who favored a separation between church and state. See Bjelajac, *Millennial Desire*, 160–161. Washington Allston removed himself from consideration also because of his obsession with *Belshazzar's Feast*, a large history painting that consumed his attention from 1817 until his death. Gerdts and Stebbins, *Man of Genius*, 150; Allston to Jarvis, June 24, 1836, in "Some Unpublished Correspondence of Washington Allston," 81–83.

18. Miller, *Patrons and Patriotism*, 51.

19. *Journal of the House of Representatives*, 23d Cong., 1st sess., January 24, 1834, 237.

20. *Journal of the House of Representatives*, 23d Cong., 1st sess., February 11, 1834, 16.

21. John Quincy Adams had expressed doubt that four competent American artists could be found, and some delegates responded by defending the artistic climate of the United States. "The country is rich in artists," rebutted Wise, who singled out Washington Allston, Thomas Sully, and John Chapman. The press also defended American artists, as in the *New-York Mirror*, January 31, 1835, 247. Aaron Ward of New York, a member of the reporting committee, added seven names for commendation, including John Trumbull, Samuel F. B. Morse, John Vanderlyn, and Robert Weir. See *Register of Debates*, House, 23d Cong., 2d sess., December 15, 1834, 791–795.

22. Ibid., 794.

23. Ibid., 793, 795.

24. *Register of Debates*, House, 24th Cong., 1st sess., June 23, 1836, Appendix, xxiii. See also *Public Statutes at Large of the United States of America*, 24th Cong., 1st sess., June 23, 1836, Joint Resolution No. 8, 5:133.

25. Miller, "John Vanderlyn and the Business of Art," 41.

26. House, *Paintings for the Rotunda*, 24th Cong., 2d sess., February 28, 1837, H. Rpt. 294. Original document in Senate Library Committee, Record Group 46, SEN 24A-D18, National Archives. As Lillian Miller has shown, these artists and others (such as Thomas Cole) had lobbied to receive the commissions. See Miller, *Patrons and Patriotism*, 54–57. See also *Public Statutes*, 24th Cong., 2d sess., March 3, 1837, 5:173. The contract made additional stipulations, including that the committee had the right to reject a subject "if it should not be deemed within the scope of the said resolution" and "the works illustrate different subjects." See Fiscal Branch, Acct. 81.296, National Archives. One letter indicates how the artists were informed about the commission. Robert Weir received instructions from William Preston, chairman of the Senate committee, and Leonard Jarvis, chairman of the House committee, who explained that the artist should select a subject from "civil or military [events] connected with the discovery of the western continent, i.e. discovery, settlement, the colonies which now compose the United States of America, the separation of those colonies from Great Britain or with the history of the United States up to the time of the adoption of the federal constitution." The committee would then approve or reject the subject proposed. See Preston and Jarvis to Robert Weir, July 4, 1836, Robert Weir Papers, Roll 531, Frames 795–796, Archives of American Art.

27. Wyeth, *Federal City*, 126, identifies Inman's subject, as do "Powell's Picture of De Soto," 574–576, and Stuart, *Powell's Historical Picture*, 2. Powell claimed that Daniel Huntington had offered to complete Inman's picture. "Powell's Painting of De Soto,"

117–120. Before Powell secured the commission, Congress received petitions in which various artists and subjects had been proposed. These petitions indicate that groups from different regions of the country concerned themselves with the Capitol decoration, selecting themes that echoed those discussed by the statesmen. Already in 1844, two years before Inman's death, forty-five citizens from Philadelphia signed a petition asking Congress to fill a vacant panel in the Rotunda with the Battle of New Orleans as painted by "a native artist." Committee of the Library, House, Record Group 128, 28th Cong., National Archives. (Ingersoll referred the petition to the committee.) Two years later, in May, friends of Samuel F. B. Morse unsuccessfully requested that the president of the National Academy of Design be hired to replace Inman. *Petition of A. B. Durand and Others*, 29th Cong., 1st sess., May 26, 1846, S. Doc. 380. Then in November of that year, more than a hundred residents of Saint Louis submitted a lengthy memorial in which they recommended that Charles Deas be commissioned to execute a subject from General George Rogers Clark's "early advance of Western settlement" when Clark successfully negotiated a peace treaty with various tribes. Joint Committee on the Library, Record Group 128, Senate, 29th Cong., 2d sess., November 23, 1846, National Archives. Earlier, in February, Congress considered the inquiry of the Joint Committee on the Library concerning Inman's commission and the proposal by William W. Campbell of New York that Daniel Huntington be asked to finish the picture. See *Congressional Globe*, 29th Cong., 1st sess., February 12, 1846, 364–365. According to William Truettner, George Catlin submitted a design for *Boone's Entrance into Kentucky* upon learning about Inman's death. See Truettner, *Natural Man Observed*, 53.

28. Wise's biography and politics can be found in Simpson, *Good Southerner*. On Verplanck, see July, *Essential New Yorker*, esp. 134.

29. I am indebted to William Truettner for sending me his essay, "Prelude to Expansion: Repainting the Past," in *The West as America*, prior to publication. Truettner accurately situates the roles of Everett, Verplanck, and Kemble in relation to the paintings and their expansionist aims.

30. *Picture of the Baptism of Pocahontas*, 6.

31. Smith wrote this to Anne of Denmark, wife of James I, in a letter published in ibid., 10. Georgia Stamm Chamberlain convincingly suggests that Chapman derived the features of Pocahontas and Nantequaus from portraits of Plains Indians by Charles Bird King, his former teacher. Chamberlain, *Studies on Chapman*, 18–19.

32. Engravings derived from these small canvases can be found in the *New-York Mirror* (1841) and *Graham's Magazine* (1842). See Chamberlain, *Studies on Chapman*, 39.

33. Among the documents cited are George Percy's *Observations Gathered out of "A Discourse of the Plantation of the Southern Colony of Virginia by the English, 1606,"* and letters from John Smith, John Rolfe, and Thomas Dale.

34. *Picture of the Baptism of Pocahontas*, 5, 3.

35. Ibid., 3.

36. The pamphlet furthermore provides information about Chapman's historical accuracy, evident, as the text asserts, in the architectural setting, "adopted from one now in existence, built about the time of that of Jamestown," and also found in such details as the "greene Velvet Chaire with a Velvet Cushion" behind the governor, "the pulpit, with its cloth embroidered with the Arms of Virginia and initials of King James." Ibid., 7–8.

37. Quoted in Glanz, *How the West Was Drawn*, 39. Glanz provides an excellent discussion of miscegenation as a policy and its imagery in American art (36–43).

38. Chapman had solicited Wise's support, writing on January 29, 1836, "I must again . . . ask you to remind my Virginia and southern friends of me." Chapman to Wise, January 29, 1836, Etting Collection, Archives of American Art.

39. *Picture of the Baptism of Pocahontas*, 4.

40. *Picture of the Embarkation of the Pilgrims from Delft-Haven in Holland*, 2. According to the pamphlet, the boat's difficulty derived from "the treachery of Capt. Reynolds,

who was hired by the Dutch merchants either to frustrate the voyage, or carry them to some place remote from their own settlements. This deceit, aided by a storm caused the subsequent settlement at Plymouth, the destination of the colony having been Hudson's River." Upon learning about his commission—garnered through the support of Gulian Verplanck, whose assistance he solicited—Weir initially proposed as his subject the storming of Stony Point. He then selected the departure of the Pilgrims, although he preferred "the Departure of the Pilgrims for the New World as described in Mather's Magnolia," which his friend Samuel F. B. Morse wanted to depict and Weir had agreed to avoid. See Weir to Verplanck, June 12, 1836, New-York Historical Society; Weir to William Preston, April 19, 1837, Robert Weir Papers; Ahrens, "Robert Weir's 'Embarkation of the Pilgrims,'" 60–62.

41. These sketches can be found in Ahrens, "Robert Weir's 'Embarkation of the Pilgrims,'" 64–66. Ahrens proposes that Weir's composition in the final work derived from Rembrandt's *Hundred Guilder Print* (66–69). For a more general study of Weir's painting and the other murals in the Rotunda, see Ahrens, "Nineteenth Century History Painting and the United States Capitol."

42. Weir derived his subject from Nathaniel Morton's *New-England Memorial* and provided the passage that inspired his picture in a letter to William Preston, April 14, 1838, Robert Weir Papers, Roll 531, Frames 807–809.

43. *Picture of the Embarkation of the Pilgrims*, 4.

44. I have derived this idea from Arner, who applies the anthropological concept of the rite of passage to the Pilgrim myth. See Arner, "Plymouth Rock Revisited," 29.

45. "Pilgrim Fathers," 93.

46. Winthrop, "Pilgrim Fathers," 12, 13, 28.

47. *Picture of the Embarkation of the Pilgrims*, title page.

48. Angela Miller discusses the regional rivalries at greater length in her forthcoming book, *The Empire of the Eye: Cultural Form and Meaning in American Landscape Art, 1820–1870*, where she coins the term *Jamestown countermyth*. See also Norton, *Alternative Americas*, 183; and Simms, "Pocahontas: A Subject for the Historical Painter." Simms identified the rescue as the more dramatic subject, criticizing Chapman, "a southern artist," for having "avoided the nobler event which first brought us to the knowledge of her character" (116).

49. *Picture of the Embarkation of the Pilgrims*, 4. Weir also explains, "In selecting this subject for one of the national pictures, the artist was influenced by the high moral character of the scene, and the great events which grew out of the principles imparted by the actors in it to their descendants, and which finally led to that separation from the dominion of the old world which made us an independent people." Ibid.

50. Bulfinch, *Discourse Suggested by Weir's Picture*, 4.

51. Quoted in Irene Weir, *Robert W. Weir, Artist*, 93.

52. Schoonmaker, *John Vanderlyn*, 70.

53. Vanderlyn visited the West Indies in 1839 and executed the painting while living in Paris. Schoonmaker, *John Vanderlyn*, 51. Truettner, "Art of History," has discussed the influence Irving's book had on American artists, correctly connecting the revival of interest during the 1840s and 1850s to westward expansion.

54. Berkhofer, *White Man's Indian*, 122, identifies Columbus's erecting the cross as a symbolic act of possession. Todorov, *Conquest of America*, 27, argues that in the renaming of the island from Guanahani to San Salvador, Columbus symbolically took possession of the land.

55. Irving, *Columbus*, 109.

56. Ibid., 109, 110.

57. The pamphlet published to explain the painting, *Vanderlyn's National Painting of the Landing of Columbus*, contains the same descriptions of the natives (4). The artist, however, omitted the variety of body painting that Irving details. *Columbus*, 111.

58. Vanderlyn has derived his tripartite structure from Benjamin West's *William Penn's Treaty with the Indians* (1771), replacing West's left foreground merchants with a tree

stump and the Quakers with the Spanish voyagers in a similar semicircular arrangement. Ann Abrams, "West's Documentation," 60, analyzes West's three-part composition.

59. *Vanderlyn's National Painting*, 6.

60. Todorov, 27, 42, 46.

61. For the idea of Columbus's discovery as an invention, see O'Gorman, *Invention of America*.

62. Cabot is located above Vanderlyn's *Landing of Columbus*, Columbus above Trumbull's *Surrender of General Burgoyne*, La Salle above Powell's *Discovery of the Mississippi*, and Raleigh above Trumbull's *Surrender of Lord Cornwallis*.

63. *Congressional Globe*, 29th Cong., 2d sess., February 1, 1847, 303; February 2, 1847, 310. Henry Brevoost contacted his friend Washington Irving, asking him to write a letter of support to the Library Committee. See Brevoost to Irving, May 26, 1844; Brevoost to the Library Committee, January 7, 1847; Irving to the Library Committee, January 7, 1847. Irving wrote that Powell "possesses genius and talent of a superior order, and . . . is destined to win great triumph for American art." Copies of these letters were given to Charles Fairman by Adelaide Powell, the artist's daughter-in-law, in 1926 and are in the Office of the Architect of the Capitol. According to "Powell's Columbus," in the *National Intelligencer*, January 20, 1847, *Columbus before the Council of Salamanca* represented "Columbus expounding his theory of the rotundity of the earth and the existence of another continent, before the Council of Ecclesiastics at Salamanca. . . . The great discoverer is represented as standing with calm dignity and in a noble attitude, with one hand touching a chart, and regarding, with a look of conscious superiority, the haughty Cardinal and frowning Ecclesiastics. . . . The finger of the Cardinal points with emphasis to a passage in the Bible, where the 'four corners' of the earth are spoken of, to prove it not a sphere, and to convict Columbus of heresy."

64. *Congressional Globe*, 29th Cong., 2d sess., March 2, 1847, 568. The short debate involved recommendations by members of the House, who suggested, among other subjects, the landing of the Pilgrims at Saint Mary's in Maryland in 1634, the crossing of the Mississippi River by de Soto, and the council held by Rogers Clark at North Bend in 1794. Members also recommended other artists, such as Thomas P. Rossiter.

65. The members of the committee were John Quincy Adams (Massachusetts), Franklin Pierce (New Hampshire), John Y. Mason (Virginia), Jefferson Davis (Mississippi), William C. Preston (South Carolina), and Thomas B. King (Georgia). Powell had written a letter to *Putnam's Monthly* 3 (January 1854): 118, explaining the work's evolution and stating that the committee selected the subject. This is reiterated in Hunter, *Fernando de Soto*, 2, and Stuart, *Powell's Historical Picture*, 2.

66. Stuart, *Powell's Historical Picture*, 12–13. Powell himself provides these sources in *Putnam's Monthly* 3 (January 1854): 118.

67. "Landing of De Soto in Florida," *Ballou's Pictorial and Drawing Room Companion* 8 (April 7, 1855): 217; Schoolcraft, *Scenes and Adventures* (1853); and Wilmer, in *The Life, Travels and Adventures of Ferdinand de Soto* (1858). For Wilmer's petition that Congress purchase ten thousand copies "for general distribution among the various State Libraries," see Record Group 128, Joint Committee on the Library, National Archives.

68. Miller, "A Muralist of Civic Ambitions," 193.

69. Stuart, *Powell's Historical Picture*, 9, and Hunter, *Fernando de Soto*, 4. The Stuart pamphlet constituted the official text to accompany the painting. Alfred Hunter requested permission to describe the picture in a small pamphlet, a request approved of by the commissioner of public buildings. See Hunter to B. B. French, February 14, 1855, Letters of the Commissioner of Public Buildings, Record Group 42, National Archives.

70. Hunter, *Fernando de Soto*, 3.

71. Stuart, *Powell's Historical Picture*, 7–9. Hunter in *Fernando de Soto* repeated Stuart's analysis in his guidebook, 3–4.

72. Stuart, *Powell's Historical Picture*, 8.

73. Ibid., 16.

74. Ibid., 10.

75. Ibid., 3, and Hunter, *Fernando de Soto*, 16. Powell's emphatically peaceful scene gains significance when Alfred Hunter's biography of de Soto and the artist's defense of his painting are considered. In his pamphlet, Hunter details the Spaniards' earlier "bloody engagements" against the "populous" and "revengeful" natives in Florida whom his "gallant troops" eventually subdued through captivity (6). Powell also provides evidence of de Soto's struggles with "infuriated savages," and then explains that the "hostile savages" along the Mississippi initially resisted until they recognized "their relative weakness" in the face of Spanish equipment. According to the artist, who presents Irving's *Conquest of Florida* as his primary source, the chief proclaimed, "As you are superior to us in prowess, and surpass us in arms, we likewise be-believe [*sic*] that your God is better than our god." *Putnam's Monthly* 3 (January 1854): 118–119. Powell wrote this editorial in defense of his Rotunda painting, which had been severely criticized in an earlier issue: "Its subject belongs to Spain, and its manner to Paris, where it was painted, from French models. There is nothing American about it, and it has no right to be placed in the national capitol." *Putnam's Monthly* 2 (November 1853): 574–575.

76. Stuart, *Powell's Historical Picture*, 2.

77. *Washington Sentinel*, February 17, 1855, 3.

78. *National Intelligencer*, April 25, 1853, 2. The author of the editorial in *Putnam's Monthly* that had criticized Powell's painting argued, in fact, that the subject and commission of Powell, "a Western man," derived from the "baleful effects of sectionalism in political affairs." In short, the work was condemned for being one that applied to western sympathies rather than national ones, and for its lack of "historical correctness, elevated sentiment, high finish," and "general truthfulness." *Putnam's Monthly* 2 (November 1853): 574–575.

79. Hunter, *Fernando de Soto*, 2.

80. Potter, *Impending Crisis*, 1, 7. See also Johannsen, "Douglas and the American Mission," 127.

81. Truettner, "Art of History," 31.

82. Jehlen, *American Incarnation*, 9.

83. The best literature on American millennialism is Sacvan Bercovitch, *American Jeremiad*; Burns, *American Idea of Mission*; and Tuveson, *Redeemer Nation*. Literature on manifest destiny and westward expansion is extensive. Most helpful are Weinberg, *Manifest Destiny*, and Merk, *Manifest Destiny and Mission*. See also Henry Nash Smith, *Virgin Land*; Slotkin, *Fatal Environment*; and Limerick, *Legacy of Conquest*. On the Puritan origins and religious connotations of the belief in divine mission, see Perry Miller, *Errand into the Wilderness*.

84. Ross, "Historical Consciousness in Nineteenth-Century America," 915.

85. Ekirch, Jr., *Idea of Progress in America*.

86. "Colony of New Plymouth," 337.

87. Ross, "Historical Consciousness," 912.

## Chapter 3
### Greenough's Washington

An earlier version of this chapter is my article, "Horatio Greenough's *George Washington*: A President in Apotheosis," *Augustan Age*, occasional papers, no. 1 (1987).

1. *Register of Debates*, House, 22d Cong., 1st sess., February 16, 1832, 1829. Jarvis was referring to the fact that three states, Virginia, North Carolina, and Massachusetts, had commissioned portrait statues from Houdon (1788), Canova (1818), and Chantry (1826), respectively, for their capitol buildings.

2. *Journals of the Continental Congress* 24 (1783): 494–495. The resolution further

required that the base illustrate scenes from the Revolutionary War and contain an inscription that would emphasize the memorial's function in celebrating Washington as a military hero.

3. For information concerning the colonial statue, see Marks, "State of King George III in New York." Kirk Savage, "Self-Made Monument," cites another precedent, Edme Bouchardon's statue of Louis XV (1748–1762).

4. Senate, *Obsequies of General Washington*, 6th Cong., 1st sess., December 23, 1799, American State Papers, no. 115:191.

5. House, *Statue and Monument to the Memory of General Washington*, 6th Cong., 1st sess., May 8, 1800, American State Papers, no. 135:214. See also House, *Mausoleum to General Washington*, 6th Cong., 2d sess., December 19, 1800, American State Papers, no. 138:215–216, for concern over the expenses of these two ways of commemorating the first president.

6. Savage, "Self-Made Monument," 228–231. Proposals for Washington's sculpted likeness in the Capitol continued to provoke partisan confrontation. Congressmen at the outset of the third decade of the nineteenth century expressed less concern about the format of the Washington monument, however, focusing instead on issues related to the burgeoning nullification crisis.

7. House, *Monument to the Memory of General Washington*, 14th Cong., 1st sess., March 14, 1816, American State Papers, no. 404. The resolution called for four scenes on the sides of the monument: Washington as defender of his country against the French and Indians; as the general of the army during the Revolutionary War; as the first president, "administering the public affairs"; and as a private citizen involved in agricultural pursuits.

8. *Register of Debates*, House, 16th Cong., 1st sess., April 1820, Appendix, 1792–1793.

9. House, *Entombment and Statue of Washington*, 21st Cong., 1st sess., February 22, 1830, H. Rpt. 318:1.

10. *Register of Debates*, House, 22d Cong., 1st sess., February 16, 1832, 1818–1820; House, *Resolutions of the Legislature of the State of Virginia*, 22d Cong., 1st sess., February 24, 1832, no. 124:1–2; House, *Register of Debates*, 22d Cong., 1st sess., February 25, 1832, 1857–1858.

11. *Register of Debates*, House, 22d Cong., 1st sess., February 16, 1832, 1817–1820, 1829–1830.

12. *Register of Debates*, House, 22d Cong., 1st sess., February 14, 1832, 1809.

13. *Register of Debates*, Senate, 22d Cong., 1st sess., February 13, 1832, 367–374; House, February 13, 1832, 1782–1809; February 14, 1832, 1809–1813; Senate, February 14, 1832, 390–392; House, February 16, 1832, 1818–1821; House, February 16, 1832, 1824–1827. Warren, *Odd Byways in American History*, 192–220, reviews the debates and provides information on the centennial celebration.

14. Senate, *Report of the Committee of the Senate and House of Representatives of the Celebration of the Centennial Birthday of George Washington*, 22d Cong., 1st sess., February 13, 1832, S. Rpt. 62, 1–2. See also *Register of Debates*, Senate, 22d Cong., 1st sess., February 7, 1832, 297–298, in which some senators declined to serve on the committee in protest of "man-worship."

15. Martha Washington's consent to have her husband's remains buried in the Capitol can be found in *Removal of the Remains of General George Washington to the City of Washington*, 6th Cong., 1st sess., January 8, 1800, American State Papers, no. 118:195; and *Register of Debates*, House, 18th Cong., 1st sess., January 15, 1824, 1044.

16. *Register of Debates*, House, 22d Cong., 1st sess., February 13, 1832, 1798. Some Congressmen debated another issue: whether a monument was appropriate. Littleton Tazewell of Virginia argued in the Senate, "In the days of barbarism and ignorance, when it was not possible to communicate instruction to the heart of man, except through his eye, statues were erected to perpetuate the memory of those who were supposed to have been eminent for their virtues or their achievements; but, since the invention of the art of printing has enabled us to carry to distant generations the lesson

taught by the life of Washington, no statues are necessary to commemorate the virtues that are recorded on more imperishable materials." *Register of Debates*, Senate, 22d Cong., 1st sess., February 13, 1832, 372. In the House, William F. Gordon of Virginia made a similar remark: "It degraded Washington to the measure of little men, who needed a monument to preserve their name. Since the art of printing had been invented, pillars and monuments were but idle records. Letters were the best, the enduring monument." *Register of Debates*, House, 22d Cong., 1st sess., February 13, 1832, 1785. John Forsyth of Georgia contended that a monument was unnecessary, for one already existed "in our hearts." *Register of Debates*, Senate, 22d Cong., 1st sess., February 13, 1832, 375.

17. Schwartz, *George Washington*, 79.

18. Richard Coke, Jr., of Virginia, in *Register of Debates*, House, 22d Cong., 1st sess., February 13, 1832, 1785.

19. For example, Wiley Thompson of Georgia agreed with the Virginians: "Virginia [has] a right . . . which cannot be properly divested without her consent. . . . It is true that the fame of the illustrious man belongs, not only to Virginia, but to the United States, and the world; but Virginia's interest is more immediate, intimate, and direct, and his remains now lie entombed within her limits." Edward Everett, on the other hand, countered, "The sacred remains are . . . a treasure of which every part of this blood-cemented Union has a right to claim its share." Those who justified Virginia's "right to the possession of the remains of her most distinguished son" defended states' sovereignty, whereas those who "wished the interment of those remains in common ground" supported the nationalist program. Ibid., 1789, 1787, 1786.

20. On the nullification crisis, see Ellis, *Union at Risk*, and Freehling, *Prelude to Civil War*. Both authors interpret the nullification crisis as a significant precedent for the Civil War.

21. This interpretation is supported by the debates themselves, for a number of congressmen couched their polemics within the larger platform of disunion. Richard Coke, Jr., a Jacksonian, immediately followed his assertion that Virginia retained the right to Washington's remains with an explicit reference to "some distant period" when the twenty-four stars on the flag will "be dimmed of their original brightness, and present . . . twenty-four fragments of a great and powerful republic, warring the one with the other." Others reasoned that the very placement of Washington's remains in the U.S. Capitol would solidify the Union. The anti-Jacksonian Charles Fenton Mercer of Virginia proclaimed, "Congress would perform an act, which, next to our beloved constitution itself, would tend to consolidate the Union of these States," and Jonathan Hunt of Vermont declared that the best way to unite the people and cement the Union would be to place "these sacred remains at the base of this durable edifice, so that it may serve not only as the seat of the national legislature, but as the mausoleum of the father of his country." *Register of Debates*, House, 22d Cong., 1st sess., February 13, 1832, 1785, 1784, 1794.

22. Ibid., 1788, 1784; Senate, June 25, 1832, 1126–1127.

23. As Wendy Steiner has explained regarding the semiotics of portraiture, "The portrait tries to 'render present' its subject by replacing him or by creating a necessary linkage between itself or him." See *Exact Resemblance to Exact Resemblance*, 4–11.

24. *Register of Debates*, House, 24th Cong., 2d sess., March 4, 1837, 2166–2168.

25. Livingston to Greenough, February 23, 1832, House, *Statue of Washington*, 27th Cong., 1st sess., August 4, 1841, H. Doc. 45, 2.

26. *Register of Debates*, House, 22d Cong., 1st sess., March 15, 1832, 175; Senate, April 24, 1832, 833–834; Senate, April 27, 1832, 867; House, *Statue of Washington*, 22d Cong., 1st sess., April 30, 1832, Rpt. no. 459, 1; *Register of Debates*, Senate, 22d Cong., 1st sess., June 25, 1832, 1126–1127.

27. Craven, *Sculpture in America*, 105–106, and Wright, *Horatio Greenough*, 118.

28. *Register of Debates*, House, 22d Cong., 1st sess., February 16, 1832, 1829–1830.

29. Ibid., February 14, 1832, 1809–1810.

30. On March 15, James Fenimore Cooper had informed Greenough of the congressional commission. See *Letters of Horatio Greenough, American Sculptor*, ed. Wright, 113, 115. By June, Greenough had received a letter from the secretary of state, Edward Livingston, who officially informed him of the order. Livingston to Greenough, February 28, 1832, Record Group 59, General Records of the Department of State, Domestic Letters, National Archives. For Greenough's reply to Livingston, see Greenough to Livingston, July 8, 1832, ibid., 138–141.

31. See Brilliant, "Gesture and Rank in Roman Art," for examples and a discussion of the *adlocutio* gesture in Roman art.

32. See Crawford, "Classical Orator in Nineteenth-Century American Sculpture," for a discussion of the orator type in American sculpture. I have discussed the image of the statesman orator elsewhere, in "Hiram Powers's Bust of *George Washington*."

33. Everett to Greenough, July 29, 1832, Edward Everett Papers, Massachusetts Historical Society. Wayne Craven, "Greenough's Washington and Phidias' Zeus," first identified the Pheidian Zeus as Greenough's source and discussed the written descriptions and earlier images of the work.

34. Reynolds, *Hiram Powers and His Ideal Sculpture*, 82–83. Ingres's 1811 *Jupiter and Thetis* may also be a precedent, as Reynolds suggests. William H. Gerdts proposes that Washington Allston's *Jeremiah Dictating His Prophecy of the Destruction of Jerusalem* influenced Greenough's pose with "the outstretched arm, . . . one leg raised higher than the other" and the "treatment of the drapery around the legs and knees." Gerdts and Stebbins, *Washington Allston*, 122. Reynolds concurs, proposing that John Vanderlyn's *Marius amidst the Ruins of Carthage* may be yet another source (84).

35. Crawford, "Classical Tradition in American Sculpture," 38.

36. Greenough to Lady Rosina Wheeler Bulwer-Lytton, before May 8, 1841, *Letters*, ed. Wright, 309. Behind the throne, Greenough inscribed "Simulacrum istud ad magnum libertatis exemplum nec sine ipsa duraturum Horatius Greenough faciebat" (Horatio Greenough made this statue as a great example of liberty without which it [the statue] would not exist). I want to thank Barbara Tsakirgis for this translation.

37. In Greenough's bill to the federal government for the statue, he listed "Portrait of Washington, copied after Stuart, by F[rancis] Alexander" and "Casts of the head by Houdon, in the chateau at Fontainebleau." See Greenough to Daniel Webster, March 12, 1841, *Letters*, ed. Wright, 302–305.

38. Huntington, *Art and the Excited Spirit*, 11; Wright, *Horatio Greenough*, 123.

39. *Register of Debates*, House, 22d Cong., 1st sess., February 14, 1832, 1810.

40. See L'Orange, *Apotheosis in Ancient Portraiture*, 30–35, for a discussion of hairstyles in Hellenistic portraits of inspired rulers. L'Orange also outlines the development of apotheosis iconography in ancient portraiture, providing the basis for my analysis of Greenough's bust. See also Fryd, "Horatio Greenough's *George Washington*."

41. Some differences exist between the two works. In the Pheidian Zeus, the god's legs cross and the position of the arms is reversed: the left arm is extended and the right gestures forward. Most significant, however, are the changes in iconography. Zeus holds a scepter crowned by an eagle and a winged Victory, and the throne is adorned with various allegorical reliefs and figures that pertain to Greek mythology.

42. Tolnick, "Public Patronage," 19–23.

43. "Congress," *Niles' Weekly Register* (May 21, 1842): 179–180.

44. Greenough himself defended the statue's partial nudity by citing Canova's 1806 *Napoleon*. U.S. Congress, Senate, *Memorial of Horatio Greenough*, 3–4. For similar remarks, see Greenough to Samuel F. B. Morse, May 24, 1834, *Letters*, ed. Wright, 177–178.

45. *Diary of Philip Hone*, 2:216.

46. Quoted in Wills, *Cincinnatus*, 68.

47. Quoted in Crane, *White Silence: Greenough, Powers and Crawford*, 77.

48. Stein, "Peale's Expressive Design," 144–145. For the tradition of the emblematic portrait established for English courtiers and royalty in Elizabethan times and

continued in eighteenth- and early nineteenth-century American painted and engraved portraits, see also Miller, "Peale as History Painter," 54–58.

49. Jarvis reported the resolution for the employment of John Vanderlyn "to paint a full length portrait of Washington, to be placed in the Hall of Representatives opposite the portrait of Lafayette; the head to be a copy of Stuart's Washington, and the accessories to be left to the judgment of the artist." This action preceded Jarvis's reading the resolution for Greenough's statue. *Register of Debates*, House, 22d Cong., 1st sess., February 14, 1832, 1809. Some questioned whether the resolution for the painted portrait should specify the artist, while others believed that Peale's likeness "bore a closer resemblance" to the subject, suggesting that it replace Stuart's as the model. *Register of Debates*, House, February 16, 1832, 1824–1827.

50. This excellent catalog of the signs of office is from Wills, *Cincinnatus*, 171.

51. Greenough to Bulwer-Lytton, *Letters*, ed. Wright, 309.

52. This is Garry Wills's interpretation as outlined in *Cincinnatus*. Wills argues that Washington carefully orchestrated his decision not to serve a third term as president.

53. For a discussion of Washington's humility and its importance to the development of Washington as a symbol, see Schwartz, *George Washington*, especially his discussion of the symbolism behind Washington's resignation from the military, 137–143.

54. Greenough to Bulwer-Lytton, *Letters*, ed. Wright, 309.

55. I would like to thank Barbara Tsakirgis for clarifying for me the philosopher type in ancient art and for this appropriate comparison. See Grant, *Cities of Vesuvius*, 161, for an illustration of the wall painting.

56. "Washington," *National Intelligencer*, February 23, 1852, 3.

57. Greenough to Bulwer-Lytton, *Letters*, ed. Wright, 309.

58. Plymouth, "Indian History," *National Intelligencer*, June 19, 1832.

59. J. F. Cooper, *The Pioneers*, 68, 309.

60. Greenough to Washington Allston, December 18, 1833, *Letters*, ed. Wright, 171. Greenough had also considered placing a Negro on the chair, a proposal rejected by Charles Sumner, who applauded the sculptor's decision to replace the African American with an image of Columbus. See *Letters*, ed. Wright, 270n3 and 271n23.

61. Greenough to Bulwer-Lytton, *Letters*, ed. Wright, 309. Greenough also explained to Charles Sumner on November 16 and 18, 1839, that the relief illustrates Virgil's phrase from *Eclogue* 4, "Incipe parve puer cui non risere parentes!" (Begin small boy on whom parents have not smiled!). Ibid., 267, 270n6. By representing the United States as Hercules, Greenough stayed within iconographic tradition. For example, Augustin Dupré followed Benjamin Franklin's advice in representing Hercules as America on the reverse of *Libertas Americana*. Drawings of the subject of Hercules and Iphikles can be found on the same sheet as that of Stuart's *Washington* in the Roman Sketchbook, as well as on sheets 41 and 42 (Rinhart Collection).

62. Greenough to Bulwer-Lytton, *Letters*, ed. Wright, 309, "The bas relief on the right side of the chair represents the Rising Sun which was the first crest of our national arms—under this will be written *Magnus ab integro saeclorum nascitur ordo*" (The great sequence of ages is born anew), Virgil, *Eclogue* 4, as translated by Wright, *Letters*, 270n5. See drawings of Helios and Phaeton on sheets 93, 44, and 45 in the Rinhart Collection for the basis of this design.

63. Thistlethwaite, *Image of George Washington*, 72–78.

64. Greenough to Morse, May 24, 1834, *Letters*, ed. Wright, 176–177.

65. MacDonald, *Pantheon*, 89.

66. When Greenough first visited the Capitol to view the future site for his monument in 1836, he assessed the lighting as inadequate and recommended that the statue be situated between the center of the hall and the door of the library. But because the architect of public buildings, Robert Mills, favored the position specified in the resolution, he placed the monument in the nucleus of the Rotunda on December 1, 1841. The sculptor returned to this country again in the fall of 1842 to lobby for an alternative placement of the monument, as well as for a pedestal. Two years earlier,

Robert Mills proposed in an elaborate drawing to the commissioner of public buildings that a double grand staircase ascend from the crypt and wind around the statue's pedestal. House, *Foundation for Statue of Washington*, 26th Cong., 1st sess., March 5, 1840, H. Doc. 124, 2; House, *A Bill*, 26th Cong., 1st sess., March 5, 1840, H. Rpt. 244; Committee on Public Buildings and Grounds, February 26, 1840, HR26A-D21.2, National Archives. However, complaints from the artist concerning the poor lighting conditions resulted in the work's placement in February 1842 between the center of the hall and the door of the library (the statue faced east). House, *Statue of Washington*, 27th Cong., 1st sess., August 4, 1841, H. Doc. 45, 3. For Congress's consideration of Greenough's request, see *Congressional Globe*, 27th Cong., 1st sess., August 26, 1841, 390; 27th Cong., 2d sess., December 22, 1841, 48. Again in 1843 Greenough objected to the statue's placement, arguing that the lighting disfigured the work. Senate, *Memorial of Horatio Greenough*, 27th Cong., 3d sess., January 11, 1843, S. Doc. 57, 1; this document is discussed and reproduced in Wright, "Horatio Greenough's Memorial to Congress." The Joint Committee on the Library decided to move the portrait to the eastern grounds, "directly in front of the main entrance of the rotundo." House, *Removal of Greenough's Statute* [sic] *of Washington*, 27th Cong., 3d sess., February 22, 1843, H. Rpt. 219, 1; see also *Congressional Globe*, 27th Cong., 3d sess., March 2, 1843, 381. There it was covered by a wooden shelter until 1844, when a rail was placed around the work. *Congressional Globe*, 28th Cong., 1st sess., May 25, 1844, 663–664. See also Wright, *Horatio Greenough*, 142–157.

<div align="center">

*Chapter 4*
*Persico's* Discovery *and Greenough's* Rescue

</div>

An earlier version of this chapter is my article, "Two Sculptures for the Capitol: Horatio Greenough's *Rescue* and Luigi Persico's *Discovery of America*," *American Art Journal* 19 (1987).

1. Fryd, "Hiram Powers's Bust of *George Washington*," 18–19.

2. *Register of Debates*, Senate, 24th Cong., 1st sess., April 28, 1836, 1314–1318. The Philadelphia Artist Society submitted a memorial to Congress recommending Persico for the execution of both statues for the Capitol's east facade, arguing that Congress should not discriminate between American and European artists. House, *Sculpture for the Capitol, Memorial from the Philadelphia Artist Society*, 24th Cong., 2d sess., February 13, 1837, H. Doc. 159.

3. *Register of Debates*, Senate, 24th Cong., 1st sess., April 28, 1836, 1314.

4. Ibid., 1316.

5. Senate, *Resolution*, 24th Cong., 1st sess., May 17, 1836, S. Rpt. 17.

6. House, *A Bill Making Appropriations for the Public Buildings and Public Grounds, and for Other Purposes*, 24th Cong., 2d sess., February 14, 1837, H. Rpt. 933. For the contract with Persico, signed April 3, 1837, see Treasury Department, Miscellaneous Letters, Series K., Letters Received, National Archives, 375. See also *Register of Debates*, Senate, 24th Cong., 2d sess., March 2, 1837, 1015, for a discussion of the appropriation when Buchanan specified Persico's name, but Daniel Webster recommended that no artist be designated. The bill for the commission can be found in *Public Statutes at Large*, 24th Cong., 2d sess., March 3, 1837, 5:173.

7. Horatio Greenough to John Forsyth, July 1, 1837, *Letters*, ed. Wright, 214. Nathalia Wright provides a detailed sequence of events that involved Greenough's commission in *Horatio Greenough: The First American Sculptor*, 159–177. As she explains, Greenough had proposed two designs, one of Washington with sword and America crowned, the other of the *Rescue* with only one alteration from the final work: a wound in the Indian's side, the only element in the design that the President rejected. Greenough signed the contract on January 2, 1839.

8. Luigi Persico to Forsyth, December 14, 1838, May 13, 14, 1840, Records of the Office of the Architect of the Capitol.

9. *Register of Debates*, Senate, 24th Cong., 1st sess., April 28, 1836, 1316.

10. Greenough to Forsyth, July 1, 1837, *Letters*, ed. Wright, 214.

11. For a general introduction to the captivity theme in literature, see Carleton, "Indian Captivity," and Pearce, "Significances of the Captivity Narrative." See also Slotkin, *Regeneration through Violence*. For a feminist perspective, see Kolodny, "Turning the Lens on 'The Panther Captivity.'" Strong, "Captive Images," refers to *Rescue* and Vanderlyn's *Death of Jane McCrea*. Luft, "Charles Wimar's *The Abduction of Daniel Boone's Daughter by the Indians*," discusses the captivity theme in Wimar's two pictures. For Cooper's *Last of the Mohicans* as a captivity novel, see Haberly, "Women and Indians." The Garland Library of Narratives of North American Indian Captivities reprints 311 narratives, beginning with Mary Rowlandson's 1632 account and ending with twentieth-century versions of the captivity tale.

12. Luft, "Wimar's *Abduction*," 303. The composition for the illustration derives from Theodor de Bry, plate 17, published in 1590, after a watercolor by John White illustrated in Hulton, *America 1585*, plate 39. *Affecting History* was first published in 1793.

13. Vanderlyn never completed the illustration for Barlow's poem, but his conception, realized in paint for the Paris Salon, became the basis for Robert Smirke's image that did accompany Barlow's 1807 published text. Both Vanderlyn's painting and Smirke's engraving dramatize the Indian's brutality and domination over the helpless and terrified woman whose exposed breast implies sexual abuse and the violation of Christian purity. For Vanderlyn's literary and historical sources, as well as other representations of Jane McCrea's capture, see Edgerton, "Murder of Jane McCrea."

14. For an examination of Bingham's work within the context of his oeuvre and political career, see Groseclose, "'Missouri Artist' as Historian," in *George Caleb Bingham*, 53–91.

15. Kasson, *Marble Queens and Captives*, 77–78.

16. O'Sullivan, "Annexation," 5. See also Pratt, "Origin of 'Manifest Destiny'" and "John L. O'Sullivan and Manifest Destiny," for a discussion of O'Sullivan's importance in defining and proselytizing manifest destiny.

17. Quoted in Pratt, "Origin of 'Manifest Destiny,'" 795.

18. House, *Congressional Globe*, 29th Cong., 1st sess., February 3, 1846, 301.

19. "Persico's Columbus," *United States Magazine and Democratic Review* 15 (July 1844).

20. House, *Congressional Globe*, 28th Cong., 2d sess., January 3, 1845, 43.

21. *Register of Debates*, Senate, 18th Cong., 2d sess., February 22, 1825, 639.

22. Edward G. Loring to James Pearce, February 1859, Records of the Architect of the Capitol; Meigs to James A. Pearce, March 14, 1859, Meigs Letterbook; Henry Greenough to Everett, September 1, 1853, copy in the Records of the Architect of the Capitol from Records of the National Archives, vol. 33, nos. 3233–3306, January 6, 1852–December 23, 1853; and Wright, *Horatio Greenough*, 163.

23. Edward G. Loring to James Pearce, February 1859, Records of the Architect of the Capitol.

24. J. A., "Greenough the Sculptor, and His Last Production."

25. Trennert, *Alternative to Extinction*, 178, 185.

26. *Inaugural Addresses of the Presidents*, 198–201.

27. Ibid., 236.

28. *Letters*, ed. Wright, 214.

29. Greenough to Forsyth, July 1, November 15, 1837, *Letters*, ed. Wright, 214, 221. Greenough did consult "Indian skulls, dresses, and drawings," which nevertheless did not help, obliging him "to make my savage by guess-work or description." Greenough to Henry Greenough, February 25, 1839, *Letters*, ed. Frances B. Greenough, 129.

30. House, 76th Cong., 1st sess., April 26, 1939, House Joint Resolution 276, 2. Submitted by Clark Burdick, representative from Rhode Island, the resolution declared, "This monument is a constant reminder of ill-will toward the American Indian, who has now become a part of this Nation and has, as far as this Government will permit,

assumed the duties of citizenship and has become as law abiding, as honorable, and as patriotic as any other race in our complex civilization" (1).

31. House, 77th Cong., 1st sess., April 14, 1941, H. Rpt. 176, 2. Submitted by James Francis O'Connor, representative from Montana, the resolution asserted, "This statuary group is an atrocious distortion of the facts of American history and a gratuitous insult to the great race" (1).

32. Leta Myers Smart, an Omaha Indian from Nebraska, to David Lynn, Architect of the Capitol, October 6, 1952, Records of the Architect of the Capitol. The letter is written on the letterhead of the California Indian Rights Association, "A Self-help Organization of Indians for Indians." In this letter, Smart requested that *Rescue* be replaced by works created by the Indians themselves. Smart again wrote Lynn on November 3, explaining that a national convention of Indians would convene in Denver, at which time she hoped a resolution would be passed for the statue's removal. "We feel we are justified in this endeavor," Smart wrote Lynn, "in light of present-day conditions and because this statue has been a source of great humiliation to every Indian who has set foot in Washington." Smart to Lynn, November 3, 1952, Records of the Architect of the Capitol. Lynn replied that the removal could occur only through an act of Congress, which he considered unlikely. Lynn to Smart, November 5, 1952, Records of the Architect of the Capitol.

33. Smart to Lynn, November 1, 1953; Petition drafted for the California Indian Day in Los Angeles, December 1, 1953, enclosed in Smart to Lynn, November 1, 1953; Smart to Lynn, December 19, 1953; Smart to J. George Stewart, Architect of the Capitol, January 24, 1955; Smart to William Langer, senator from North Carolina, January 24, 1955; Smart to Senator Theodore Francis Green, Chairman of the Joint Committee on the Library, August 15, 1958; Smart to Stewart, November 5, 1958, Records of the Architect of the Capitol. On November 5, 1959, Alice Shoemaker wrote to the Architect of the Capitol on behalf of the Indian Committee of the Friends Committee on Legislation, Southern California Office (a Quaker organization), requesting that *Rescue* and *Discovery* be destroyed rather than replaced. Records of the Architect of the Capitol. In 1953 and again in 1958, Smart contacted the National Sculpture Society, eliciting its support in requesting the statues' removal. Smart to the National Sculpture Society, September 9, 1953, September 14, 1958, Records of the Architect of the Capitol. On October 22, 1958, Adolph Block, secretary of the National Sculpture Society, informed Smart that the society decided it should not become involved "in this controversial issue." Block to Smart, October 22, 1958, Records of the Architect of the Capitol.

34. Smart, "Last Rescue," 92.

35. Washburn, *Indian and the White Man*, 393. See also Dippie, *Vanishing American*, 271–322.

## Chapter 5
### *Crawford's* Progress of Civilization

1. Brown, *History of the United States Capitol*, 2:120.

2. Allen, "Construction of the Dome of the Capitol."

3. For information about Davis's duties and accomplishments as secretary of war, see Eaton, *Jefferson Davis*, 81–98.

4. Captain William B. Franklin of the Corps of Topographical Engineers replaced Meigs that year. On the circumstances that led to Meigs's dismissal, see Brown, *History of the United States Capitol*, 2:124–135; Rosenberger, "Walter and the Completion of the Capitol"; and Weigley, "Captain Meigs and the Artists of the Capitol."

5. On Meigs's life, see Weigley, *Quartermaster General of the Union Army*.

6. These events contributed to the formation of the American or Know-Nothing party, a nativist and anti-Catholic movement that combatted foreign influences and promoted native-born Protestants in the government. Cheap immigrant labor contributed to the rise of the new party, which advocated the restoration of early republicanism.

Information about the rise and fall of the Know-Nothing party can be found in Billington, *Protestant Crusade*; Holt, *Political Crisis of the 1850s*, 155–181; and Gienapp, *Origins of the Republican Party*, 92–102.

7. *Report of the U.S. Art Commission*, 36th Cong., 1st sess., February 22, 1860, House Exec. Rpt. 43, 3. This report was published in full in *Crayon* 7 (April 1860): 106–109. The best review of the Art Commission can be found in Miller, *Patrons and Patriotism*, 79–84. See also Memorial of the National Art Association, February 29, 1860, Record Group 128, Joint Committee on the Library, National Archives; *Report from the Select Committee on the Memorial of the Artists of the United States*, 35th Cong., 2d sess., H. Rpt. 198; and *Memorial of the Artists of the United States*, HR 35A-D, 23.10, National Archives.

8. Meigs to Thomas Crawford, August 18, 1853, Meigs Letterbook.

9. Meigs to Edward Everett, July 7, 1853, Meigs Letterbook.

10. Everett to Crawford, July 12, 1853, Everett Letters. Everett met Crawford in Rome and Powers in Florence in the winter of 1841–1842. Robert L. Gale, *Thomas Crawford*, 104; Crane, *White Silence*, 239–240.

11. Fryd, "Hiram Powers's *America*."

12. Information on Thomas Crawford can be found in Gale, *Thomas Crawford*; Crane, *White Silence*; Dimmick, "Catalogue of the Portrait Busts"; Dimmick, "Veiled Memories"; Dimmick, "Thomas Crawford's *Orpheus*."

13. Senate, *Congressional Globe*, 35th Cong., 1st sess., May 28, 1858, 2463.

14. Meigs to Powers and Crawford, August 18, 1853, Meigs Letterbook.

15. Meigs to Crawford, August 18, 1853, Meigs Letterbook.

16. Korshak, "Birth of Athena."

17. Crawford executed the models in plaster and then shipped them to the United States, where American craftsmen carved them into marble.

18. Yvonne Korshak has explained the cap's origins and later meanings in "The Liberty Cap as a Revolutionary Symbol in America and France."

19. I have elaborated on the meaning and evolution of America as Liberty in "Hiram Powers's *America*." Crawford said of America's outstretched hand that "she asks the protection of the Almighty for the pioneers." For Crawford's description of the pediment, see Crawford to Meigs, October 31, 1853, Meigs Letterbook. See also Gale, *Thomas Crawford*, 111–112.

20. Cikovsky, "Ravages of the Axe." Barbara Novak also discusses the meaning of the ax in "Double-Edged Axe" and in *Nature and Culture*, chap. 8. On Inness's painting, see Cikovsky, "George Inness and the Hudson River School."

21. "The Pioneer," *Family Magazine* 7 (1840): 281; 283–284; Cooper, *The Pioneers*, 148.

22. "The forest—the flood—the savage—all disputed their [settlers'] progress" ("The Pioneer," 283).

23. *Writings of Thomas Jefferson*, 214.

24. Takaki, *Iron Cages*, 78.

25. Ibid., 75, 100.

26. "Domestic Art Gossip," 156.

27. Crawford to Meigs, October 31, 1853. Meigs applauded this figure as "a very noble one" because it accurately reflected the Indian "lamenting the gradual destruction of his race which he sees [as the result] of the advance of civilization settlement." See Meigs to Jefferson Davis, December 18, 1856, Office of the Chief Engineers, Capitol Extension and Washington Aqueduct, Record Group 77, National Archives.

28. Florentia, "Crawford and His Last Work," 41.

29. Catlin, *Letters and Notes on . . . the North American Indians*, 2:403.

30. Cikovsky, "Ravages of the Axe," 615.

31. Ibid., 615. For other examples of pictures that contain both tree stump and lamenting Indians, see ibid., 615 n. 29. Lydia Maria Child, in her short story "The Lone Indian," first published in 1828, connects the white man's ax, his destruction of trees, and the demise of the Indians in her elegiac story of Powontonamo's sorrow over

the death of his wife, son, and tribe. See Child, "Lone Indian," in *Hobomok and Other Writings on Indians*, 154–160.

32. Cikovsky, "Ravages of the Axe," 615.

33. "Crawford and His Last Work," 167–168.

34. Meigs wrote Crawford on December 27, 1853, "For the accessories of Indian Life I hope to be able to send you the work upon the manners and courtesies of our Indian tribes, even in the course of publications by the Government." Then on December 29 Meigs wrote, "Upon applying for old books on Indian manners published by the Government, I learn that there are several copies in Rome accessible to you without difficulty and there are not here any spare copies of the 2nd volume . . . [which] you will find in the English Academy of Fine Arts." Crawford tells Meigs, "I shall look for McKenney's Book to which you allude." Crawford to Meigs, October 23, 1854, Meigs Letterbook. The Plains Indians became a generic type in the United States, symbolizing all North American Indians rather than any one particular tribe. Ewers, "Emergence of the Plains Indian."

35. Crawford wanted the soldier to look like George Washington, thereby "directing the imagination to the qualities of prudence and valour without which the soldiers['] efforts are of little value," but Meigs advised that "many will say that you have attempted a portrait and failed." Crawford to Meigs, October 31, 1853; Meigs to Crawford, December 27, 1853, Meigs Letterbook.

36. *American Review* 3 (January 1846): 98.

37. Quoted in Merk, *Manifest Destiny and Mission*, 119–120.

38. Senate, March 17, 1848, *Papers of Jefferson Davis*, 3:286.

39. Fryd, "Sculpture as History," 59–73.

40. Crawford to Meigs, October 31, 1853.

41. Speech to the House of Representatives, February 6, 1846, *Papers of Jefferson Davis*, 2:439. Davis's advocacy of the forty-ninth parallel instead of the more extreme position of 54° 40′ resulted from his desire to avoid war. See Eaton, *Jefferson Davis*, 54.

42. Smith, *Virgin Land*, 123–124.

43. Senate, *Congressional Globe*, 30th Cong., 1st sess., January 12, 1848, 157.

44. Smith, *Virgin Land*, 123–132.

45. Eaton, *Jefferson Davis*, 85.

46. Smith, *Virgin Land*, 123–124, 3–12.

47. Crawford to Meigs, October 31, 1853.

48. Ibid.

49. Ibid.

50. "Forest Life and Progress," 20.

51. Cikovsky, "Ravages of the Axe," 618–619.

52. "The Pioneer," 284.

53. Pearce, *Savagism and Civilization*, 240–241.

54. Davis, Report of the Secretary of War, December 1, 1853, *Jefferson Davis, Constitutionalist*, 2:304. See also Davis's report of the following year, December 4, 1854, in which he again addresses the frontier skirmishes, advocating an increase in military involvement. Ibid., 389–394.

### Chapter 6
#### Rogers's Bronze Doors and Brumidi's Frieze

1. Meigs to Crawford, December 27, 1853, Meigs Letterbook.

2. Crawford to Meigs, June 28, 1855, Meigs Letterbook. As S. D. Wyeth states in his guidebook to the Capitol, Crawford's doors thus glorify "the Birth of American Independence, and the Progress of Constitutional Liberty." Wyeth, *Description of the Crawford Bronze Door*, 263.

3. Thomas Crawford designed and modeled the doors in Rome between 1855 and 1857. Upon his death in 1857, William H. Rinehart was commissioned to complete the work.

James T. Ames cast the doors at his foundry in Chicopee, Massachusetts, between 1864 and 1868.

4. Crawford to Meigs, June 28, 1855, Meigs Letterbook. Other pre–Civil War works in the Capitol represent themes of war and peace: Trumbull's Rotunda paintings, Persico's *War* and *Peace*, and Crawford's *Statue of Freedom*. See Fryd, "Sculpture as History," 59–73.

5. The Senate doors are arranged sequentially in the left and right valves, but there is no temporal continuation between the two vertical sections. The ovation for George Washington at Trenton, located above the bottom medallion, chronologically begins the left valve's subjects of George Washington's civilian role in the early federal republic. Featuring Washington on horseback framed by a flower arch, this image represents his triumphant reentry into Trenton en route to his 1789 inauguration in New York City, the subject of the next relief. In the top left panel, Washington is shown laying the cornerstone of the Capitol in 1793. The top right panel shifts to the Battle of Bunker Hill and the death of Warren on June 17, 1775. The next relief features a military event of 1778, when General Washington rebuked General Lee for failing to hold the ground in the Battle of Monmouth. Completing the right valve's sequence of war scenes is the Battle of Yorktown, which led directly to the British surrender and the end of the war. In the House doors, however, no logical time sequence can be discerned. If we read the panels from left to right, for instance, the subjects are arranged as follows: massacre of Wyoming, Pennsylvania (1778); public reading of the Declaration of Independence (1776); Battle of Lexington (1775); signing of the Treaty of Paris (1783); presentation of the flag and medal to General Greene (1781); Washington's farewell in New York (1783).

6. Meigs to Rogers, February 16, 1855, Meigs Letterbook.

7. Meigs to Rogers, March 8, 1855, Meigs Letterbook.

8. Rogers to Meigs, March 17, 1855, Meigs Letterbook.

9. Ibid.

10. Contract, May 24, 1855, Records of the Architect of the Capitol; Millard F. Rogers, *Randolph Rogers*, 45–46. Crawford received six thousand dollars for each door. See W. B. Franklin to John B. Floyd, June 5, 1860, Meigs Letterbook.

11. Walter felt that "there is nothing in the location [inside the Capitol extension] that requires such a door, nor is there any reason why an opening so entirely subordinate and unimportant in the design of the building should be embellished with so magnificent and expensive a work of art." Report of the Architect of the Capitol, November 1, 1862. Upon receiving the completed casting, however, Walter changed his mind, feeling that the work "has too much fine detail for outside exposure in a climate like this." Report of the Architect of the Capitol, November 1, 1863.

12. Meigs to Rogers, March 19, 1855, Meigs Letterbook.

13. Meigs to Crawford, May 11, 1855, Meigs Letterbook.

14. House, *Report of the Secretary of War*, 33d Cong., 2d sess., November 16, 1855, Ex. Doc. 1, 118.

15. Meigs carefully studied the Parthenon frieze in relationship to the Capitol dome, explaining that the situation would be different. "The point of sight however is fixed, and the work must be seen under a high angle. The necessities of construction limit the depth of the recess I fear to 9″. I had thought at first of placing detached figures upon a cornice, but they would not then be properly connected with the building of which they form a part, and would look too much like a row of casts upon a plasterers self for sale. . . . I suppose that the round of the figures might somewhat project beyond the face of the wall." Meigs to Crawford, September 11, 1856, Meigs Letterbook.

16. In his letter to Meigs of June 10, 1855, Crawford discusses his ideas for the execution of the bas-relief in the dome, indicating that he planned to execute the work. Meigs Letterbook.

17. Crawford wrote Meigs on August 8, 1855, "I am perfectly willing . . . to execute to

the best of my ability the entire frieze for the sum of $50,000 within five years from the receipt of the order." Meigs Letterbook.

18. "Now, with the committee of artists and that of the Library, and various other obstructions, I do not know when, if ever in my life time, it will be accomplished." Meigs to Rogers, July 23, 1859, Meigs Letterbook.

19. Brumidi to L. M. Morrill, Chairman of the Committee on Appropriations of the U.S. Senate, February 1876, SEN 44A-E1, Committee on Appropriations, Tray 79—Sundry Civil Expenses, National Archives. Material on Brumidi is scarce. For the most comprehensive survey, see Wolanin, "Brumidi's Frescoes." Other sources are Tighe, "Brumidi, Michael Angelo of the Capitol," and Murdock, *Constantino Brumidi.* Brumidi executed two additional frescoes involving the theme of exploration and discovery. Located in the President's Room (S-216), these works represent Amerigo Vespucci with charts and a spyglass, and Christopher Columbus with sexton and compass studying a globe placed on a map.

20. Meigs to Rogers, July 23, 1859, Meigs Letterbook.

21. Merk, in *Manifest Destiny and Mission,* coins the term *Caribbeanized manifest destiny,* which I have adopted.

22. Rogers to Meigs, August 20, 1856, Meigs Letterbook.

23. Ibid.

24. Washington Irving writes that the Italian mariner saw himself as "standing in the hand of Heaven, chosen . . . for the accomplishment of its high purpose. . . . The ends of the earth were to be brought together, and all nations and tongues and languages united under the banners of the Redeemer. This was to be the triumphant consummation of his enterprise, bringing the remote and unknown regions of the earth into communion with Christian Europe; carrying the light of the true faith into benighted and pagan lands, and gathering their countless nations under the holy dominion of the church." Irving, *Life of Columbus,* 38.

25. Rogers to Meigs, August 20, 1856, Meigs Letterbook.

26. For more information about Columbus's slave trade, see Stone, "Columbus and Genocide."

27. Meigs to Rogers, October 29, 1856, Meigs Letterbook; Rogers, *Randolph Rogers,* 57.

28. Rogers to Meigs, August 20, 1856, Meigs Letterbook. Whether these portraits represent the people Rogers identified in his letter is unclear because of the lack of inscriptions. The *Crayon* of June 1859, for example, reported that these busts represent "Peter Martyr, Las Casas, Diego Mendez, Mendoza, Bernal Diaz, and Marco Polo." "Foreign Correspondence, Items, Etc.," 185.

29. For information about Méndez, see Morison, *European Discovery of America,* 235, 250. For Rogers's identification of Toscanelli, see Rogers to Meigs, May 5, 1857, Meigs Letterbook.

30. Thomas U. Walter identifies two of the busts as representing Irving and Prescott. *Report of the Architect of the Capitol Extension,* November 1, 1862.

31. Rogers to Meigs, August 20, 1856, Meigs Letterbook.

32. Le Corbeiller, "Miss America and Her Sisters." See also Backlin, "Four Continents," and Honour, "Land of Allegory." For an examination of how another American sculptor represented the Four Continents, see Greenthal and Richman, "Daniel Chester French's *Continents.*"

33. Rogers to Meigs, August 20, 1856, Meigs Letterbook.

34. Fryd, "Hiram Powers's Bust of George Washington," 18–19.

35. Rogers to Meigs, August 20, 1856, Meigs Letterbook.

36. Rogers to Meigs, May 5, 1857, Meigs Letterbook. Rogers indicated that he also "represented the four cardinal virtues, the first line horizontally represents *Faith* . . . the second *Hope, Charity,* and *Clemency,*" but these emblems are not evident in the final work.

37. Rogers to Meigs, August 20, 1856.

38. Edward Clark, Architect of the Capitol who directed Brumidi's frieze, used this phrase. See "American History Graven on Stone," *New York Herald*, 22 February 1891, 14–15. According to this article, Clark considered adding such figures beside the allegory of America to fill up space, but it is clear from Brumidi's sketch that these figures already reside in the area beside Columbus, a scene omitted in the discussion of the frieze.

39. Ibid.

40. I appreciate the assistance of Steve Houston and Emily Umberger in identifying the Aztec objects and gods. The images of these gods differ from William H. Prescott's description in *History of the Conquest of Mexico*, 2:148–152. The Stone of the Sun remained embedded in the cathedral until 1885. See Bernal, *History of Mexican Archaeology*, 134.

41. In a book that Brumidi and Meigs could have consulted, Patrick Tailfer asserts that the first thing Oglethorpe did after he arrived in Georgia was "to *make* a kind of *solemn treaty* with a parcel of *fugitive Indians*" who resided in the area. Tailfer, *A True and Historical Narrative of the Colony of Georgia in America* (1741), 44.

42. For information about Oglethorpe's relations with the Creek Indians, see Spalding, *Oglethorpe in America*, and Spalding and Harvey, eds., *Oglethorpe in Perspective: Georgia's Founder after Two Hundred Years*.

43. David Levin, *History as Romantic Art*.

44. Brown, *Agents of Manifest Destiny*, 17.

45. For information about American intervention in the Caribbean, see Rauch, *American Interest in Cuba*; Robert E. May, *Southern Dream of a Caribbean Empire*; Brown, *Agents of Manifest Destiny*; Merk, *Manifest Destiny and Mission*.

46. May, *Southern Dream of a Caribbean Empire*, 4, 96; Eaton, *Jefferson Davis*, 101.

47. March 17, 1848, *Papers of Jefferson Davis*, 3:286.

48. Davis to Thomas J. Hudson, November 25, 1855, *Papers of Jefferson Davis*, 5:138; Eaton, *Jefferson Davis*, 104–106.

49. Speech at Vicksburg, November 27, 1858, *Papers of Jefferson Davis*, 6:228.

50. House, February 6, 1846, in Rowland, ed., *Jefferson Davis, Constitutionalist*, 1:34.

51. William H. Smith to James Foster, January 3, 1853, quoted in May, *Southern Dream of a Caribbean Empire*, 22.

52. Quoted in Potter, *Impending Crisis*, 190.

53. Meigs to Rogers, March 19, 1855, Meigs Letterbook.

## Chapter 7
### Ethnographic Exclusions

1. Dippie, *Vanishing American*, 21.

2. Child, *Hobomok*, xv.

3. Dippie, *Vanishing American*, 34–40.

4. Truettner, *Natural Man Observed*, 280.

5. Jedidiah Morse, *Report to the Secretary of War*, 70.

6. "The American Aborigines," *Niles' Weekly Register* 15 (November 14, 1818): 185.

7. Dippie, *Vanishing American*, 13.

8. Sprague, "American Independence," in Sprague, *Poetical and Prose Writings*, 152–153.

9. McLellan, "Last of the Tribes," 538–539.

10. Brian W. Dippie has detailed the Vanishing American in fin-de-siècle photography in "Photographic Allegories and Indian Destiny." The quotation that so eloquently describes the code of the vanishing race is from Dippie, "Indian Symbols," 1.

11. Quoted in Pearce, *Savagism and Civilization*, 163.

12. The attitude toward the Indians expressed by Francis Parkman, George Bancroft, William H. Prescott, John Motley, and other romantic historians is detailed in Levin, *History as Romantic Art*. For Parkman's beliefs, see 132–141.

13. Richardson, ed., *Compilation of the Messages and Papers of the Presidents*, 2:520–521.

Jackson also referred to the Indians as "savage dogs" and "blood thirsty barbarians." Takaki, *Iron Cages*, 95–96. As Ronald Takaki noted about Jackson, "A leader of his people, he recognized the need to explain the nation's conduct toward Indians, to give it moral meaning. In his writings, messages to Congress, and personal letters, Jackson presented a philosophical justification for the extermination of native Americans." Ibid., 100.

14. *Register of Debates*, Senate, 18th Cong., 2d sess., February 22, 1825, 640.

15. *Congressional Globe*, 29th Cong., 1st sess., June 3, 1846, 918.

16. Davis, *Captain Smith and Princess Pocahontas*, 65; Owen, *Pocahontas*, 21.

17. "The Indians in American Art," *Crayon* 3 (January 1856): 28.

18. William H. Gerdts briefly discusses the Vanishing American typology in nineteenth-century sculpture in *American Neo-Classic Sculpture*, 128–129. See also Gerdts, "The Marble Savage."

19. Like Pearce in *Savagism and Civilization* and Schimmel in "Inventing 'the Indian,'" I divide the traditional noble savage into two types: one who is kind (the noble savage) and one who is a fierce opponent of white civilization (the ignoble savage). There is yet another work in which the Indian is stereotyped as the noble savage who willingly retreats before Anglo-Saxon progress: James Walker's *Battle of Chapultepec*. This battle scene from the Mexican War was commissioned by Meigs (who recommended the subject) in 1857 for the House Military Committee room. After working on the canvas for six or seven months, Walker stopped receiving payment from the government because of an act of Congress that directed the Art Commission to review all works. In 1862, Walker requested the balance of his commission, which he received upon completion of the work. The painting was placed in the western staircase of the Senate wing, but is now in storage. See Meigs to Walker, October 9, 1857, Meigs Letterbook; Thomas U. Walter to Caleb B. Smith, May 17, 1862; Caleb B. Smith to Benjamin B. French, July 18, 1862; and Edward Clark to D. W. Voorhees, February 24, 1880, Records of the Architect of the Capitol. Patricia Hills, "Picturing Progress in the Era of Westward Expansion," in *The West as America*, 97–147, briefly discusses this mural. Hills provides a different account of the fate of the mural, 141 n. 31.

20. The clock decorated the House chamber until 1949, when it was removed for restoration. The monumental Rinehart clock is now on display in the Capitol crypt.

21. For West's comment, see Galt, *Life, Studies, and Works*, 99–101.

22. Crawford, "Classical Tradition in American Sculpture," 43.

23. Child, *Hobomok*, 16, 36, 17.

24. Cooper, *Last of the Mohicans*, 294, 336, 61. For an analysis of Cooper's Leatherstocking tales as source of the frontier myth, see Slotkin, *Regeneration through Violence*, 466–516.

25. Two satirical burlesques on this type are John Brougham's *Metamore, or the Last of the Pollywogs* (1847) and *Pocahontas, the Gentle Savage* (1855). See Berkhofer, *White Man's Indian*, 95.

26. Roy Harvey Pearce discusses the censure and pitying of the savage in *Savagism and Civilization*.

27. Kathryn S. Hight, in "Doomed to Perish," has demonstrated that Catlin, Eastman, and Stanley distorted reality.

28. Catlin recalled, "When a delegation of some ten or fifteen noble and dignified-looking Indians, from the wilds of the 'Far West,' suddenly arrived in the city, arrayed and equipped in all their classic beauty," he recognized them as fine subjects for "the painter's palette." Catlin, *Letters and Notes*, 1:19. For Catlin's statement about the white man's allurements, see *Letters and Notes*, 1:2–5.

29. Truettner, *Natural Man Observed*, 71–73.

30. Mitchell, *Witnesses to a Vanishing America*, 113.

31. Truettner, *Natural Man Observed*, 36.

32. Catlin, *Letters and Notes*, 1:35. For a similar comment, see Catlin, *Last Rambles amongst the Indians*, 357–358. At times, he did adopt standard poses of authority from

the history of art, as in *Osceola* (1838) and *Little Spaniard* (1834), both of which emulate the *adlocutio* pose of the Augustus Prima Porta and the regal attitude of monarchs and landed gentry found in seventeenth- and eighteenth-century portraits.

33. *Letters and Notes*, 1:35.

34. Hight, "Doomed to Perish," 121.

35. Catlin said of Black Hawk, "This man, whose name has carried a sort of terror throughout the country where it has been sounded, has been distinguished as a speaker or counselor rather than a warrior." Truettner, *Natural Man Observed*, 143.

36. Catlin, *Letters and Notes*, 1:36.

37. Kathryn S. Hight argues differently. She sees Catlin's works as "presenting the public not so much an ethnological report as a validation of the most widely embraced theory behind the national Indian policy" of removal. See Hight, "Doomed to Perish," 119.

38. Catlin, *Letters and Notes*, 1:36.

39. Truettner, *Natural Man Observed*, 13.

40. Catlin, *Letters and Notes*, 1:19. Truettner has successfully identified all of these various reasons why Catlin selected the North American Indians as his subject matter. See Truettner, *Natural Man Observed*, 14, 61–68.

41. Putnam Catlin to Francis Catlin, March 18, 1838, in Roehm, *Letters of George Catlin and His Family*, 127.

42. Horan, *McKenney-Hall Portrait Gallery*, 23.

43. *Congressional Globe*, 41st Cong., 1st sess., March 11, 1869, 47; 42d Cong., 2d sess., May 6, 1872, 3097; 42d Cong., 3d sess., January 31, 1873, 991, 1023. Earlier Catlin had sold his Indian gallery to locomotive manufacturer Joseph Harrison, whose daughter donated the collection to the nation in 1879; it is located in the Smithsonian. In 1912, the American Museum of Natural History bought Catlin's cartoon collection, his second Indian gallery, created in the 1860s. Paul Mellon purchased the collection in 1965, donating it to the National Gallery in Washington, D.C. Ironically, then, both Catlin's Indian galleries are owned by the federal government. I am indebted to Nancy Anderson for clarifying the provenance of these two collections.

44. Mitchell, *Witnesses to a Vanishing America*, 119.

45. For the prices paid for each work of art, see Brown, *History of the United States Capitol*, 1:110–113.

46. *Congressional Globe*, 29th Cong., 1st sess., July 24, 1846, 1138.

47. Meigs to Ashur B. Durand, October 11, 1856, Meigs Letterbook.

48. *House Journal*, 25th Cong., 2d sess., May 28, 1838, 974; 25th Cong., 3d sess., February 11, 1839, 518–519; *Memorial of R. R. Gurley*, 30th Cong., 1st sess., July 18, 1848, S. Misc. Rpt. 152, 1, 2. See also Dippie, *Catlin and His Contemporaries*, 64–66. *House Journal*, 26th Cong., 1st sess., March 9, 1840, 563. This time George Sweeney, a Democrat from Ohio, submitted the resolution.

49. *Memorial of George Catlin*, 29th Cong., 1st sess., June 5, 1846, S. Rpt. 374; and *Memorial of A. B. Durand, and other Artists of New York*, 29th Cong., 1st sess., July 9, 1846, S. Rpt. 424.

50. *Report of the Joint Committee on the Library in Relation to the Purchase of Catlin's Indian Gallery*, July 24, 1846, in S. Misc. Rpt. 152, 9.

51. *Catlin's Indian Gallery*, 29th Cong., 1st sess., July 24, 1846, H. Rpt. 806, 1. See also *Congressional Globe*, 29th Cong., 1st sess., July 9, 1846, and July 24, 1846, 1072, 1138.

52. Dippie, *Catlin and His Contemporaries*, 114.

53. *Congressional Globe*, 29th Cong., 2d sess., March 2, 1847, 529.

54. Ibid. For Westcott's position in Florida politics and his views on the Indians, see Dippie, *Catlin and His Contemporaries*, 118; Thompson, *Jacksonian Democracy on the Florida Frontier*.

55. Mitchell, *Witness to a Vanishing American*, 102. See also *Congressional Globe*, 30th Cong., 1st sess., August 8, 1848, 1050; *Catlin's North American Indians*, 30th Cong., 1st sess., August 8, 1848, H. Rpt. 820, 2. Dippie, *Catlin and His Contemporaries*, 128–131,

gives a full account of this attempt by Gurley to convince Congress to purchase Catlin's collection.

56. *Daily National Intelligencer*, March 5, 1849, 1.

57. Ibid., 2–3.

58. William H. Seward of New York submitted the resolution on June 8, 1852, in the Senate. *Congressional Globe*, 32d Cong., 1st sess., June 8, 1852, 1533. Two days later, the Senate considered Seward's proposal and debated whether the Library Committee or the Committee on Indian Affairs should inquire into the matter. The chairman of the Library Committee, James Pearce, explained that his group would not write a favorable report because they believed that another committee should consider the issue. Ibid., June 10, 1852, 1547–1548. Finally, the Senate resolved to appoint a select committee. Ibid., June 14, 1852, 1566. For the select committee's report, see ibid., June 25, 1852, 1601, and "Report," 32d Cong., 1st sess., June 23, 1852, S. Rpt. 271. For Catlin's appeal to Daniel Webster for assistance, see his letter of April 4, 1852, in Roehm, *Letters*, 441–443.

59. *Congressional Globe*, 32d Cong., 1st sess., July 20, 1852, 1845–1846.

60. Ibid. Dippie has shown that the vote broke along sectional and party lines. *Catlin and His Contemporaries*, 150–155.

61. Catlin, *Last Rambles*, 50–51. Davis, "Remarks on Purchasing George Catlin's Collection," February 27, 1849, *Papers*, 4:16–17.

62. For the iconography of the Indian princess as an allegory of America, see Fleming, "American Image as Indian Princess," and "From Indian Princess to Greek Goddess."

63. Davis attested to the accuracy of Catlin's works: "He has painted the Indian as he lives, unfettered by art, untamed and degraded by the contact of the white man." February 27, 1849, *Papers*, 4:16.

64. Holzhueter, "Chief Buffalo," 284–288. Meigs had asked Eastman to inform him when Indians traveled to the capital city so that models could be used for Crawford's pediment. Meigs to Seth Eastman, February 17, 1855; Eastman to Meigs, February 17, 1855, Meigs Letterbook. See also Meigs to Vincenti, February 18, 1855, Meigs Letterbook. These busts are now located in the east corridor of the Senate wing on the third floor.

65. *National Intelligencer*, March 5, 1849; *Congressional Globe*, 30th Cong., 2d sess., February 27, 1849, 604. Dayton again raised the issue the following day when the Senate once again voted his motion down. *Congressional Globe*, 30th Cong., 2d sess., February 28, 1849, 613.

66. *National Intelligencer*, March 5, 1849.

67. *Congressional Globe*, 32d Cong., 1st sess., June 10, 1852, 1518; July 20, 1852, 1846. Henry Sibley, a northern Democrat and territorial delegate from Minnesota, had convinced Borland to raise Eastman's name. Formerly in charge of the American Fur Company, Sibley rankled at Catlin's criticism of the fur company and deliberately damaged Catlin's case for congressional patronage by promoting Eastman. Dippie, *Catlin and His Contemporaries*, 188.

68. *Congressional Globe*, 32d Cong., 1st sess., July 20, 1852, 1846.

69. Dippie describes Borland's politics in *Catlin and His Contemporaries*, 215.

70. Lanman, *Summer in the Wilderness*, 59.

71. This information derives from two sources: Mitchell, *Witnesses to a Vanishing America*, 123–125, and McDermott, *Seth Eastman*.

72. The committee, renamed the Committee on Interior and Insular Affairs in 1951, moved to the Longworth House Office Building in 1945, where eight of the nine paintings still hang. Eastman's 1867 commission underscores the financial considerations that contributed to Congress's refusal to commission Catlin. The army officer retired because of medical problems but remained within the military employ through the Architect of the Capitol to create the series, receiving his same salary. *Congressional Globe*, 40th Cong., 1st sess., March 26, 1867, 361–362.

73. Charles E. Grounds, Seminole Intra-Tribal Business Association, in a letter to

Office of the Architect of the Capitol, June 27, 1950, was the first to object to the painting, and his objection led to its removal between January 1951 and July 1952. The letter is in the Records of the Architect of the Capitol; see also *Evening Star*, August 13, 1959, for a discussion of the work's initial removal. When in 1987 Congressman Ben Nighthorse Campbell, a Northern Cheyenne from Colorado on the House Committee on Interior and Insular Affairs, opposed the exhibition of *Death Whoop* in the Longworth committee room, it was placed in storage in the Capitol building. The transcript of the October 7, 1987, committee meeting indicates that the members agreed to the work's removal merely to appease Campbell, for they made fun of the situation and of Campbell's objections.

74. *Congressional Globe*, 32d Cong., 1st sess., July 20, 1852, 1846.

75. *Congressional Globe*, 32d Cong., 2d sess., December 28, 1852, 158. See also *To the Honorable Senate and House of Representatives of the United States of America, in Congress Assembled*, Record Group 46, SEN 34A-H10, Senate Library Committee, National Archives, which holds the letter in which Eastman supports Stanley over Catlin, which Clemens submitted on July 20, 1852.

76. *Congressional Globe*, 32d Cong., 2d sess., March 3, 1853, 1084. See also Stanley's letter to W. K. Sebastian, chairman of the Senate Committee on Indian Affairs, January 13, 1853, Record Group 46, 34A-H10, Senate Library Committee, National Archives, in which he argued, "The nation must have these portraits for the gratification of public curiosity, and from motives of an elevated State policy."

77. Dippie, *Catlin and His Contemporaries*, 285.

78. On April 2, 1856, John J. Crittendon of Kentucky moved that Stanley's memorial of 1852 be again considered by the Committee on Indian Affairs. *Congressional Globe*, 34th Cong., 1st sess., April 2, 1856, 792. William Sebastian, chairman of the committee, asked on July 9 that the committee be discharged from further consideration of the memorial. Ibid., July 10, 1856, 1581. On August 11, Sebastian suggested that the memorial be referred to the Committee on the Library, but the Senate adjourned seven days later without having taken any action. Ibid., August 11, 1856, 2017. Stanley's letter to the Committee on Indian Affairs of April 14, 1856, is preserved in Record Group 46, SEN 44A-H10, Senate Library Committee, National Archives.

79. *Memorial to the Honorable Senate and House of Representatives of the United States of America*, January 12, 1863, Record Group 128, Joint Committee on the Library, 37th Cong., 4, National Archives. Stanley's letter to the chairman of the Joint Committee on the Library, dated January 19, 1863, called the collection "an important chapter in the history of a race soon to pass away forever from the family of man." Record Group 128, Joint Committee on the Library, National Archives.

80. *Troy Daily Journal*, September 7, 1850, quoted in Schimmel, "Stanley and Imagery of the West," 91.

81. *Memorial to the Honorable Senate and House of Representatives*, July 20, 1865, Record Group 128, HR 38A-G11.1, Committee on the Library, National Archives.

82. *Joint Resolution Relative to the Employing of John Mix Stanley*, Record Group 128, HR 38A-G11.1, Committee on the Library, National Archives. Although the document is not dated, the reference to the fire in the Smithsonian indicates that it was drafted after January 14, 1865.

83. Ibid.

<div align="center">

### Chapter 8
*Liberty, Justice, and Slavery*

</div>

1. For a philosopher's interpretation of the political symbolism of Crawford's *Freedom*, see Griswold, "The Vietnam Veterans Memorial and the Washington Mall," 692–693.

2. On the images of blacks by these artists, see Boime, *Art of Exclusion*.

3. On the changing interpretations of Liberty in the United States, see Kammen, *Spheres of Liberty*.

4. On the iconography of Justice in the Renaissance and its theological meanings, see

Edgerton, *Pictures and Punishment*, 23–30. Lorenzetti differentiated three types of Justice: Distributive Justice, Commutative Justice, and Vindictive Justice (ibid., 38–39). In the seventeenth century, Cesare Ripa distinguished among four kinds of Justice: Justice wears a crown; Inviolable Justice holds a scepter, crown, and scales; Rigovrevse Justice holds a sword and scales and wears a crown; and Divine Justice resembles Rigovrevse Justice but has a dove in a ray of light above her head and is a beautiful, classically draped woman rather than a draped skeleton. Ripa, *Iconologie* 2:56–58. See also Richardson, *Iconology*, 2:21, pl. 60. Arthur Asa Berger, *Signs in Contemporary Culture*, 19–20, briefly discusses the relationship between the signifier (scales) and the signified (justice). For the reasons why women personified abstract ideas and for the history of these forms, see Warner, *Monuments and Maidens*.

5. Force, *Picture of Washington*, 51.

6. Exactly what this winged boy represents is puzzling, for the figure does not correspond to any traditional personifications in the history of art. The identification of this personification as the Young Nation is from *Art in the United States Capitol*, 291. Knapp, *History and Topography of the United States*, discusses the figure's ambiguity by observing it is "too lank and lean for a cupid, or an angel; but is probably intended for one or the other of these supernatural beings, or perhaps for the Genius of the constitution" (2:428). Robert Mills, *Guide to the Capitol*, identifies this figure as Fame (9).

7. Bulfinch wrote, "The Tympanum of the great pediment of the Portico will also offer an opportunity for an extensive display of sculpture, in an allegorical or historical subject." Charles Bulfinch to Henry Couceci [*sic*], July 8, 1822, Record Group 42, Commissioner of Public Buildings, National Archives. That Causici executed a design is evident in Bulfinch's January 15, 1823, letter to Joseph Elgar, Record Group 42, National Archives. At least one artist objected to the commissioners' decision: William J. Coffee. See Coffee to the Commissioner of Public Buildings, November 30, 1825, and December 1, 1825, Record Group 42, National Archives; and Coffee to the Senate and House of Representatives, January 11, 1826, Record Group 233, HR 19A-G6.1, Committee on Expenditures on the Public Buildings, National Archives. The commissioners recommended that the five-hundred-dollar premium be divided so that two hundred dollars would be given to the anonymous author of one drawing, which contained "the Figure of Justice in the centre on a Pedestal, supported by wisdom & truth." The committee then suggested that one hundred dollars each be given to John R. Penniman, Arthur J. Stansbury, Luigi Persico, and Nicholas Gevelot. William Thornton, George Bomford, and Charles B. King to Joseph Elgar and Charles Bulfinch, August 13, 1825, Record Group 233, HR 19A-G6.1, Committee on Expenditures on the Public Buildings, National Archives. In the letter, the commissioners explained that none of these designs would be commissioned. Apparently Robert Mills submitted a design including "Washington, in a chariot drawn by six horses abreast, coming out of the Capitol, crowned by Liberty & Wisdom; the whole encircled by a glory, studded with thirteen stars, representing the Federal Union." Mills, *Guide to the Capitol*, 12. The account of President Adams's involvement with the design competition for and iconography of the central pediment is from Bulfinch's letter to Thomas Bulfinch, June 22, 1825, in *Life and Letters of Charles Bulfinch, Architect*, 247–250.

8. According to President Adams, Persico's design evolved from suggestions made by Bomford and King. For this statement and his description of the pediment composition, see May 30, 1825, and May 31, 1825, *Memoirs of John Quincy Adams*, 7:20.

9. Ibid.

10. My information about Adams is from Ellis, *Union at Risk*, 9, 19–20, 103–104.

11. Daniel Webster, "An Address Delivered at the Laying of the Cornerstone of the Bunker Hill Monument," in *The Works of Daniel Webster*, 1:59–78; Edward Everett, "Principle of the American Constitutions," in *Orations and Speeches on Various Occasions*, 1:103–130.

12. Everett, "Principle," 109.

13. Meigs to Crawford, August 18, 1853, Meigs Letterbook.

14. Crawford sent drawings for the pediment sculpture on November 28, 1853, forgetting to include the cornice designs, which were forwarded on January 27, 1854. See Meigs to Crawford, November 28, 1853, and Crawford to Meigs, January 17, 1854, Meigs Letterbook. Although Crawford's description and model for his initial design of *Liberty and Justice* are no longer extant, the following letters enable its reconstruction: Meigs to Crawford, April 24, 1854; April 27, 1854; June 13, 1854, Meigs Letterbook.

15. Meigs to Crawford, April 27, 1854. If Crawford retained the fasces, Davis recommended that the "rods & the scales to indicate that if punishment be inflicted, the cause is well weighed, first convey that rod & pen which your sketch shows." Crawford considered replacing the fasces with the sword and scales in the hand of Justice. Crawford to Meigs, June 13, 1854, Meigs Letterbook. Davis recommended instead "the scales to weigh & the pen to record the decisions of justice." Meigs to Crawford, April 27, 1854.

16. Ibid. Meigs took this phrase from Davis. See Davis to Meigs, January 15, 1856, Davis, *Papers*, 6:6–7.

17. Latrobe to Mazzei, March 6, 1805, *Thomas Jefferson and the National Capitol*, 357; Garlick, *Philip Mazzei, Friend of Jefferson*, 151. For a description of Franzoni's *Liberty*, see Benjamin Latrobe to Samuel Harrison Smith, editor of the *National Intelligencer*, November 22, 1807, Latrobe, *Correspondence and Miscellaneous Papers*, 2:504. Latrobe had made a drawing of Liberty in 1804 in which she holds the pole surmounted by a cap. That Latrobe influenced Franzoni's work is evident in a letter from the architect to Lenthall in which he expresses his distaste for the club, recommending instead the cap and pole. Latrobe to Lenthall, December 31, 1806, ibid., 2:347.

18. Yvonne Korshak has distinguished the differences between the Phrygian cap, which flips over and can be traced back to the ancient Greek people in Phrygia, and the Roman pileus or rounded cap, which refers to Roman manumission: "It appears that in the eighteenth century the distinction between the cap of these foreign captives [the Phrygians] and the *pileus* cap of the freed slave was blurred through the association of both types of headgear with enslavement, a confusion abetted by a plethora of antique cap types on illustrated monuments." See Korshak, "The Liberty Cap as a Revolutionary Symbol," 59–60.

19. Smith, "Liberty Displaying the Arts and Sciences."

20. Latrobe to Mazzei, December 19, 1806, *Correspondence*, 2:329.

21. The nineteenth-century authors (Force in *Picture of Washington*, 63; Haas in *Public Building and Statuary*, 6; and Mills in *Guidebook to the Capitol*, 33) each identify the plaster cast as representing Liberty, and twentieth-century works (Fairman in *Art and Artists in the Capitol*, 50–52, and *Art in the United States Capitol*, 279) follow suit. Two nineteenth-century documents call Causici's plaster cast *Genius of the Constitution: Register of Debates*, House, 16th Cong., 2d sess., November 1820, 457; Records of the U.S. House of Representatives, Reports of the Committee on Public Buildings, HR 14 CB 3, National Archives.

22. Latrobe to Smith, November 22, 1807, *Correspondence*, 2:504.

23. *Art in the United States Capitol*, 279; Haas, *Public Building and Statuary*, 7; Mills, *Guidebook to the Capitol* (1834), 33. Wayne Craven corrected the identification in *Sculpture in America*, 66.

24. The rattlesnake often accompanied images of America in eighteenth-century prints to announce, "Don't Tread on Me!" See Fleming, "American Image as Indian Princess," 69.

25. Mills, *Guidebook to the Capitol*, 33.

26. Meigs to Crawford, April 24, 1854, Meigs Letterbook.

27. Korshak, "Liberty Cap as a Revolutionary Symbol," 53; Wiedemann, *Greek and Roman Slavery*.

28. Edward Everett to Hiram Powers, January 22, 1849, Hiram Powers Papers. Everett, however, had incorrectly attributed the modern use of the cap to revolutionary France,

maintaining that the symbol had been misunderstood and "travestied rather than adopted." Yvonne Korshak has demonstrated that Paul Revere appropriated the emblem from William Hogarth, initiating its application in the United States before the French Revolution. According to Korshak, Hogarth "became the first artist in modern times to use the liberty cap to symbolize political rebellion." "Liberty Cap as a Revolutionary Symbol," 57.

29. Korshak, "Liberty Cap as a Revolutionary Symbol," 54.

30. Ibid., 62.

31. Weigley, *Quartermaster General of the Union Army*, 117, discusses Meigs's friendship with southern statesmen and his assessment of slavery.

32. Walter to Rest Fenner, May 25, 1869, Library of Congress, Manuscript Division.

33. Meigs to Rogers, March 19, 1855, Meigs Letterbook.

34. Meigs to Crawford, May 11, 1855, Meigs Letterbook.

35. Crawford to Meigs, June 20, 1855, Meigs Letterbook.

36. The term *synthomorphosis* is from Marvin Trachtenberg, *Statue of Liberty*, 65.

37. Crawford to Meigs, October 18, 1855, Meigs Letterbook.

38. Jefferson Davis to Meigs, January 15, 1856, Meigs Letterbook.

39. Crawford to Meigs, March 19, 1856, Meigs Letterbook.

40. Trachtenberg, *Statue of Liberty*, 66. Albert Boime has discussed the political nature of Bartholdi's monument in greater detail and has clearly delineated the creation and destructions of Dumont's statue on the Vendôme Column in *Hollow Icons*, 17. Marina Warner proposes a different way of analyzing Bartholdi's monument, as well as female allegories in general, identifying the statue as "a penetrable container" and "universal mother." *Monuments and Maidens*, 10.

41. Boime, *Hollow Icons*, 122.

42. Information of the iconographic development of America is extensive. Most helpful are Fleming, "American Image as Indian Princess" and "From Indian Princess to Greek Goddess"; Honour, *New Golden Land*; and Taylor, "America as Symbol." I have discussed the iconography of America in relationship to Libertas in "Hiram Powers's *America*."

43. As far as I can tell, neither Meigs nor Davis reacted to Rogers's America, who wears a Phrygian cap, or to Crawford's America, who stands in the center of his Senate pediment. Perhaps they ignored the object's presence in these two works because they did not think they could be easily seen.

44. Crawford could also have been inspired by the replica of the ancient goddess in Antoine Etex's sculpture, *Peace* (1815), carved on the Arc de Triomphe in Paris, a city he visited in 1845.

45. Prucha, *Indian Peace Medals*, 75–87.

46. Because Crawford died without having completed the statue, Robert Mills cast the model in bronze.

47. *Congressional Record*, 88th Cong., 1st sess., June 11, 1963, 10558.

48. Eaton, *Grant, Lincoln, and the Freedman*, 89.

49. For the documents concerning the work's inauguration, see Special Order No. 448, Walter to W. T. Otto, Assistant Secretary of the Interior, November 30, 1863, Records of the Architect of the Capitol; Usher to Edwin Stanton, Secretary of War, November 30, 1863; Stanton to Usher, November 30, 1863; Otto to Walter, December 1, 1863, Records of the Architect of the Capitol.

50. *New York Tribune*, December 10, 1863, 5.

51. Ibid.

52. Ibid.

53. That Carpenter had hoped the painting would inhabit the halls of Congress is evident in his letter to Thaddeus Stevens, chairman of the Committee on Appropriations, February 27, 1867, Records of the Architect of the Capitol. He claimed that Lincoln also expressed a desire that the picture be purchased by Congress. Elizabeth Thompson donated the work to Congress; her petition is in *Congressional*

*Record*, 45th Cong., 2d sess., January 16, 1878, 359. See also January 29, 1878, 632; February 11, 1878, 938; and February 12, 1878, 968–971. For a more detailed discussion of this painting, see Holzer, Boritt, and Neely, "Francis Bicknell Carpenter."

54. Morgan, *American Slavery—American Freedom*. Morgan's thesis is of course more complex than this. He demonstrates among other things how English attitudes toward the poor became the basis for attitudes in this country, and how black slaves inevitably replaced white indentured servants in Virginia's tobacco agricultural society.

55. December 1855, 3:826, Henry Kirke Bush-Brown Papers, Library of Congress, Manuscript Division.

56. Brown to Meigs, January 21, 1856, Meigs Letterbook.

57. Brown to Meigs, February 12, 1856, 3:832A–B, Henry Kirke Bush-Brown Papers. Brown was just one of at least four sculptors who submitted proposals for the House pediment. Through its subject of the European settlement in the New World wilderness and conquest of the "savage red men," Henry Dexter's pedimental decoration would have fit into the Capitol program. Erastus Dow Palmer selected the landing of the Pilgrims as the motif for his design, and Thomas Dow Jones, a more obscure artist than the others, suggested the settlement of Kentucky and its "Civic age" under the stewardship of Henry Clay. Only Brown, then, did not conceive of a subject that would have thematically related to works both inside and outside the Capitol. The disapproval of his design may have resulted from its lack of continuity with the artistic program in the Capitol, but more likely it was because of Brown's initial intention of including the slave. Yet none of the works proposed by these artists was selected, in part because Meigs awaited Hiram Powers's model, which Powers refused to submit because of the government's refusal to purchase his *America*. For a description and photograph of Palmer's design, see Webster, *Erastus D. Palmer*, 155–156, 186–187. For Meigs's correspondence concerning the proposals by Palmer and Jones, see Meigs to Palmer, April 15, 1857; Meigs to Palmer, April 28, 1857; Meigs to Floyd, July 14, 1857; Edwin B. Morgan to Meigs, July 27, 1857; Meigs to T. D. Jones, November 20, 1857, Meigs Letterbook. In a letter to Jefferson Davis, Meigs summarized the events that led to the House's empty pediment, claiming that he still hoped Powers would submit a design. Meigs to Davis, July 27, 1855, Meigs Letterbook.

58. Brown to Meigs, February 12, 1856, 3:832C, Henry Kirke Bush-Brown Papers.

59. Brown to Morris Davis, January 27, 1856, 3:832, Henry Kirke Bush-Brown Papers.

60. Wayne Craven discusses Brown's marble Indian subject matter in "Henry Kirke Brown." For Brown's comments about the result of civilizing the Indians, see ibid., 50.

61. Both the Brown Papers and the Meigs Letterbook contain extensive correspondence detailing the intrigue involved in the Walter-Meigs disagreements and Brown's role in urging Congress and other artists to campaign for Meigs's removal. Weigley, "Captain Meigs and the Artists of the Capitol," provides the most succinct summary of these events. See also Rosenberger, "Thomas Ustick Walter." For the formation of the Art Commission, see the petition signed by more than a hundred artists that called for such a panel; see also *Report of the Select Committee on the Memorial of the Artists of the United States*, 35th Cong., 2d sess., HR 35A-D23.10, National Archives, and "Report of the U.S. Art Commission," February 22, 1860, 36th Cong., 1st sess., H. Exec. Doc. 43.

62. Whether Powers intended to refer to southern slavery through this symbol (the marble statue had chains under the foot) is uncertain. I have addressed this issue, the complexity of *America*'s iconography, and some statesmen's objections to the liberty cap in "Hiram Powers's *America*."

63. Everett to Powers, July 30, 1855, Edward Everett Papers.

64. Everett to the Senate and the House of Representatives, December 23, 1850, Record Group 233, HR 32A-G18.3, National Archives. This petition on behalf of Powers's *America*, referred to the Committee on Public Buildings, was also signed by William H. Prescott, George Ticknor, Francis C. Gray, Rufus Choate, Jared Sparks, Cornelius C. Felton, Theophilus Parsons, and Henry W. Longfellow. It was read in the House on December 31, 1850, and referred to the Committee on the Library.

*Congressional Globe*, House, 31st Cong., 2d sess., December 31, 1850, 145. For the favorable report of the Committee on Public Buildings, see *Statue of America*, March 3, 1851, Record Group 233, HR 31A-D17.1, National Archives.

65. Powers to Lewis D. Campbell, September 10, 1857, Hiram Powers Papers.

66. Powers to Hamilton Fish, December 1858, Hiram Powers Papers. Earlier, Powers had stated that it was America's "mission," not its "business" to persuade rather than coerce mankind. See Powers to George P. Marsh, October 22, 1857, Hiram Powers Papers.

67. Meigs to Davis, October 1855, Meigs Letterbook.

68. An anonymous letter to Meigs, dated December 14, 1857, voiced objections to the mural, arguing that it should be removed because the "subject is considered inappropriate and the execution execrable." The engineer attached a note to this letter that the fresco "serves to show what the effect of painting on the panels will be which is all I intended. It cost little, and I have not the least objections to a better painting being by Congress put over it, but it is the best that could be done at the time and no more time was at my disposal." "Officious" to Meigs, December 15, 1857, Meigs Letterbook.

69. In showing Africa in the top right of the door, Rogers reversed what had been a traditional location of the allegory beneath, and hence subservient to, the other continents, as demonstrated by Boime, *Art of Exclusion*, 10–13.

*Epilogue*
*Leutze's* Course of Empire

1. Berkeley, *Works*, 7:369–373.

2. Leutze proposed this subject to Meigs in a letter of May 13, 1861, Meigs Letterbook. For the contract of July 9, 1861, see Records of the Architect of the Capitol. See also Leutze to the Committee on Public Buildings, June 6, 1862, Record Group 42, HR 37-A G14.1, Committee on Public Buildings and Grounds, National Archives.

3. Meigs to Leutze, January 12, 1854, Meigs Letterbook. Leutze had earlier submitted a memorial to Congress, petitioning for a commission to execute his *Washington Crossing the Delaware* and *Washington Rallying the Troops at the Battle of Monmouth* for the Capitol extension or "Executive Mansion." See "The Memorial of E. Leutze," April 5, 1852, Record Group 128, Joint Committee on the Library, National Archives.

4. Leutze to Meigs, February 14, 1854, Meigs Letterbook.

5. Leutze to Meigs, February 1857 (the day is illegible); Meigs to Leutze, March 13, 1861; Leutze to Meigs, May 13, 1861, Meigs Letterbook. For the captain's 1857 reply, see Meigs to Leutze, February 17, 1857, Meigs Letterbook. Meigs forwarded this letter to James Pearce, recommending that the Library Committee sponsor a competition for "the best designs for historical pictures for certain places in the extension." Meigs to Pearce, February 17, 1857, Meigs Letterbook.

6. Some argue that Alfred Bierstadt painted the sky of the predella, which Raymond Lewis Stehle disputes in his unpublished manuscript, "The Life and Works of Emanuel Leutze" (1972), 126–129, housed in the Records of the Architect of the Capitol, and in "Westward Ho."

7. For Leutze's explanation of the mural from which this quotation derives, see Turner, "Emanuel Leutze's Mural," 14–16, in which Leutze's manuscript from the Library of Congress has been published.

8. Ibid., 14–15.

9. "Leutze's New Painting," *National Intelligencer*, November 27, 1862.

10. Turner, "Emanuel Leutze's Mural," 15.

11. Leutze reported his return from the Colorado Territory in his letter to Meigs, September 27, 1861, Records of the Architect of the Capitol.

12. Turner, "Emanuel Leutze's Mural," 15.

13. Ibid., 16.

14. Bercovitch, "Typology of America's Mission," 138.

15. Turner, "Emanuel Leutze's Mural," 15.

16. The oil sketches are housed in the Gilcrease Institute in Tulsa, Oklahoma, and in the National Museum of American Art. Patricia Hills suggests that Secretary of War Cameron, an expansionist opposed to the emigration of blacks into the West, approved the mural on the basis of the oil sketch, which did not include the African American. See Hills, "Picturing Progress," 119.

17. Barbara S. Groseclose saw the addition of the African American as indicative "of his unwavering courage in delineating his belief in the ideal of liberty for all mankind." *Emanuel Leutze*, 62. Dawn Glanz also noted the presence of the black figure, linking this allusion to slavery and the Civil War to millennial expectations, "the battle described in the Apocalypse in which the forces of good (liberty and Union) combatted the powers of evil (slavery and secession) prior to the institution of the millennial state." *How the West Was Drawn*, 80. I would like to thank Angela Miller for giving me her paper, "Emanuel Leutze's 'Westward the Course of Empire,'" in which she also examines the significance of the black male's presence in relation to the pioneer's migration.

18. "Emmanual Leutze, the Artist," *Lippincott's Magazine 2* (November 1868): 536. There are actually three groups of figures that evoke the "new Madonna": the one in blue and red protected by the colossal pioneer to the left, the woman seated on a donkey, and the mother and child on the right seated in a covered wagon. The woman in the wagon holds a black book inscribed in gold letters, "Holy Bible," reflecting eager hope in her taut pose and facial expression as she looks in the direction of the Eldorado Valley.

19. Ibid. According to Brewster, Leutze agreed with her interpretation of the mural, claiming that she was the first American to understand the picture.

20. *Daily National Intelligencer*, June 27, 1862, 1.

21. Hawthorne, "Chiefly about War-Matters," 46.

22. Quoted in Stehle, *Life and Works of Emanuel Leutze*, 118.

23. Meigs to Leutze, May 23, 1861, and Meigs memo, June 20, 1861, Meigs Letterbook. For Meigs's delight that the government resumed financing of the mural, see memo from Meigs to Secretary of War Cameron, June 20, 1861, Meigs Letterbook.

24. In a letter to Cameron, dated June 20, 1861, Meigs argued that work on the Capitol would give "a welcome assurance of [the government's] confidence in its own strength and the patriotism of its people." Fairman, *Art and Artists of the Capitol*, 202.

25. Miller, "Leutze's 'Westward,'" 9.

# Bibliography

*Government Documents and Archival Sources*

Brown, Henry. Henry Kirke Bush-Brown Papers. 4 vols. Library of Congress, Manuscript Division.

Chapman, John. Etting Collection. Archives of American Art.

Everett, Edward. Edward Everett Papers. Microfilmed by the Massachusetts Historical Society, Boston.

Fairman, Charles E. *Art and Artists of the Capitol of the United States of America.* Washington, D.C.: Government Printing Office, 1927.

Files and Correspondence. Records of the Architect of the Capitol, Washington, D.C.

Leutze Collection. Library of Congress, Manuscript Division. Accession 12,771.

Meigs, Captain Montgomery. Meigs Letterbook. Office of the Architect of the Capitol.

National Archives. Committee on Appropriations, Tray 79—Sundry Civil Expenses. February 1876. Constantino Brumidi to L. M. Morrill, Chairman of the Committee on Appropriations of the U.S. Senate. SEN 44A-E1.

——. Committee on Expenditures on the Public Buildings. January 11, 1826. Record Group 233. William J. Coffee to the Senate and House of Representatives. HR 19A–G6.1.

——. August 13, 1825. Record Group 233. William Thornton, George Bomford and Charles B. King to Joseph Elgar and Charles Bulfinch. HR 19A–G6.1.

——. Committee on Public Buildings and Grounds. HR 26A–D21.2.

——. June 6, 1862. Record Group 42. Leutze to the Committee on Public Buildings. HR 37A–G14.1.

——. Committee on the Library. After January 14, 1865. Record Group 128. *Joint Resolution Relative to the Employing of John Mix Stanley.* HR 38A–G11.1.

——. July 20, 1865. Record Group 128. *Memorial to the Honorable Senate and House of Representatives.* HR 38A–G11.1.

——. Files of the Commissioner of Public Buildings. Record Group 42.

——. Files of the Joint Committee on the Library. Record Group 128.

——. Fiscal Branch. Acct. 81.296.

——. General Records of the Department of State. Domestic Letters. Record Group 59.

——. House Committee on Public Buildings. January 29, 1829. Charles Bulfinch to Joseph Elgar. 20 AG 16.1.

——. Joint Committee on the Library. April 5, 1852. Record Group 128. The Memorial of E. Leutze.

——. January 12, 1863. Record Group 128. *Memorial to the Honorable Senate and House of Representatives of the United States of America.* 37th Congress.

——. *Memorial of the Artists of the United States.* HR 35A–D.23.10.

——. Office of the Chief Engineer. Capitol Extension and Washington Aqueduct. Record Group 77.

——. Records of the U.S. House of Representatives. Reports of the Committee on Public Buildings. HR 14C–B3.

——. *Select Committee on the Memorial of the Artists of the United States' Report.* 35th Cong., 2d sess. HR 35A–D23.10.

——. Senate Library Committee. January 13, 1853. Record Group 46. John Stanley to W. K. Sebastion, Chairman of the Senate Committee on Indian Affairs. 34A–H10.

——. Senate Library Committee. *Memorial of John M. Stanley Praying Congress to Purchase His Gallery of Indian Paintings Now Deposited in the Smithsonian Institution.* Record Group 46. SEN 34A–H10.

———. Treasury Department. Miscellaneous Letters. Series K. Contract with Luigi Persico. 375.

Powers, Hiram. Hiram Powers Papers. Archives of American Art. Washington, D.C.

*The Public Statutes at Large of the United States of America.* Edited by Richard Peters. Vol. 5. Boston: Little, Brown, 1850.

Records of the Architect of the Capitol. *See* Files and Correspondence.

U.S. Congress. *Annals of the Congress of the United States, 1789–1824.* Washington, D.C.: Gales and Seaton, 1834–1856.

———. *Art in the United States Capitol.* 91st Cong., 2d sess. 1976. H. Doc. 91-368.

———. *Biographical Directory of the United States Congress, 1774–1989.* 100th Cong., 2d sess. 1989. S. Doc. 100-34.

———. *Congressional Globe.* Washington, D.C., 1834–1860.

———. *Documentary History of the Construction and Development of the United States Capitol Buildings and Grounds.* 1904.

———. *Register of Debates in Congress.* 1815–1860. Washington, D.C.: Gales and Seaton.

———. *Removal of the Remains of General George Washington to the City of Washington.* 6th Cong., 1st sess. January 8, 1800. American State Papers, no. 118.

———. House. *A Bill.* 26th Cong., 1st sess. March 5, 1840. H. Rpt. 244.

———. *A Bill Making Appropriations for the Public Buildings and Public Grounds, and for Other Purposes.* 24th Cong., 2d sess. February 14, 1837. H. Rpt. 933.

———. *Catlin's Indian Gallery.* 29th Cong., 1st sess. July 24, 1846. H. Rpt. 806.

———. *Catlin's North American Indians.* 30th Cong., 1st sess. August 8, 1848. H. Rpt. 820.

———. *Designs of Paintings.* 19th Cong., 2d sess. December 19, 1826. H. Rpt. 8.

———. *Entombment and Statue of Washington.* 21st Cong., 1st sess. February 22, 1830. H. Rpt. 318.

———. *Foundation for Statue of Washington.* 26th Cong., 1st sess. March 5, 1840. H. Doc. 124.

———. *Mausoleum to General Washington.* 6th Cong., 2d sess. December 19, 1800. American State Papers, no. 138.

———. *Monument to the Memory of General Washington.* 14th Cong., 1st sess. March 14, 1816. American State Papers, no. 404.

———. *Paintings for the Rotunda.* 24th Cong., 2d sess. February 28, 1837. H. Rpt. 294.

———. *Removal of Greenough's Statue [sic] of Washington.* 27th Cong., 3d sess. February 22, 1843. H. Rpt. 219.

———. *Report of the Secretary of War.* 33d Cong., 2d sess. November 16, 1855. H. Exec. Doc. 1.

———. *Report of the Select Committee on the Memorial of the Artists of the United States.* 35th Cong., 2d sess. March 3, 1859. H. Rpt. 198.

———. *Report of the U.S. Art Commission.* 36th Cong., 1st sess. February 22, 1860. H. Exec. Doc. 43.

———. House. *Resolutions of the Legislature of the State of Virginia.* 22d Cong., 1st sess. February 24, 1832. H. Doc. 124.

———. *Sculpture for the Capitol. Memorial from the Philadelphia Artist Society.* 24th Cong., 2d sess. February 13, 1837. H. Doc. 159.

———. *Statue and Monument to the Memory of General Washington.* 6th Cong., 1st sess. May 8, 1800. American State Papers, no. 135.

———. *Statue of Washington.* 22d Cong., 1st sess. April 30, 1832. H. Rpt. 459.

———. *Statue of Washington.* 27th Cong., 1st sess. August 4, 1841. H. Doc. 45.

———. Report. Office of the Architect of the Capitol. December 6, 1823. *Message from the President of the United States, Transmitting a Report of the Commissioner of Public Buildings.* 18th Cong., 1st sess. December 18, 1823.

———. December 27, 1827. *Message from the President of the United States, Transmitting the Annual Report of the Commissioner of the Public Buildings.* 20th Cong., 1st sess. January 4, 1828.

———. Senate. *Memorial of A. B. Durand, and Other Artists of New York.* 29th Cong., 1st sess. July 9, 1846. S. Rpt. 424.

———. *Memorial of George Catlin.* 29th Cong., 1st sess. June 5, 1846. S. Rpt. 374.

———. *Memorial of Horatio Greenough.* 27th Cong., 3d sess. January 11, 1843. S. Doc. 57.

———. *Memorial of R. R. Gurley.* 30th Cong., 1st sess. July 18, 1848. S. Misc. Rpt. 152.

———. *Obsequies of General Washington.* 6th Cong., 1st sess. December 23, 1799. American State Papers, no. 115.

———. *Petition of A. B. Durand and Others.* 20th Cong., 1st sess. May 26, 1848. S. Doc. 380.

———. *Report of the Committee of the Senate and House of Representatives of the Celebration of the Centennial Birthday of George Washington.* 22d Cong., 1st sess. February 13, 1832. S. Rpt. 62.

———. *Resolution.* 24th Cong., 1st sess. May 17, 1836. S. Rpt. 17.

Weir, Robert. Robert Weir Papers. Archives of American Art. Washington, D.C.

*Other Sources*

Abrams, Ann Uhry. "Benjamin West's Documentation of Colonial History: *William Penn's Treaty with the Indians.*" *Art Bulletin* 64 (March 1982): 59–75.

Adams, John Quincy. *An Oration, Delivered at "Plymouth," December 22, 1802. At the Anniversary Commemoration of the First Landing of Our Ancestors, at That Place.* Boston: Russell and Cutler, 1802.

———. *Memoirs of John Quincy Adams.* Edited by Charles Francis Adams. Vol. 7. Philadelphia: Lippincott, 1875.

Adolf, Leonard A. "Squanto's Role in Pilgrim Diplomacy." *Ethnohistory* 2 (Summer 1964): 247–261.

Ahrens, Kent. "Nineteenth Century History Painting and the United States Capitol." *Records of the Columbia Historical Society* 50 (1980): 191–222.

———. "Robert Weir's 'Embarkation of the Pilgrims.'" *Capitol Studies* 1 (1972): 59–71.

Allen, William. "The Construction of the Dome of the Capitol." Paper presented at the United States Capitol Historical Society Symposium on the Art and Architecture of the Capitol, Washington, D.C., March 15, 1990.

"The American Aborigines." *Niles' Weekly Register* 15 (November 14, 1818): 185–187.

*American Review: A Whig Journal* 3 (January 1846): 98.

Anderson, Marilyn J. "The Best of Two Worlds: The Pocahontas Legend as Treated in Early American Drama." *Indian Historian* 12 (Summer 1979): 54–64.

*Appleton's Cyclopaedia of American Biography.* Edited by James Grant Wilson and John Fiske. Vols. 1–6. New York: Appleton, 1898.

Arner, Robert D. "Plymouth Rock Revisited: The Landing of the Pilgrim Fathers." *Journal of American Culture* 6 (Winter 1983): 25–35.

*Art and Architecture in the Service of Politics.* Edited by Henry A. Millon and Linda Nochlin. Cambridge, Mass.: MIT Press, 1978.

"Art-Desecration of the Capitol." *Cosmopolitan Art Journal* 11 (March and June 1858): 134.

Backlin, Hedy. "The Four Continents: An Allegory for Artists." In *The Four Continents from the Collection of James Hazen Hyde.* New York: Cooper Union Museum for the Arts of Decoration, 1961.

Barbour, Philip L. *Pocahontas and Her World.* Boston: Houghton Mifflin, 1970.

Bercovitch, Sacvan. *The American Jeremiad.* Madison: University of Wisconsin Press, 1978. 1978.

———. "The Typology of America's Mission." *American Quarterly* 30 (Summer 1976): 135–155.

Berger, Arthur Asa. *Signs in Contemporary Culture: An Introduction to Semiotics.* New York: Longman, 1984.

Berkeley, George. *The Works of George Berkeley, Bishop of Cloyne.* Edited by A. A. Luce and T. E. Jessop. London: Thomas Nelson, 1955.

Berkhofer, Robert F., Jr. *The White Man's Indian: Images of the American Indian from Columbus to the Present.* New York: Vintage Books, 1978.

Bernal, Ignacio. *A History of Mexican Archaeology: The Vanished Civilizations of Middle America.* New York: Thames and Hudson, 1980.

Billington, Ray Allen. *The Protestant Crusade, 1800–1860.* Chicago: Quadrangle Books, 1964.

Bjelajac, David. *Millennial Desire and the Apocalyptic Vision of Washington Allston.* Washington, D.C.: Smithsonian Institution Press, 1988.

Boime, Albert. *Art in an Age of Revolution, 1750–1800.* Chicago: University of Chicago Press, 1987.

———. *The Art of Exclusion: Representing Blacks in the Nineteenth Century.* Washington, D.C.: Smithsonian Institution Press, 1990.

———. *Hollow Icons: The Politics of Sculpture in Nineteenth-Century France.* Kent, Ohio: Kent State University Press, 1987.

Bogart, Michele H. *Public Sculpture and the Civic Ideal in New York City, 1890–1930.* Chicago: University of Chicago Press, 1989.

Borden, Philip. "Found Cumbering the Soil: Manifest Destiny and the Indian in the Nineteenth Century." In *The Great Fear: Race in the Mind of America,* edited by Gary B. Nash and Richard Weiss. New York: Holt, Rinehart and Winston, 1970.

Bowling, Kenneth R. *Creating the Federal City, 1774–1800: Potomac Fever.* Washington, D.C.: American Institute of Architects Press, 1988.

Brilliant, Richard. "Gesture and Rank in Roman Art: The Use of Gestures to Denote Status in Roman Sculpture and Coinage." *Memoirs of the Connecticut Academy of Arts and Sciences* 14 (February 1963).

———. *Visual Narratives: Storytelling in Etruscan and Roman Art.* Ithaca, N.Y.: Cornell University Press, 1984.

Brown, Charles H. *Agents of Manifest Destiny: The Lives and Times of the Filibusters.* Chapel Hill: University of North Carolina Press, 1980.

Brown, Glenn. *History of the United States Capitol.* 2 vols. 1st ed. Washington, D.C.: Government Printing Office, 1903. Rev. ed. New York: Da Capo Press, 1970.

Brownell, Charles E. "Latrobe and Programs of Ornamentation at the U.S. Capitol, 1803–13 and 1815–17." Paper presented at the Society of Architectural Historians, Washington, D.C., April, 1986.

———. "Latrobe, His Craftsmen, and the Corinthian Order of the Hall of Representatives." In *The Craftsman in Early America,* edited by Ian M. G. Quimby. New York: Norton, 1984.

Bryan, Daniel. *The Mountain Muse: Comprising the Adventures of Daniel Boone; and the Power of Virtuous and Refined Beauty.* Harrisonburg, Va., 1813.

Bulfinch, S. G. *A Discourse Suggested by Weir's Picture of the Embarkation of the Pilgrims.* Washington: Gales and Eaton, 1844.

Bulfinch, Ellen Susan, ed. *The Life and Letters of Charles Bulfinch, Architect.* Boston: Houghton Mifflin, 1973.

Burns, Edward M. *The American Idea of Mission: Concepts of National Purpose and Destiny.* New Brunswick, N.J.: Rutgers University Press, 1957.

Butler, Jeanne F. "Competition 1792: Designing a Nation's Capitol." *Capitol Studies* 4 (1976): 11–96.

Campioli, Mario E. "The Original East Central Portico of the Capitol." *Capitol Studies* 1 (Spring 1972): 73–85.

Carleton, Philip D. "The Indian Captivity." *American Literature* 15 (May 1943): 169–180.

Castiello, Kathleen Raben. "The Italian Sculptors of the United States Capitol, 1806–1834." Ph.D. diss., University of Michigan, 1975.

*Catalogue of Pictures, in Stanley & Dickerman's North American Indian Portrait Gallery; J. M. Stanley, Artist.* Cincinnati: Daily Enquirer Office, 1846.

Catlin, George. *Last Rambles amongst the Indians of the Rocky Mountains and the Andes.* New York: Appleton, 1867.

———. *Letters and Notes on the Manners, Customs, and Conditions of the North American Indians.* 2 vols. Philadelphia: Willis P. Hazard, 1857.

Chamberlain, Georgia Stamm. *Studies on John Gadsby Chapman.* Annadale, Va.: Turnpike Press, 1962.

Child, Lydia Maria. *Hobomok and Other Writings on Indians.* Edited by Carolyn L. Karcher. New Brunswick, N.J.: Rutgers University Press, 1986.

Cikovsky, Nicolai, Jr. "George Inness and the Hudson River School: *The Lackawanna Valley.*" *American Art Journal* 2 (Fall 1970): 36–57.

———. "'The Ravages of the Axe': The Meaning of the Tree Stump in Nineteenth Century American Art." *Art Bulletin* 61 (December 1979): 611–626.

Clark, T. J. *Image of the People: Gustave Courbet and the 1848 Revolution.* Princeton: Princeton University Press, 1973.

Clarkson, Thomas. *Memoirs of the Public and Private Life of William Penn.* 2 vols. London: Longman, Hurst, Rees, Orme, and Brown, 1813.

———. *Memoirs of the Public and Private Life of William Penn.* Rev. ed., illustr. London: C. Gilpin, 1849.

*The Classical Spirit in American Portraiture.* Providence: Brown University, 1976.

Clebsch. "America's 'Mystique' as Redeemer Nation." *Prospects* 4 (1979): 79–94.

"The Colony of New Plymouth." *New England Quarterly* 107 (April 1840): 337.

*A Compilation of the Messages and Papers of the Presidents, 1789–1897.* Edited by J. D. Richardson. Vol. 2. New York: Bureau of National Literature, 1897.

"Congress." *Niles' National Register.* (May 21, 1842): 179–180.

Cooper, James Fenimore. *The Last of the Mohicans.* New York: New American Library, 1962.

———. *The Pioneers.* New York: Airmont, 1964.

Cords, Nicholas, and Patrick Gerster, eds. *Myth and the American Experience.* New York and Beverley Hills: Glencoe, 1973.

Craig, Lois. *The Federal Presence: Architecture, Politics and Symbols in United States Government Buildings.* Cambridge, Mass.: MIT Press, 1978.

Crane, Sylvia E. *White Silence: Greenough, Powers and Crawford: American Sculptors in Nineteenth-Century Italy.* Coral Gables: University of Miami Press, 1972.

Craven, Wayne. "Henry Kirke Brown: His Search for an American Art in the 1840's." *American Art Journal* 4 (November 1972): 44–58.

———. "Horatio Greenough's Statue of Washington and Phidias' Olympian Zeus." *Art Quarterly* 26 (Winter 1963): 429–440.

———. *Sculpture in America.* 1968. Rev. ed. New York: Cornwall Books, 1984.

Crawford, John Stephens. "The Classical Orator in Nineteenth-Century American Sculpture." *American Art Journal* 6 (November 1974): 56–72.

———. "The Classical Tradition in American Sculpture: Structure and Surface." *American Art Journal* 11 (July 1979): 38–52.

"Crawford and His Last Work." *Crayon* 1 (March 14, 1855): 167–168.

Custis, George Washington. *Pocahontas, or the Settlers of Virginia.* Philadelphia: C. Alexander, 1830.

Davis, Jefferson. *Jefferson Davis, Constitutionalist: His Letters, Papers and Speeches.* Edited by Dunbar Rowland. Vols. 1–4. Jackson: Mississippi Department of Archives and History, 1923.

———. *The Papers of Jefferson Davis.* Vol. 2. Edited by James I. McIntosh. Baton Rouge and London: Louisiana State University Press, 1974.

———. *The Papers of Jefferson Davis.* Vol. 3. Edited by James I. McIntosh, Lynda Lasswell Crist, and Mary Seaton Dix. Baton Rouge: Louisiana State University Press, 1981.

———. *The Papers of Jefferson Davis.* Vol. 4. Edited by Lynda Lasswell Crist, Mary Seaton Dix, and Richard E. Beringer. Baton Rouge: Louisiana State University Press, 1983.

———. *The Papers of Jefferson Davis.* Vol. 5. Edited by Lynda Lasswell Crist and Mary Seaton Dix. Baton Rouge and London: Louisiana State University Press, 1985.

———. *The Papers of Jefferson Davis.* Vol. 6. Edited by Lynda Lasswell Crist and Mary Seaton Dix. Baton Rouge: Louisiana State University Press, 1989.

Davis John. *Captain Smith and Princess Pocahontas: An Indian Tale.* Philadelphia: Benjamin Warner, 1817.

Dimmick, Lauretta. "A Catalogue of the Portrait Busts and Ideal Works of Thomas

Crawford (1813?–1857)." Ph.D. diss., University of Pittsburgh, 1986.

———. "Thomas Crawford's *Orpheus:* The American *Apollo Belvedere.*" *American Art Journal* 19 (1987): 46–84.

———. "Veiled Memories, or Thomas Crawford in Rome." In *The Italian Presence in American Art, 1760–1860,* edited by Irma B. Jaffe. New York: Fordham University Press; Rome: Istituto della Enciclopedia Italiana, 1989.

Dippie, Brian W. *Catlin and His Contemporaries: The Politics of Patronage.* Lincoln: University of Nebraska Press, 1990.

———. "Mt. Tacoma as an Indian Symbol." *Columbia* 3 (Summer 1989): 17.

———. "Photographic Allegories and Indian Destiny." Paper presented at the Photograph and the American Indian Conference, Princeton, N.J., September 1985, and at the Buffalo Bill Historical Center, Cody, Wyo., June 1988.

———. *The Vanishing American: White Attitudes and U.S. Indian Policy.* Middletown, Conn.: Wesleyan University Press, 1982.

"Domestic Art Gossip." *Crayon* 4 (May 1857): 155–156.

Drinnon, Richard. *Facing West: The Metaphysics of Indian-Hating and Empire Building.* Minneapolis: University of Minnesota Press, 1980.

Eagleton, Terry. *Ideology: An Introduction.* New York: Verso, 1991.

Eaton, Clement. *Jefferson Davis.* New York: Free Press, 1977.

Eaton, John. *Grant, Lincoln, and the Freedman.* New York: Longman Green, 1907.

Edgerton, Samuel Y., Jr. *Pictures and Punishment: Art and Criminal Prosecution during the Florentine Renaissance.* Ithaca, N.Y.: Cornell University Press, 1985.

———. "The Murder of Jane McCrea: The Tragedy of an American *Tableau d'Histoire.*" *Art Bulletin* 47 (December 1965): 481–492.

Ekirch, Arthur A., Jr. *The Idea of Progress in America, 1815–1860.* New York: Peter Smith, 1951.

Elliot, Jonathan. *Historical Sketches of the Ten Miles Square Forming the District of Columbia.* Washington, D.C.: J. Elliot, Jr., 1830.

Ellis, Richard E. *The Union at Risk: Jacksonian Democracy, States' Rights, and the Nullification Crisis.* New York: Oxford University Press, 1987.

"Emmanual [*sic*] Leutze, the Artist," *Lippincott's Magazine* 2 (November 1868): 533–538.

"Enrico Causici." *Niles' Weekly Register* 45 (September 21, 1833): 53.

Everett, Edward. "Principle of the American Constitutions." In *Orations and Speeches on Various Occasions.* Vol. 1. Boston: Little, Brown, 1895.

Ewers, John C. "The Emergence of the Plains Indian as the Symbol of the North American Indian." In *Indian Life on the Upper Missouri.* Norman: University of Oklahoma Press, 1968.

Filson, John. *The Discovery of Kentucke and the Adventures of Daniel Boone.* Wilmington, 1784; New York: Garland, 1978.

Flagg, Jared B. *The Life and Letters of Washington Allston.* New York: Scribner's, 1892.

Fleming, E. McClung. "From Indian Princess to Greek Goddess: The American Image, 1783–1815." *Winterthur Portfolio* 3 (1967): 37–66.

———. "The American Image as Indian Princess, 1765–1783." *Winterthur Portfolio* 2 (1965): 65–81.

Flint, Timothy. *Biographical Memoir of Daniel Boone, the First Settler of Kentucky: Interspersed with Incidents in the Early Annals of the Country.* Cincinnati, 1833.

Florentia. "Crawford and His Last Work." *Art-Journal* 1 (1855): 41.

Folgarait, Leonard. *So Far from Heaven: David Alfaro Siqueiros'* The March of Humanity *and the Mexican Revolutionary Politics.* London and New York: Cambridge University Press, 1987.

Force, William Q. *Picture of Washington and Its Vicinity, for 1848.* Washington, D.C.: William Q. Force, 1848.

"Foreign Correspondence, Items, Etc." *Crayon* 6 (June 1859): 184–185.

"Forest Life and Progress." *New American Magazine of Literature, Science, and Art* 1 (July 1852): 19–20.

*Fyrd (1995) 'Rescaig the Indian in Benjamin West
Death of General Wolfe " American Art
Vol 9 No 1 Spring 1995*

Fox, Nichols. "NEA under Siege." *New Art Examiner* (Summer 1989): 18–23.

Frary, I. T. *They Built the Capitol.* Richmond, Va.: Garrett and Massie, 1940.

Freehling, William W. *Prelude to Civil War: The Nullification Controversy in South Carolina, 1816–1836.* New York: Harper and Row, 1966.

Frese, Joseph R. "Federal Patronage of Painting to 1860." *Capitol Studies* 2 (Winter 1974): 71–82.

Fryd, Vivien Green. "Hiram Powers's *America:* 'Triumphant as Liberty and in Unity.'" *American Art Journal* 18 (1986): 54–75.

———. "Hiram Powers's Bust of *George Washington:* The President as an Icon." *Phoebus* 5 (1987): 15–28 and 125–129.

———. "Horatio Greenough's *George Washington:* A President in Apotheosis." *The Augustan Age,* occasional papers, no. 1 (1987): 70–86.

———. "The Italian Presence in the United States Capitol." In *The Italian Presence in American Art, 1760–1860,* edited by Irma B. Jaffe, 132–149. New York: Fordham University Press; Rome: Istituto della Enciclopedia Italiana, 1989.

———. "Sculpture as History: Themes of Liberty, Unity, and Manifest Destiny in American Sculpture, 1825–1865." Ph.D. diss., University of Wisconsin, 1984.

———. "Two Sculptures for the Capitol: Horatio Greenough's *Rescue* and Luigi Persico's *Discovery of America." American Art Journal* 19 (1987):16–39.

Gale, Robert L. *Thomas Crawford: American Sculptor.* Pittsburgh: University of Pittsburgh Press, 1964.

Galt, John. *The Life, Studies, and Works of Benjamin West.* London, 1820.

Gardner, Albert TenEyck. *Yankee Stonecutters: The First American School of Sculpture, 1800–1850.* Freeport, N.Y.: Books for Libraries Press, 1945.

Garlick, Richard Cecil, Jr. *Philip Mazzei, Friend of Jefferson: His Life and Letters.* Baltimore: Johns Hopkins University Press, 1933.

Garvey, Timothy J. *Public Sculptor: Lorado Taft and the Beautification of Chicago.* Urbana and Chicago: University of Illinois Press, 1988.

Gerdts, William H. *American Neo-Classic Sculpture: The Marble Resurrection.* New York: Viking, 1973.

———. "The Marble Savage." *Art in America* 62 (July–August 1974): 64–70.

———. *The White Marmoreal Flock: Nineteenth-Century American Women Neo-Classical Sculptors.* Poughkeepsie, N.Y.: Vassar College Art Gallery, 1972.

———. "William Rush: Sculptural Genius or Inspired Artisan?" In *William Rush: American Sculptor.* Philadelphia: Pennsylvania Academy of Fine Arts, 1982.

Gerdts, Willam H., and Theodore E. Stebbins, Jr. *"A Man of Genius:" The Art of Washington Allston, 1779–1843.* Boston: Museum of Fine Arts, 1979.

Gienapp, William E. *The Origins of the Republican Party 1852–1856.* New York and Oxford: Oxford University Press, 1987.

Glanz, Dawn. *How the West Was Drawn: American Art and the Settling of the Frontier.* Ann Arbor: UMI Research Press, 1982.

Goode, James. *The Outdoor Sculpture of Washington, D.C.* Washington, D.C.: Smithsonian Institution Press, 1974.

Goodrich, Samuel Griswold. *Stories about Captain Smith, of Virginia: For the Instruction and Amusement of Children.* Hartford, Conn.: H. F. J. Huntington, 1829.

Grant, Michael. *Cities of Vesuvius: Pompeii and Herculaneum.* London: Weidenfeld and Nicolson, 1971.

Green, Rayna. "The Pocahontas Perplex: The Image of Indian Women in American Culture." *Massachusetts Review* 16 (Autumn 1975): 698–714.

Greenough, Horatio. *Letters of Horatio Greenough.* Edited by Frances B. Greenough. Boston: Ticknor, 1887. Reprint. New York: Da Capo Press, 1970.

———. *Letters of Horatio Greenough, American Sculptor.* Edited by Nathalia Wright. Madison: University of Wisconsin Press, 1972.

Greenthal, Kathryn T., and Michael Richman. "Daniel Chester French's *Continents." American Art Journal* 8 (November 1976): 47–58.

Griswold, Charles L. "The Vietnam Veterans Memorial and the Washington Mall: Philosophical Thoughts on Political Iconography." *Critical Inquiry* 12 (Summer 1986): 688–719.

Groseclose, Barbara S. "American Genius: The Landing of Christopher Columbus." In Getty Museum Research Series, edited by Heinz Ickstadt and Thomas Gaetgens, forthcoming.

———. *Emanuel Leutze, 1816–1868: Freedom Is the Only King.* Washington, D.C.: Smithsonian Institution Press, 1975.

———. "The 'Missouri Artist' as Historian." In *George Caleb Bingham.* New York: Saint Louis Art Museum and Harry N. Abrams, 1990.

Guilbaut, Serge. *How New York Stole the Idea of Modern Art: Abstract Expressionism, Freedom, and the Cold War.* Chicago: University of Chicago Press, 1983.

Gurney, George. *Sculpture and the Federal Triangle.* Washington, D.C.: Smithsonian Institution Press, 1985.

Haas, P. *Public Building and Statuary of the Government: The Public Buildings and Architectural Ornaments of the Capitol of the U. States, at the City of Washington.* Washington, D.C.: P. Haas, 1839.

Haberly, David T. "Women and Indians: *The Last of the Mohicans* and the Captivity Tradition." *American Quarterly* 28 (Fall 1976): 431–443.

Hall, Captain Basil. *Travels in North America, in the Years 1827 and 1828.* Vol. 3. Edinburgh: Cadell, 1829; New York: Arno Press, 1974.

Hamlin, Talbot Faulkner. *Benjamin Henry Latrobe.* New York: Oxford University Press, 1955.

Harris, Ann Sutherland, and Linda Nochlin. *Women Artists, 1550–1950.* New York: Knopf, 1986.

Harris, C. M. "The Significance of William Thornton's Design for the U.S. Capitol." Paper presented at the United States Capitol Historical Society's Symposium on the Art and Architecture of the Capitol, Washington, D.C., March 15, 1990.

Harris, Neil. *The Artist in American Society: The Formative Years, 1790–1860.* New York: Braziller, 1966.

Hawthorne, Nathaniel. "Chiefly about War-Matters." *Atlantic Monthly* 10 (July–December 1862): 43–61.

Hazelton, George C., Jr. *The National Capitol, Its Architecture, Art and History.* New York: J. F. Taylor, 1914.

Herbert, Robert L. *David, Voltaire, 'Brutus,' and the French Revolution: An Essay in Art and Politics.* New York: Viking Press, 1973.

Hicks, Thomas. *Eulogy on Thomas Crawford.* New York: Privately printed, 1865.

Hills, Patricia. "Picturing Progress in the Era of Westward Expansion." In *The West as America: Reinterpreting Images of the Frontier, 1820–1920,* edited by William H. Truettner, 97–147. Washington, D.C.: Smithsonian Institution Press, 1991.

Hight, Kathryn S. "'Doomed to Perish': George Catlin's Depictions of the Mandan." *Art Journal* 49 (Summer 1990): 119–124.

———. "The Frontier Indian in White Art, 1820–1876: The Development of a Myth." Ph.D. diss., University of California, Los Angeles, 1987.

Hodgkins, George W. "Naming the Capitol and the Capital." *Records of the Columbia Historical Society* 60–62 (1960–1962): 36–53.

Holt, Michael F. *The Political Crisis of the 1850s.* New York: Norton, 1978.

Holzer, Harold, Gabor S. Boritt, and Mark E. Neely, Jr. "Francis Bicknell Carpenter (1830–1900): Painter of Abraham Lincoln and His Circle." *American Art Journal* 16 (Spring 1984): 66–89.

Holzhueter, John O. "Chief Buffalo and Other Wisconsin-related Art in the National Capitol." *Wisconsin Magazine of History* 56 (Summer 1973): 284–288.

Hone, Philip. *The Diary of Philip Hone, 1821–1851.* Edited by Bayard Tuckerman. Vol. 2. New York: Dodd, Mead, 1889.

Honour, Hugh. *The New Golden Land: European Images of America from the Discoveries to the*

*Present Time.* New York: Pantheon Books, 1975.

Horan, James D. *The McKenney-Hall Portrait Gallery of American Indians.* New York: Bramhall House, 1986.

Horsman, Reginald. *Race and Manifest Destiny: The Origins of American Racial Anglo-Saxonism.* Cambridge, Mass.: Harvard University Press, 1981.

Hulton, Paul. *America 1585: The Complete Drawings of John White.* Chapel Hill: University of North Carolina Press, 1984.

Hunter, Alfred. *An Historical Account of the Adventures of Fernando de Soto.* Washington: Alfred Hunter, 1855.

Huntington, David Carew. *Art and the Excited Spirit: America in the Romantic Period.* Ann Arbor: The University of Michigan Museum of Art, 1972.

*The Inaugural Addresses of the Presidents.* Edited by Renzo D. Bowers. Saint Louis: Thomas Law Book, 1929.

"The Indians in American Art." *Crayon* 3 (January 1856): 28.

Irving, Washington. *The Life and Voyages of Christopher Columbus.* Chicago: Belford, Clarke, 1828.

J. A. "Greenough the Sculptor, and His Last Production." *Bulletin of the American Art-Union* (September 1851): 96–98.

Jaffe, Irma B. *John Trumbull: The Declaration of Independence.* New York: Viking, 1976.

──────. *John Trumbull: Patriot-Artist of the American Revolution.* Boston: New York Graphic Society, 1975.

Jefferson, Thomas. *The Writings of Thomas Jefferson.* Edited by Paul Leicester Ford. Vol. 8. New York: Putnam's, 1897.

Jehlen, Myra. *American Incarnation: The Individual, the Nation, and the Continent.* Cambridge, Mass.: Harvard University Press, 1986.

Jennings, Francis. "Brother Miquon: Good Lord!" In *The World of William Penn*, edited by Richard S. Dunn and Mary Maples Dunn. Philadelphia: University of Pennsylvania Press, 1986.

──────. *The Invasion of America: Indians, Colonialism, and the Cant of Conquest.* Chapel Hill: University of North Carolina Press, 1975.

Johannsen, Robert W. "Stephen A. Douglas and the American Mission." In *The Frontier Challenge: Responses to the Trans-Mississippi West*, edited by John G. Clark. Lawrence: University of Kansas Press, 1971.

July, Robert William. *The Essential New Yorker, Gulian Crommelin Verplanck.* Durham, N.C.: Duke University Press, 1951.

Kammen, Michael. *Spheres of Liberty: Changing Perceptions of Liberty in American Culture.* Madison: University of Wisconsin Press, 1986.

Kasson, Joy. *Marble Queens and Captives.* New Haven: Yale University Press, 1990.

Knapp, Samuel L. *The History and Topography of the United States of North America from the Earliest Period to the Present Time.* Edited by John Howard Hinton. 2 vols. Boston: Samuel Walter, 1834.

Kolodny, Annette. *The Land before Her: Fantasy and Experience of the American Frontiers, 1630–1860.* Chapel Hill: University of North Carolina Press, 1984.

──────. "Turning the Lens on 'The Panther Captivity': A Feminist Exercise in Practical Criticism." *Critical Inquiry* 8 (Winter 1981): 329–345.

Korshak, Yvonne. "The Birth of Athena on the East Pediment of the Parthenon: Narrative of the Imperial City." Paper presented at the annual meeting of the College Art Association, Houston, February 1988.

──────. "The Liberty Cap as a Revolutionary Symbol in America and France." *Smithsonian Studies in American Art* 1 (Fall 1987): 53–69.

"Landing of De Soto in Florida." *Ballou's Pictorial and Drawing Room Companion* 8 (April 7, 1855): 217.

Lanman, Charles. *A Summer in the Wilderness, Embracing a Canoe Voyage up the Mississippi and around Lake Superior.* New York: Appleton, 1847.

Latrobe, Benjamin. *The Correspondence and Miscellaneous Papers of Benjamin Latrobe.* Edited

by John C. Van Horne. 3 vols. New Haven: Yale University Press, 1986.

Le Corbeiller, Clare. "Miss America and Her Sisters: Personifications of the Four Parts of the World." *Metropolitan Museum of Art Bulletin*, 2d ser., 19 (April 1961): 209–223.

Levin, David. *History as Romantic Art: Bancroft, Prescott, Motley, and Parkman.* Stanford, Calif.: Stanford University Press, 1959.

Limerick, Patricia Nelson. *The Legacy of Conquest: The Unbroken Past of the American West.* New York: Norton, 1987.

L'Orange, Hans Peter. *Apotheosis in Ancient Portraiture.* Oslo: Aschehoug, 1947.

Luft, Martha Levy. "Charles Wimar's *The Abduction of Daniel Boone's Daughter by the Indians,* 1853 and 1855: Evolving Myths." *Prospects* 7 (1982): 301–314.

McDermott, John Francis. *Seth Eastman: Pictorial Historian of the Indian.* Norman: University of Oklahoma Press, 1961.

MacDonald, William Lloyd. *The Pantheon: Design, Meaning, Progeny.* Cambridge, Mass.: Harvard University Press, 1976.

McLellan, I., Jr. "The Last of the Tribes." *Southern Literary Messenger* 11 (September 1845): 537–539.

Marin, Louis. "Towards a Theory of Reading in the Visual Arts: Poussin's *The Arcadian Shepherds.*" In *Calligram: Essays in New Art History from France,* edited by Norman Bryson. Cambridge: Cambridge University Press, 1988.

Marks, Arthur S. "The Statue of King George III in New York and the Iconology of Regicide." *American Art Journal* 13 (Summer 1981): 61–82.

Marrinan, Michael. *Painting Politics for Louis-Philippe: Art and Ideology in Orléanist France, 1830–1848.* New Haven: Yale University Press, 1988.

May, Robert E. *The Southern Dream of a Caribbean Empire, 1854–1861.* Baton Rouge: Louisiana State University Press, 1973.

Merk, Frederick. *Manifest Destiny and Mission in American History.* New York: Vintage Books, 1966.

Miller, Angela. "Emanuel Leutze's 'Westward the Course of Empire.'" Paper presented at the New England American Studies Association Annual Meeting, Boston, April 1986.

———. *The Empire of the Eye: Cultural Form and Meaning in American Landscape Art, 1820–1870.* Ithaca, N.Y.: Cornell University Press, Forthcoming.

———. "A Muralist of Civic Ambitions." In *Carl Wimar: Chronicles of the Missouri River Frontier,* 188–219. New York: Abrams, 1991.

Miller, Lillian B. "Charles Willson Peale as History Painter: *The Exhumation of the Mastodon.*" *American Art Journal* 13 (Winter 1981): 47–68.

———. "John Vanderlyn and the Business of Art." *New York History* 32 (January 1951): 33–44.

———. *Patrons and Patriotism: The Encouragement of the Fine Arts in the United States, 1790–1860.* Chicago: University of Chicago Press, 1966.

Miller, Perry. *Errand into the Wilderness.* Cambridge, Mass.: Harvard University Press, Belknap Press, 1976.

Mills, Robert. *Guide to the Capitol and to the National Executive Offices of the United States.* Washington, D.C., 1834.

———. *Guide to the Capitol and to the National Executive Offices of the United States.* Washington, D.C.: J. C. Greer, 1854.

Mitchell, Lee Clark. *Witnesses to a Vanishing America: The Nineteenth-Century Response.* Princeton: Princeton University Press, 1981.

Morgan, Edmund. *American Slavery—American Freedom: The Ordeal of Colonial Virginia.* New York: Norton, 1975.

Morison, Samuel Eliot. *The European Discovery of America: The Northern Voyages, A.D. 500–1600.* New York: Oxford University Press, 1971.

Morse, Jedediah. *A Report to the Secretary of War of the United States, on Indian Affairs.* New Haven, 1822.

Mossiker, Francis. *Pocahontas: The Life and the Legend.* New York: Knopf, 1976.

Murdock, Myrtle Cheney. *Constantino Brumidi, Michelangelo of the United States Capitol.*

Washington, D.C.: Monumental Press, 1950.

Nielson, George R. "Paintings and Politics in Jacksonian America." *Capitol Studies* 1 (Spring 1972): 87–92.

Nochlin, Linda. *The Politics of Vision: Essays on Nineteenth-Century Art and Society.* New York: Harper and Row, 1989.

Norton, Anne. *Alternative Americas: A Reading of Antebellum Political Culture.* Chicago: University of Chicago Press, 1986.

Norton, Paul F. *Latrobe, Jefferson and the National Capitol.* New York: Garland, 1977.

Novak, Barbara. "The Double-Edged Axe." *Art in America* 64 (January–February 1976): 44–50.

———. *Nature and Culture: American Landscape and Painting, 1825–1875.* New York: Oxford University Press, 1980.

O'Gorman, Edmundo. *The Invention of America: An Inquiry into the Historical Nature of the New World and the Meaning of Its History.* Bloomington: Indiana University Press, 1961.

O'Sullivan, John L. "Annexation." *United States Magazine and Democratic Review* 17 (July–August 1845): 5.

Owen, Robert Dale. *Pocahontas: A Historical Drama in Five Acts.* New York: George Dearborn, 1837.

Padover, Saul K., ed. *Thomas Jefferson and the National Capitol.* Washington, D.C.: Government Printing Office, 1946.

Parry, Elwood C., III. *The Image of the Indian and the Black Man in American Art, 1590–1900.* New York: Braziller, 1974.

Paulding, James Kirke. *Westward Ho!* 2 vols. New York: J. J. and Harper, 1832.

Peale, Rembrandt. "Reminiscences." *Crayon* 3 (January 1856): 6.

Pearce, Roy Harvey. *Savagism and Civilization: A Study of the Indian and the American Mind.* Baltimore: Johns Hopkins University Press, 1967.

———. "The Significances of the Captivity Narrative," *American Literature* 19 (March 1947): 1–20.

Percy, George. *Observations Gathered out of "A Discourse of the Plantation of the Southern Colony of Virginia by the English, 1606."* Edited by David B. Quinn. Charlottesville: University of Virginia, 1967.

"Persico's Columbus." *United States Magazine and Democratic Review* 15 (July 1844): 95–97.

*The Picture of the Baptism of Pocahontas.* Washington, D.C.: Peter Force, 1840.

*The Picture of the Embarkation of the Pilgrims from Delft-Haven in Holland, painted by Robert W. Weir.* New York: Boggs, 1843.

"The Pilgrim Fathers." *Ballou's Pictorial Drawing-Room Companion* 9 (August 11, 1855): 93.

"The Pioneer." *Family Magazine, or Monthly Abstract of General Knowledge* 7 (1840): frontispiece, 283.

Pohl, Frances K. *Ben Shahn: New Deal Artist in a Cold War Climate, 1947–1954.* Austin: University of Texas Press, 1989.

*Portraits of North American Indians, with Sketches of Scenery, etc., painted by J. M. Stanley.* Washington, D.C.: Smithsonian Institution, 1852.

Potter, David M. *Impending Crisis, 1848–1861.* Edited by Don E. Fehrenbacher. New York: Harper Torchbooks, 1976.

"Powell's Painting of De Soto." *Putnam's Monthly* 3 (January 1854): 117–120.

"Powell's Picture of De Soto." *Putnam's Monthly* 2 (November 1853): 574–576.

Pratt, Julius W. "John L. O'Sullivan and Manifest Destiny." *New York History* 14 (July 1933): 213–234.

———. "The Origin of 'Manifest Destiny.'" *American Historical Review* 32 (July 1927): 795–798.

Prescott, William H. *History of the Conquest of Mexico.* 3 vols. New York: Harper and Brothers, 1843.

Prioli, Carmine A. "Wonder Girl from the West'": Vinnie Ream and the Congressional

Statue of Abraham Lincoln." *Journal of American Culture* 12 (Winter 1989): 1–20.

Prown, Jules David. "John Trumbull as History Painter." In *John Trumbull: The Hand and Spirit of a Painter*, edited by Helen A. Cooper, 22–41. New Haven: Yale University Press, 1982.

Prucha, Francis Paul. *American Indian Policy in the Formative Years*. Madison: University of Wisconsin Press, 1971.

————. "American Indian Policy in the 1840s." In *Frontier Challenge: Responses to the Trans-Mississippi West*, edited by John G. Clark. Lawrence: University Press of Kansas, 1971.

————. *Indian Peace Medals in American History*. Madison: State Historical Society of Wisconsin, 1971.

————. *Indian Policy in the United States*. Lincoln: University of Nebraska Press, 1981.

Rauch, Basil. *American Interest in Cuba, 1848–1855*. New York: Columbia University Press, 1948.

Reynolds, Donald Martin. *Hiram Powers and His Ideal Sculpture*. New York: Garland, 1977.

Richardson, George. *Iconology; or, a Collection of Emblematical Figures*. 2 vols. London: G. Scott, 1789.

Richardson, James D., ed. *A Compilation of the Messages and Papers of the Presidents, 1789–1902*. Washington, D.C.: Bureau of National Literature and Art, 1904.

Ripa, Cesare. *Iconologie*. Translated by Jean Baudouin. Paris, 1644; New York: Garland, 1976.

*Robert Weir: Artist and Teacher of West Point*. West Point, N.Y.: Cadet Fine Arts Forum of the United States Corps of Cadets, 1976.

Roehm, Marjorie Catlin. *The Letters of George Catlin and His Family: A Chronicle of the American West*. Berkeley and Los Angeles: University of California Press, 1966.

Rogers, Millard F., Jr. *Randolph Rogers: American Sculptor in Rome*. Amherst: University of Massachusetts Press, 1971.

Rogin, Michael Paul. *Fathers and Children: Andrew Jackson and the Subjugation of the American Indian*. New York: Knopf, 1975.

————. *Ronald Reagan, the Movie, and Other Episodes in Political Demonology*. Berkeley and Los Angeles: University of California Press, 1987.

Rosenberger, Homer T. "Thomas Ustick Walter and the Completion of the United States Capitol." *Records of the Columbia Historical Society* 50 (1948–1950): 273–322.

Ross, Dorothy. "Historical Consciousness in Nineteenth-Century America." *American Historical Review* 89 (October 1984): 909–928.

Roundtree, Helen C. *Pocahontas's People: The Powhatan Indians of Virginia through Four Centuries*. Norman: University of Oklahoma Press, 1990.

Satz, Ronald N. *American Indian Policy in the Jacksonian Era*. Lincoln: University of Nebraska Press, 1975.

Savage, Kirk. "The Self-Made Monument: George Washington and the Fight to Erect a National Memorial." *Winterthur Portfolio* 22 (Winter 1987): 225–242.

Schimmel, Julie Ann. "Inventing 'the Indian.'" In *The West as America: Reinterpreting Images of the Frontier, 1820–1920*, edited by William H. Truettner, 149–189. Washington, D.C.: Smithsonian Institution Press, 1991.

————. "John Mix Stanley and Imagery of the West in Nineteenth-Century American Art." Ph.D. diss., New York University, 1983.

Schoolcraft, Henry Rowe. *Scenes and Adventures in the Semi-Alpine Region of the Ozark Mountains of Missouri and Arkansas*. Philadelphia: Lippincott, Grambo, 1853.

Schoonmaker, Marius. *John Vanderlyn, Artist, 1775–1852: Biography*. Kingston, N.Y.: Senate House Association, 1950.

Schwartz, Barry. *George Washington: The Making of an American Symbol*. New York: Free Press, 1987.

Scott, Pamela. "Building the Original Capitol: The Work of Benjamin Henry Latrobe and Charles Bulfinch." Paper presented at the United States Capitol Historical Society's Symposium on the Art and Architecture of the Capitol, Washington, D.C., March 15, 1990.

Senie, Harriet, and Sally Webster, eds. "Critical Issues in Public Art." *Art Journal* 48 (Winter 1989).

Sheehan, Bernard W. *Seeds of Extinction: Jeffersonian Philanthropy and the American Indian.* Chapel Hill: University of North Carolina Press, 1973.

Simms, William Gilmore. "Pocahontas: A Subject for the Historical Painter." In *Views and Reviews in American Literature, History, and Fiction*, edited by C. Hugh Holman, 112–127. Cambridge, Mass.: Harvard University Press, Belknap Press, 1962.

Simpson, Craig M. *A Good Southerner: The Life of Henry A. Wise of Virginia.* Chapel Hill: University of North Carolina Press, 1985.

Slotkin, Richard. *The Fatal Environment: The Myth of the Frontier in the Age of Industrialization, 1800–1890.* Middletown, Conn.: Wesleyan University Press, 1985.

———. *Regeneration through Violence: The Mythology of the American Frontier, 1600–1860.* Middletown, Conn.: Wesleyan University Press, 1973.

Smart, Leta Myers. "The Last Rescue." *Harper's* 219, no. 1313 (October 1959): 92.

Smith, Henry Nash. *Virgin Land: The American West as Symbol and Myth.* 1950. Rev. ed. Cambridge, Mass.: Harvard University Press, 1970.

Smith, John. *Captain John Smith: A Select Edition of His Writings.* Edited by Karen Ordahl Kupperman. Chapel Hill: University of North Carolina Press, 1988.

Smith, Robert C. "Liberty Displaying the Arts and Sciences." *Winterthur Portfolio* 2 (1965): 84–105.

Smith, Seba. *Powhatan: A Metrical Romance in Seven Cantos.* New York: Harper and Brothers, 1841.

"Some Unpublished Correspondence of Washington Allston." *Scribner's Magazine* 9 (January 1892): 68–83.

Spalding, Phinizy. *Oglethorpe in America.* Chicago: University of Chicago Press, 1977.

Spalding, Phinizy, and Harvey H. Jackson, eds. *Oglethorpe in Perspective: Georgia's Founder after Two Hundred Years.* Tuscaloosa: University of Alabama Press, 1989.

Sprague, Charles James. "American Independence: An Oration Pronounced before the Inhabitants of Boston, July 4, 1825." In *The Poetical and Prose Writings of Charles Sprague.* Boston: Ticknor, Reed and Fields, 1851.

Stehle, Raymond Lewis. *The Life and Works of Emanuel Leutze.* Washington, D.C.: Office of the Architect of the Capitol, 1972.

———. "'Westward Ho': The History of Leutze's Fresco in the Capitol." *Records of the Columbia Historical Society* 60–62 (1960–1962): 306–322.

Stein, Roger B. "Charles Willson Peale's Expressive Design: The Artist in His Museum." *Prospects* 6 (1981): 139–185.

———. "Thomas Smith's Self-Portrait: Image/Text as Artifact." *Art Journal* 14 (Winter 1984): 316–327.

Steiner, Wendy. *Exact Resemblance to Exact Resemblance: The Literary Portraiture of Gertrude Stein.* New Haven: Yale University Press, 1978.

Stone, Edward T. "Columbus and Genocide." *American Heritage* 26 (October 1975).

Strong, Pauline Turner. "Captive Images." *Natural History* 94 (December 1985): 50–57.

Stuart, Henri L. *William H. Powell's Historical Picture of the Discovery of the Mississippi.* New York: Baker, Godwin, 1854.

Tailfer, Patrick. *A True and Historical Narrative of the Colony of Georgia in America.* Edited by Clarence L. Ver Steeg. Charlestown, S.C.: Peter Timothy, 1741. Reprint. Athens: University of Georgia Press, 1960.

Takaki, Ronald. *Iron Cages: Race and Culture in Nineteenth-Century America.* New York: Knopf, 1979.

Taylor, Joshua C. "America as Symbol." In *America as Art*, 54–76. New York: Harper and Row, 1976.

Thistlethwaite, Mark Edward. *The Image of George Washington: Studies in Mid-Nineteenth-Century American History Painting.* New Haven: Garland, 1979.

Thompson, Arthur W. *Jacksonian Democracy on the Florida Frontier.* Gainesville: University of Florida Press, 1961.

Tighe, Josephine Gillenvater. "Brumidi, Michael Angelo of the Capitol." *Fine Arts Journal* (August 1910): 106–115.

Todorov, Tzvetan. *The Conquest of America.* Translated by Richard Howard. New York: Harper and Row, 1982.

Trachtenberg, Marvin. *The Statue of Liberty.* New York: Viking Press, 1976.

Trennert, Robert A., Jr., *Alternative to Extinction: Federal Indian Policy and the Beginnings of the Reservation System, 1846–51.* Philadelphia: Temple University Press, 1975.

Truettner, William H. "The Art of History: American Exploration and Discovery Scenes, 1840–1860." *American Art Journal* 14 (Winter 1982): 4–31.

———. *The Natural Man Observed: A Study of Catlin's Indian Gallery.* Washington, D.C.: Amon Carter Museum of Western Art and Smithsonian Institution Press, 1979.

———. "Prelude to Expansion: Repainting the Past." In *The West as America: Reinterpreting Images of the Frontier, 1820–1920,* edited by William H. Truettner, 55–95. Washington, D.C.: Smithsonian Institution Press, 1991.

Trumbull, John. *The Autobiography of Colonel John Trumbull, Patriot–Artist, 1756 to 1841.* Edited by Theodore Sizer. New Haven: Yale University Press, 1953.

———. *Description of the Four Pictures, from the Subjects of the Revolution.* New York: William A. Mercein, 1827.

Turner, Justin G. "Emanuel Leutze's Mural: *Westward the Course of Empire Takes Its Way.*" *Manuscripts* 18 (Spring 1966): 5–16.

Tuveson, Ernest Lee. *Redeemer Nation: The Idea of America's Millennial Role.* Chicago: University of Chicago Press, 1968.

*Vanderlyn's National Painting of the Landing of Columbus.* Washington, D.C. 1846. Archives of American Art, N52, frames 1006-1, 6.

Verheyen, Egon. "John Trumbull and the U.S. Capitol: Reconsidering the Evidence." In *John Trumbull: The Hand and Spirit of a Painter,* edited by Helen A. Cooper, 260–271. New Haven: Yale University Press, 1982.

Vermeule, Cornelius. *Hellenistic and Roman Cuirassed Statues.* Boston: Boston Museum of Fine Arts, 1980.

*Virginia, or, the Fatal Patent: A Metrical Romance.* Washington, D.C.: Davis and Force, 1825.

Warner, Marina. *Monuments and Maidens: The Allegory of the Female Form.* New York: Atheneum, 1985.

Warren, Charles. *Odd Byways in American History.* Cambridge, Mass.: Harvard University Press, 1942.

Washburn, Wilcomb E., ed. *The Indian and the White Man.* Garden City, N.Y.: Anchor Books, 1964.

Watterston, George. *A New Guide to Washington.* Washington, D.C.: Robert Farnham, 1842.

Webster, Daniel. "An Address Delivered at the Laying of the Cornerstone of the Bunker Hill Monument at Charlestown, Massachusetts, on June 17, 1825." In *The Works of Daniel Webster.* Vol. 1. Boston: Little, Brown, 1853.

Webster, J. Carson. *Erastus D. Palmer.* Newark: University of Delaware Press, 1983.

Weems, Parson M. L. *The Life of William Penn, the Settler of Pennsylvania.* Philadelphia: Uriah Hunt, 1836.

Weigley, Russell F. "Captain Meigs and the Artists of the Capitol: Federal Patronage of Art in the 1850's." *Records of the Columbia Historical Society* (1969–1970): 285–305.

———. *Quartermaster General of the Union Army: A Biography of M. C. Meigs.* New York: Columbia University Press, 1959.

Weinberg, Albert Katz. *Manifest Destiny: A Study of Nationalist Expansionism in American History.* Baltimore: Johns Hopkins University Press, 1935. Reprint. Chicago: Quadrangle Books, 1963.

Weir, Irene. *Robert W. Weir, Artist.* New York: House of Field-Doubleday, 1947.

Whiting, Cécile. *Antifascism in American Art.* New Haven: Yale University Press, 1989.

Wiedemann, Thomas. *Greek and Roman Slavery.* Baltimore: Johns Hopkins University Press, 1981.

Wills, Garry. *Cincinnatus: George Washington and the Enlightenment.* Garden City, N.Y.: Doubleday, 1984.

Wilmer, Lambert A. *The Life, Travels and Adventures of Ferdinand de Soto, Discoverer of the Mississippi.* Philadelphia: J. T. Lloyd, 1858.

Winthrop, Robert C. "The Pilgrim Fathers: An Address, Delivered before the New England Society, in the City of New York, December 23, 1839." In *Addresses and Speeches on Various Occasions.* Boston: Little, Brown, 1852.

Wolanin, Barbara S. "Constantino Brumidi's Frescoes in the United States Capitol." In *The Italian Presence in American Art, 1760–1860.* Edited by Irma B. Jaffe. New York: Fordham University Press; Rome: Istituto della Enciclopedia Italiana, 1989.

Woodward, Grace Steele. *Pocahontas.* Norman: University of Oklahoma Press, 1969.

Wright, Nathalia. *Horatio Greenough: The First American Sculptor.* Philadelphia: University of Pennsylvania Press, 1963.

———. "Horatio Greenough's Memorial to Congress Praying the Removal of His Statue of Washington from the Capitol." *Art Quarterly* 20 (Winter 1957): 400–406.

Wyeth, Samuel D. *Description of the Crawford Bronze Door.* Washington, D.C.: Gibson Brothers, 1865.

———. *The Federal City; or, Ins and Abouts of Washington.* Washington, D.C.: Gibson Brothers, 1865.

———. *The Rotunda and Dome of the U.S. Capitol.* Washington, D.C.: Gibson Brothers, 1869.

Young, Philip. "The Mother of Us All: Pocahontas Reconsidered." *Kenyon Review* 24 (Summer 1962): 391–415.

# Index

Page references to artworks are in boldface.